Sculpture 1900–1945

Oxford History of Art

Penelope Curtis was born in London in 1961 and grew up in Glasgow. Postgraduate research in Paris led to her PhD on 'É.-A. Bourdelle and Monumental Sculpture in France 1880–1930'. In 1988 she joined the new Tate Gallery Liverpool as Exhibitions Curator. In 1994 she moved to the Henry Moore Institute in Leeds, where as Curator she is now responsible for a programme of historical and contemporary sculpture exhibitions and other activities. She has published studies of Oto Gutfreund, É.-A. Bourdelle, Barbara Hepworth, Julio González and twentieth-century British sculpture, and has written catalogue essays for a number of contemporary artists.

Oxford History of Art

Sculpture 1900–1945

After Rodin

Penelope Curtis

Oxford University Press, Walton Street, Oxford OX2 6DP

Oxford New York
Athens Auckland Bangkok Bogota Bombay
Buenos Aires Calcutta Cape Town Dar es Salaam
Delhi Florence Hong Kong Istanbul Karachi
Kuala Lumpur Madras Madrid Melbourne
Mexico City Nairobi Paris Singapore
Taipei Tokyo Toronto Warsaw
and associated companies in
Berlin Ibadan

Oxford is a trade mark of Oxford University Press

Published in the United States by Oxford University Press Inc., New York

First published 1999 by Oxford University Press

British Library Cataloguing in Publication Data
Data available

Library of Congress Cataloging in Publication Data
Data available

0–19–284228–5 (Pbk)
0–19–210045–9 (Hbk)

10 9 8 7 6 5 4 3 2 1

Picture research by V. Stroud-Lewis
Designed by Esterson Lackersteen
Typeset by Paul Manning

Printed in Hong Kong on acid-free paper
by C&C Offset Printing Co., Ltd

Contents

Acknowledgements

I am grateful to David Fraser Jenkins for his encouragement at the outset of this project, and to Simon Mason for his engaged and positive outlook as my editor. I wish to thank Nicola Kalinsky, Philip Ward-Jackson, Patrick Elliott, Jennifer Mundy, Fiona Bradley, Christina Lodder and Martin Hammer, Elizabeth Cowling, and Erich Ranfft for reading individual chapters, and am particularly grateful to Christina Lodder for her help. I am grateful to Paul Andriesse and Laure de Margerie for hospitality during my stay in Amsterdam and Paris, which turned into reading-weeks. I must record genuine, if unspecific, gratitude to all those people I have met through the course of my work who have furthered my knowledge of sculpture. I should also like to thank friends for their support in the early months of 1998, particularly Hermione Wiltshire and Mary Ottaway, and, most of all, Richard Wrigley.

I am conscious that this book may, to some extent, have been written from the standpoint of a curator rather than that of an academic. Much of my life is spent grouping and re-grouping historical sculpture and working with contemporary sculptors. I very much believe in the need for interaction between the two areas, and conversations with Juan Muñoz, Richard Deacon, and Jorge Pardo allow me to hope that this book might make a contribution to that interaction. Indeed, I should most like to think that it might be read, with interest, by sculptors, or rather, artists today.

Penelope Curtis

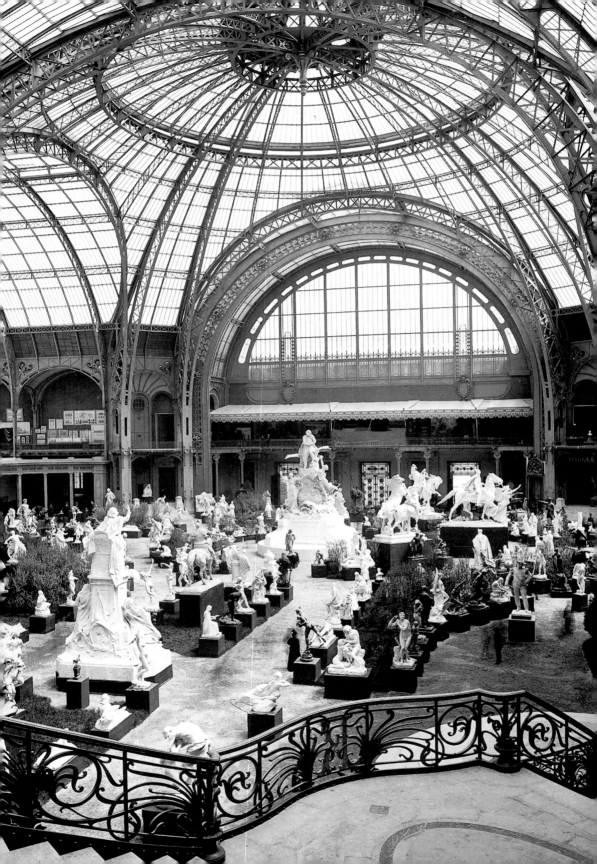

Preface

When I set out to write this book I tried to remember what would have been useful to me when I was a new student of the subject in the mid-1980s. The book I have written is neither a history of sculptors, nor of sculptures, but a more general account focusing on certain defining themes. Though it has many omissions, it tries to suggest a context within which a range of individual examples might be positioned. I am conscious of the preliminary nature of my attempts to find a way of talking about different kinds of sculptures and sculptors in the same narrative, but believe that, as such, it offers a useful starting-point.

Trying to fashion a survey for the history of sculpture is made difficult because of the lack of synthetic accounts giving sculpture a historical context. Sculpture has been so effectively set apart that one has little choice but to use monographic accounts and from them attempt to put together some kind of a story. The few other concise histories are now over 30 years old, and this book falls uncomfortably into a yawning gap.

The lack of attention which has been paid to sculpture could be seen as having spared it the canonic approach that has been applied to modern painting. Indeed, sculpture's diverse modes (including the monumental, the commemorative, and the architectural) should have saved it (at least before the Second World War) from being so narrowly conceived as painting. Given sculpture's deep-rooted and multifarious interactions with other art forms, media and sites, and therefore, in a sense, with history, the lack of any inclusive historical accounts may seem especially surprising. Or perhaps it is because of its very integration with other forms that writers have made it their task to separate out the sculpture, attempting to define what is peculiarly sculptural. This book might be seen as something of a reaction to the modernist orthodoxy, attempting as it does to put sculpture back into relation with a range of other phenomena. This perspective embraces a wide spectrum, encompassing many kinds of architects, sculptors, and painters, with widely differing kinds of practice. Such links emerge, in

different ways, in almost every chapter. Their prevalence explains why it is so hard, and perhaps so misguided, to attempt to write a 'history of sculpture' at all.

The form of this book derives from my original commission from Oxford University Press to write a book entitled 'Sculpture from Rodin to 1945'. Uncertain at first about allowing Rodin such a dominant position, I began to find that using him as my starting-point was more than a convenient shorthand. Accordingly, as the book has developed, Rodin has provided the point of departure for most of the thematic chapters, each of which attempts to cover the period from 1900 to 1945. Each is something of an essay in itself, but together they build up into what, I hope, gives a representative account of the ways that sculpture was practised in the period.

This means that this book is neither a comprehensive survey of sculpture, nor even a survey of Western sculpture, but a story which necessarily begins in the city of Paris. It develops around responses and reactions to Rodin, as manifested principally by sculptors in France, Germany, Britain, and America, and though the book may seem unduly biased towards Paris, it is worth pointing out how much more centralized the sculptor's education was in this period, and how common it was for sculptors from all parts of Europe, the Americas, and Australasia to study in Paris at the beginning of our period.

Introduction

Auguste Rodin was born in Paris in 1840; this book begins with him at the age of 60. As was common for sculptors at the time—and has been the case, to a lesser extent, until recently—Rodin had spent decades working up from being an apprentice to the point when, in 1900, he was able to promote his first solo exhibition in his own country, the point at which he could be said securely to have established his reputation.

Rodin chose to mount his own retrospective exhibition alongside the 1900 Universal Exhibition. It was held in a pavilion (the Pavillon de l'Alma, paid for by his patrons) which was later removed to his home in the suburbs of Paris. The site chosen in 1900 was that which had previously been occupied by pavilions dedicated to the work of Courbet and Manet, and Rodin was aware of these prestigious—and controversial—precedents. He exhibited over 150 sculptures, and many works on paper. This exhibition represented a kind of 'unveiling' for many of the ambitious schemes—the 'Burghers of Calais', 'Balzac', 'Victor Hugo'—on which Rodin had been working over the last decade, but there was one project in particular which his public knew it wanted to see. Rodin had received a commission for the work that was to become 'The Gates of Hell' in 1880, but it was not until 1900 that this work was finally shown in public.

The strong impression which Rodin's pavilion made on its visitors was undoubtedly heightened by its proximity to the Universal Exhibition. The experience of one man's obsessive and highly individual vision must have been strengthened by the bureaucratic eclecticism of the world fair. Rodin's unorthodox presentation was at once like a studio and a museum [1]. Leading thinkers in various disciplines—literature, aesthetics, and philosophy—now engaged with Rodin as a case study. Critical writing affirmed Rodin as the most modern, the most necessary, the equal of any historical predecessor. In France the Symbolist writers and poets were particularly appreciative, and organized a banquet to express their admiration, but the exhibition also

Rodin in his exhibition,
Pavillon de l'Alma,
Paris, 1900

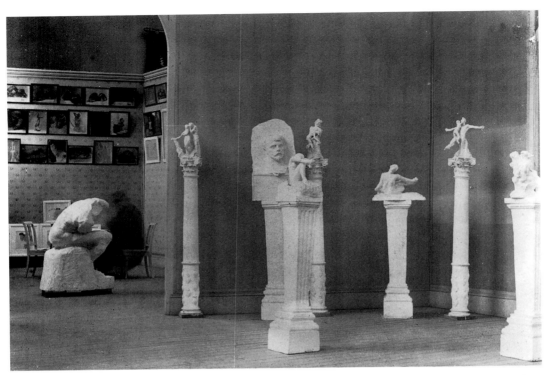

1 The Rodin exhibition,
Pavillon de l'Alma, Paris,
1900

Much of the 1900 Exposition
opened late, and Rodin's
exhibition was no exception. It
lasted from June to November
and Rodin was there in person
most days. Such was the
comparative grandeur of his
pavilion that many visitors took
it to be an official part of the
Exposition. The hall was
brightly lit by tall windows
and divided by screens into
smaller rooms which gave
the impression of an informal
intimacy, a significant combi-
nation that was later to be
repeated in the Musée Rodin.
It was something of a do-it-
yourself exhibition; the artist's
friend Arsène Alexandre took
on the catalogue, and Eugène
Druet arranged publicity and
invigilation, as well as a counter
where he sold his own photo-
graphs of Rodin's work.

brought Rodin into contact with a more international circle, and in particular, with some new, and influential, German admirers.

Rodin did very well from this venture, not only in terms of celebrity, but also financially. It established him internationally and brought him many new clients from all over the world. In the years to follow, before his death in 1917, Rodin's studio became a Mecca for the international world of art patronage. It was from this date that Rodin's workshop started to grow exponentially, in order to meet the new demands for his work, and in particular, for his portrait busts.

Rodin's workshop employed many who were developing their own careers, and among this group Frenchmen were most numerous. Sculptors like Despiau, Drivier, Pompon, and Wlérick worked for Rodin in various capacities, but as sculptors in their own right they also sought, and received, favours from their employer. Rodin was by now the voice which counted on the Jury for the sculpture submissions to the annual exhibition of the Société nationale des Beaux-Arts. His *praticiens* established successful careers in France, but have not achieved lasting fame. Those ready to be closest to him—and one might also cite American disciples, like Malvina Hoffman—are those whose work has been judged least favourably by later generations.

It was around this time that the acknowledged centre in artistic training passed from Germany to France, and thus artists from central Europe—from the countries that were part of the Austro-Hungarian

Empire—went to Paris instead of Munich or Düsseldorf, and sought out Rodin on their arrival. But beyond this, Rodin was a unique object of fascination for most young sculptors, who made pilgrimages from all over Europe and America. Many sculptors who went to visit either never worked for him and were never really integrated into his workshop, or sought to make their careers outside the French Salon system. In consequence it is easier for us to demarcate individual careers among the sculptors who came to see Rodin from outside France.

For anyone establishing a sculptural career in the first years of the century, Rodin was an obvious bench-mark. Though most of the more distinctive sculptors reacted against him, he was their point of departure. This was the case for a whole range of sculptors from the next generation (mostly born between 1860 and 1880) from all over Europe: Bernhard Hoetger, Max Klinger, Georg Kolbe, Karl Albiker, Ernesto de Fiori, Edwin Scharff and Wilhelm Lehmbruck from Germany, Elie Nadelman from Poland, Carl Milles from Sweden, George Minne from Belgium, Gustav Vigeland from Norway, Joseph Csáky from Hungary, Josef Mařatka and Bohumil Kafka from Czechoslovakia, Jacques Lipchitz from Lithuania, Anna Golubkina, Nikolai Andreev, Ossip Zadkine and Alexander Archipenko from Russia, Josep Clara from Spain, and, most famously, Constantin Brancusi from Romania.

Rodin serves to introduce, and to act as a foil for, developments which might be seen as the keys to an understanding of the evolution of sculpture in this period. Paris was already the major artistic centre; Rodin's reputation strengthened and complicated its attraction for sculptors. He worked within the Salon tradition, but also created space for a developing avant-garde. Rodin returned sculpture to the forefront of artistic discussion; once again a sculptor was as pertinent as a painter.

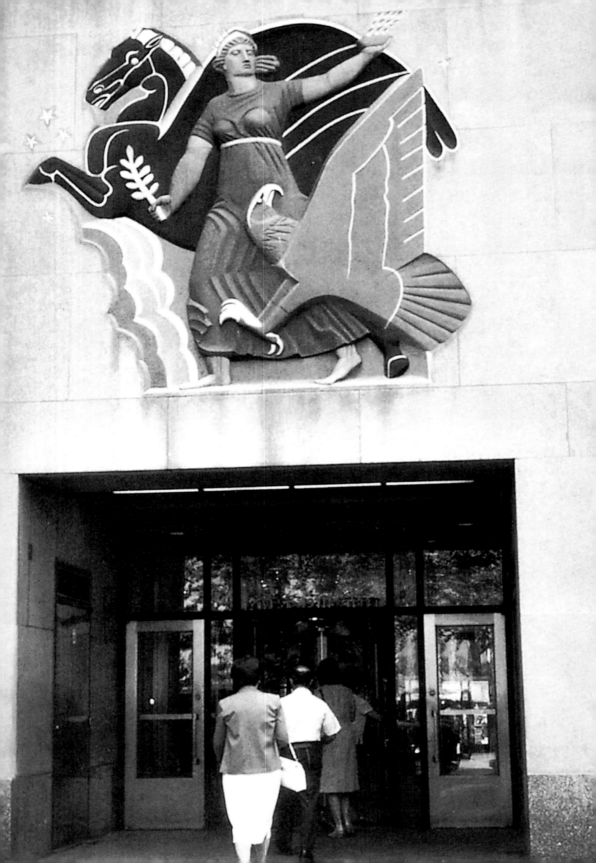

The Public Place of Sculpture

1

All around us, in our streets and city squares and on the façades of the buildings we walk past, is the work of the sculptors of the early twentieth century [2]. Our towns and cities are predominantly late nineteenth or early twentieth century in their current appearance, and sculpture is a recurrent part of their fabric. Its place ranges from the doorway to the façade to the tympanum; from the garland to the putto to the statue. Despite its prevalence, the authors of this work are largely ignored, and indeed few ever expected to be named. Sculpture's close association with the fabric of the built environment meant that it took much longer than painting to shake off its deep-rooted connection with a public function. Sculpture was only quite rarely assessed for itself in the gallery; it was mostly made for other arenas, where it followed a different set of conventions. Sculpture had a task to perform; it was a filter to something else beyond itself.

Sculpture's durability suited outdoor and public sites, and especially commemorative purpose. Memorials were designed to preserve the names of those they commemorated, rather than those who designed them. Sculptors were at the service of their clients. Sculpture was used to mark and demarcate, to record and embellish. Though some sites may have been relatively inconspicuous—the façade or the fountain—others—the tablet or panel—were downright 'invisible'. But even important monuments, occupying key positions on city streets and squares, were seldom known by the name of their authors, even at the time of their making.

It is notable how, in the speeches of inauguration delivered at the unveiling of monuments, the sculptor's name is rarely mentioned. Sculptors worked behind the scenes, and were employed for their ability to perform and conform, not for their individuality. Inaugural speeches by ministers in the French Third Republic unite the government, the citizens, and the artist in their celebration of individual achievement. The artist, however, almost invariably remains an anonymous concept, rather than a named individual.

Urbanization

From the mid-nineteenth century onward, sculpture was increasingly allied to the aims and ideals of the bourgeois state. Sculpture's own role, however, was substantially unchanged. Though his patron was now government rather than king or church, the sculptor was still employed to carry through a public programme. At the same time, and for the first time, countries saw their populations increasingly weighted in favour of city-dwellers. Britain was ahead of other countries in this respect, where by 1850 a numerical balance had been achieved between the rural and urban populations. As the industrial revolution spread across Europe, other countries experienced the same shift. This reversal of the demographic status quo had many implicit effects on sculpture, but one explicit one should be emphasized. As cities grew from being essentially medieval clusters to sprawling conurbations, it became increasingly necessary to bring in town planners to give order to the results of unregulated growth. With the wider boulevards that were part of the new grid plans—from Paris or Vienna to Buenos Aires— came empty spaces that demanded embellishment or identity. As cities were rerouted and replanned, sculptors were employed to provide definition, or focus, or simply to fill unsightly gaps. Sculpture provided the imagery to express otherwise anonymous improvements in sanitation, health, and housing. Some crossroads were filled with important commemorative statues, while others were adorned with more decorative sculpture, often in the form of pools and fountain arrangements, marking the 'improved spaces' made possible by municipal planning [3, 4].

3 Raoul Larche
La Seine et ses affluents,
Grand Palais, Paris, 1910

4 Carl Milles
Orpheus Fountain, Concert
Hall, Hotorget, Stockholm,
1926–36

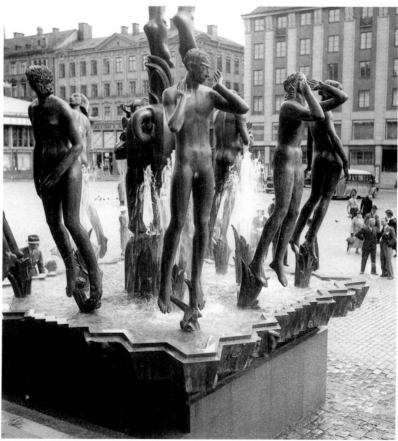

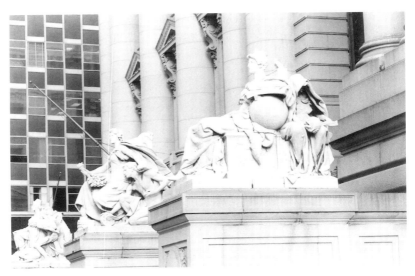

The new seats of government, culture, and learning which came with the bourgeois state required significant new public buildings. In Vienna the construction of the Ringstrasse in the last decades of the nineteenth century offered many sculptors employment on prestigious public buildings for the Crown: the theatre, art gallery, and university. In Belgium, King Leopold II's ambitions to make Brussels as grand as Paris led to the employment of the French architect Charles Girault on a lavish building programme. The grand buildings erected in Stockholm in the early years of the twentieth century—the Law Courts, Town Hall, Technical University, Svenska Lloyd—were decorated by the sculptors Gustave Sandberg, Ivan Johnson, Carl Fagerberg, and Sidney Gibson. The expansion and specialization of American federal government at this time necessitated the building of many new government buildings, courthouses, and state capitols, all of which brought work for the sculptor. The United States Custom House [5] was the first structure in New York City to be built under the provision of the 1893 Tarnsey Act, a measure designed to protect architects and allow them to compete in a fair market-place. The chosen architect, Cass Gilbert, attempted to protect sculptors in their turn, and to provide them with proper working procedures, without being subjected to a contractor.

The urbanism of New York, Barcelona, or Brussels required buildings which demonstrated status, even if it was, quite literally, only on the surface. Company headquarters, as much as public buildings, offered employment to the sculptor who was ready to throw in his lot with a brief that was primarily architectural. As the *New York Tribune* noted in 1897, 'cautious proprietors ... see now that without sculpture a new building looks somehow inferior to its neighbours. In other words, art is getting to be the fashion ...' One year later the sculptor

Karl Bitter, writing in *Municipal Affairs*, suggested that 'it will be necessary for the landscape gardener, the architect and the sculptor to go hand-in-hand ...'.

As the civic map was completed, the spaces available to architects and sculptors descend the hierarchy from public to private, from civic to commercial to residential, radiating out from the centre towards the suburbs occupied by the growing middle classes. One can take almost any element of such urbanism—from the town hall, train station, or office building, to the park, bridge, or apartment block—and trace a surprisingly uniform trajectory across Europe and America. It is in such places, and on the very building types which represent nineteenth-century innovation, that we find the bulk of sculpture made in our period.

Centralized planning

In the United States the 'City Beautiful' movement led by Daniel Burnham took hold around the turn of the century with its demand for greater civic planning—wide boulevards punctuated with public spaces adorned with decorative features—in order to deal with dramatic urban growth. The architect Richard Morris Hunt (trained at the École des Beaux-Arts in Paris) was an influential promoter of the sculptor's role. He worked with the sculptor John Quincy Adams Ward, while fellow architects McKim, Mead, & White used Augustus Saint-Gaudens to realize a similar ideal. In the first decade of the century the partnership of municipal government and powerful trustee bodies ensured that the new buildings for New York's museums and libraries were realized on an ambitious scale, with an important place for architectural sculpture.

The laying out of ordered and symmetrical urban spaces, adorned with statuary, was widespread among cities at this time, though the scale depended largely on the effectiveness of municipal governments. Though town planning may be seen as the result of municipal democracy—its visible and symbolic test—it was most thoroughly implemented by the authoritarian regimes which emerge in the latter part of our period. The master plans for Rome, Moscow, and Berlin date from 1932, 1935, and 1937 respectively. Though Mussolini and Hitler looked to a nominal imperial past, neither was over-concerned about the preservation of the historical monuments in the way of their new schemes. Mussolini aimed to recreate Rome as it had been in the time of the Emperor Augustus, a marvel of the world, 'vast, ordered, powerful', but his Via dell'Impero buried much of the recently excavated Forum. Hitler regarded architecture as 'the Word in stone' and spoke of 'building for eternity'. In Albert Speer, who made his own calculations as to the likely presence of his buildings in distant centuries, Hitler hoped he had found the architect who would 'immortalize [our ideals] in stone'.

World fairs and *expositions universelles*

Some of the most remarkable examples of sculpture from this period, and of architectural sculpture in particular, arise out of the wave of international exhibitions held in the second half of the nineteenth century and the first half of the twentieth. Exhibition planning allowed the temporary realization of theories and arguments that otherwise remained on the page. The Columbian Exposition, the 'White City', gave many American architects and sculptors a concrete experience of working together in coordinated teams to produce the 'City Beautiful' [**6**]. Karl Bitter worked under the supervision of Saint-Gaudens at this 1893 Exposition, and went on to mastermind the Exhibitions at Buffalo (1901) and St Louis (1904). The 1915 Panama–Pacific Exposition in San Francisco brought together those American sculptors who had mostly been trained in Europe, with European sculptors who had made America their home.

In addition to providing an international showcase for individual exhibitions (at the 1911 Rome and Turin Expositions, Meštrović and Ligeti produced sensations in their respective Serbian and Hungarian pavilions), Expositions were also occasions for bravura displays of 'holiday' architecture. The Grand Palais, built for the 1900 Exhibition in Paris, carries some exuberant examples of the sculptor's art, none more striking than Recipon's copper quadriga, 'Harmony mastering

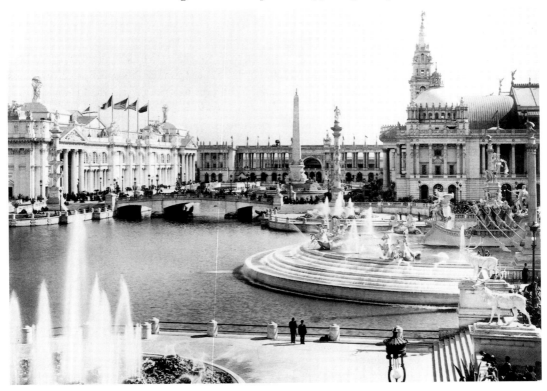

Discord' atop the roof. Jan Stursa collaborated with Jan Kotěra on the Pavilion of Commerce and Industry at the Prague 1908 Jubilee Exhibition, learning how to make effective monumental and architectural sculpture. Things had changed very little at the end of our period. For the 1939 New York World Fair Carl Milles made the vast 'Pony Express' (in plaster), William Zorach the 5-metre 'Builders of the Future', and Malvina Hoffman the 'International Dance Fountain'.

These projects were directed by professionals who had made their names as 'exhibition' architects, known for their ability to supervise large teams of sculptors working in very short periods of time. For the St Louis Fair Bitter had to mastermind the creation of 250 sculptural groups and 1500 single figures within the space of a year. Much of the exhibition sculpture was never intended to be permanent, and was indeed fabricated in 'staff', a modelling amalgam suited to speedy work and ease of transportation. We are in consequence normally reliant on photographs for information about the nature of these Expositions which allowed interesting, if temporary, alliances, some of which speak of more fluid aesthetic parameters than those which have come down to us in permanent form. Showcase collaborations brought together the 'traditional' sculptor with the 'modernist' architect; Gerhard Marcks, Richard Scheibe, and Moissey Kogan provided the sculpture for Walter Gropius's machine exhibition hall at the 1914 Cologne Werkbund Exhibition and Georg Kolbe's 'Bather' adorned the fountain outside. In 1929, at the Barcelona Fair, another work by Kolbe graced the pool within Mies van der Rohe's pavilion.

Some projects were designed for the longer term, and indeed Expositions have permanently marked the layouts of some of the cities where they were held, Paris first among them. As cities became more used to the phenomenon, they took the chance to plan ahead. This shift towards longer-term planning allowed for the 'petrification' of an exhibition architecture which had traditionally employed a good deal of decorative sculpture.

Barcelona still bears witness to its 1929 International Fair, and to the sculptural ensembles created by Josep Llimona, Josep Clara, and Pablo Gargallo among others, for the new avenues, squares, and fountains. In Paris, whereas little survived the 1925 Exposition, further opportunities in 1931 and 1937 were better planned, refining the style which had emerged in 1925. The Musée des Colonies, with Alfred Janniot's monumental bas-relief, was first erected for the 1931 Exposition coloniale, but specifically designed to be permanent. Such forethought allowed for the matching of key institutions to key sites, involving their creators in higher-quality and more prestigious commissions. We see this in the sites which have survived the 1937 Exposition, the Musée d'Art Moderne and the Palais and Jardins de Chaillot, both amply adorned with free-standing and relief sculpture [134].

6 Frederick MacMonnies

Columbian Fountain, World's Columbian Exhibition, Chicago, 1893

The fair designed to celebrate Columbus's discovery of America and the nation's coming of age ran for six months in Chicago's Jackson Park. It acquired its nickname because of the guidelines which Burnham laid down so as to ensure uniformity; the buildings were to be Beaux-Arts, to a standard height, and all painted white. Sculptors were enthused by the significant role which the fair afforded them — their largest ever opportunity. Saint-Gaudens advocated the use of young Americans who had trained in Europe, and even women — Janet Scudder, Enid Yandell, Bessie Potter Vonnoh — received commissions. The illustration shows Frederick MacMonnies's 'Columbian Fountain' with its 'Barge of State'.

The hierarchy of labour

Sculpture was rendered anonymous in different ways: in terms of its 'ownership', its function, its physical position, and the collective nature of its fabrication. Much civic sculpture was nominally owned by the citizenry, and was a fountain, a portrait, a marker or a tablet before being a work of art. The possibility of attribution was (and is) complicated by its very real distance, high up off the street, far from our eyes. The fact that the chain of command involved different workers with different degrees of authority has further encouraged the tendency not to differentiate work which, after all, was designed to be cohesive. The 'named' sculptor was invariably backed by a whole team of trusted helpers, many of whom would be practising or aspiring sculptors themselves.

In the opening decades of his career Rodin had his place among the teams of sculptors working on the façades of the new buildings that were going up in Paris. He worked with, or as assistant to, other sculptors for a considerable part of his early career: first for Carrier-Belleuse in Paris and Brussels (displaced by reason of the Franco-Prussian War), then in partnership with Van Rasbourgh, and then for Charles Cordier in Nice. The buildings on which Rodin worked in Brussels give a good indication of the kind of work taken up even by talented sculptors and of how elusive it is to our eyes: the enormous Exchange building, the Palais Royal and the Boulevard Anspach, the Conservatoire de Musique and the Palais des Académies [7].

Back in Paris from 1877 Rodin continued to work for Carrier-Belleuse, who had become director of the Sèvres porcelain factory. He was also employed by Eugène Legrain, whose commission for the following year's Universal Exhibition meant that Rodin was represented by unattributed decorative heads on a fountain rather than by an attributed submission of a 'work of art'. In 1879 he was one of over a hundred sculptors offered employment on the decorative scheme for the new Hôtel de Ville [8], a replacement for the building which was burned down in 1871 and a building site for the next 20 years. (We find counterparts in London's Victoria & Albert Museum, with a scheme of 42 portrait statues executed by a team of sculptors including Bayes, Drury, Goscombe John and Pegram; in Stockholm's Dramatic Theatre which brought together Milles, Borgesson, Lundberg, Lindberg, and Neujd; in New York's Supreme State Court (1896–1900) which united twelve sculptors, or in Prague's Municipal House (Obecní Dům, 1905–11) undertaken by a large team of artists including Saloun, Maratka and Uprka.) Such sculptural works attract little attention, but if we do not recognize the subjects, still less do we recognize their authors. The individual sculptures had to be subordinated to an overall design. Only by looking specially, and out of context, do we see the figure of d'Alembert on the Hôtel de Ville as a 'Rodin'. Such 'invisibility' did cause sculptors some concern, but more worrying was sculpture's secondary position

**7 Henri Rieek (arch)
and Auguste Rodin (sc)**

Cornelis building, Boulevard
Anspach, Brussels, 1872
(destroyed 1929)

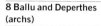

**8 Ballu and Deperthes
(archs)**

Hôtel de Ville, Paris, 1873–92
The new Hôtel de Ville — an
enlarged but largely faithful
version of its predecessor —
was one of the largest building
projects of the French Third
Republic and provided work
for 230 sculptors. In deciding
the commemorative and
decorative programme for the
106 (later 108) niches on the
four façades, the restorers
chose to commemorate only
personalities born in Paris,
which meant that about half
those originally represented
among the 46 statues of the
previous building now disap-
peared. Well over half the
niches (71) were filled by
portraits of men of letters and
the arts, and Aubé, Boucher,
Chapu, Dampt, Idrac, Injalbert,
A. Lenoir, Marqueste, Moreau-
Vauthier and Turcan counted
among Rodin's many
colleagues.

to architecture. Most sculptors were educated to work with architects, and the question was not how to disengage from this relationship, but how to make the collaboration more actively equal.

The alliance of sculpture and architecture: the relief

Around the turn of the century there was an increasing interest in blending architecture and sculpture into a sympathetic whole. A text-book example of this concern is in London's Institute of Chartered Accountants (1893) [9], the twin project of an architect, John Belcher, and a sculptor, Hamo Thornycroft, both founding members of the Art Workers' Guild which was pledged to unite all the aesthetic arts. Belcher chaired the meeting at which the Guild was founded in 1884. The Guild deplored the 'trade decorations of our buildings', and in 1888 Belcher gave a paper to a new Association for the Advancement of Art and its Application to Industry which aimed at a more constructive dialogue between artists and artisans. His speech was entitled 'The Alliance of Sculpture and Architecture', and in it he begged architects to treat the work of sculpture 'as a jewel whose beauty is to be enhanced by an appropriate setting'. (Words echoed by the prolific Scottish sculptor, James Pittendrigh Macgillivray, in 1917: 'Architecture is the necessary setting or background of sculpture. Sculpture inhabits architectural places; it is for the jewelling of cities.') Nevertheless, it was quite clear to Belcher that it was the architect who chose from the panoply of sculptural devices and settings:

What a wide range of the sculptor's art is at his disposal, internally and exter-nally, on pedestals, in niches and pediments, figures and groups, symbolising the purpose of the building, and the work to be carried out in it; figures in re-lief, friezes and panels; in a lesser degree also by the representation of animal or vegetable life in connection with decorative forms.

It should be noted that the alliance on the scheme went further than simply that of two men; Thornycroft was assisted by sculptors like C.J. Allen and John Tweed, and also by the firm Farmer & Brindley, with whom the sculptor Harry Bates worked to carry out the decora-tive detailing.

Belcher cautioned against adding on sculpture at the end of a build-ing project simply for the sake of variety in texture, profile, or silhou-ette. He proposed the broad brush instead of the detail—'fresco work' instead of 'pedestal work', as he put it—so that sculpture would unify the building. His words of caution can be seen to be directed against the prevailing trend of the previous decades. A work that echoes his advice is the scheme for Lloyd's Shipping Register (1900–1), also in London, where the sculptor George Frampton collaborated with the architect T.E. Collcutt. Frampton was also a Master of the Art Workers' Guild, and indeed preferred the title 'art worker' to that of 'sculptor'.

**9 John Belcher (arch)
and Hamo Thornycroft (sc)**

Institute of Chartered
Accountants Building,
Moorgate Court, London,
1888–93

Such concerns were widespread at this time. Collaboration between sculptor and architect was unusually wholehearted in Holland. Van den Eijinde's work on the Navigation House in Amsterdam, van Lunteren's on Rotterdam Post Office and Lambertus Zijl's with H.P. Berlage on the Netherlands Insurance Company at the Hague are examples of such partnerships. Berlage's Bourse [**10**] in Amsterdam, built in the first years of the century, carried verses on its façade by the poet Albert Verwey which echoed the architect's wish that the various elements in his building be seen as one:

> Whoever tries to clothe this bourse with art—
> For Architecture's Grace is Ornament—
> Look in your spirit how its space is blent
> Together separate, whole and yet apart

Lambertus Zijl carved reliefs to accompany these quatrains around the exterior, and with his colleague Mendes da Costa supplied bas-reliefs for the interior. Here was a more spirited attempt at successfully reconciling the complementary roles of architect and sculptor. The success of the frieze formula as a way of balancing the contribution of architect and sculptor, architecture and sculpture, is shown in its use, over the succeeding years, all over Europe and America.

Art Nouveau

The interest in 'sculptural frescoes' was well suited to the concerns of Art Nouveau to unify aesthetic environments by means of collaborative work across a number of disciplines. Art Nouveau was used as much on the interior environment as the exterior, and was indeed first unveiled, in 1895, within the space of a shop, a retail *Gesamtkunstwerk*. This domestic—or holistic—emphasis was perpetuated in Art Nouveau's subsequent manifestations within the 'Maison d'Art' in Brussels, and the 'Maison Moderne' and 'L'Art dans l'Habitation' in Paris. Art Nouveau, or its central European counterpart, Jugendstil, allowed unusually generous scope to the sculptor in the creation of a total ambience. While some might argue that this scope was primarily functional and small-scale, it encouraged a different approach to subject and material, and some of the most considered contributions are details such as door-handles in silver or copper, or decorative pieces in ivory. A good example is Josef Hoffmann's luxurious Palais Stoclet in Vienna (1905–12) where the sculptor George Minne provided table and foyer decorations, and the stone-carver and fellow member of the Wiener Werkstatte, Franz Metzner, designed the four beaten copper figures for the tower. The role accorded to the sculptor was perhaps more generous in the interior, for the very flexibility of Art Nouveau allowed the architect to become his own sculptor and the façades of Gaudí, Guimard, Horta, Endell, or Shektel' had little need of additional input.

In Russia the work of Viktor Vasnetsov across a range of media set the tone for the vigorous teamwork which emerged around the turn of the century. The architect Fedor Shektel' credited Vasnetsov with demonstrating how 'mood' could be created by the incorporation of sculpture and painting into architecture, as did his own protégé, the

11 Stanislav Sucharda (sc) and Jan Kotěra (arch)

Okresní Dům, Hradec Králové, 1903–4

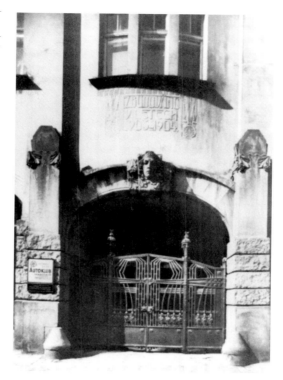

12 Mikhail Vrubel'

Majolica stove-seat at Abramtsevo, 1890

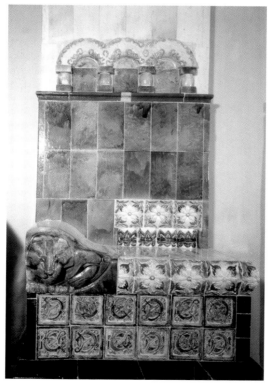

artist Mikhail Vrubel'. Vasnetsov was an important participant in the studios at Abramtsevo, near Moscow, where a communal style, deriving from past and present folk traditions, established across disciplines to create an integrated living environment, was developed in the 1880s and 1890s. The church which he designed there set the precedent for later buildings, such as the Moscow Arts Theatre (1902) by Shektel', with an entrance relief designed by Anna Golubkina, and the Hotel Metropol (Walcot, 1898–1903), for which Vrubel' and Golovin made majolica panels and Nikolai Andreev the frieze.

The Czech architect Jan Kotěra (who trained in Vienna with Otto Wagner before returning home to teach at Prague's School of Decorative Arts) was particularly engaged in working out the contemporary problem of the role of decoration—seeking a balance between mass and surface—and used the resurgence of interest in Czech folk art as a way forward. Kotěra's partnership with sculptors was always sympathetic, and one might cite his work with Stanislav Sucharda in Hradec Králové on both the Okresní Dům [11] (1903–4) and (though no longer in Art Nouveau style) on the Museum.

The international and the national

In many ways Art Nouveau was an international language, understood from Glasgow to St Petersburg. At the same time, however, the flatness of its forms seemed to encourage an alliance with the folkloric motifs which were taken up by the many nationalist movements emerging in central Europe in the years before the First World War. Thus, for example, in Russia one can identify both a westward-looking St Petersburg *Moderne* and a backward-looking Moscow *Moderne* based on a historicist nationalism.

Abramtsevo was influenced by the ideas of William Morris and John Ruskin and their concern with the restoration of true craftsmanship and its anonymous medieval tradition. Its amalgam of national art with Art Nouveau or Style Moderne found great international success in 1900 as Le Style Russe and led to the creation of other artists' colonies with workshops for crafts such as woodcarving, furniture-making, and ceramics. Folk art, deriving from different material disciplines, offered a way out of the narrow cul-de-sac in which a number of sculptors found themselves. While Vrubel' exploited the ceramic workshop to the full [12], with adventurous majolica works which took their place on every part of the Style Moderne building, others, such as Sergei Malyutin, who ran the joinery workshop at Abramtsevo, and Sergei Konenkov, looked to their own backgrounds in the local peasant carving tradition for their contributions to the furnishing and decoration of the new interior.

A museological interest in indigenous folk art is part of the wider historicism which marks the nineteenth century, and which also

13 Émile-Antoine Bourdelle
(sc) and Auguste Perret (arch)

Théâtre des Champs-Elysées,
Avenue de Montaigne, Paris,
1913

É.-A. Bourdelle, who played
a central role in the complex
evolution of this project, was
formally commissioned in
1911 to provide the 15m-long
frieze and five reliefs for the
façade. His schemes drew
on notes taken during perfor-
mances given in Paris by
Isadora Duncan. Although
the theatre is famous for
being in reinforced concrete,
Bourdelle's reliefs were carved
in marble, on only two planes,
one of which is that of the
building's façade, thus rein-
forcing its simple plasticity.
Bourdelle was also respon-
sible for reliefs and frescoes
in the theatre's interior.

affected sculptors in terms of the growing concern to restore historic buildings. Though widespread geographically, such restoration was often phrased in nationalist terms, especially after the damage wrought by the First World War. Sculptors were employed on programmes of stone-carving: some were deeply impresssed by a way of working that was new to them, though others found it a deception. Between 1898 and 1908 Gustav Vigeland earned his living by working on the restoration of the medieval cathedral at Trondheim. Though Vigeland later considered his obedience to any one 'style' to have been a waste of his time, the influence of his Gothic foundation is nevertheless apparent in his work.

'To mingle with the architect': the façade

One way of being 'modern' in the decades at the turn of the century was to be interested in collaboration, necessarily putting individual pre-eminence to one side. Sculpture had to look as if it was not simply added on at the end, but was thought through, from the beginning, by the sculptor in tandem with the architect, as a fundamental part of the building. In part this was realized by means of a changed relationship with material so that, as sculptors became more interested in stone, their own contribution could more effectively take its place as a real element of the façade as a whole.

For the first two or three decades of this century, the façade was an important place for the avant-garde sculptor, and the work by Émile-Antoine Bourdelle on the Théâtre des Champs Élysées (1910–13) [13] in Paris, carried out in association with the architects van de Velde and

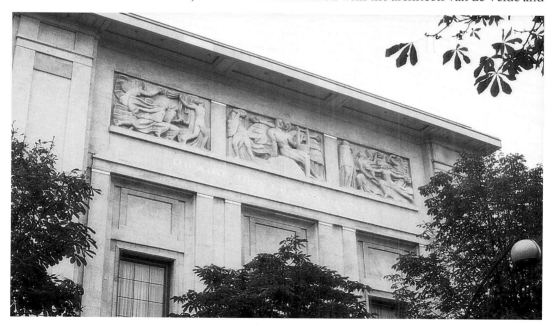

Perret, was often held up as an example of the new architectonic honesty. The fact that its panels were carved off-site by a team of workmen did not prevent the theatre's admirers from seeing Bourdelle's frieze as integral to the building itself.

A notable example of the union of sculpture and architecture is in the work of the Austrian Franz Metzner on the Haus Tietz department store in Düsseldorf and the Haus Rheingold restaurant in Berlin [14]. In his 1917 lectures the American sculptor–critic Lorado Taft noted that here the 'sculptural adornments are not the casual groups and figures that are set upon shelves on our façades, but are, as it were, an efflorescence of its rough stones ... they are organic, growing out of the very structure itself. Its treatment seems to have been dictated by the stone of which it is made ...'

Metzner's flattened and graphic relief work was an influence on the later style of Karl Bitter, an Austrian who went to America as a young man and used his early experience of the Viennese building projects to establish an influential role for himself there as an architectural sculptor and organizer. Bitter's return visits to Vienna weaned him away from American Beaux-Arts realism towards a stylization in greater

14 Frans Metzner
Gable sculpture, Haus Rheingold, Bellevuestrasse, Berlin, sandstone, 1906 (destroyed)

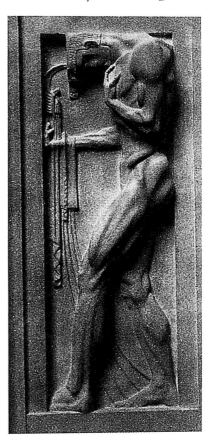

harmony with the plane of the façade. In 1914 Bitter lamented the fact that the sculptor was no longer trained 'to mingle with the architect', but had become primarily a producer of gallery pieces, which he identified as the work of the *statuaire*.

Partnerships

While Bitter regretted his peers' focus on the gallery rather than on the building, architectural sculpture was enjoying some (intermittent) favour with the avant-garde. The visionary patron Karl-Ernst Osthaus put his faith in the union of the architect and the sculptor, not only commissioning George Minne to make a fountain for the entrance to his Folkwang Museum, but even supporting Milly Steger with her decorative architectural sculpture so that in 1914 she became official sculptor to the city of Hagen.

It will already be becoming clear that certain architects were especially predisposed towards giving sculptors a defining role. In Czechoslovakia Jan Kotěra is notable for the quality of his teamwork first with Sucharda, and then with Jan Stursa. Stursa later worked with the architect Josef Gŏcár, on his Banka Legii, Prague, 1921–3, along with the sculptor Oto Gutfreund. Gŏcár, who had himself trained with Kotěra, was similarly concerned to move out of academicism by working with sculptors on a more equal footing. In Sweden Milles had owed his civic commissions to the architects I.G. Clason, Ferdinand Boberg, and Ivar Tengbom, and was able to establish himself in the United States from 1931 because of the interest shown by Holabird & Root in harnessing his style to their practice. Milles stressed, 'architecture means cooperation between architects, engineers, sculptors and painters. The two last ones must come to the same monumental level as the architects and in the first place it has to be architects who wish for their co-operation and give them their support' with the aim that 'the works of the sculptor be of the same monumental character as the development of the modern architecture of the United States'.

In Britain John Belcher might be seen to be followed by Charles Holden, who shared his love for their mutual predecessor, C.R. Cockerell, and who was responsible for two of the London buildings which famously brought avant-garde sculpture into an alliance with architecture: the British Medical Association building on the Strand (1907–8), and the London Underground Headquarters (1928). If Holden had had his way, a third would have been added to this list, London University's Senate House (1934).

While the form of Jacob Epstein's British Medical Association decoration is perhaps more traditional than Belcher's earlier advocacy of the fresco-like frieze, Epstein's subjects are a radical departure in being more or less a series of private works. Indeed, this was how they were taken by a section of the press, who regarded them as gallery works,

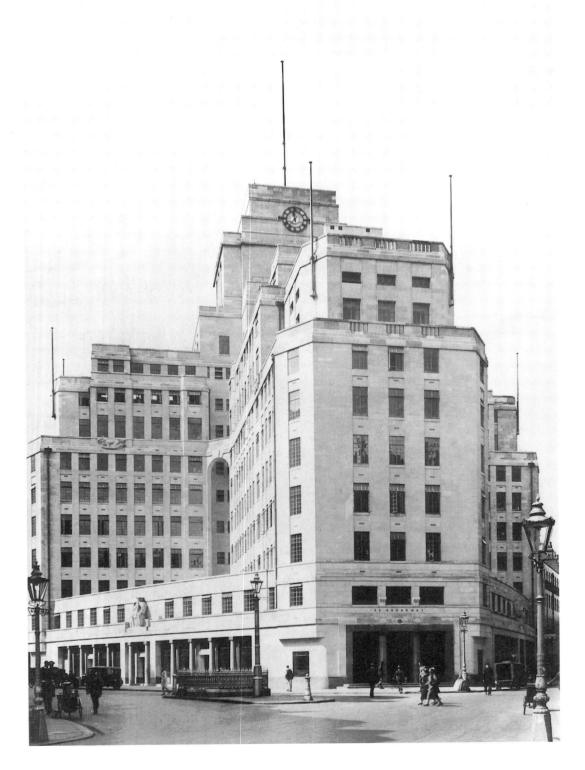

22 THE PUBLIC PLACE OF SCULPTURE

unsuitable for outdoor public display. However, if their subject matter was unconventional, their execution was not. This took place in the studio, and in this sense was absolutely traditional in preserving the split between sculptor and architect, and between the sculpture and the building. Plaster-casts were taken of the eighteen separate figures as modelled by the artist, and transported to the building's façade where they were reproduced in stone by a firm of architectural carvers.

The next project which brought Holden and Epstein together was that for the Headquarters of the London Underground Electric Railways, 20 years later [**15**]. This time Holden set a brief in which the figures were to be 'carved direct in the stone without the use of mechanical means of reproduction'. Nevertheless, much of the preliminary carving was done before the stones were winched up into position. Epstein carved 'Day' and 'Night' over the entrances, and younger sculptors—Eric Aumonier, A.H. Gerrard, Henry Moore, Frank Rabinovitch, and Allan Wyon—each carved one of the winds high up on the seventh storey, while their leader, Eric Gill, carved three. Sheds were erected around the areas of the façade which were to bear the sculptures so as to allow the artists to work in privacy. Despite Holden's wish to integrate his sculptors into the building scheme, they felt themselves to be out of place, and their work to be unimportant, in comparison with the hundreds of builders swarming around them.

In 1933 the critic Herbert Maryon summarized developments over the previous three decades:

So it was that at the beginning of the 20th century, in architectural sculpture at least, the ground had been surveyed already, and, with the introduction of new sculptural methods, design based upon steel and reinforced concrete construction largely superseded that based upon traditional forms. Buildings of the type exemplified by the Headquarters of the Underground Railway ... naturally called for sculpture endowed with a breadth of modelling which would enable it to hold its own against their immense areas of flat stonework, and their almost infinite repetition of rectangular forms.

It could be argued that Holden's attempts failed because the sculptures did not hold their own, or because avant-garde sculptors either did not know (or did not want to know) how to work with architects.

Art Deco

Many less controversial examples of collaboration—still manifest in the frieze—arise out of the widespread decorative style which took its name (Art Deco) from the Exposition des Arts Décoratifs held in Paris in 1925, long delayed by reason of the First World War (as was its successor, the Exposition coloniale internationale). This exhibition functioned as an international shop-window for architects looking for new partners. Those countries which did not participate, including,

for different reasons, both the United States and Germany, nevertheless sent many delegates to Paris to report back. Some of the most striking set pieces of these two exhibitions were presented in the form of the sculpted frieze—by Joseph Bernard, Alfred Janniot, Carlo Sarabezolles—which encouraged the international growth of decorative sculpture in tandem with architecture. The frieze allowed for a symbolic narrative which could be suited to public schemes, but its style, and mythic repertoire, strongly connoted the *Moderne* and the pursuit of leisure.

Art Deco came to be the style of the inter-war period, closely linked to the needs and aims of exhibition-making, ostentatious in all senses, and in its decorative and mural qualities suitable for the distinguishing advertisement of retail space. Such showcase projects facilitated a coming together of a variety of skilled trades—ironwork, lamps, lacquer, fresco, cabinet-making, marquetry—to create the complete decorative scheme. With its combinations of exotic materials and decorative detailing, Art Deco was also suited as a luxury style for the conspicuous display of wealth. Prestige private and commercial commissions for villas and liners united craftsmen and materials from all over the world, and notably from those colonies whose produce a given client might exploit. The Scottish sculptor Norman Forest, who worked on the *Queen Mary* and other liners, specialized in carving not only walnut, but also rubber. The 1931 Paris Colonial Exposition only extended this tendency in deliberately promoting the material resources of France's colonies, as did the launch of luxury liners from the mid-1920s, culminating in 1935 with the *Normandie*.

Some of the most arresting presentations were brought about by the alliance of art and commerce in terms of a sponsorship in kind which allowed artists free use of innovative materials. Just as Mies van der Rohe's 'Glass Room' was made possible by the German glass industries, so the Martel twins were sponsored to use both traditional materials and synthetic inventions like Galalithe, Bakelite, Lakarme, Plexiglass and Rhodoid. They described their 'harmonious quartet' as 'cement, glass, metal and electricity', and made good use of reconstituted stone and artificial marble in their work for luxury shops and the *Normandie*. American commercial Art Deco was both opulent and innovative: the Chrysler Building had lift-door reliefs in 'metyl-wood', the Cincinnati Union Terminal a jungle mural carved in linoleum by Jean Bourdelle, the Rockefeller Building polychromed reliefs by Lee Lawrie and Leon Solon with glass blocks bonded with Vinylite. But with its flexible vocabulary and graphic, mural qualities, Art Deco featured on a more mundane level—on shop-fronts, cinemas, and hotels—across the fabric of buildings erected in this period, and especially in northern France, where funds were at last available to repair the devastation brought about by the First World War.

The cemetery

Funerary sculpture had long provided sculptors with work at various levels, carved stone being sufficiently durable to withstand the climate of the cemetery, and of the church. The grave-marker was traditionally permanent; asking an artist to add lustre to memory only elaborated that convention. In the earlier part of the century, and especially in Roman Catholic countries, the tombs of the wealthy tended towards greater extravagance in decorative and portrait sculpture. Some funerary commissions in fact gave the sculptor a chance to pursue a more private programme of inspiration and creation than was possible on any commission for a public building. In Italy Leonardo Bistolfi, for example, made his name through the greater freedom allowed to the artist within the confines of the cemetery, and Enrico Tadolini also placed the majority of his work in the church and the graveyard.

Though the memorial might have been a complicated site for sculptors, with competing demands between artist and patron, artwork and grave, tomb architecture set many important precedents for the design of monuments. However, funerary monuments were no longer the vehicle for a sculptor to make his name, as they had been for instance in London's Westminster Abbey in the eighteenth century, and the freedom with which the sculptor occasionally responded to such commissions could increasingly be found elsewhere. Nevertheless, there are a handful of examples which show the gravestone as the vehicle for private creative freedom in the early years of the twentieth century: Alfred Gilbert's 'Tomb for the Duke of Clarence' (1895–1927), George Minne's 'Monument to Georges Rodenbach' (1899) at the Beguinage in Ghent, František Bilek's 'Sorrow' (1908) on the tomb of Trebisky in Vyšehrad Cemetery, and Epstein's tomb for Oscar Wilde (1909–12) in the Père Lachaise Cemetery, Paris. Such examples, plentiful in the nineteenth century, and at the beginning of the twentieth, peter out thereafter.

Most sculptural funerary work was at the other end of the spectrum, routine and visually unremarkable. But gravestones provided work, and played their part in the continuum of sculpture's public role. Eric Gill began his career as a monumental mason and letter-cutter, and brought in sculptors to help with the tombstones. 'Of course on a tomb stone or memorial tablet there would occasionally be a shield with heraldic emblems, and there would be simply mouldings and perhaps occasional flowery borders, but carvings of the "human figure" whether naturalistically represented or otherwise, seemed to me another trade and not mine.' This was partly because Gill was not good at drawing from life—and at this date the practice of sculpture as a 'fine art' demanded such facility—but also because he plainly saw this work as derivative, and used to call in a sculptor friend to do that part of the job. 'Obviously I did not become a lettercutter and monumental mason in

order to become one of the hack carvers who follow architect's "de-tails".' The fact is that Gill did not want to be a sculptor as 'sculptor' was defined at that time.

The Church no longer provided a privileged stage for sculpture, and the Church itself was a less important patron at this period than ever before, though it continued to provide a steady, if modest, source of work. An exception to this trend is the launch, by Cardinal Verdier in France in 1931, of the Chantiers du Cardinal, which brought architects and artists together in a campaign to build a hundred new churches in previously neglected areas. They celebrated their achievement at the 1937 Exposition Internationale des Arts et Techniques (under the aegis of the Vatican), where they built their hundredth church, which, like its counterparts, and appropriately enough for this exposition, was constructed in contemporary styles and materials by a regular team of gifted exponents. The Church had shown its vigour as a patron at each of the three Paris exhibitions between 1925 and 1937, using both the manner and the artists most associated with the Art Deco building programme.

Mass graves

The architecture of the great metropolitan cemeteries—and some of their most resolved treatments of space, subject, and audience, as in Albert Bartholomé's centrepiece 'Monument aux Morts' (1899) at the Père Lachaise cemetery [29]—was soon to inform the monumental funerary sculpture which, after the First World War, found its place outside the cemetery.

The task of commemorating the dead of the First World War reinforced the anonymous nature of the sculptor and the architectural quality of the marker. So many thousands of memorials were erected that the notion of artistic individuality, never mind merit, all but disappeared. What the public wanted, indeed needed, was a style that was sufficiently unremarkable to allow their grief to be expressed without being waylaid by artistic work which they found unconventional or questionable.

The First World War memorial was more often in the tradition of grave sculpture than in that of the monument. Even where communities could afford a 'monument', they often bought a ready-made work from a catalogue. Establishment bodies in France and Britain were concerned about the potential proliferation of unsightly memorials, and set up advisory committees. In France, 30,000 monuments were erected between 1920 and 1925, an average of 15 a day for 5 years. The commonest category, the simple tombstone type, outnumbered the next most common, the figure of the soldier, by more than two to one. In Britain, by contrast, the cross is by far the most common type among the 16,436 parish memorials. Whether the stone slab or the cross, it is clear that we have here a very elementary kind of sculpture,

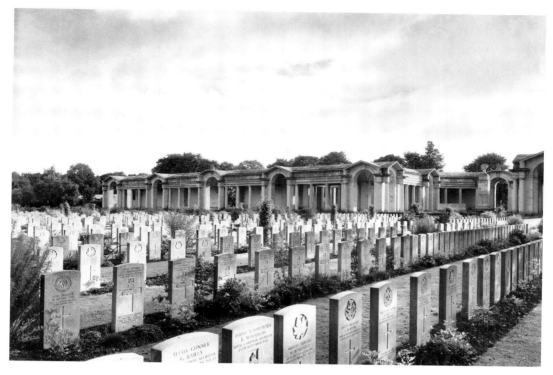

which, while affording work to those professing to be sculptors, hardly raised the profile of sculpture.

In France nearly every one of 40,000 communes erected a war memorial which, supported by government funds, had to be secular in its imagery. Most of the official British commemoration took place on French soil, as British families were banned from repatriating their fallen. Their numbers amounted to close on three-quarters of a million, and each was marked by a uniform official headstone, as designed and approved by the Imperial War Graves Commission, which comprised the three architects Edwin Lutyens, Herbert Baker and Reginald Blomfield, who were later joined by Holden [16]. These stones served as a non-denominational foil, and the fact that they were not in the shape of a cross aroused fierce controversy. Both Britain and France had imposed a state ideology over and above individual wishes, though the dead of this war were essentially volunteer and conscripted civilians rather than professional soldiers. In both countries, a need for a different iconography, whether religious or figurative, was a stimulus to private initiatives made necessary by establishment restrictions. Thus while French communities may have felt the need for the religious succour they were officially denied, British communities sought some kind of physical marker to represent the absence of their loved ones' graves at home. The British suffered one kind of rupture in funerary conventions, the French another.

Seen but not heard

Though the kind of architectural sculpture—both the style and the place—changes in this period, the framework for that sculpture changed very little. A sculptor working on a public building such as a theatre or a customs house in the 1890s is working to a similar brief as one working on an ocean liner or a cinema in the 1930s. Even at the end of our period, at the time of the Second World War, a conventional training in the sculpture schools of European or American art academies would emphasize, above much else, the sculptor's responsibility to work effectively and congruously within a schema that comprised the hopes and expectations of patrons, clients, architects, fellow sculptors and the general public. There were two basic options: one was to work on site for certain sympathetic architectural practices on small-scale jobs; the other was to set up a workshop, train apprentices to work within an agreed stylistic framework, and to tout for work on one's own terms. Certain more celebrated sculptors—Bourdelle, Epstein, Gill—may have their names linked to architectural schemes in such a way that we think of the relationship the other way around. They are however the exception that proves the rule.

Most sculptors made a living by working for or with architects; the requirement for a certain kind of sculpture came before the choice of sculptor. Some of the more grandiose buildings used sculpture, especially the sculpted frieze, as a matter of course, even when it could not be seen. The link between the architect and the sculptor was sufficiently ingrained in academic protocol to go almost unquestioned. Such embellishment was a sine qua non of any smart building. Despite the significance of the site, the work of Charles Wheeler on the Bank of England or of Evelyn Beatrice Longman on New York's AT&T Building (1915) has gone unnoticed by most art historians, as by most passers-by.

The parting of the ways

The condemnation of sculpture added as an afterthought lay behind many of the projects which characterize the new partnerships of the early twentieth century. Progressive architects associated their projects with the active contribution of sculptors, rather than with the piece-work farmed out through outside contractors. The collaborative venture of the early years of the century, which brought architecture and sculpture together on the façade of the building, had necessarily involved a sublimation of individual status in the interests of an 'anonymous' communal effort. Nevertheless, though anonymity enjoyed a certain currency for those who saw an exemplary way of working in the model of the medieval workshop, it was increasingly felt to be an illusion which did little to challenge the traditional position of the architect. Even in the showcase examples of collaboration, some

of which we have listed above, the architect was still the lead player. We might go back to John Belcher, and highlight the fact that even Belcher maintained that 'It is absolutely essential when sculpture is allied with architecture that it should be subordinate.' Henry Moore expressed contemporary scepticism of the collaborative venture when he hesitated to accept the London Underground commission. And though Moore agreed to work with Holden in 1928, he declined to collaborate on Senate House, London University. Seeking parity with the architect had been proved to be, at best, a hard-won privilege, but, more often, a sham. Sculptors moved now to seek an autonomy on their own terms.

In the United States the ties which sculptors and architects had worked so hard to create in the first two decades of the century now fell apart; architects gave up on sculptors, and sculptors themselves began to work at a new kind of sculpture. Architects either didn't want any sculpture, or instead used sculptors who were more pliable, and less concerned about their status as artists. Architects wanted to train sculptors specifically for architectural work, for a context in which the architects would have control. By the 1920s the Studio for Decorative Sculpture proved an effective riposte to all that fine art sculptors had hoped to achieve at the beginning of the century. In 1929 a major topic at the annual National Sculpture Society meeting was the rift between architects and sculptors. Moreover the new zoning regulations introduced into New York during the First World War forced buildings to grow up rather than out, and thus diminished the potential role of sculptors. Design on a building then became primarily graphic. By 1931, one of the city's architects, Raymond Hood, declared, 'There has been entirely too much talk about the collaboration of architect, painter and sculptor; nowadays, the collaborators are the architects, the engineer, and the plumber ...' One of the few capital projects to be pushed through during the Depression—the privately sponsored Rockefeller Center (1931–9) [17]—demanded of its sculptors that they integrate themselves entirely with other members of the team. This project signalled a parting of the ways, in which private companies took with them the more 'streamlined' designers, whose graphic facility tended towards the art of publicity, while civic schemes used academic sculptors trained in a more traditional Beaux-Arts kind of architectural and allegorical sculpture.

The increasingly well-defined parameters of 'official' sculpture—its training, rewards, and honours—had allowed wide margins for those who wished to 'sculpt' in other ways. Artists who had not embarked upon the academic ladder—those from different, and in particular from artisanal backgrounds—were freer to find other ways of making sculpture. They were not taken up by the race to win the Rome

Scholarship, take monumental commissions, model prestigious portrait busts, or compete for the best sites. Sculpture was a hard business, with a long slow climb from the architectural 'hack-work' that kept so many going. Even at the heights of sculptural fame, the prize was still measured as much by the fame of the person to be commemorated as by any distinction accorded to the sculptor. Sculpture had to be removed from this often thankless public arena before it could bring a different kind of status to its practitioners.

17 Reinhard and Hofmeister et al. (archs), Lee Lawrie (sc)

Rockefeller Center, 48th to 51st Streets, Fifth and Sixth Avenues, New York City, 1931–9

Originally a site for a new Metropolitan Opera House, the 1929 stock market crash left John D. Rockefeller holding a long lease for a project in which he had lost his other partners. A philosophy professor devised a scheme entitled 'New Frontiers and the March of Civilization', underscoring the role of international technological and business systems which was executed by 14 sculptors — including Lee Lawrie, Leo Friedlander, Carl Jennewein, Attilio Piccirilli and Albert Janniot — assigned to 60 individual parts. Rockefeller's wife, Abby Aldrich, seems to have been influential in introducing William Zorach, Robert Laurent and Isamu Noguchi as participating sculptors.

Seen and heard

In 1880 Rodin secured the commission to make a pair of monumental doors for the proposed Museum of Decorative Arts in Paris. This commission was to emerge as the project on which he worked for the rest of his life, 'The Gates of Hell' [18]. Rodin absorbed and internalized this project to such an extent that he abandoned the idea of its ever being used as a public commission. (In fact in 1904 he came to an agreement that the credit established for casting the Gates should be

18 Auguste Rodin

La Porte de l'Enfer from 1880, posthumous cast

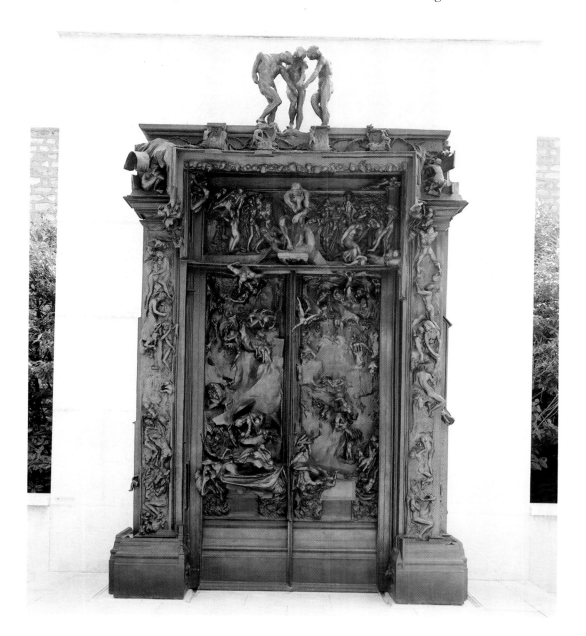

removed. The following year the Museum was in fact installed within the Louvre, instead of in its own building.) The Gates were never then to be used as such, but became instead Rodin's single most important theme.

Significant as the 'Gates' project is within any account of Rodin's career, it is of wider significance in understanding what was happening in sculpture in the early years of the century. Rodin was interesting to younger sculptors because he showed how private themes might hold more for sculpture than even the most prestigious public project, yet some of the most unusual of the combinations which might be seen as arising out of this lead succeed in merging the studio with the public place.

We have seen that sculpted ensembles were a conventional part of the urban environment in the early years of the century. On occasion this context allowed for the production of work fusing an extraordinary and introverted vision with the conventional forms of large-scale public sculpture. Such constructions—which we can now too easily read as almost exclusively personal 'installations'—emerge out of sculpture's established claim to exist in the public place, in collaboration with architecture.

Rodin's 'Gates of Hell' played an important influence on Ivan Meštrović's development of serial sculpture. Meštrović was concerned not only to create cycles of figures, but also to find a way of housing them. He developed an interiorizing architecture based primarily on ecclesiastical structures. The cycle with which he made his name in the first decade of the century, the 'Temple of Vidovdan', remained a concept, much like the 'Gates of Hell', no more a temple than the 'Gates' were a portal, but after the war Meštrović saw the realization of a number of mausolea with their associated sculptural cycles.

In Bremen another early, and equally eclectic, disciple of Rodin, Bernhard Hoetger, chose to use the most basic part of the townscape— the street—to make a fairy-tale-like environment in which his 'ideal' sculptures were displayed within the larger totality of his creation. His choice of a medievalizing Gothic architecture for the Böttcherstrasse created a protected space that was at once indoors and out. The patronage of the coffee merchant Roselius, which made the scheme possible, extended into adjacent buildings housing lavish interior spaces like the Himmelsalon and staircase in the Haus Atlantis (1930–1).

In the suburbs of Stockholm, Carl Milles worked more privately to create a complete scheme in his own garden, establishing the ideal conditions for the siting of his sculptures against the backdrop of the sea. Many of his pieces were strongly articulated, linear punctuation marks which worked as well in creating horizontal fountain groups as decorative vertical finials. In 1930 Milles took up a position at Cranbrook, near Detroit, and in the United States he developed his experience in the siting of sculpture to work on major commissions for American

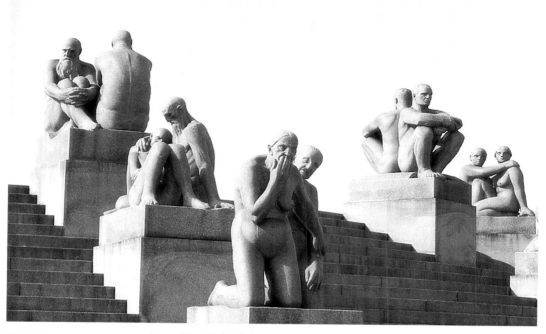

19 Gustav Vigeland
Frognerpark, Oslo, 1901–50

cities, like Falls Church, Virginia, and St Louis and Kansas City in Missouri, which laid out ambitious architectural spaces.

Gustav Vigeland might be compared to Meštrović in the nature of the debt he owed to Rodin, and indeed Meštrović's early work ('Well of Life', Zagreb, 1905) is close to Vigeland's. Vigeland's own cycle of figures developed into a life work which, conjoined with the currency of architectural and monumental ensembles, allowed him to create the extraordinary Frognerpark in Oslo. (On a less grand scale, but similar in form and content, is Kai Nielsen's Blagards Plads 1913–15 in Copenhagen which also uses folkloric motifs, cramped and contorted to create broadly architectural blocks which articulate the borders and corners of this sunken square.) Vigeland was unusual in receiving almost unqualified support from his municipality and was able to work on his scheme [19] over several decades from 1906 to 1950. At first it was agreed that Vigeland should erect a fountain group in front of the Palace, but as his plans developed the municipality came, in 1924, to approve the Frognerpark (32 hectares) for his scheme. The ensemble, in granite and bronze, was to comprise an obelisk, fountain, bridge, and 200 figurative groups mounted on plinths in descending rows down ranks of steps. In 1921 Vigeland signed a contract with the City Council which gave them all the rights to his work, and in 1923 he moved into a specially designed building which functioned simultaneously as studio and museum.

The close relationship between a city and a sculptor is echoed in that of Chicago and Lorado Taft, whose ambitious Midway beautification

project involved full-scale city planning with three bridges, fountains, and a Hall of Fame with 100 statues. By the time the first part of his scheme was inaugurated in 1922, Taft found that all the assumptions which he and his committee had taken for granted before the war as regards the scheme's desirability no longer held good. The time-lag that such grand schemes entailed was a difficult one for sculptors to overcome, and both Vigeland and Taft suffered a fall from grace. However, though such ensembles may have been seen as eccentric and isolated coda to a tradition which had played itself out, it might be more helpful to consider their role as a bridge to what was to come, establishing the possibility for personal vision to manifest itself across an arena that was both public and spatial.

The Tradition
of the Monument

2

Monuments for the people

Urbanism is closely connected to—and contemporaneous with—the consolidation of the new nation states and the move towards secular democracies. As power was no longer invested in the one, or even in the few, so its representation, which until that point had been a specialism of sculpture, and a prerogative of the monarch, became more broadly based. Whereas monuments had previously shown the king, the emperor, or the victorious general, the monumental form now came to express the ideals of the bourgeois state. The making public of the private individual brought even the private monument out of the cemetery and on to the street.

In a meritocracy, merit must be celebrated. Statues were erected not simply to commemorate the achievements of great men, but also to show how the state celebrated them, making visible the bond between the elected assembly and the people, revealing an open society where merit was recognized and rewarded. Governments habitually stressed the fact that the impetus came from the individual and not from an authoritarian state. As the French Under-Secretary for Public Instruction and the Fine Arts pointed out in 1913, 'French art has often submitted to the State's instructions but the help given to artists by the citizenry is a great deal more effective in the nation's education'. Thus this art—the art of the monument—was made to seem as if it arose out of the will of the people, joined in voluntary association with the artist. This active association of the state, the citizen, and the sculptor was in full swing across Europe and America by 1900, and its success can be measured by the increasing numbers of statues on the streets.

Governments encouraged programmes of statufication tacitly rather than explicitly, leaving it to their citizens to choose which schemes to support with their subscriptions. So successful was this strategy that the citizens themselves usually paid the bulk of the costs for a commission, and very often initiated the subscription themselves, on the grounds of local rather than national pride. Municipal

initiatives only slightly outweighed those which came from learned societies and special associations. Most monuments were backed by a committee of the great and the good who launched the subscription, circulating details to the range of potential supporters, including local and national government. The burden of raising the funds was borne by private individuals who resorted to more and more colourful group efforts to bolster the sums raised by subscription. Postcards, exhibitions, gala evenings, tombolas, school subscriptions, and commemorative medals all featured as ways of raising funds and awareness of the campaign. Vigeland's 'Monument to Camilla Collett' was supported by a fund-raising competition promoted by 500 Norwegian women, and that to the composer Nordraak was paid for by benefit concerts given by Grieg. The local and the national press became more and more involved as the medium for fund-raising activity, especially when the subject was well known.

Statuemania

It is generally agreed that in Victorian Britain it was the death of Robert Peel in 1850 that initiated the spread of monuments to the middle class. In France, following the Franco-Prussian War, the trend took hold with the secure establishment of the Third Republic after 1875. Similarly, the United States gradually gathered confidence in asserting its own identity after the Civil War. In 1889 both France and the States celebrated the first centenary of their republican foundations with monuments, and the early years of the new century saw many South American republics turn to France in the celebration of their own republican centenaries. The French love of statues quickly outpaced the British, so that within one generation the French capital was suffering under the effect of too many statues, or *statuomanie*. Germany experienced a similar *Denkmalpest*, 'monument inflation', or *Denkmalwitz*. German satires and cartoons paint a similar picture to those in France, in which statues threaten to take over the streets and crowd out the parks.

Concerns about an epidemic of statuary go back to the mid-nineteenth century, but only really take hold in the twentieth. By then newspapers were running questionnaires about which statues were the ugliest and should be first to be destroyed. (In Paris, Saint-Marceaux's 'Daudet' and Puech's 'Sainte Beuve' topped one competition, but the usual favourite was Aubé's 'Gambetta'.) One French critic suggested they should indeed invite the Futurist activist Marinetti to deliver them from these evils with his dynamite. In the United States *Leslie's Weekly* nominated its eight worst 'Deformities in Sculpture', and the country's Civil War columns, particularly Scofield's in Cleveland (1894), were strongly criticized. Some blamed the commissioners—the committees or the state —but others blamed the sculptors themselves.

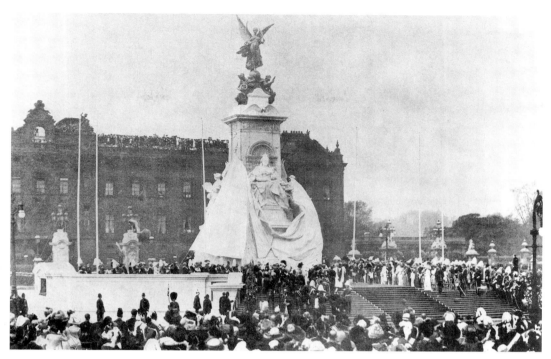

20 Thomas Brock

Queen Victoria Memorial,
Pall Mall, London, 1901–11
The monument was un-
veiled in May 1911, at a
ceremony headed by the
King and the Kaiser. The
Executive Committee chose
to entrust the whole work to
Brock, rather than to a team
of sculptors. The more
elaborate of the two models
submitted by Brock was
approved by the King in 1902,
and the sculptor went on to
develop an allegorical scheme
representing the Army, Navy,
Science, Art, Peace, Progress,
Labour, Agriculture, Manu-
facture, Justice and Truth
in support of the Queen and
her Empire. Brock had always
estimated that his work would
probably take ten years, and
six bronze groups remained
to be set in position even
after the inauguration.

By 1904 the Parisian municipal authorities decided to impose a ten-year moratorium after the death of any potential subject for statufication. For many, siting was the problem, and in 1911 the Conseil Municipal of Paris demanded that a full-scale two-dimensional mock-up had to be provided by any applicant. They also began to be much more careful in terms of establishing a series of stages, both aesthetic and practical, to which any proposal must be submitted.

At the dawn of the new century the status of the *statuaire* was un-challenged; the apogee of statuemania occurred between 1900 and 1910 and was only consolidated by the coincidence of the deaths of some of the most important figures of the previous century, namely Queen Victoria and Chancellor Bismarck. The Queen's death in 1901 saw a wave of commemoration that embraced the British Empire [**20**]. In France, the deaths of Carnot and Pasteur increased the wave of com-memoration, finally gathering pace around 1900 with monuments to the *Anciens Combattants* or veterans of 1871. By 1910, however, the tide was already turning. Between 1900 and 1910 at least 50 monuments had been erected on the streets of Paris, but this dropped sharply to only a dozen in the succeeding decade. This was unfortunate for the sculptors who had been trained in the expectation that their natural destination was to make statues of great men, and most particularly on the streets of their capital. Though the bureaucrats themselves knew that the flood must be stemmed, they too found it hard to relinquish an ideal with which they had been thoroughly imbued.

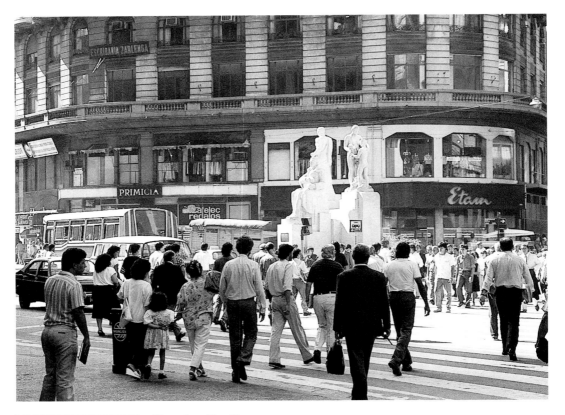

Carrying the flag

As authorities in Europe became troubled by statufication, sculptors turned to opportunities abroad, particularly within the colonial system. British sculptors executed many monuments for the Indian subcontinent, while the French put down markers in North Africa. New republics sought to validate and commemorate their own establishment by following the French model of statufication and town planning [21]. The 'École des Beaux-Arts' cachet enjoyed particular favour, and many French sculptors won commissions in Argentina, Bolivia, Chile, Colombia, Cuba, Ecuador, Nicaragua, and Uruguay. South American sculptors themselves—such as the Chileans Guillermo Cordoba and Rebecca Matte de Iñiguez—propagated the French school by studying in Paris with Injalbert, Bouchard, Landowski, Dubois, and Puech. When the French had foreign competition, it came from Italian and Spanish sculptors, like Mateo Inurria and Mariano Benlliure y Gil, who both won important commissions in Argentina.

The steady development of a system of training and commissioning necessary to monumental work brought non-European would-be sculptors back to the 'home' country. Commonwealth and North and South American sculptors generally came to Europe (Paris or London) to study, going on to pursue truly international careers by means of the

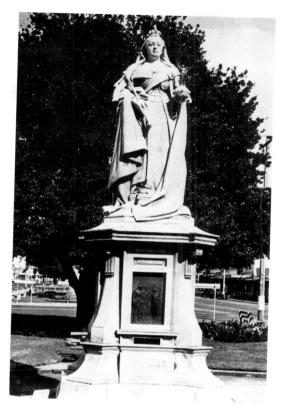

monuments that were placed throughout the Empire; Bertram MacKennal for example made 'Queen Victoria Memorials' for Lahore, Blackburn, and his birthplace Australia [22], and 'Edward VII' in London, Melbourne, Adelaide, and Calcutta. Australian sculptors continued to train and show at the Royal Academy in London, or at the Royal College of Art, and the English establishment was essentially the Australian one too.

The European model

The statuary in European capitals was a matter of envy to New World visitors, some of whom were sufficiently impressed to attempt to stimulate such activity at home. In 1905, B.F. Ferguson left a million dollars in his will to the city of Chicago for 'the erection and maintenance of enduring statuary and monuments ... commemorating worthy men or women of America or important events of American history'. Ferguson had been impressed by the 'City Beautiful' concept in which the statue was a natural part of the civilized metropolis which America must now start building. The attractive and instructive city was intended to create happier citizens imbued with civic pride. The Ferguson Fund facilitated beliefs which were now widely held, at both national and local level, across the United States, and which indeed occasioned

some inter-city rivalry. The Chicago sculptor–lecturer Lorado Taft was well placed to benefit from the city's new source of funds. Others were less keen. By 1925 the American sculptor Janet Scudder condemned 'this obsession of male egotism that is ruining every city in the United States with rows of hideous statues of men-men-men—each one uglier than the other—standing, sitting, riding horseback ...'.

Paris also inspired the Norwegian writer Gunnar Heilberg to propose the work of Gustav Vigeland for Oslo's Parliament Place:

With the Place de la Concorde in mind, I suddenly came to think of our own 'Place' at home ... which might be so lovely, and which could be so easily disfigured, especially if Norwegian–German architects are given free rein with decorative stairs and straight lines, with rocky cascades and turtles spouting water, with nymphs and gas-lights.

The Archibald Fountain commissioned from the French sculptor François Sicard for Sydney in 1926 arose out of its patron's Francophilia. In Mexico the plans of Porfirio Diaz for an outdoor pantheon on the Paseo de la Reforma harked back to those of d'Angivillier in late eighteenth-century France, and bore fruit in the form of different countries' gifts of statues of their own generals, martyrs and educationalists. The first such 'ambassadors'—the statues from Spain, the United States, France, and Italy—were unveiled in 1910.

The formula

The French Third Republic monument had a form which evolved, with only slight internal variations, through the 50-year history of official 'statuemania' in France, and elsewhere. Jules Dalou's monument to the painter Delacroix [23], inaugurated in 1890, is often seen (at least by Anglo-American writers) as defining the monumental form used so frequently thereafter. An American commentator, writing in 1913, observed, 'His "monument to Delacroix" is one of the earliest of its kind; that is where the subject is represented by a bust only; while allegorical or historical figures, grouped about it, carry out the artist's conception. The style has proved very popular in France.' An earlier model, Carrier-Belleuse's 'Monument to Massena' for Nice, shown at the 1868 Salon, similarly demonstrated the conceit of a 'living' muse writing the homage to the subject of commemoration. In the States, Saint-Gaudens's 'Farragut' memorial (1881) [24] has assumed a seminal position somewhat similar to Dalou's 'Delacroix'. His portrait was both personal and general, both lively and monumental; it represented a new model of 'national life' for a country that was learning quickly about civic formulas.

Forms differed according to the nature of the figure commemorated, but fell into certain broad groups which might be categorized as isolated busts, busts with allegories, full-length figures, and equestrian

monuments. Whereas around the turn of the century full-length figures were by far the most popular, after 1914, and in line with growing nerves about statuemania, busts assume the lead. Equestrian monuments traditionally accounted for a secure, if small, proportion of commissions, and featured much more heavily in monarchist states than in democracies.

A weariness with the formulaic nature of commemoration led some sculptors to essay something more spirited. Again, one might point to Dalou, whose monument to the automobilist Levassor (Paris, 1907) suggests a possible precedent for the introduction of dynamic pictorialism into the static monumental profile. Further examples can be seen in Ettore Ferrari's elaborate 'Monument to Mazzini' (1902–22) in Rome [25], and Frederick MacMonnies's 'Monument to the Battle of Princeton' in Princeton (1913–22). Their similarity of style—and its

clearly French quality—reminds us how many of these seemingly disparate sculptors had studied under the same masters, particularly Alexandre Falguière and Antonin Mercié, at the École des Beaux Arts in Paris. The education of sculptors in the early twentieth century was much more international than it is now, but also more uniform, in that a few great centres acted as the filters for sculptors from all over the world, thus ensuring the cohesion of the monumental tradition. Kineton Parkes, writing in England in 1921, deplored this centralization of sculpture in Paris, both because it led to a 'cosmopolitanism' rather than 'nationality in art', and also because it was a symptom of the neglect of sculpture in Britain.

A photographic survey of Paris statuary just before the First World War (*L'Illustration*, 1913) provides us with a useful source from which to make a simple formal breakdown of monuments in this capital of statuemania. Of the 84 full-length single figures, 61 are standing and 23 are seated. Twenty-one full-length figures are shown with allegories. Of 52 busts, 23 are isolated, while 29 are portrayed with allegories. Ten

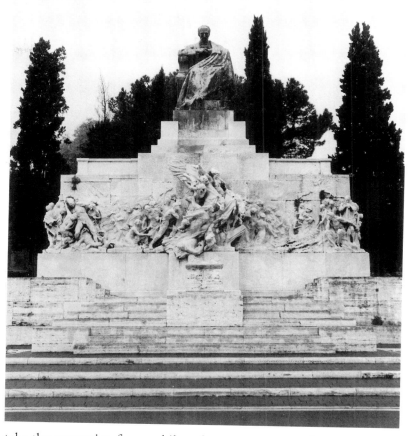

take the equestrian form, while only 9 represent two figures together.
The form is overwhelmingly dedicated to the commemoration of the
single individual. The choice of form depended, of course, on the nature
of the subject, and most particularly on whether or not the subject was
a creative artist. This latter category most often utilized the bust with
the full-length animating figure of the female muse. (Many commen-
tators remarked on the stereotypical marble nymph weeping at the feet
of a man in evening dress.) Most British monuments, like French ones to
politicians or soldiers, tended to show the subject in a full-length statue.

The cone-like profile of establishment statuary was widely recog-
nized. Rodin called it the 'dada' of the Prix de Rome scholars. Bourdelle
echoed Rodin in his criticism of the *'pyramide pompier'*, which he
described as being made of cloths (*'un chiffonage'*) or of melting choco-
late. Medardo Rosso also described the form of statuary as 'cloths
soaked in plaster', seeing this as the superficial drapery laid over casts
from nature. Bourdelle went so far as to include Rodin in his criticisms,
describing Rodin's treatment of the form as *'charcuterie Rodinienne'*.

Another formula for attaining grandiosity in variety was to use a national memorial, like that to Prince Albert in Victorian London, as a means of uniting a team of a country's pre-eminent sculptors. Three turn-of-the-century American triumphal arches—the Dewey, the Washington, and the Soldiers' and Sailors'—united teams of sculptors, and the Dewey in particular (a temporary manifestation) brought fifteen artists together in a flamboyant showcase for sculpture. The architect Stanford White supervised the other two projects, which united MacMonnies, MacNeil, and Calder, and MacMonnies, Eakins, and O'Donovan. The National Monument to Victor Emmanuel II in Rome, finished in 1915, had employed Zanelli, Bistolfi, Maccagnani, Drei, and Rubino.

Sites and subjects

Subjects for commemoration suggested not only the appropriate form of their monument, but also its site. Doctors were put outside their hospitals, academics in universities, or founders beside the buildings they had founded. More generally, men of action were put out to face the hustle and bustle of the city square, while writers, poets, and painters were commemorated in parks and leafy glades [26]. The park was often the unwonted battleground for those who sought to preserve their havens against those various lobbies keen to find a resting-place for a pet project. Despite his interest in promoting public statuary, Lorado Taft himself criticized the incursion of statues into parks, often as a result of various nationalist sentiments, which led to a 'petrified congress of nations, a sculptural card-index', and whose resulting admixture he characterized as a badly planned dinner party.

The hierarchy of commissions was based on subject and site. A capital city was normally more desirable than a provincial one, though major regional centres might, on occasion, offer more generous resources for local projects. Within the capital, as within any town or city, those sites central to the business of government, or cherished by virtue of historical associations, were particularly prestigious. The landowner—municipal or governmental, ecclesiastical or aristocratic—had to grant permission for the site to be used, and a more subtle pattern underlies the matching of statue to site, according to the political significance of the figure and the affiliation of the land-owner. The conflicting ideologies of different landowners can be thus demonstrated to have encouraged rival schemes of statufication.

The ambition vested in the public monument was of the highest order for contemporary sculptors. A successful commission proved a sculptor's artistic and civic maturity, and the term *statuaire* connoted this particular status. Most ambitious *statuaires* won their first commissions from their home towns as a result of local affiliations. Young sculptors advanced their careers by entering competitions—and this

26 Alexandre Falguière

Monument to Ambroise Thomas, Parc Monceau, Paris, 1902

In Paris the Parc Monceau and the Luxembourg Gardens were favourite homes for statues to the arts. The Parc Monceau was an eighteenth-century park redesigned in 1861 in the 'English style'; among its follies and 'souvenirs' can be found part of the Hôtel de Ville which had burned down in 1871. The statues here are dedicated above all to composers — Chopin, Gounod and Ambroise Thomas — by Jacques Froment-Meurice (1906), Antonin Mercié (1897) and Alexandre Falguière (1902).

was often the only way to break out of the local and into the regional or national arena—but established sculptors only rarely agreed to compete against their peers, and then only by invitation. This complex of territorial connections inevitably marginalized the displaced artist. As a result, the production of emigrant sculptors shows few of the links with local and national patronage which manifested themselves in the form of the commemorative monument.

The process

Whether an artist was invited or selected by competition, the executive committee liked to have a clearly presented visual proposal on which to hang its fund-raising campaign. The competition formula was designed to provide visual proof of an artist's intentions. Candidates submitted their ideas, either on paper, or more often in the form of a scale model, and the jury chose their favourite. The continued dependence of the jury on this early model was one of the reasons why more senior sculptors shied away from the competition, and why problems arose in the ensuing relationship between sculptor and committee. Both sides felt a strong claim to the project, and few juries were sufficiently confident to leave their artist in peace to elaborate his or her ideas. Senior artists knew that a maquette which won a competition might well not be the right solution to the actual problems of the site, and the site was

often one of the last components to be decided. Sculptors demanded the freedom to allow ideas to evolve and mature; committees protested that the sculptor had been chosen on the basis of a specific proposal.

Just as committees wanted to be able to rely on their chosen sculptor, so sculptors needed to be able to rely on their team of workers to translate their ideas faithfully and efficiently. Sculptors organized their studios, and their location, according to their needs for different kinds of materials, the division of skills and local resources. Individual ambitions had no place within the work-place; a sculptor needed to be sure that the assistant understood his or her intention. To establish such a solid working base needed time and continuity; sculptors had then to ensure that demand warranted it, or they would be left paying wages for insufficient labour. Just as the commissioning committee paid for the job in instalments to keep the sculptor at work, so contractors and assistants were similarly paid in stages by the sculptor. (The war upset all such well-regulated establishments.)

Sculptors who already enjoyed their own independent careers as fine artists continued to work for others, while employing their own workmen in turn. Bourdelle worked for Rodin, Casanovas for Llimona, Lachaise for Manship, Rosandić for Meštrović, Noguchi for Brancusi, Louise Bourgeois for Robert Wlérick. Further down the hierarchy were those who never expected to be singled out by name. Arturo Martini, who had himself spent five years in the 1920s working on Maurice Sterne's monument to the Pioneers of America in Massachussetts, later described the Carrara artisans who helped him with his huge 'Corporate Justice' relief for the Milan Courts (1937) as 'genuine Stradivarii'.

Around the turn of the century sculptors attempted to clarify the divison of labour, so that gentlemen clients would understand that they would be working with an equal if they were to commission sculpture. The (National) Sculpture Society of America, founded in 1893, aimed to standardize professional 'rules of engagement'. The society was a self-defining club which helped to sieve out the unwanted 'artisanal' elements, and to link their own careers with the furtherance of the country's own ideals. Lay members, particularly deputies and Congressmen, helped to make the sculptors' contribution an element of wider federal and civic agendas. This attempt at the 'professionalization' of sculpture in America (as in Britain, where the Society for British Sculpture was founded in 1904) went hand in hand with the urge to create the necessary infrastructure for its practice and display in the home country, rather than in the Salons of Paris.

Personal compositions
Across Europe and America, around the turn of the century, there were a number of really extraordinary monuments, works which often involved their authors in a sustained programme of creative work over a

long period of years. In this they approach the 'Gates of Hell', and the central position which it occupied in Rodin's creative life. For example, in Norway, Vigeland's monument to the poet Wergeland (1908) developed over a period of ten years, but inspired themes and motifs which fed into his most personal work throughout his life. Prague offers us three striking examples: Josef Myslbek's 'Wenceslas Monument', which took him from 1887 to 1922, the 'Palacký Monument' by Stanislav Sucharda, which took from 1898 to 1912, and Ladislav Jan Saloun's 'Monument to Jan Hus', 1900–1915 [27]. Extended reworking of a theme seems to build up into the accumulation of detail, making for complicated and large-scale compositions, involving not just the central figure, but a whole melée of supporting figures and reliefs. Such monuments are as much pictures as sculptures, with a narrative fabric which insists on a primarily pictorial reading. Such works threaten the quiescent stasis which had traditionally made it possible for sculpture to become 'statuary'.

A sculptor's making a monumental project into a personal one tended to have as its corollary an extended time-scale. This was a risk of which sculptors were just as aware as their commissioning committees. One has only to look at the dates of the works cited above to see how lengthy these projects could become. Although such long periods may have resulted in some extraordinary works, they did not make for a successful monumental career, and the sculptors who received the most commissions were the ones who delivered on time. Monumental work has particularly poignant deadlines, in that committees are loath to let

27 Ladislav Jan Saloun
Monument to Jan Hus,
Old Town Square, Prague,
1900–1915

too long a time elapse after the death of the commemorated, a situation which is only exacerbated in the case of the war dead. Thus the most prolific *statuaires* are indeed often those who worked to order.

The success and failure of Rodin

Rodin was very much involved in the monumental art of the Third Republic, and very much involved also in its highly frustrating complex of inimical requirements. Rodin was not a good player in the monumental game, but continued to engage in it, by no means as successfully as he must have wished. His early submissions for monumental competitions were rejected in favour of rival candidates; later pieces were judged critically in the press. Nevertheless, Rodin designed his fair share of monuments, and a good number—those erected to Claude, Bastien-Lepage, Sarmiento, Becque, or his designs for those which were not erected, to Whistler, Carrière, Vicuña-MacKenna, General Lynch—reveal a formal framework reminiscent of Dalou's 'Delacroix'. Indeed, Rodin's career as a *statuaire* gives a not unrepresentative cross-section of contemporary monumental practice: his erected statues commemorated painters, playwrights, historical figures and contemporary statesmen; they were erected in the provincial birthplaces of the commemorated, in small Parisian squares, or in the capitals of South American republics; the figures were represented *en pied*, with accompanying muses, or as simple busts.

However, the monuments which Rodin did erect failed to attract much attention. Much more was said about the ones which were never erected, or which changed course and definition on the way. We forget now how, judged by the criteria of an age attuned to monument-

28 Auguste Rodin

Monument to Victor Hugo, from 1889, installed in the Jardins du Palais-Royal, Paris, 1909

The Third Republic's plans (1889) to refurbish the Panthéon began with commissions for monuments to Mirabeau, given to Jean-Antoine Injalbert, and to Hugo, awarded to Rodin. Rodin's maquette showed Hugo in exile on Guernsey, surrounded by muses. After its rejection for the Panthéon, this model was rescheduled for erection in a park. In the ensuing years Rodin made more progress on this model than on the revised version for the Panthéon, and it was eventually installed in the gardens of the Palais-Royal in 1909.

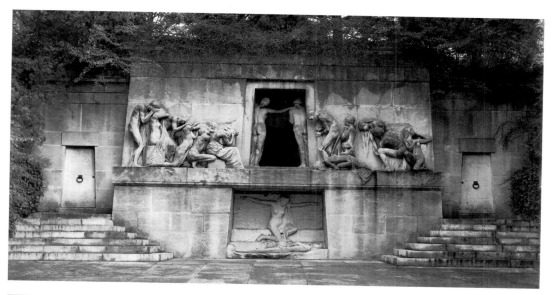

29 Albert Bartholomé
Monument aux Morts, Père
Lachaise, Paris, 1899

making, Rodin was not successful. Though his circle may have been
aware that his failure 'to deliver' meant that something else was going
on, many of his contemporaries were troubled by his repeated inability
to complete his public commissions. Vigeland is typical in noting that
Rodin was not a monumental sculptor; that his figures had no equilib-
rium and were indeed '*antimonumentale*'. Rodin himself is recorded as
having told the critic Vauxcelles that 'Hoetger found the way I was
looking for ... the way to the monumental, which is the only right one.'

Rodin's 'Victor Hugo' [**28**], commissioned for the Panthéon in
1889, was rejected by the committee in 1890 as lacking 'breadth and ele-
vation'. Some critics felt the jury was wrong to have expected Rodin to
subordinate his work to the decorative ensemble as a whole, but it was
nevertheless clear that Rodin's model was resolved on its own terms
and without reference to the site for which it was intended.

Such concerns about the weakness of Rodin's structures were
echoed by Adolf von Hildebrand, who was of Rodin's own generation,
and a careful critic of what he represented. Hildebrand was unusual in
designing the whole surround for his own monuments (such as the
Brahmsdenkmal in Meiningen (1898) or the Schillerdenkmal in
Nuremberg (1908)) and, more spectacularly, for his fountain complexes
in Munich [**122**], Jena, Strasbourg, Worms and Cologne. In his 1893
text *Das Problem der Form in der bildenden Kunst* Hildebrand argued for
an 'architectonic' quality—'an inner construction'—achieved by means
of a single viewing point, as for a relief. He put a premium on visual
rather than tactile effects, which related to his own background in
drawing and relief, and his preference for carving over modelling. His
ensembles lead the eye to a central point, most usually by means of a
symmetrical semi-circular or ovoid architectural frame.

Sculptors like Aristide Maillol and É.-A. Bourdelle were lauded for their wholeness, either for the complete roundedness of their forms, or for their architectural understanding of the composition of the public monument. While Maillol might have considered his own sculpture as architecture, Bourdelle retained the more traditional components of the monument but promoted his own role as its architect as well as its sculptor. Maillol's approach was rather different, in that his ideal sculptures were mounted on ordinary plinths, but taken outdoors, and asked to do the job of monuments. Albert Bartholomé's was the third name used in opposition to Rodin's: his 'Monument aux Morts' in the cemetery of Père Lachaise was widely admired for its ordered calm, and his 'Monument à Jean-Jacques Rousseau' for the Panthéon develops the strongly horizontal, frieze-like character of his work, creating an architectural solid instead of leaving a lone hero up on his pedestal [29]. Like Bourdelle, Bartholomé wished to provide his work with its own architectural elements, and like Maillol he was able to commemorate the 'absent' by sole recourse to the female figure which was more normally simply additional to the *statufié*.

A reprise: the war memorial

Just at the point when the demand for public monuments was drying up, or when authorities were consciously trying to slow down their proliferation, the First World War erupted. By 1920 the monument was back on a large scale, but with a very different import. Perhaps because of this wholesale monumentalizing of European towns and villages in the wake of war, the monument took on a rather different dynamic.

Even before the war had ended there was talk of its commemoration. In France it was assumed that Rodin had to be given this challenge, but he died in 1917. The question of his 'heir' exercised the art press—Bartholomé, Bourdelle, and Maillol were all brought into the debate—but the sheer scale of the commemoration of the First World War rather dwarfed the question of succession. In the end the 'honours', if such they can be called, were apportioned among a wider group of younger sculptors, many of whom had served in the war.

Though the majority of the memorials were extremely modest, a minority of significant commissions offered some sculptors a chance to make their name [30]. Richer communities, notably large towns, but also individual regiments, companies and institutions, offered such opportunities, which occupied sculptors well into the 1930s. While the simpler monuments used the single figure on the pedestal, more ambitious ones tended towards friezes of soldiers and grieving figures, quite often at ground level. The frieze represented not only the scale of the tragedy, but also the non-hierarchical nature of its commemoration [31]. Certain sculptors became particularly associated with the war

30 Charles and Henri Malfray

Victory Monument, Orléans, France, 1922–9

This monument fell victim to an aesthetic conservatism allied to a xenophobia manifested in criticisms of its Germanic and unclassical character. The Malfrays had repeatedly to defend their work before the monument was finally erected in 1929.

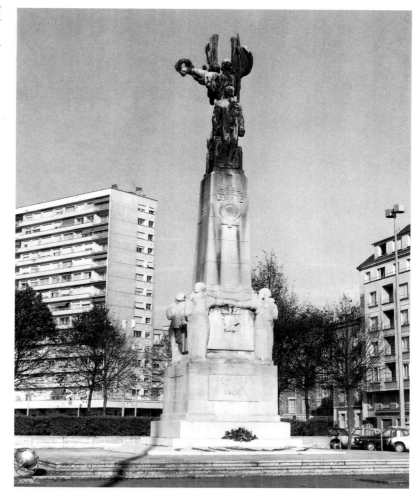

31 Richard Kuohl

Kriegerdenkmal des Infanterie Regiments 76, Hamburg, 1936

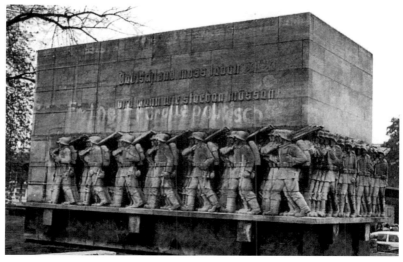

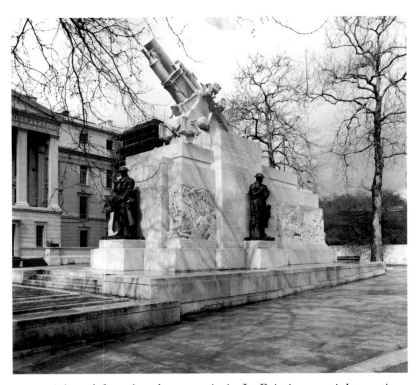

memorial, and few played no part in it. In Britain we might particularly note C.S. Jagger, Gilbert Ledward, and L.F. Roslyn, all of whom had served in the war. Jagger and Ledward secured two prime London positions: Jagger at Hyde Park Corner, with his Royal Artillery Memorial [**32**], and Ledward on Horse Guards' Parade, with his Guards Division Memorial. Jagger's energetic and realistic depiction of modern warfare contrasts strongly with its neighbour, a languid naked youth by Derwent Wood commemorating the Machine Gun Corps. In France Henri Bouchard, Carlo Sarabezolles, Maxime Real del Sarte, Georges Saupique, and L.H. Nicot predominate as the sculptors of the grander war memorials. In all Bouchard realized 22 memorials, Sarabezolles around 20, the others around 10 or 12 apiece. In Australia, C. Web Gilbert made 9, and the new arrival Rayner Hoff (fresh from England, an ex-serviceman and a sculptor with excellent references) was commissioned to make first Adelaide's war memorial, and then to collaborate on Sydney's Anzac memorial. He introduced a svelte and seductive Art Deco into Australian neo-classicism, and went on to create a number of other official memorials.

The battlefields offered the sites for the most prestigious commissions. Here the sculptors elaborated complex and massive iconographical ensembles. British sculptors had their share of commissions for monuments on the French Front, including Jagger at Louveral and Eric Kennington at Soissons, while the architects of the Imperial War

Graves Commission took on some of the most important sites at Ypres, Thiepval and Arras in collaboration with the sculptor Reid Dick. The architectural nature of these memorials, as established primarily by Edwin Lutyens in his Cenotaph—originally simply a temporary wooden structure to accompany a peace ceremony in London's Whitehall—had considerable repercussions for the style of commemoration throughout the British Empire.

As in Europe, American civic and municipal support for public statuary waned throughout the 1920s, and sculpture was no longer allied with the civic programmes of influential politicians and city fathers. Nevertheless, the United States saw a similar privileging of the war over any other kind of memorial, and most public commissions in the 1920s were for war memorials, most of which were tablets or flagpoles. Larger memorials were topped by single female allegorical figures or by a doughboy. In New York alone, 34 were approved by the city's commission in the 1920s in contrast to a much reduced number of non-war subjects, but the shift in public opinion is demonstrated by the fact that funds collected for a memorial in Central Park lay dormant for years before eventually being used to create borough playgrounds. An additional problem complicating the commemoration of the war was that many of North America's sculptural establishment were of Austro-German stock.

Changing opinion

The enormous effort of commemorating the lost soldiers of the First World War (literally lost, and thus recreating) ennervated the figurative tradition of monumental statuary. Whereas before the war local and national governments liked to recognize outstanding individuals in the form of the monument, the First World War memorial effectively killed off the form. The form of the monument had become too closely associated with the war.

By 1930, apart from some overdue war memorials, the commemorative monument was no longer in favour in America, France, or Britain. Even when the Second World War provided ample reason for further commemoration, any memorial was frequently simply supplementary, by inscription, rather than in the form of a new monument. This shift away from the established pattern of the previous 50 years can be attributed to three factors: the bad press which statuemania had attracted, the overwhelming campaign of commemoration for the First World War, and the realignment of monumental art within Fascist culture during the 1930s. These factors can be set aside, or seen as a background, but should always be considered as a corollary to the development of sculpture as a studio or gallery art.

In Italy, Germany, or the USSR the monumental tradition was realigned in association with the developing authoritarian regimes in those countries. This kind of statuary was neither strictly commemorative

nor decorative, but rather a cross between the two. There is, however, a clear correlation between the renaissance of monumental form in these countries and an increasing distaste for it elsewhere. Though 'monumental' may now have come to mean—before anything else—'impressive', the root meaning 'to remind' retained its validity. As the new regimes used large-scale sculpture as a way of reinforcing their own ideologies, statuemania made a more overt shift from commemorating the past to commemorating the present; from the other to the self.

Of course, and as I have argued above, statuemania had always been connected to the ideology of a ruling class, and to nationalism. War memorials were not only a way of paying tribute to the dead, but also a way of reasserting national identity, especially after the loss of national pride, as with the Boer War or the Franco-Prussian War. Indeed it is important to go back to 1870–71 to understand how the victors, the newly unified Germany, moved towards a much more explicit use of the monument as a symbol of national power, and how such a shift, which gained force through the 1930s, is repeated in the USSR and Italy.

The rise of German nationalism

In Germany the monuments to the Franco-Prussian War, and to Kaiser Wilhelm, were succeeded by monuments to Bismarck. The monuments to Wilhelm linked him to his twelfth-century predecessor, Kaiser Friedrich Barbarossa, and extended the parallel between the medieval and the modern by placing such statues on historic sites. After Bismarck's death in 1898, nearly 500 municipalities chose to erect a Bismarck memorial. These followed in the wake of the first Bismarck Monument [33], a colossal statue by Reinhold Begas, which had been

33 Reinhold Begas
Monument to Bismarck,
Berlin, 1897

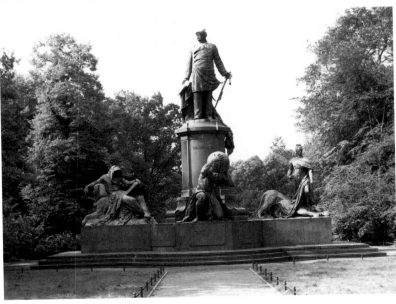

erected in Berlin in front of the Reichstag just before the Chancellor's death. However, many of the subsequent Bismarck monuments commemorated Bismarck obliquely, not in person, but rather by what he represented; they were monuments intended to inspire, and indeed to create, feelings of nationhood. Abstract monuments were a different means, both more and less visible, of proselytization. If these monuments spoke in code, it was one writ large, of a massive scale disproportionate to their surroundings.

The most common 'abstract' alternative to the figurative monument was the Bismarck Tower, a scheme initiated by the Association of German Students, and promoted as a competition with set guidelines. At least 50 versions of the winning design were subsequently erected. The 'Bismarckturm' consciously referenced the medieval Roland Columns which were particularly associated with the border areas of northern Germany. Such connections were also made in a more

34 Hugo Lederer
Monument to Bismarck,
Helgolaender Allee,
Hamburg, 1901–6

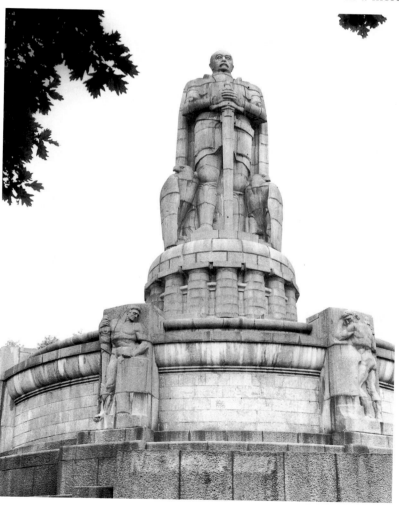

explicitly figurative, and non-serial commission, Hugo Lederer's Bismarck monument in Hamburg [**34**] (1901–6). Lederer's work informed the shift in the contemporary definition of the monumental, inspiring a thoughtful response from critics such as Aby Warburg and Peter Behrens who were interested by its modernity, and by its ability to stir the masses. Franz Metzner's collaboration with Bruno Schmitz on the massive Volkerschlacht Monument in Leipzig (1913) confirmed the assertive constructed masonry used by Lederer as a definitive style.

The British critic Kineton Parkes, writing in 1921, identified the tendency to colossal sculpture as being something to which all the countries subject to German and Austrian influence—particularly Sweden, Italy, and Holland—had succumbed. He warned against 'big, arid masses of granite'; against the 'theory that a great mass is equivalent to a great impression'. He was also unsure about the validity of uncarved stone, unsculptured mass which meant that bigness went hand in hand with baldness. Later in the 1920s an American writer, Agnes Rindge, similarly recognized the 'blunt and bulky forms' as a 'German idiom'. The dominance of a definite 'German' style began to worry commentators around the time of the First World War, and through into the 1920s, when the French were particularly keen to lay claim to something that was essentially 'French'. This led to the '*colossale*' being dubbed '*kolossale*', for the same, but more justifiable, reasons as those which led some critics to rename cubism '*Kubisme*'.

Whereas the conventions of statuemania required that there should be some kind of link between the site and the monument which stood on it, such national monuments frequently eschewed such niceties. One contemporary German architectural writer went so far as to label these monuments '*Reichsplakate*' or advertisements for the new nation state. Hubert Schrade (a sculptor later beloved of the Third Reich) admired the Hamburg Bismarck because it dominated its landscape. Thirty years later, another German writer, Walter Horn, described much the same phenomenon: 'Grandeur of Form, which is an appropriate icon for our era, bestows on sculpture a new audacious language. The Giant Sculptures have become a symbol of the creative politics of state ...'

Fascist propaganda

As the Bismarck tower represented 'Germany', so the Third Reich used an 'abstract' and repetitive system of statufication to represent itself. A 1934 decree required the use of sculpture—reliefs and frontal sculptures—on all new public buildings (and there were many at this time). The association of Third Reich sculptures with the buildings against which they were positioned is notable: this was a site-specific programme in which the sculpture's authority depended on its backdrop and which might be seen to have evolved out of Germany's Hildebrandian tradition. A few sculptors repeated certain motifs

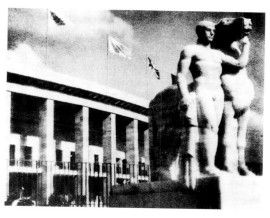

across the institutional fabric; Kurt Schmid-Ehmen made the eagles, Adolf Wamper the figures, for the party buildings in Munich, Berlin, and Nuremberg; Fritz Klimsch's figures were disseminated through German towns. Certain projects concentrated these arts of propaganda, significant among which is the 1936 Olympic Stadium for which Josef Wackerle and Karl Albiker created monumental groups [**35**]. These groups hark back to Lederer, and the tradition of constructing monumentality in stone, like a building. By 1937—as with the groups which Josef Thorak made for the German pavilion in Paris—the party style had turned to bronze sculpture against the foil of stone architecture. Arno Breker, now 'Official State Sculptor', was given studios and an enormous studio work-force to turn out a production line of sculpture. These monuments were not dedicated to an individual person, but instead represented the regime through generic figures of strength and beauty. Though busts of Hitler were disseminated

through party buildings, his image did not enter the monumental arena. Nazi sculpture is 'monumental', in that it represented first and foremost, the Third Reich, and secondly, because of its size.

The Fascist regime in Italy disseminated the more personalized image of Mussolini in paintings and posters from the mid-1920s. As the state made increasing links with its imperial past, statuary came to play a larger role. The developing plans for the Foro Mussolini were to have included a 100m high statue of The Leader, designed by Aroldo Bellini in 1934, though only the head and limbs were ever completed [36], and his portrait was built on a colossal scale by Italian troops in Ethiopia (1936). Fascist statuary represented the state, and its desired links with Imperial Rome, by means of the outward forms and scale of the classical age. Giorgio Gori's 'Spirit of Fascism' at the 1937 Paris exhibition harked back to the seminal equestrian monument of Marcus Aurelius on the Roman Capitol.

At first modernism enjoyed something of a creative partnership with Italian Fascism, and Mussolini was prepared to defend modernist architects until at least the mid-1930s, when he abandoned practitioners such as Terragni and Pagano who had enjoyed such opportunity until then. Even then a 2 per cent law which enforced artistic commissions within new building projects benefited modernist sculptors such as Fausto Melotti, Lucio Fontana, and Arturo Martini. Since the early 1920s, with his war memorial at Vado Ligure, Martini had been experimenting with innovative arrangements of commemorative architecture, setting figures within or against increasingly ambitious and open stagelike settings. In the mid-1930s Martini had fought to gain the commission for the monument to Duke d'Aosta, but lost it to Eugenio Baroni whose athletes feature in the Foro Mussolini. Martini's 'Minerva' fronted Piacentini's Città Universitaria as Bourdelle's 'La France' fronted the Palais de Tokyo. What might have been seen as nuanced variations within the tradition of siting monumental statuary now found themselves closely connected to the frontal and axial arrangements of Fascist architectures.

Even during the war, Mussolini continued to plan on a grand scale. The Esposizione Universale di Roma (EUR or E'42) was designed to commemorate 20 years of Fascist rule and represented the Stile Littorio, the Fascist modern style which was the result of the search for an Italian modernism. Anniversaries were important events for regimes with short histories: in 1940, exactly one year after declaring the end of civil war in Spain, Franco announced work on the monumental Holy Cross of the Valley of the Fallen beside the Escorial. The Fascist regime in Portugal liked to trace its lineage to Portugal's Golden Age, commissioning an enormous monument to the Discoveries from its favourite sculptor, Leopoldo de Almeida, which was erected only in 1960, 20 years after it was first presented.

The Union of Soviet Socialist Republics

In the USSR, where in the first years after 1917 the new government was intimately connected with new forms of art-making, the 'monumental' nevertheless continued to be represented by the figurative statue on the plinth. Though one of Lenin's early acts was to order the removal of the monuments to the Tsarist regime (1918), his next was to organize a competition for monuments to commemorate the Revolution. The list of people to whom monuments were to be erected (66 names from a range of backgrounds) included not only Marx and Bakunin, but also Vrubel' and Chopin, who brings us sharply back to the statuemania of the French Third Republic.

After Lenin's death in 1924, monuments began to be erected representing his image; these are traditional commemorative monuments in the real sense of the word. (I.D. Shadr was a particularly faithful portraitist.) The first important monument, by Vladimir Shchuko and Sergei Evseev, erected in 1926 outside the Finland Station in Leningrad, established a form which was much repeated [37]. From the mid-1930s Lenin's image was replaced by that of Stalin—the difference being that Stalin's monumentalization took place during the subject's lifetime—and indeed the cult of Stalin meant that a number of schemes dedicated to Lenin, such as the enormous Palace of the

37 Vladimir Shchuko and Sergei Evseev
Monument to Lenin, Finland Station, Leningrad, 1926

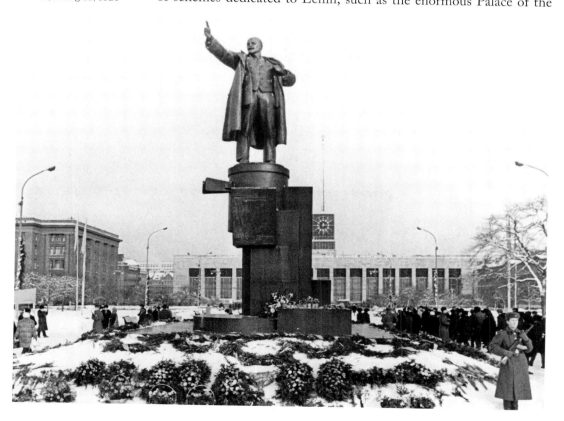

38 B.M. Iofan and Vera Mukhina/Albert Speer, Kurt Schmid-Ehmen and Josef Thorak

Soviet and German pavilions, Paris, 1937

In his memoirs the architect Albert Speer recounted that the French organizers had determined that the German and Soviet sites should confront each other. Having 'by chance stumbled into a room containing the secret sketch of the Soviet Pavilion' as drawn up by Boris Iofan, Speer was able to plan a German pavilion which would at least match, if not better, it. At its foot were two bronze groups by Josef Thorak, the one on the left, 'Comradeship', developed out of his Security Monument in Ankara. Both pavilions won gold medals.

Soviets crowned by his 100m statue, were never built. Vuchetich's Stalin on the Volga–Don canal was, however, realized at a similar scale.

It is at the time of the secure establishment of Stalinism—through a series of show trials, and with the collectivization of agriculture—that the optimistic imagery of the Soviet worker emerges most strongly in sculpture, and memorably at the 1937 Paris Exhibition with Vera Mukhina's 'Industrial Worker and Collective Farm Worker' [139] which was opposite Schmid-Ehmen's eagle. Mukhina's 24m high steel group outdid the eagle, though Albert Speer's pavilion brought it up to the same overall height. Though the two pavilions were juxtaposed critically as well as physically [38], they are more different than alike, not least in their sculpture. The bronze figurative groups by Josef Thorak which stood at either side of the entrance to the German pavilion had gravitas derived from their vertical and frontal disposition. In contrast, Mukhina's group had an all-round aerial silhouette whose dynamism was enhanced by its stainless steel covering. On the next world stage, the 1939 New York World Fair, I.D. Shadr's 'Girl with Torch' did a similar job in representing the Soviet Union. The Soviet 'hero' is very different to the German, in facture as much as content. Soviet imagery portrays the worker, both male and female, while Nazi iconography contrasts the male athlete with the woman as mother or as object of desire. Nazi types tend to be at rest, in contrast to the forward thrust of the Soviet worker. An accompanying brochure introduced the Soviet pavilion as bearing 'the definite imprint of the artistic method we call Socialist Realism', characterized by 'the fullness of its imagery, its ideological completeness'. The 'Positive Hero' was spirited and optimistic in appearance; indeed Nikolai Andreev's famous statue to Gogol, erected at the beginning of the century, was now deemed too pessimistic, and taken down. Few Stalinist or Nazi monuments commemorate specific figures from the past. Instead they use mainly anonymous 'types' to mark the present and the future.

Shedding meaning

The monument is a complicated mixture of form, subject, site, scale, author and public, and the different and combined connotations of each. In the years after the First World War the monument retained these elements, minutely altering a balance which had been established through the nineteenth century, but after the 1930s such subtle evolution was abruptly jeopardized. Apart from the very occasional statue to an outstanding statesman or leader, the traditional form died after the Second World War. The need to make it possible to make a monument at all invited artists to manipulate the established balance. The monument had to be realigned and appropriated, or it was no longer workable. Part of this realignment derived, in fact, from precedents established in the work of Rodin and Maillol.

The extent to which Rodin was responsible for changing the monumental tradition, so that at the end of his life it indeed became possible to erect monuments which had ostensibly 'failed', is an important question. Was the way in which his work failed as monument the way in which it established different criteria for success? This possibility opened a door to his successors, as it does to us. Thus we might see the monumental form as being released for other kinds of uses, and given a new and different lease of life. Indeed, as the monument became less acceptable, relegated to the margins, it became an area of experiment which led to the monumental re-emerging within the arena of modernist debate.

Anti-monuments

Private memorials may well represent a position which has been officially discredited. Wilhelm Lehmbruck's famous 'The Fallen' (1915–16) must not be read so much as a war memorial as an anti-war memorial on the part of a pacifist. Isamu Noguchi's model for a 'Monument to Heroes' (1943), in which bones pierce a cylinder, was a 'dirge for futile heroes who killed themselves—for what?' Julio González's 'Montserrat' took its part as one of a few carefully chosen components in the 1937 pavilion which represented the Spanish Republican government's attempt to use art to tell the story of its fight against Franco's Nationalists. Pablo Picasso's 'Guernica' is the best known element of this montaged ensemble, but González's sculpture—a woman with a sickle and a baby—stands in poignant (and perhaps deliberate?) contrast to the scale of Mukhina's and Thorak's work outside. Its modesty thus genuinely enhances its commemorative function.

Certain sculptures relate to the experience of the Second World War in a similar way, and might also be seen as personal memorials: 'L'Adieu', made by Henri Laurens during the Fall of France in 1941, Ossip Zadkine's 'France Prisonnière', or Kolbe's 'Liberated Man' of 1945, which, contrary to its title, shows a man burying his face in his hands. Käthe Kollwitz's tiny 'Tower of Mothers' from 1937 to 1938 exploits monumental potential not simply in terms of its title and form, but also because of its associations with communal grieving.

There is a small but significant strand of monumental work which uses architecture in its attempt to open up space within the traditional hierarchy. The tower or beacon form, which goes back to ancient times, was redeployed by Rodin and developed thereafter by Obrist, Itten, and Tatlin. The non-figurative architectural structure was appropriate to mark the many rather than the one, an aspirational instead of a hierarchical regime. (Nevertheless, the remarkably similar form of Hildebrand's model for a Bismarck Tower (1894) should be cited to break up this apparently utopian lineage.) Rodin's 'Monument to Labour' (1898–9) was ascribed to 'The Workers'; Tatlin's 1920 model for a 'Tower' was dedicated to the Third International.

A more ambitious use of the 'anonymous' forms of architecture is demonstrated by Walter Gropius in his extraordinary memorial to the Kapp Putsch in Weimar (1922). Mies van der Rohe's 'Monument to Karl Liebknecht and Rosa Luxembourg' in Berlin (1926) might be read, in its very eclecticism, and despite the unquestioned Socialist significance of its subjects, either as revealing a complete loss of faith in the monumental tradition, and indeed in politics too, or as offering a way forward. The subjects of such monuments, like those of the war, have no face. The monument had to be loosened from its figurative and commemorative roles so as to be realigned. This realignment has ensured a continued, if changed, use of the monument in terms of its demarcation of site.

Picasso's drawings from Cannes (1927) and Dinard (1928) represented his 'Projects for a Monument' as reproduced in *Cahiers d'Art* in 1929. These line drawings contained within them the notion of enlargement (and indeed Picasso envisaged them on the Croisette of Cannes). Picasso's work at this point hovers between the private and the public, stimulated by the commission for a monument to Apollinaire to make work that internalized the notion of monumental commemoration. The drawings for 'Metamorphosis' were seen by the Committee at the end of 1927, and rejected. In 1928 Picasso presented them with the wire constructions which González had fabricated from his drawings, and these too were rejected. Despite this double rejection, Picasso continued to be inspired by the idea of a monument to his friend—as revealed in further sculpture, both the 'Metamorphosis' of 1928 and 'Woman in a Garden' of 1929–30.

Monuments to their makers

Before the end of his life, Rodin began to see some of his more self-indulgent monumental designs erected in ways which defied the conventional norms. This trend only increased as he became more famous, so that major local commissions like 'The Burghers of Calais' could be erected well away from the original site, as pieces of art, in places which had no connection with the original reasons for the commission. Even monuments which had 'failed' were resuscitated and erected. They were often put up in unfinished form, and already betray signs of that later shift in which the artist was to become as significant as the subject. The 'Victor Hugo' first intended for the Panthéon was promised a home in a Parisian park, erected in an ad hoc manner as much as an artwork as a statue, and the erection of 'The Thinker' on the steps of the Panthéon in 1906 was similarly due to the pressure of Rodin's influential friends. 'The Thinker' was thus the first statue by Rodin to be erected on the streets of Paris. It had been translated from another commission, 'The Gates of Hell', which had itself been altered in status. The fact that Rodin's first public statue was a monument to

no one—other than the artist himself—was in both a literal and an abstract sense a result of his having failed at the monumental game up to then. Rodin's great supporter, Geffroy, remarked on its rare beauty as a statue, making his point implicitly rather than explicitly. 'The majority of our statues have no significance as art.'

Maillol had already prefigured this change in designing monuments which denoted 'Maillol' more than the figure they commemorated. Whatever the monument—whether to a revolutionary socialist (Auguste Blanqui), the war dead, or a famous painter (Paul Cézanne)—the motif, figuration, and style were so consistent as to be apparently interchangeable. What Maillol did was to be very useful for authoritarian regimes, who took up this new possibility of making a space monumental—that is to say, impressive—through the apparently invisible arts of propaganda, which works by infiltration and subconscious suggestion rather than by overt homage to any one individual.

Rodin's 'Balzac' was commissioned by the Société des Gens des Lettres in 1892 on the basis of a maquette. When they saw the full-size plaster at the 1898 Salon, they refused it. It was judged to be too personal, unable to represent Balzac more than it already represented Rodin. Well after Rodin's death his 'Balzac' [39] was finally erected, on another crossroads in the capital, as a monument 'A Balzac/A Rodin'. This double dedication accurately conveys the pivotal position of the monument, which represents the transition between the monument representing its subject and representing its maker. This transition is significant and highlights the shift at work throughout the early decades of the century.

This new phase of monumental practice was only to be confirmed by the destruction of older monuments, particularly during the Second World War, and particularly in Paris, where an army's need for bronze, combined with the wish of the occupying force to obliterate the markers of a previous regime, led to over 70 statues in the French capital being melted down. Those which survived had been judged to be of exceptional artistic quality, and thus act as unrepresentative witnesses to a more mixed tradition.

'Balzac' opened the way to the monument which celebrates its maker, as much as any subject. After the war (1959) Picasso's monument to Apollinaire was finally erected, its form vastly tamer than his earlier excursions, but its status altered to embrace this double subject; it celebrated the artist at least as much as the poet. Just as a Maillol commemorated Cézanne, so a Moore commemorated Christopher Martin at Dartington Hall (1945), and indeed the form is strikingly parallel. From this there was only a short step to the way in which 'monuments' in the second half of the century have chiefly been about their artists and not about commemoration at all.

Monument to Balzac,
Boulevard Raspail, Paris,
erected 1939

Rodin's 'Balzac' monument
was inaugurated on the
Boulevard Raspail in 1939,
after the Société des Gens
de Lettres which had at first
rejected it asked to make a
cast from Rodin's original
plaster. The earlier com-
mission — which had gone
to Alexandre Falguière
in 1899 and was finished
after his death by Laurent
Marqueste — had been
inaugurated on the Carrefour
Friedland–Balzac in 1902.

Beyond being by a 'named' artist, the conditions for this new breed of monument depended on their being large, placed outdoors, and visible to the public. They might create a special site, by virtue of the successful conjoining of work and space. This left the way open for the socially committed abstract art of the 1930s to become monumental after the war by means of large-scale public commissions from public or private landowners, developers, municipal councils, or commercial enterprises who wished to have a share in an apparently progressive humanism. This kind of thinking was so new as to be almost unspoken in the 1920s and 1930s. Nevertheless, we see it emerging. This new role for the monument has, however, very little to do with the monumental tradition. Though many of these works have significance as art, they also come close to the corporate logo, or even the implicit sign of a regime committed to the 'free' art of capitalist individualism. Though works by Moore or Calder are simply scaled-up art-gallery pieces, placed in the city, or even more radically in the country, and have nothing directly to do with remembering, they may, and often will, if inadvertently, make of their site a special place.

Earlier in the century sculptors were keen to create a space for grieving over and above the nominal 'statuary', and First World War memorials, partly perhaps because they commemorate so many, and bring together so many others, have a tendency towards wide horizontal and architectural expansion. The demarcation of a spatial arena for the monument assumes primary importance in Brancusi's Tirgu Jiu monument—which commemorates the dead of the First World War and was built in Romania between 1936 and 1938—and thereafter in Noguchi's significant (though much frustrated) ambition to use the site in a much more active way than simply as something on which sculptures are erected.

A new centre

The monument had declined from representing a sure and prestigious career for a sculptor, to being an unsure one: discredited, unwanted, superfluous. Though the monument crops up on numerous isolated occasions throughout the story of 'modern' sculpture, it no longer provides the backbone to sculptural practice. Whereas most sculptors made their living by means of a judicious mix of portraiture, ideal, and monumental work between 1880 and 1930, by the late 1930s not even the 'establishment' was sure that it wanted monuments.

Before the First World War, and even after it, the elite of a country's sculptors were identified with those who made its public statues. In the United States we group Saint-Gaudens, Daniel Chester French, Taft, Grafly, MacMonnies, George Grey Barnard, the Borglums, Alexander Stirling Calder, and Paul Wayland Bartlett as just such an elite. In France, around the First World War period, one would single out

Bartholomé, Bouchard, Boucher, Bourdelle, and Landowski. In Britain we could cite Thomas Brock, George Frampton, Goscombe John, Reid Dick, Charles Sargeant Jagger, Ledward, and Pomeroy. These sculptors represented the 'Academy': those who had won the Rome Scholarships, exhibited at the official Salons and who continued to sit in judgement on others.

While monumental art was increasingly identified with those who made war memorials, another kind of sculpture was developing elsewhere. There was now a split between the artist who worked to commission, and the studio artist who developed the language of sculpture more privately. (Very often this split was exacerbated along national lines: indigenous sculptors naturally expected to receive portrait and public commissions from private and professional, local and regional contacts. Foreign sculptors, being outside this nexus, had been freer, earlier, to work on their own account.) Whereas previously the two sides were joined, meaning that both public and private sculptures, large- and small-scale, were developed by the same people, the increasing separation of the monumental from the non-monumental caused a division that deeply affected the practice and the reading of the sculpture of this period.

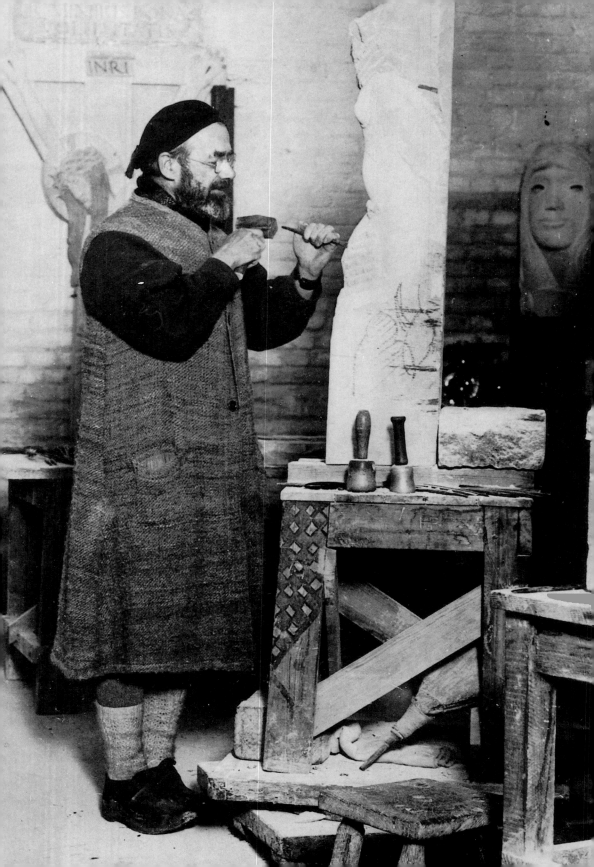

Direct Expression through the Material

3

True or false?

Rodin provoked another question—that of authenticity. At the height of his fame, Rodin was employing around 50 assistants on his own premises alone. After his death in 1917, the question was raised as to the extent to which the master would actually have been involved in much of the work that was sold as his. The affair of the 'faux Rodin'—in which a sculptor named Charles Émile Jonchéry was accused as a forger—occupied the courts during the first six months of 1919, and as other examples emerged, it became clear that technically speaking there was very little difference between a genuine Rodin and a fake Rodin.

Once again, Rodin was caught up at the very heart of the changed expectations for sculpture. It was by no means new for a sculptor to have a workshop, and the high turnover in the late nineteenth century had only made more necessary a large and efficiently disciplined production line. But Rodin had not only been promoted as an exceptional individual, he had himself cultivated his inspiration as being unique and intensely personal. In order for his clients to feel that the works they owned spoke of the sculptor's innermost being, they felt they had to believe that Rodin had himself made them. This was, however, rarely the case. Their carvings were reproduced from Rodin's original clay model by means of the pointing machine, a three-dimensional pantograph which allowed almost exact replicas and enlargements to be made by any skilled technician from any given original [40].

Reaction to industrialization

The interest raised by the scandal of the Rodin fakes can be attributed not only to the recent opening of the Musée Rodin, but also to the fact that industrialization was causing growing concern. In England writers such as John Ruskin and William Morris had already called for a return to pre-industrial working methods as a way of avoiding the alienation of the worker from his product. In Germany the debate which led to the creation of the Werkbund in 1907 invoked the 'inner

40 Charles Sargeant Jagger
Studio photograph with
assistant and pointing
machine, taken from his
1933 book, *Modelling and
Sculpture in the Making*

truthfulness' or 'truth to materials' (*Materialgerechtigkeit*) in opposition to the 'surrogates' produced as a result of the misuse of the machine. Art industries were as affected as any.

The ever-increasing rate of production of architectural and monumental sculpture in the later nineteenth century had been possible only because of the continual evolution of new technical processes, centred upon improved enlarging and mould-making techniques. Increasing demand pushed technical invention, which in turn permitted demand to grow. Although these technical improvements allowed sculpture to be made more quickly, more cheaply, and on a larger scale than ever before, the results were somewhat questionable. Deterioration in the quality of material, craftmanship, and longevity, never mind aesthetic conception, was soon open to view. In smaller-scale sculpture new technologies for reproduction and retail led to a steady decrease in both artistic quality and authorial control. Clay originals destined for bronze were cast by skilled plaster-casters, and the resulting mould allowed an edition of bronzes to be made at the foundry. To a

considerable extent the artistic process had indeed been taken out of the hands of the artist, its corollary being the increasing specialization within the division of labour. Some assistants were employed for their skills using the pointing machine, others were allowed to finish off the last layer of carving by hand; some worked only as plaster-casters, others only as patinators and chasers of the bronze.

Before he became a 'sculptor' Eric Gill was deeply involved in the 'lettering business' and, as we saw in Chapter 1, 'if ever it happened that a customer ordered a cherub to be carved on a stone I used to call in a sculptor friend to do that part of the job'. When Gill first made a carving—'a woman of stone'—he was surprised how well it was received, but put this down to the fact that 'not one single person was doing stone carving!' When Gill says no one was doing stone carving he means 'nobody except the trade stone carvers and they, sad to say, didn't count'. Gill was very much conscious of the split between the artist and the craftsman, and hoped his own evolution went some way towards a reconciliation. Such fragmentation had made possible the increase in pace which the industrialized and urbanized world had both demanded of and allowed to sculpture. It took perhaps 50 years to take stock of what such progress meant, to slow down and turn around this relentless machine, but by the 1920s the most topical questions in sculpture involved escaping the bit-part efficiency of the production line and reserving the whole process to oneself.

Material change

We see the vast majority of nineteenth-century sculpture in one of two materials: marble or bronze. But nineteenth-century sculptors developed their original ideas in a variety of media: clay first among them, but also wax, plasticine, and plaster. The variety of original materials is concealed, however, by the dominance of the two materials into which they were transposed. The difference between the sculptor's working material and the material of the finished product is the invariable factor.

This transposition involved not only a shift in material, but also in work-force. It may have been unexceptionable for a monumental scheme to be carried out by a team of workmen, but the example of Rodin alerted clients to similar working practices even in the case of small-scale portrait busts or ideal work. Although some of the affront in the case of the bust may have had something to do with the special rapport with the artist which sitters felt their portraits should represent, the fundamental question was that of the transposition of materials. In that difference lay a gap both temporal and conceptual which involved the hand, or hands, of another. That gap came to represent a betrayal of the creed which was now developing—the creed of truth to material. As Eric Gill pointed out, 'stone carving properly speaking isn't just

doing things in stone or turning things into stone, a sort of petrifying process; stone carving is conceiving things in stone and conceiving them as made by carving'. Gill moved on from masonry and lettercutting to produce his first sculptures in 1910, carving these, as he would have his craft work, without intermediary material or interpreter [41].

Focusing on the importance of the original material brought with it an interest in its diversity and its local and historical associations. Whereas most nineteenth-century busts and statues had been carved in Italian marble, in the early twentieth century sculptors began to use native stones; Hornton or Hoptonwood in England, Caen or Lorraine in France. Eric Gill saw his carving activity in line with that of the medieval stonemason on England's churches, as in Germany Ernst Barlach could ally his woodcarving with Germany's historic tradition of religious woodcarving. However, an essay written in 1930–1 by Max Sauerlandt, the curator who did much to establish the Brücke group's art-historical position, is perhaps unusual in distinguishing recent German wooden sculpture from that of its medieval predecessors. He

41 Eric Gill
At work in his studio at Pigotts, High Wycombe, 1932

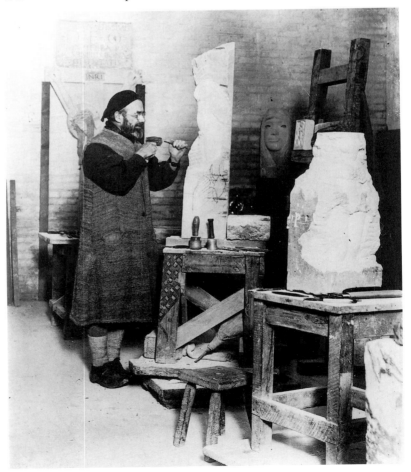

makes the point that whereas colour had previously been built up to make the 'wooden core completely disappear', the new work is an 'unconcealed art of wood sculpture', distinct by virtue of its 'fresh and lively treatment of the wood surface'. The return to a direct engagement with the material meant a heightened role for the material itself. Carvings from the 1910s, 1920s and 1930s are in a range of coloured stones and textured woods. Now the difference between an exotic hardstone and an English softstone, between an African hardwood such as lignum vitae and a softwood such as lime, became crucial. Sculptors use the material to advantage, associating the image with its material, engaging the viewer by linking sight and touch.

Modelling versus carving

Not only should direct carving ensure authenticity (in that the named sculptor did all the work him- or herself), but also honesty, in that stone was revealing of every decision, whereas clay allowed endless effacement and revision. The American sculptor William Zorach was to emphasize: 'The actual resistance of tough material is a wonderful guide. He cannot make changes easily, there is no putting back tomorrow what was cut away today ... Slowly the vision grows as the work progresses.' Carving could be promoted as honest in every way. As a result, clay assumed somewhat 'decadent' associations. Lipchitz gives us an interesting account of Modigliani's position in 1913: 'Modigliani, like some others at the time, was very taken with the notion that sculpture was sick, that it had become very sick with Rodin and his influence. There was too much modelling in clay, too much "mud". The only way to save sculpture was to begin carving again, directly in stone.' Paul Dardé declared, 'Kneading wax, or mixing clay, disgusts me. They offer no resistance, they take any form, they are easy and sloppy.'

Certain critics, and certain sculptors, made capital out of the new climate of public opinion to promote direct carving—'la taille directe' - as the necessary purgative. While on the one hand a quintessentially modernist sculptor, such as Brancusi, might be reported as declaring that 'direct cutting is the true road to sculpture', this new climate also embraced otherwise eccentric, even marginalized sculptors (and Paul Dardé is a prime example).

For an older critic, and one who already represented an 'alternative' to Rodin, the debate hinged also on the choice between carving and modelling. In 1917 Adolf von Hildebrand wrote a short essay on Rodin which made the same charge as that of his younger colleagues: fragmentation. Hildebrand found that Rodin's works 'fell apart', and accused him of a superficial understanding of Michelangelo's marble carvings. Hildebrand's alternative brought together two current concerns: one for unity and stasis in form, and the other for this to be achieved by means of the thorough treatment of the stone.

Ironically enough, clay itself was perhaps the most intimate and direct of all the sculptor's materials, but it lost this status once the original was put through the procedure necessary for casting. Clay remained a mainstay for those (and there were many) who were not unduly exercised by the new debate. Explaining in his autobiographical notes that he learnt at the academy to begin with a clay sketch, Lipchitz proclaims 'I have continued to use this method ever since that time because I believe strongly that it is superior to all others.' A sculptor like Epstein, who was so committed to carving stone, still used clay with equal virtuosity for his portrait work. But Epstein's portraiture was cast in bronze, and thus lost whatever distinction might accrue from its being direct. It was carving which was associated with 'attitude'. It might have been possible to ally the cause of 'truth to material' with ceramic sculpture, which preserved the very mark of the hand, and the conception of a work in one material. This returns us to Gauguin's realization that 'truth to material' could, and should, be applied to a wider rather than a narrower range of materials in his own review of the ceramic section of the 1889 Universal Exposition:

Let us get back to our knitting, sculpture like drawing, in ceramics, ought to be modelled 'harmoniously with the material'. I will beg sculptors to study carefully that question of adaptation. Plaster, marble, bronze and fired clay ought not to be modelled in the same fashion, considering that each material has a different character of solidity, of hardness, of appearance.

Though a few sculptors, especially in Holland and Germany, now promoted the use of clay—the German sculptor P.R. Henning even wrote *Clay: a Manifesto* (1917)—the direct school nevertheless affiliated itself to carving, characterizing itself by its very opposition to modelling. Between 1907 and 1909 Brancusi made the move from modelling to carving. Indeed, by his own account this step represented the move to sculpture itself, as he had decided that modelling was fundamentally antithetical to real sculpture. In his quoted phrases Joseph Bernard presents the modeller as an interventionist who disturbs the direct worker's relation with the material: 'The artist must understand and love stone, carve it himself, and not allow the modeller to come between it and his idea.' Joachim Costa, who published a book contrasting modelling and carving in 1921, used the Louvre to provide illustrations for the two traditions. In this binary history the lineage of stone carving, as represented in Egyptian and Assyrian relief-work, Cambodian, archaic Greek, and medieval French carving, represented the only true path.

The autograph product
The reaction to Rodin was to argue for a directness that would not only ensure the authorship of the finished product, but also the authenticity

of its conception. To deny the need, or the desirability, of an intermediate stage, and of an intermediary, was to ensure that the work was only that of the sculptor whose name it bore. The cry for 'direct work' was a cry for work that was unmediated. In an article of 1925 Ernst Ludwig Kirchner made this clear in offering his simplistic explanation for the 'dismal uniformity of our sculpture exhibitions':

One has to realize that in the case of the old working method, only the clay model is actually created by the artist, whereas the end result and all work toward it is done by other hands ... How different that sculpture appears when the artist himself has formed it with his hands out of the genuine material, each curvature and cavity formed by the sensitivity of the creator's hand, each sharp blow or tender carving expressing the immediate feelings of the artist.

The central change was that many sculptors now wished to make their work entirely themselves. They nevertheless wished for their work to be durable and to retain the permanence which the previous methods had ensured. Because this was difficult to carry through in metal, the change was mostly effected in carving. Work slowed down, and, because many of these sculptors had never learnt to carve (for carving was only a craft, which a fine artist would never have learnt in an art school of that period), the works were quite simple [42, 43]. The lack of technical facility was nevertheless rather appreciated, partly because it allowed the qualities of the material to show through and effect a change on the artist's technique. These artists were not simply incapable of realistic figuration, but actually cultivated the new stylization which was the result of the conjoining of different priorities with a resistant material. In a 1922 monograph on Max Pechstein, the author explains the watershed which wood offered the artist in 1909 because 'The material was problematic; it offered stronger resistance; therefore the depiction of nature was reduced to what constitutes its critical surface complexes.'

Sculptors had, however, to get used to critics who, accustomed to the extraordinary competence of professional carvers to reproduce detailed modelling in clay [44], saw these new carvings as clumsy and primitive. Nevertheless, although direct carvings were at this date relatively few and far between, the approach proved sufficiently fertile to come to dominate twentieth-century sculpture. In the first decade of the century a number of sculptors, in different countries, began to carve their own work. Certain examples which may have seemed anomalous or isolated at the time can now be seen to presage a much wider trend. The names of Brancusi, Derain, Epstein, Gill, and Barlach belong to this narrative, in France, Britain, or Germany, but that of Joseph Bernard in France was more influential on the development of a broader school of direct carving in the succeeding decades. In

common with others who developed this approach, Bernard had a
background in artisanal stonecutting, though he followed a conven-
tional academic training at art school. Bernard had carved a few pieces
since around 1902, and these '*pierres directes*', as he called them, became
better known when exhibited at the Salons of 1911 and 1912. One of
them, 'Effort vers la Nature' [**45**], made between 1903 and 1907, is now
in the Musée d'Orsay. 'Juno' (1910), by the Spanish sculptor Enric
Casanovas, who was carving stone heads directly by the same date, is a
comparable work. Both heads are thickened and simplified versions of
a Rodin bust, exaggerating Rodin's conceit of allowing the fashioned

43 Constantin Brancusi

Kiss, stone, 28cm, 1907–8

This is Brancusi's first 'Kiss' and dates from the year in which he began his '*pierres directes*'. He made another in 1908, and that of 1909 was installed in 1911 on the grave of a young girl who had committed suicide. That version, in the Parisian cemetery of Montparnasse, stands on a plinth which bears an epitaph carved by Brancusi in Cyrillic. A 1912 version was given to the critic Walter Pach as a wedding gift, sold to the collector John Quinn in 1916, and later entered the Philadelphia Museum of Art as part of the Arensberg Bequest. The motif reappears in the 'Gate of the Kiss' at Tirgu Jiu (finished 1938).

44 Bertram MacKennal

Diana Wounded, marble, 147.3cm, 1907

image seemingly to take shape as it emerged from its bed of base material [46]. If it was unusual to carve one's own ideal work, to carve monumental work alone was unheard of, but in 1905, on receiving a commission to make the monument to Michel Servet, Bernard announced that he would carve the work himself.

45 Joseph Bernard
Effort vers la Nature, Lens stone, 32cm, 1906–7

46 Auguste Rodin
Lady Warwick, marble, 74.8cm, 1909

Sources in wood and stone

Carving has indigenous traditions; its rootedness gives it an 'anonymous' or generic quality which some artists have relished, and they have similarly played on its seemingly 'essentialist' character. Brancusi's roots in Oltenia, within the recently formed Romania, informed the education he received at the Craiova School of Arts & Crafts. Carving's indigenous connections were of special interest for countries refinding their own roots in the nationalist movements of the late nineteenth and early twentieth centuries. For countries throwing off the yoke of their neighbours' domination—Czechoslovakia or Finland, for instance—and restoring their own artistic schools, instead of looking always to Munich, Paris, or Düsseldorf, the example of folk art, and folk carving, was an important one.

Because artists need sources from which to learn—and because the sources for direct carving were in folk art or non-Western art—we discern the influence of the material in which sculptors sought alternative models. African, Oceanic, Indian, Assyrian, Egyptian, or Mexican carvings showed a holistic treatment in which image and material depended on each other, and a power derived very much from the original block. Those who used wood for their carvings looked to certain sources; those who used stone looked to others.

Beyond the indigenous folk-carving traditions, it was in African and Oceanic woodcarving that sculptors in wood found particularly exciting examples. Paul Gauguin began to carve wood from 1881, inspired first by decorative traditions, and by painting, and then by the folk art of Brittany, and the exhibits at the 1889 Exposition Universelle, especially the Javanese village. He already seemed able to mix European Art Nouveau with a proto-Oceanic style, and in Tahiti, in 1891-3 and again in 1895, and in the Marquesas from 1901, Gauguin absorbed carving into the environment in which he lived [47]. Symbolism gives us another context in which to understand Gauguin's semi-narrative, semi-functional wooden reliefs as it does for the Czech sculptor František Bilek. The 1906 Salon d'Automne retrospective of Gauguin's work, which included sculptures, was a revelation to many artists, including Brancusi.

The kind of non-Western sources which stimulated sculptors depended very much on a country's colonial links and museum collections. In Germany artists in the Brücke group—Kirchner, Pechstein, Heckel, Schmidt-Rotluff—used the ethnography collections in their local museum in Dresden, where at that time the Oceanic collections were prioritized over other ethnic collections. Nolde and Pechstein even visited their sources just before the outbreak of war in 1914, and on the Palau Islands Pechstein used indigenous carving tools. They furthered these initial impressions with their study of Carl Einstein's *Negerplastik*, published in 1915.

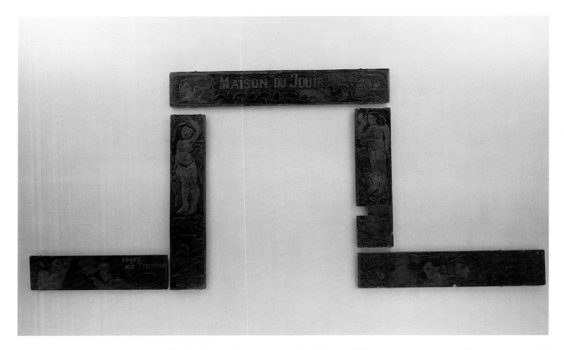

In Paris artists in search of non-Western examples of carving could visit the Musée Guimet, but the Louvre was more important to those who tended towards stone carving. The Louvre offered important examples to Epstein on his journey between America and Europe, but the British Museum lured him from Paris to London. The young Henri Gaudier made the same trip for much the same reasons. Both Epstein and Gaudier stayed to make their homes in London; most, like Derain in 1906, or Casanovas in 1913, returned home after studying the museum collections. At this time both Epstein and Gill were very interested in Indian carving, which they saw at the South Kensington Museum, and talked of collaborating on a great temple to the sun on the South coast of England, with carvings of gods and giants [48]. A decade later the young Henry Moore followed their footsteps to the British Museum where he was particularly impressed by the Egyptian and Mexican carvings.

Reciprocity between artist and material

The block—the original shape and size of the stone or the wood—is of signal importance to the carver, both in practical terms of the result, and also in conceptual terms as part of the creed of direct carving. The block features as both inspiration and impediment; a balance which it is difficult if not impossible for us now to gauge. Wood has an even more 'primary' form than stone, and its trunk shape led naturally to an upright figuration. To what extent was the apparently characteristic stylization of the series of elongated heads which Modigliani carved between 1909 and 1914 [49] due to the material which the artist was

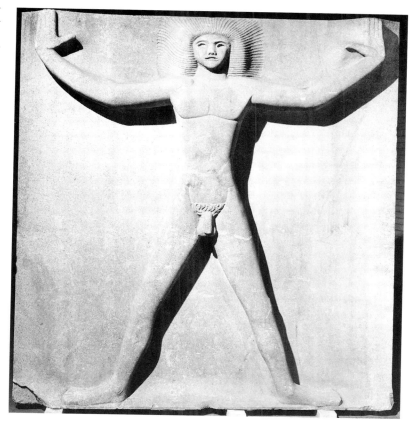

48 Jacob Epstein

Sun God, Hoptonwood stone, 213cm, 1910

Epstein had apparently envisioned a 'Temple of Love' and a 'Temple of the Sun' when a student in Paris in the early years of the century, and the vision seems to have resurfaced in 1910 when he and Eric Gill inspected a site (Asheham House) on the Sussex Downs for their '20th century Stonehenge'. Epstein made four works which might be linked to a 'Temple of the Sun', and this one, though unfinished, makes reference to a much smaller depiction of a Sun God ('Cocky Kid') which Gill had carved that year, and of which Epstein ordered his own copy.

able to obtain: masonry from building sites and railway sleepers from the local Métro station then undergoing reconstruction?

We have seen that two concerns had pushed some sculptors to introduce a change to their working procedure: one was to reserve their work to themselves, the other to assert the importance of the original material. That material, and its original form, developed something of a mythology around it. There was certainly a current conceit that blocks had sculptures within them (Bernard's '*nymphe prisonnière*') which needed bringing out by slow and gentle communion. Bernard talks of 'dis-engaging the presence which is apprehended within the stone'. In a letter of 1911, Kirchner propounds, 'There is a figure in every trunk, one must only peel it out' [**50**]; in the carvings he made on his 1913–14 sea-journey Nolde saw 'all kinds of little figures which only needed to be released'. In America the direct carver John B. Flannagan maintained that 'there exists an image within every rock', while Gaston Lachaise ascribed the pleasure he got from a 1923 bust to the fact that he 'cut this head directly from the marble making an association of the material with a clear impulse of what I desired to do'. In his *Autobiography* Epstein makes this explicit when he says that he knows that large blocks of marble 'could contain a wonderful statue'.

49 Amadeo Modigliani
Tête, stone, 63.5cm,
*c.*1911–12

50 Ludwig Kirchner
Dancing Woman, painted
wood, 87cm, 1911

Epstein more particularly cherished the power of uncut stone, and on occasion saw himself as saving large blocks from an otherwise ignominious fate as wall-facings or interior decoration. Those who saw the results of one such act of salvation, the tomb of Oscar Wilde, recognized that the stone itself had a monumental character, which influenced the artistic idea. Brancusi's statements echo such conceits about the inspiration of the material and come particularly close to the element of spiritualism which is never far away from the creed of direct carving: the 'spirit hidden in matter'. 'The artist should know how to dig out the being that is within matter and be the tool that brings out its cosmic existence into an actual visible existence.'

Despite the constraints of the block of stone—in theory and in practice—it was at first welcomed as a concept by carvers and by the critics who wrote about them. One might see the cultivation of the

Birds Erect, limestone,
68.3cm, 1914

block as something which characterized the early works of sculptors like Moore and Hepworth in the 1920s and linked them to their pre-war predecessors [**51**], while the more conservative school of direct carving tended in the same period towards the relief form, which was anyway better suited to the public and architectural commissions which these sculptors sought.

The conceit of truth to material in stone was an important one to English writers in the 1920s and 1930s. Their suggestion that stone had its own shape gave artists licence to respond to each stone's specific quality. Adrian Stokes used his knowledge of Italian Renaissance carving to inform his own writing on contemporary British sculptors. In *Stones of Rimini,* published in 1934, he went so far as to speak of the stone block as 'female, the plastic figures that emerge from it are her children, the proof of the carver's love for the stone'. Stokes's stone was

no longer the rigid block of the 1910s and 1920s, but a soft and suggestive material [**52**]. That Moore and Hepworth came to be written of in this newly suggestive manner was probably made possible by their exploration of wood. Being softer, wood helped them to escape the confines of the block and find their own shapes within it. Whereas the English had been almost too well served by their writers and critics in the promotion of a necessary symbiosis between form and material, those working in France developed their own shapes much more spontaneously. If this is true of Brancusi, it is even more so of Hans Arp, who, by the early 1930s, was making concretions from plaster. Hepworth visited both Brancusi and Arp in the 1930s, and it is clear that she became more decisive in making her own shapes rather than allowing the material to dictate.

Brancusi described direct carving as 'the method that enabled a sculptor to triumph over matter with each new work'. His work had at first been tentatively just inside the block but soon escaped its own material origins. Brancusi's manner of describing the reciprocity between artist and material is close to that of Hepworth, who is similarly careful in ascribing dominance to neither one. They come especially close in talking of the role of the hand. Brancusi is reported, in a 1926 New York exhibition catalogue preface, as saying 'It is the hand that thinks and follows the thought of matter', and this rather brief aphorism is echoed in a number of longer passages. In her *Pictorial Autobiography* Hepworth talks of her left hand as her 'thinking' and 'listening hand'.

Most sculptors cherished both wood and stone for the resistance it offered, and the balance between 'listening' to the material and mastering it is a delicate one. In 1907 Heckel told Nolde, 'The wood was very hard, but it was wonderful to come up against resistance and also have to bring all one's physical strength into play.' Most of Modigliani's sculptures are in limestone, but Lipchitz reports that

Modigliani said that the stone itself made very little difference (hard or soft); the important thing was to give the carved stone the feeling of hardness, and that came from within the sculptor himself; regardless of what stone they use, some sculptors make their work look soft, but others can use even the softest of stones and give their sculpture hardness.

In the following decade the American *animalier*, Flannagan, explained why he liked to use the uncut stone which he found in fields: 'My aim is to produce a sculpture that hardly feels carved, but rather to have always been that way.' Max Ernst liked to carve the weathered granite he found in the fields around Giacometti's house in Graubunden, and he, Moore, Hepworth, and Braque are only some of the documented examples of artists who used pebbles as their base material. Flannagan and Ernst mirror Arp's delight in placing his sculptures in the woods around his house as if they too 'had always been there'. This is not so much an argument about the resistance of material as one about the effects—old and new, natural or man-made, real or apparent—which could be achieved by means of the choice of cut or uncut stone.

A new orthodoxy

So strong was the swing towards direct carving that some older sculptors, such as Epstein and Bourdelle, felt impelled to speak out against the moral high ground which the new school was claiming for itself. It is certainly the case that too much credit was allowed direct carving as the true, and as the restorative, path for sculpture. Costa's message was characterized by a contemporary critic in almost Jacobin terms: '*La taille directe ou la mort*'. Other practitioners were more cautious. Bernard expressed his concern in an interview of 1922 with Waldemar George, 'Convinced partisan of direct carving as he may be, Bernard nevertheless only makes calculated use of it, and by no means follows those bold young men who attribute to a simple technical procedure all the qualities of regeneration.' Brancusi himself provided the necessary caveat in speaking to the critic Carola Giedion-Welcker: 'Direct carving is the true path toward sculpture. It's also the worst for those who don't know how to do it. In the end, whether carving is direct or indirect makes no difference. It's the finished object that counts.'

In the years after the First World War direct carving had become something of an orthodoxy, lent not only a currency but also a gravitas by the Rodin affair. This was not so much the case in art schools, where carving was still not taught to aspiring sculptors, but among a surprisingly large number of 'modern' sculptors, and particularly among those working on architectural projects. Thus carving flourished among those students who either cared little for the status brought about by an academic training, or who had indeed received their training within the craft and vocational sections of art schools.

53 *La Douce France*

Pergola, stone, 1925

The pergola was presented as a piece of garden architecture, backing on to a pool surrounded by flowers in red, white and blue, with three 'cells' opening up to circulation from the Esplanade des Invalides. For the 16 bas-reliefs De Thubert chose subjects from Celtic and Arthurian legend and counted as part of his team not only the ten sculptors, but also the quarrymen of Verdun, Lens and Buxy, the workmen and the architect, Lucien Woog. The reliefs were extremely shallow, even incised, reminding critics of Egyptian carving, and Pompon used paint to accentuate the lines of his wild boar, a work which was particularly appreciated. Pompon benefited from the fine grain of the Lens stone, whereas those who worked in Rupt stone, from Verdun, had necessarily to work more roughly. The pergola survives today in Etampes.

Gradually, however, isolated proponents were installed within official teaching establishments. In America, Robert Laurent, who had been carving in wood since 1913, and in stone since 1920, began to teach at the Art Students' League in the mid-1920s. Laurent was followed in the American establishment by William Zorach and J.B. Flannagan. In London, Barry Hart, the man who had taught Moore and Hepworth to carve stone at the Royal College of Art, but outside the official syllabus of the School of Sculpture, was, in 1927, at last incorporated into the School, and woodcarving was also added to the syllabus.

Direct carving was no longer something to be exclusively identified with the avant-garde; on the contrary, many of its protagonists and its champions in the press belonged to the more conservative sections of society, who saw in it a means for the 'return to order' which coloured the period after the war. The 1925 Exposition des Arts Décoratifs provided an important showcase for direct carving, *taille directe*, in the form of the pavilion presented by Emmanuel de Thubert, the editor of the review *La Douce France* [53]. *La Douce France* advocated the return to an integrated approach in all branches of the visual arts—direct carving, fresco painting, and free-hand tapestry—and to the kind of teamwork demonstrated in the pergola presented at the Exposition, which brought together the sculptors Costa, Nicot, Saupique, the Martel brothers, Zadkine, Pompon, Hilbert, Lamourdedieu, Manes, and the *atelier* Séguin. The nationalism that was here manifested in native stone was extended elsewhere by recourse to materials from the colonies.

Taille directe enjoyed a curiously ambiguous status in relation to national heritage. While French carvers like André Abbal and Joachim Costa might be inscribed into an *Opus Francigenum*, other non-native

sculptors, immigrant carvers such as Zadkine, were all too easily grouped into the *Kubiste* school, alternatively known as *Munichois* or as 'Boche' (the colloquial French term for the German enemy). (This story is repeated in the United States, where direct carving was alternatively seen as an 'emigrants' art' or as a Yankee tradition marked out from Frenchified modelling.) Native Frenchmen were by no means immune to this charge; Bourdelle suffered on account of his Théâtre des Champs-Elysées, for stone reliefs had come to be particularly associated with German art, and with the northern and German proclivity to use monumental masonry. Germans sought their own medieval precedents in stone: the Roland Columns, castle towers, and twelfth-century imperial palaces. Though French carvers invoked the French tradition of ecclesiastical carving (the meaning of which was heightened after the destruction of so many churches in the First World War), French critics were nevertheless ready to correlate the Gothic with the German.

The sites of direct carving

In line with the historical precedents of carving in an architectural or functional context, the new direct carving in both stone and wood found its place both inside and outside the building. The vogue for direct carving promoted the particular types of work for which it was suitable. Stone-carving, in particular, found a good patron in the Church, where the relief style was particularly suited to the ecclesiastical fabric; a fine example is Eric Gill's 'Stations of the Cross' in Westminster Cathedral, London. The prevalence of the relief must in part be attributed to the fact that this form allowed the artist to map out the composition and to focus on an almost pictorial effect. The vogue for direct carving affected the look of many projects which may not have been carved direct. The popularity of the carved relief extended to the composition of commemorative monuments where it acted as a foil to a focus such as a figure or a portrait bust in bronze. (Direct carving was absolutely unsuitable for traditional portraiture, and the few such examples are outstanding but anomalous; see Gaudier-Brzeska's 'Hieratic head of Ezra Pound'.) The ambitious Mausoleum schemes executed by Meštrović in Dalmatia from the mid-1920s put stone carving to more sensational effect [**54**]. In central Europe the greater tendency towards woodcarving, and to the Expressionist tradition, found in the Church an occasional but also a difficult patron, although—or because—much of the carving was extremely religious in tone. During his most introspective period Meštrović turned to making religious carvings in walnut wood, later integrating 30 of his 'Life of Christ' reliefs into a church in his renovated Kastalet (1939–41).

Direct carvings in wood frequently took their place among the furniture of the studios and houses of the artists who made them.

54 Ivan Meštrović

Tomb of the Unknown Soldier, Avala, near Belgrade, granite, 17m, 1934

Ivan Meštrović's early background was similar to Brancusi's, and he first learnt to carve stone from an Italian carver working in Split on ecclesiastical building projects in Dalmatia. While in Paris he left his colleague Toma Rosandić at work carving the models he had left behind in Vienna. Meštrović's approach involved presenting his individual sculptures as parts of cycles which were housed within an architectural setting of his own design, and which most often took the form of the mausoleum. His greatest cycle, the 'Temple of Vidovdan', remained fragmented, but after the war his Racic, Meštrović, and Njegos Mausoleums were erected, as was the Tomb of the Unknown Soldier at Avala. The integration of carving and architecture created ensembles of solemn mass and dignity.

Gauguin's carvings appear on functional items such as canes, spoons, fan handles, clogs, and boxes, as well as on the panels of furniture and doorways, as do those of his circle, such as Émile Bernard, Ernest de Chamaillard, and Georges Lacombe. Woodcarving in general is set apart from that in stone because of the use of colour on its surfaces, which enhanced its links with craftwork. Bernhard Hoetger, who had made a study of Gauguin and of ethnographic carving, made crafts and furniture in the artistic colony of Worpswede around 1907; Brancusi always furnished much of his own home, as did Die Brücke [**55**]. In their different 'retreats', the one on the Marquesas, the other in the Haus in den Larchen in Switzerland, Gauguin and Kirchner completely surrounded themselves with their own carvings.

55

Studio of Ernst Ludwig Kirchner, a member of Die Brücke, Dresden, c.1910

Social distinctions

As we saw in Chapter 1, sculptors had devoted some time and energy around the turn of the century to establishing themselves as a professional group within respectable society. To do this they had had to distance themselves from those who merely cut stone or reproduced another's ideas by whatever technical means. However, the vogue for stone, and for direct work in general, allowed for something of a shift. Many such sculptors were the sons of stone-carvers, and even more were first apprenticed to carvers and to cabinet-makers (witness, for example, Meštrović, Milles, Noguchi, Lachaise, Rädecker). José de Creeft was first apprenticed to an image-carver, then to a sculptor, and then to a firm of monumental masons. Brancusi, whose first qualification was to 'work the wood in an artistic manner', worked for a while in a Viennese furniture factory. Nolde trained in a carving school for a furniture factory and graduated as a journeyman sculptor. It is not only notable how many of the new stone-carvers hailed from artisanal families, but also how many played upon whatever artisanal, or even local, roots they could claim. Suddenly the true sculptor was to be found among the untutored and peasant classes; witness Bourdelle as much as Brancusi, whose approach to carving is often linked to the Romanian folk carving he would have known as a shepherd in the 1880s. Costa criticized gentlemen sculptors and proclaimed himself an 'artisan sculptor'. Working roots in the material now take on some kind of essentialist virtue. Iron-workers are similarly ascribed to their background; one has only to look at Julio González, at David Smith, or, though less well known, at José de Rivera, who spent eight years in the machine-tool industry and foundry. Despite the undeniably masculine associations of direct working, direct carving was also, ironically enough, associated with women's work, and as engendering small-scale and covetable carvings for the home.

The sites and class associations of direct carving combined to give it a somewhat anti-metropolitan flavour. Studios no longer needed to be dressed up like reception cum sales rooms, with tapestries and carpets, in the best quarters of town. Direct carvers carved on their own premises, and where possible outdoors, away from city centres, both on account of the light, and also because large stones were difficult and expensive to manoeuvre. The monumental tradition fostered developing links between a locale and its material. The wish to commission war memorials from local sculptors in local stones increased this impression, and associations of local 'authenticity' persisted even when the bulk of the carving was done mechanically.

Sharing the load

Directness in carving should not be understood to imply speed. Indeed the 'direct' approach was far slower than the traditional indirect

Patio Joseph Bernard with
La Danse (1912–13),
enlarged version, 1925

A cast of *La Danse*
(1912–13), commissioned
for a private concert hall near
Paris, decorated the façade of
Bernard's studio in Boulogne.
The chief architect of the 1925
Exposition, Charles Plumet,
drew on his knowledge of this
to re-use the frieze, in
enlarged form (24m), on one
of his pavilions. He was not
alone, and *La Danse* appears
as a leitmotif of this Exposition,
such was its perceived com-
patibility with its architecture.
Patout used *La Danse* on
the exterior of his 'Hotel du
Collectionneur' and it featured
again, in increasingly frag-
mented form, inside the
'Ambassade de France' and in
the 'Pavillon de l'Intransigeant'.
The inevitable corollary of this
coming of age was that *La
Danse* was distanced from its
original method of production:
direct carving.

procedures which had normally begun with clay. Production slowed down, and quick ideas had to be carried out in drawings. Though carving in wood could allow the artist a relatively painless opportunity of seeing an idea in realized form, stone was extremely slow. In a lecture given in 1930, William Zorach makes this abundantly clear: 'For the artist to do a life size figure in stone requires at the least a year. In clay, he can make six ... Where art is concerned the element of time should not enter ... Real creation comes by slow stages of development.'

Despite this, a certain genre of 'direct carving' moves from looking difficult to looking easy, partly because it has become wedded to archi-tectural commissions, partly because it has located itself within the practice of relief, and partly because direct carvers begin to use assistant direct carvers. Bernard's frieze 'La Danse' (1912) already shows a vastly more 'sophisticated' result achieved by means of direct carving in com-parison with 'Effort vers la Nature' of only five years earlier, a result which can partly be attributed to its two-dimensional nature, but also presages a changing aesthetic. This accounts for the work's longevity, for it really came of age in the 1925 Exposition [56]. Direct carving becomes sufficiently recognizable as a 'look' to allow those very cham-pions of direct carving (like Costa) to find more expedient ways of achieving the appearance, by resorting to more traditional workshop practices. The truth was that it was too slow. The 'look' might require hard labour, but that labour could, after all, be shared.

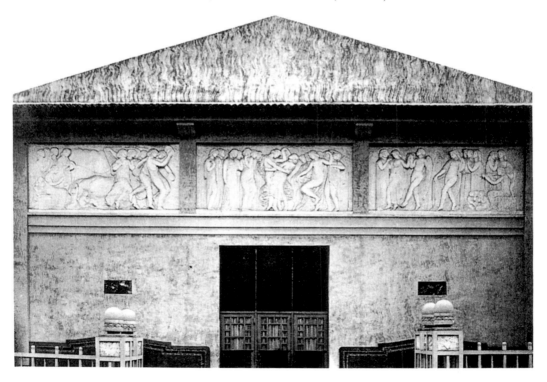

57 Hildo Krop, carving limestone, Villa Den Tex, Apollolaan, Amsterdam, 1928

Hildo Krop had learned carving from John Rädecker, a consummate technician who was part of a family of artisan–sculptors. Like the Rädeckers, Krop worked with Amsterdam School architects Michel de Klerk and Piet Kramer on municipal housing projects such as the Eigen Haard, where he executed decorations in terracotta. In 1916 Krop became staff member of the Amsterdam Department of Public Works and this position was to give him something of a monopoly in Amsterdam, a municipality which offered a particularly favourable relationship with its sculptors.

'Avant-garde' artists had to make the same choices: whether or not to carve direct, whether or not to achieve the same effect by means of collaboration or paid labour. A number of modernist artists were notably unconcerned about the direct method or even about truth to material. Lipchitz worked in clay and after his models were cast in plaster they were carved by a stonecutter. He proclaimed that he 'never cared about working directly in stone'. Giacometti's sculptures were also carved after plasters, and he was not afraid to produce versions in different materials, nor, rather later, in editions.

Those who cared more about direct carving may have used assistants, but they did not resort to the pointing machine. They worked in tandem with their helpers, marking out the stone or the wood, allowing the work to develop organically out of the material, rather than as a coldly mechanical copy. In 1927 Brancusi took on Isamu Noguchi as his morning helper. Noguchi was used to the direct working of wood from Japan, but carving stone was new to him, and 'the opposite of the tricks and easy effects of clay'. Brancusi exhorted the stonecutters working at Tirgu Jiu to be rough with the stone, to show that it was cut by hand. In Britain Moore was using assistants by the mid-1930s, and Hepworth by the late 1940s, but both were to abandon carving for bronze, partly, perhaps, because it was easier within this process to manage those assistants who had become necessary while retaining the creative work for oneself.

Direct working had led to particular moments of freshness in different countries at different times: in France and Germany before the First World War, in Britain in the inter-war period, in the United

States in the 1940s. Although some sculptors were to abandon direct carving—either because it was too slow, or because it was physically constraining—the lessons it had brought with it were not lost. One might suggest that those artists who were most alert abandoned direct carving as an unnecessary diversion, and looked instead for other kinds of directness, while the school of direct carving survived in circles which were both more conservative, and less private [57]. The close relationship which the sculptor had established with the material remained central.

Combining unity with speed

In the summer of 1918 the Spanish sculptor Julio González, long settled in Paris, learnt oxy-acetylene welding at the factory workshop of La Soudure autogène française. González, coming from a family of metal-smiths, had long been used to forging and manipulating iron, and, despite this new experience in welding, went on making his 'fine art' work in beaten copper until Picasso asked him to help weld some sculptures. 'La Tête peinte en fer' (1928) appears to be the first fruit of this occasional partnership, which lasted two or three years. At this time, from 1928 to 1932, Picasso was in a richly sculptural mode; the five or six works he made with González constitute only one of several distinctive vocabularies which emerge at this period. The collaboration with González was a seminal one in revealing a mode which went on to be developed by González rather than by Picasso. It would seem that Picasso appreciated the potential of welding—joining component to component, line to line—to fabricate ideas that, until then, could only really have existed on paper. Picasso had González make up two models from line drawings for presentation to the committee for the monument to Apollinaire. Welding was also a way to give material unity to that which previously would have had a much more fragile heterogeneity. Picasso brought a collage aesthetic—anecdotal, narrative, pictorial—to González's more sober formalism [58, 59], and left González to equilibrate these two approaches in the work he made over the next ten years.

Sheet metal and wire gave sculptors ready-formed planes and lines with which they could 'draw'. In the late 1920s Noguchi was curving and cutting sheet brass and Alexander Calder making the wire animals and people which were first exhibited in 1928. The humorous and light touch that direct working gave to sculpture could be deliberately studied; Calder's early twisted-wire silhouettes and caricatures combine the two trends to great effect. Similarly ludic manikins were made by Nadelman and, much later, by Jacobsen. An undogmatic approach to this kind of material could lead into work of graphic economy, as in Calder's later 'Volumes—Vectors—Densities' (1932), and the wire constructions of Schlemmer and Uhlmann in Germany.

58 Pablo Picasso
Tête de femme, painted iron, sheet iron, springs and colanders, 100cm, 1929–30

59 Julio González
Tête tunnel, bronze version, 46.7cm, 1932–3

When he had finished at art school David Smith went to the Virgin Islands and used some of his 'finds' there—coral, shells, and bones—to create seemingly spontaneous arrangements of materials tied together with wire and weighted down by stone and wood [**60**]. Back in the States he spent the summer of 1933 making constructions which grew out of his interest in the colour and texture of Cubist, Expressionist, and Surrealist painting. He found a way of making these very temporary constructions more permanent when he saw, in a 1932 copy of *Cahiers d'Art*, the iron constructions which Picasso had made with González. (Smith's closest patron owned three works by González, and gave him a González mask in 1934.) That autumn Smith bought a welding outfit (he had previously worked as a welder during summer vacations from college) and by 1934 he was showing his iron and wood sculptures in a gallery in New York (the gallery owner, Julian Levy, asking him whether his sculpture of a head was stuck together with chewing gum). 'Saw Head' (1933), with its primarily graphic picture plane, is close to the bricolage of Picasso, while 'Agricola Head', of the same

year, reminds us more of González's interest in describing space by means of manipulating planes and lines of metal [**61**]. From then on Smith used González's method—welding—to achieve the material unity which is also a mark of González's work.

Mixing diverse material truths

Material unity was, however, identified by others as the strait-jacket which had constricted sculpture for so long. Though stone, wood, and bronze never lost their central position, the private framework of direct carving opened the way to other kinds of direct working, provoked by simple confrontations with the material. This new liberty—stretching across all kinds of material, new or used, anonymous or characteristic—feeds into all the modernist movements of the period—Cubism, Futurism, Dadaism, Surrealism, Constructivism—and is defined by its additive approach. Rather than effecting substantial change within any single material, sculptors brought together differing pieces of one material, or pieces of several different kinds of material, in a kind of

collage or assemblage. These materials had one big advantage over stone and even wood: wire, iron, and perspex were quicker to work, especially when they were used in a process that was additive rather then subtractive, as carving had been. Moreover, the combination of diverse materials made for the play of contrasts: of opaque and transparent, thin and thick, rough and smooth.

From the years 1913–15 we see the appearance of compositions which are made up of disparate and frequently loosely assembled materials, with little material or object unity: Picasso's musical-instrument reliefs, Baranoff-Rossiné's polychrome symphonies, Boccioni's 'Dynamism of a Speeding Horse + Houses' [67]. These assemblages are not simply free of the block, they positively revel in the off-cut. The simple figures—'Dancer', 'Bather', 'Musician'—which Lipchitz made at the beginning of the First World War (1915) were made from pieces of wood, glass, metal, and cardboard, roughly and apparently expediently assembled, which Lipchitz likened to the parts of a machine.

For a Futurist such as Boccioni, part of the appeal of multiple media was to break down the 'homogeneity of materials' which 'helped make sculpture the static art par excellence'. In the 4th conclusion of his 1912 Manifesto, he proclaimed:

It is necessary to destroy the pretended nobility, entirely literary and traditional, of marble and bronze, and to deny squarely that one must use a single material for a sculptural ensemble. The sculptor can use twenty different materials, or even more, in a single work, provided that the plastic emotion requires it. Here is a modest sample of these materials: glass, wood, cardboard, cement, concrete, horsehair, leather, cloth, mirrors, electric lights, etc.

Around 1919 László Moholy-Nagy was making assemblages from the material he found on his walks in Berlin, 'scrap machine parts, screws, bolts, mechanical devices' which he 'glued and nailed' on to wooden boards. He later likened this principle of assembling materials to collage, photomontage, editing imagery and music for film, or the automatic writing/stream of consciousness found in contemporary literature. Moholy was a friend of Kurt Schwitters, with whom he shared a straightforward approach to using materials at hand. Schwitters's 'Merzbilder' and 'Merzbau', beginning around 1919, are something of a monument to the right of the artist to use whatever material he or she wanted. Around 1930 Joan Miró was making constructions and painting objects from wooden supports with doors and nails, as well as cork, shells, stones, tiles, and eggs which evoked the three-dimensional objects Ernst had made in his Dada days. Calder's 1934 'Mobile' [62] which combines eleven shards of coloured glass with seven fragments of pottery is eloquent of an apparent spontaneity in response to material quality.

This new material heterogeneity is a significant link between seemingly disparate movements: Boccioni's material repertoire prefigures that of Moholy-Nagy, especially in its suggestion of lights, and in his own text *The New Vision* (1928), Moholy refers back to a late manifesto on tactilism by the Futurist leader F.T. Marinetti (1921) which had been echoed in the Bauhaus educational syllabus by means of their exercises in tactile charts and their 'hand sculptures'. Gropius and some of the Bauhaus teachers saw themselves in parallel with artistic developments in Russia, and particularly those within INKHUK. A 1923 text by Boris Arvatov, an active member of this Institute, certainly echoes Bauhaus teaching:

The constructivists have declared that the creative processing of practical materials is the basic, even the sole, aim of art. They have widened the applicability of artistic craftmanship by introducing into easel compositions many other materials (apart from paint) that hitherto have been considered 'unaesthetic'; stone, tin, glass, wood, wire, etc., have begun to be used by artists—to the complete bewilderment of a society unable to comprehend the aim and meaning of such work.

Another text defining Constructivism, published in the Polish magazine *Blok* in 1924, echoes the approach we have already encountered in the creed of 'Truth to material', advocating 'the ECONOMIC use of material' and the 'DEPENDENCE of the character of the created object on the material used'. Constructivists had a preference for certain 'modern' materials, notably steel and glass, which were not simply functional, but also had more romantic links with the pre-war utopian architectures of German Expressionism.

While some sculptors responded intuitively to a fascination for specific material objects, others simply used material in pursuit of intellectual, experimental and functional ends. Many such ideas were, at this point, only imperfectly realized: ad hoc compositions of cardboard, glue, and string. Naum Gabo's wartime constructions in plywood or iron are matter-of-fact rather than crafted, built up according to the logic of the idea rather than the beauty of the material. These compositions were a long way from either the beauty or the permanence of the direct carving, but shared a central tenet in being executed from start to finish in the sculptor's studio. Some were sculptural exercises in space and volume like Tatlin's painterly reliefs and counter-reliefs, some of which were indeed titled 'Selection of Materials' and could include iron, stucco, glass, and asphalt as well as iron, wood, and canvas [72]. Sometimes the poverty of the material realization has led to later reconstruction, and the rights and wrongs of such reworkings are complicated. Gabo, Archipenko and Moholy-Nagy all made demonstration models which were later reconstructed in definitive materials. New scientific and commercial developments offered artists who had

62 Alexander Calder
Mobile, glass and china
fragments, wire and thread,
167cm, c.1934

experimented with transparency around 1916–18 using sections of
celluloid and glass the possibility of reworking earlier ideas. ICI's
development of plexiglass and nylon allowed Gabo to refine earlier
ideas with much greater elegance. Moholy's first light machines
(c.1921) were roughly excuted in wood, later made in glass (and exhib-
ited in the 1930 Paris International Building Exhibition), and finally
realized in plexiglass [81].

An inter-disciplinary craftsmanship

William Morris's ideal of the medieval workshop is re-encountered in
the principles of Hermann Obrist, whose argument for a broad con-
temporary craftmanship was published in 1903 as *New Ventures in
Plastic Arts* and whose Debschitz-Schule was one of several precursors
of the Bauhaus. The Bauhaus did indeed look to preceding models—
not only to the medieval *Hütten* (lodges) in which different kinds of
artists worked together, but also to the medieval cathedral—as a way of

transforming the future. The educational programme of the Bauhaus School, which Moholy-Nagy later described as being based on craftmanship, gradually came to posit the achievement of excellence by means of linking training to an architecture which embraced all aspects of the designer's workshop.

In 1919 Johannes Itten set up the Basic Course, a course of Self-Discovery, in which: 'exercises with materials and textures proved a valuable aid. In a short time each student found out which materials appealed most to him; whether wood, metal, glass, stone, clay or yarn best stimulated him to creative activity.' 'A whole new world was discovered,' wrote Itten. 'They started a mad tinkering, and their awakened instincts discovered the inexhaustible wealth of textures and their combinations. The students discovered that wood could be fibrous, dry, rough, smooth or furrowed; that iron could be hard, heavy, shiny or dull.' In 1923 Josef Albers took over the Basic Course, and the free associations and textural experiments of the Itten years were replaced by more prescriptive exercises demonstrating the structural, kinetic, and spatial articulation of materials. As Gillian Naylor has shown, this was a move from the expressive to the architectonic potential of materials. The Basic Design Workshop which Albers and Moholy developed together after 1923 was devoted to understanding the 'constructive handling' of 'wood, plywood, paper, plastics, rubber, cork, leather, textiles, metal, glass, clay, plasticine, plaster and stone'. After the move to Dessau in 1925, and despite Moholy's growing influence, Albers maintained a more tangibly material aspect to the Preliminary Course, using paper, 'straw, corrugated cardboard, wire mesh, cellophane, stick-on labels, newspapers, wall-paper, matchboxes, confetti, phonograph needles and razor blades'. Albers's aim was to develop 'constructive thinking' through the transformation of material into form, and he was careful to be on guard against a dilettantism which he defined as 'fiddling around'. To Albers's material 'potentialities' Moholy added work with light, photography, poetry, and music, with a view to 'seeing everything in relationship—artistic, scientific, technical as well as social'.

Painters and sculptors were increasingly poaching each other's territory. Though Archipenko may be credited with having invented the category of 'sculpto-painting', the inter-disciplinary ground went rather wider, and attracted many artists towards new materials and combinations. While this led, on a larger scale, to the mural and architectural interests of many sculptors at this period, on a smaller scale it leads to sculpture in a whole range of materials. If sculpture no longer required one particular training, or an established workshop, or faithful assistants, it could be done by a wider range of people. In particular it could be done by those who might, in another period, have restricted themselves to painting. In the 1920s and 1930s we see an increasing

fusion of the two disciplines. Sculpture had become a quicker, and certainly a much more personal way of trying out an idea.

This chapter has ended by suggesting the ways in which 'directness' expanded to take on a more generous definition. It can perhaps be understood as an open-minded and essentially expedient use of the right material for the job. In a text written in 1949, *Meanings in Modern Sculpture*, Isamu Noguchi expands upon the 'rediscovery of the sculptor as a direct worker':

Our expanded mechanical ability now makes it possible to handle the toughest materials with comparative ease. This has stimulated our search for the expression of reality through the direct use of materials—as by direct carving, sawing, melting, flowing, welding, glueing, braising, grinding etc. This simplification of construction has enormously widened the range of sculptural invention, and it has also improved the position of sculpture economically by eliminating the necessity of an expensive and deadening transference from one medium into another.

A more extreme understanding of the possibilities of direct working is provided by Moholy-Nagy's tale of dictating specifications to the supervisor of an enamel-sign factory who had the same colour charts and graph paper as himself, thereby establishing the premises for the fabrication of five new paintings. Whether we see this ordering of new work over the telephone in 1922 as a throwback to the past, or as a sign of the future, is for us to decide.

The Private Arena

The Possibilities of Painting, Pictorialism, and the Spatial Environment

4

Individuality within conformity

When visitors to the Salons of the turn of the century went into the rooms where the sculptures were displayed, they would have been struck by the undifferentiated whiteness of the plaster in which almost every piece was presented. The exhibits were lined up, as if in a warehouse, waiting to catch the eye of a prospective purchaser who might pay to have the plaster cast in bronze or carved in marble. Few sculptors could afford—or afford to take the risk—of finishing off a sculpture without a purchaser. Thus everything was shown to the general public in a temporary but homogenous kind of limbo. Sculptors had to prove their individuality in conformity by catching a visitor's eye with a rendition of a standard subject—one of the seasons, a nymph, or a goddess, a religious figure—that somehow stood out a little from the next one. Works which needed a client and a situation to acquire any meaning were on view to the public at large in the most vulnerable of ways.

Few sculptures withstood this cruelly unflattering market-place. Few caught the attention of the critic, especially in competition with the paintings. Though some sculptors used unusual materials and effects—tints, colours, precious materials, inset jewels—they ran the risk of being judged unseemly. Most endured the harsh arena, promoting their individual 'vision' in a near ubiquitous material, hoping that a friendly critic might single them out, or that their work might fit the decorative schemes developing in the mind of a civic commissioner. The nineteenth-century system allowed little attention to the elements of sculpture and the sculptor's process which could not take their place on the 'catwalk' of the Salon.

A singular vision

Rodin, in his celebrity, succeeded in somewhat perverting this unremitting arena. His 1900 exhibition suggested the studio as much as the Salon, in that everything on show was unfinished. It presented a private world with a chain of imagery which appeared and re-

Jean Arp
Bird Man, painted wood
29 × 20.9 cm, *c*.1920

appeared: an evolving cast of characters, waxing and waning. Process was everywhere clearly visible, and visitors commented on the 'balls of clay'. It began to be fashionable to visit Rodin in his studio, to see his plasters, his waxes, his watercolours; to understand something of his working process and the accumulation of his ideas and inspirations. The cultivation of Rodin's genius depended on this privacy, and on penetrating the world of the Master of Meudon. Rodin's secretary, the poet Rilke, told his wife Clara Westhoff, herself a sculptor, about his 1902 visit to Meudon, where Rodin had set up as his studio the very exhibition pavilion which had stood on the Place de l'Alma. 'You see, even before you have entered, that all these hundreds of lives are one life, vibrations of one force and one will. Everything is there, everything ... Like the labour of a century—an army of work ... Acres of fragments lie there, one beside the other.'

It was clear that to understand Rodin one needed to go much farther than a single figure on show in the Salon. One needed to spend as much time on the unfinished as on the finished work, and such study revealed how the artist drew upon and replenished his own inventory of forms and images. Understanding Rodin involved seeing him invent and reinvent, form and re-form. One element of a figure from the 1880s might reappear in another guise, at another angle, in a work of 20 years later. More particularly, works which had begun as public commissions had been absorbed into the private arena, whether deliberately or not, making the point that a 'Balzac' could become more important off its pedestal than on. Those muses who had been ascribed to Whistler or Puvis—monuments which were never erected—now became the artist's own; failed commissions were not abandoned but became instead personal essays, adding to the cast of characters whom Rodin claimed as his.

Private space

Those sculptors who had travelled to Paris to seek a sculptural education were less fixed to the local or national network of commissions for statuary, private or public, and were freer to work on their sculpture in more purely formal terms. Rodin was often the magnet who lured the sculptor away from his or her home country, loosening the local ties which, in sculpture as in so much else, preserve convention.

The example of Rodin encouraged some sculptors to choose to be private; others were forced into it. As we saw in Chapter 2, the age of statuemania had passed its peak by 1910, so public commissions were less plentiful. As patronage shifted away from the government toward the private patron, markets, styles, and strategies diversified. The growth of exhibition societies offered a wider range of more personal exhibiting arenas. Societies and groups increasingly engaged sculpture as part of their creed. In the first decade of the century the 'space' for

painting, the space in which the artwork had to operate, became smaller and more private. Many painters abandoned the large Salon 'machines' for the more protected space of the private gallery. Some artists were given contracts with their dealers which allowed them to get on with work in the studio without worrying about one-off sales. As painting took up the experimental ground previously allowed only to the sketch or the watercolour, so sculpture moved in a similar direction. Indeed the dividing lines between the two became less and less rigid.

Painters had always been less dependent than sculptors on the commissioning process, freer to spend more time on the preparatory sketch, and to move from finished work to finished work with relative speed. They were less in need of the committee's casting vote, and had less need of capitalizing on the time spent on a single model by re-using and recasting it. But artists in general, both painters and sculptors, now had alternatives to going through the traditional and time-consuming process of making and exhibiting full-size models, thereby hoping to attract the funds necessary for their completion in a permanent material.

Traditionally sculptors had waited to see if the model they had on show at the Salon was the one someone else wanted for their city square, park, or collection. The sculpture was only complete when it had been chosen. This kind of contract could be replaced—more creatively—by a much closer one with a dealer. As the gallery system developed, and as sculpture joined painting there in the gallery, the sculptor was free to work out the finished piece in the studio. Sculpture was enjoying a new range of possibilities; the public stage promoted private experimentation.

Fixing change

The new space in which the sculptor was allowed to be a private artist sanctioned a wider range of media and mediations. As painters might use sculpture for pictorial problems, so sculptors exploited two-dimensional imagery for their own ends. Just as painters such as Matisse and Picasso were to use sculpture infrequently but regularly throughout their careers as something which gave substance to their imagery while offering itself up as a motif to be reabsorbed into their painting, so sculptors used two-dimensional imagery to assess the presence of their sculpture. This became at once more possible, and more pressing, with the increasing availability of photography.

Rodin is again notable for the wide range of techniques which he used to help him to re-see his own vocabulary. As an artist now can photocopy or cut and paste on the computer, Rodin pursued some contemporary equivalents, pursuing links between two- and three-dimensional 'print-making': the photo, the cast, the *estampage*. He was an innovative user of photography, establishing creative partnerships with

particular exponents—Druet, Bodmer, Bulloz, Haweis and Coles, as well as Steichen—who allowed him to 'see' his sculptures before they were finished, and to document the stages they went through. Photographs enabled Rodin to essay draft corrections, in ink on the photographic print (as he did for example with 'Claude Lorrain', the 'Hugo' and 'Christ and Mary Magdalene'), to alter pedestals, fill in the backgrounds, or deepen the shadows.

For Brancusi the photographic print was similarly a way to fix rhythms and echoes between works across the studio space, and also to try out different combinations of sculptures and plinths, giving life to something that could otherwise be only temporary. Rodin not only gave his works different lives by means of different presentations, he found other ways of preventing his sculpture from becoming fixed. Using plaster moulds and liquid plaster, Rodin literally recast old figures in new juxtapositions. He added clay to plaster casts, or joined existing elements with white wax. In the same letter Rilke went on to describe

... the torso of one figure with the head of another stuck on to it, with the arm of a third ... as though an unspeakable storm, an unparalleled cataclysm had passed over his work. And yet the closer you look the deeper you feel that it would all be less complete if the separate bodies were complete ... you forget that they are only parts and often parts of different bodies which cling so passionately to one another.

Just as he drew on the photographs, and indeed on the marbles themselves, so Rodin seems to have cherished the casting seams for their graphic qualities of over-drawing.

A poignant example of Rodin's use of the reprise, and of remembering and forgetting, is in the occurrence of the head of Camille Claudel in a series of works which spanned over 20 years and sprang out of a straight portrait of 1884. The most striking piece, dated after 1900, combines a plaster cast of the head of Camille together with the hand of one of the Burghers of Calais in the most overt demonstration of Rodin's power over a stock of plaster components [63]. 'The Centauress' (c.1901–4) is another good example of Rodin's metamorphoses: the body of the horse from the monument to General Lynch is joined to the torso of a woman with the head of one of 'Ugolino''s sons and completed with a new pair of arms.

In looking at the use of repetition within the sculptural oeuvre, Rodin's contemporary, Medardo Rosso, provides further interesting examples. During the last 20 years of his life Rosso turned to re-inventing and re-presenting his earlier work, which he recast, enlarged, reduced, coloured, and repatinated. He changed scale, material, and colour, tailoring his production and his legacy. Rosso also worked with photographers, intervening on the photographic plate to veil, scratch, and mask the image, cropping and framing

the prints according to his own vision. Rosso attached even more importance to photography than Rodin, as it helped him to control the ways in which his work was seen.

The notion of repeat and re-presentation is taken to its logical conclusion by Matisse, who hired the model who had posed for Rodin's 'Walking Man' and from him modelled his first nude figure in clay, 'Le Serf' of 1900. This deliberate reprise is a striking demonstration of homage, but, more interestingly, might suggest a model for the way Matisse was to make use of sculpture thereafter, and must have been reinforced by Matisse's familiarity with Maillol's working practice. By putting his own sculptures into his paintings, as he did quite regularly, and most particularly with 'Reclining Nude I' which appeared no less than nine times, Matisse was able to re-present his work, and by making sculptures from photographs he was able to imagine and reconstruct the three-dimensional presence of the models. Gauguin, and later the Brücke artists and particularly Kirchner, also peopled their paintings with their ceramics and sculptures, although rather less systematically than Matisse.

Rodin used photography to document the evolution of a work. Matisse went further, and made the evolution of a work, and the possibility of recording this by means of the sculptural process, the subject of

the work itself. This was the case with the 'Head of Jeanette', made over three years in five versions, and more strikingly with the four 'Back' reliefs. Here each new version began life as a print of the previous one, which Matisse, like Rodin with his photos, worked on to readjust his vision [**64**]. Brancusi made many versions of his sculptures; the same and not the same. The profiles of some motifs were subtly refined, others were altered on the surface, so that no two works were alike. A work like 'Sleeping Muse' exists in fourteen versions, and five plasters remained in the studio to bear witness to the different stages of its evolution. As Brancusi explained in a 1917 letter to his patron, these 'repeats ... must not be considered as reproductions of the first ones, for they have been differently conceived, and I did not repeat them merely to do them differently, but to go further'. Thus sculptures can be both concrete moments which catch an evolutionary process and points of departure in a way that paintings could never be.

The spatial envelope

Photography allowed Rodin to stage his sculptures in different kinds of atmospheric settings. He created temporary 'installations', indoors

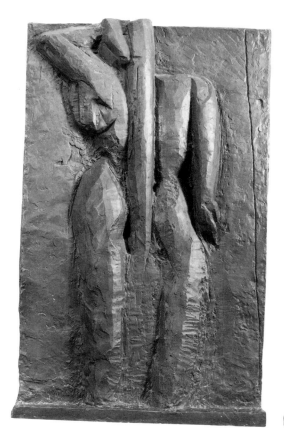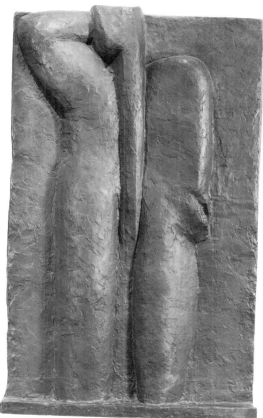

and out, for works that were hardly finished, and were very often still only in plaster. The photograph of the 'Balzac' by night at Meudon by Steichen [65] is one of the most memorable of such images, by means of which the sculpture lives on. Rodin gave his creations light and space—particular space—in which to live, rather than forcing them into the anonymous climes of the mixed exhibition hall.

It was around 1914 that Brancusi began to photograph his own work, though not until 1922 did Man Ray set him up more professionally. Though thoroughly committed to the representation of his sculpture by means of photography, Brancusi was unconcerned with standard photographic procedures. He was happy to accept images that were unclear, uninformative, or over-exposed if they provided the right atmosphere. He used strong sun or light to provide his polished works with an aura, a suggestion of 'infinity', and a double exposure of the 'Endless Column' in Steichen's garden gives the impression of vibration. Having given his 'Leda' a motor to make it revolve, he documented the effect with a cine-camera. Steichen, whom Brancusi met in Rodin's studio in 1907, himself took one of the most renowned images of Brancusi's work, in which the 'Bird in Space'

65 Edward Steichen

Rodin's *Monument to Balzac* seen at night at Meudon, gelatin silver print, 1908

After his *Balzac* had been on view at the 1898 Salon for two weeks Rodin took it back to Meudon where he had it erected on a pedestal and photographed by several photographers to show the views which he considered successful. J.-E. Bulloz took a striking series of subtle clarity (1898), but Rodin preferred Steichen's later image as illustrated here. Rodin had told Steichen that he had moved the cast outdoors and asked him to photograph it by moonlight. Steichen duly worked through the night using varying exposures to produce a number of images to which he later gave different titles. Rodin apparently told him, 'You will make the world understand my Balzac through these pictures. They are like Christ walking in the desert'.

of 1924 (in the 1926 Brummer Gallery exhibition) resembles a beacon, or even an explosion.

Rodin used photography because he recognized the importance of the image, more especially so in this period when photography was replacing the drawn image as the regular method of art reproduction. If sculpture was to preserve its own particular aura—its sense of a three-dimensional creation in space—the sculptor had to make a friend of photography and use it for his own ends. An image had to preserve the spatial envelope in which the sculpture was seen by the viewer. It is well known that painters working in the late nineteenth century such as Manet, Degas, and Monet had been influenced by the compositional devices used in Japanese prints, which counteracted the centralized perspectival frame of the Western Renaissance. A similar kind of non-finito, non-framing, can be seen in some of the stranger of Rodin's amalgams, which lack symmetry and stasis, or which emerge indistinctly from the material in which they are made.

Rodin was a fan of the veiled, atmospheric paintings of Eugène Carrière, and it is helpful to see Rodin's position, and his significance, in a context that includes painting as well as sculpture. Many of Rodin's figures emerge (as we saw for his busts in the previous chapter) out of the uncut marble, a setting which provides the sculpture not only with a sense of inevitability, but also with a spatial surround which is absolutely different to the cleanly delineated profile of the majority of contemporary sculpture. One might argue here that Rodin is at once making it impossible for the graphic arts to capture his work in reproduction, while simultaneously sketching or painting in his own background. This method of working was widely copied, as for example in the work of the American Chester Beach, of whose marble 'Unveiling of Dawn' a critic wrote in 1913: 'The method by which this conception is realised, so that much of the modeling is purposely undefined, while here and there a part is brought into significant clearness—the whole effect being one of suggestion demanding imagination on the spectator's part to evolve it—is, of course, derived from Rodin.'

A similar point can be made about Medardo Rosso, whose painterly wax or terracotta compositions come into focus only when framed by the camera's lens. Degas, a friend of Rosso's, even described his work as painting. Rosso wished to 'forget matter' in his art, but to 'summarize the impressions received'. Such impressions would, he argued, have been affected by their subject's location, whether alone in a garden or among a group on the street. Rosso was somewhat obsessive about claiming the conditions of pictorialism for sculpture, and even went so far as to add small backdrop walls to his sculptures to prevent their circumnavigation. (The backdrop is reminiscent of Camille Claudel's 'Gossips' (1897) or 'The Wave' (1900), which were themselves influenced by Japanese prints, though there is no evidence of her sharing

Rosso's concern.) 'One does not move around a statue or around a picture, because one does not move around a form in order to conceive the impression. Nothing is material in space,' Rosso wrote for Edmond Claris's 1902 anthology, *De l'Impressionisme en sculpture*. He reiterated the same sentiment in 1907, in an article for the London *Daily Mail*— 'There is no more need to walk around a work in clay, or wood, or bronze, or marble, than there is to walk around a work on canvas ...'— and went on doing so throughout his life. Though Rosso and Rodin had been friendly, they fell out over the question of perceived influence. Rosso's criticism of Rodin was that he was still 'doing the statue', the convention of which was indeed to find stasis and thereby dignity. Much of Rosso's quarrel was with 'the statue', for it was the statue which demanded to be circled, whereas Rosso maintained that 'nothing is statue' and that 'We are incidents of light. Everything has only one day and can only be seen from the point of view on a single day. You cannot go around it.'

It could certainly be argued that Rosso goes further than Rodin in detaching his figures from a material background, while nevertheless evoking a sense of air and space around them. This is particularly clear with a work like 'The Conversation in the Garden' of *c*.1896 [**66**]. Rosso's portraits—from 'Yvette Guilbert' of 1894 to 'Madame X' of 1913—reduce the delineation of characteristic features to an 'impression', an aura, which is carried by the surface of the material in conjunction with the overall attitude of the head. The use of surface, and of light upon it, is particularly strong in 'Boulevard Impressions', which seems to attempt to escape the constraint of any one profile, and to evoke not only movement, but also fragmentation.

66 Medardo Rosso

Conversation in a Garden, wax on plaster, 33cm, 1893–6

Thirty years later, the ceramic works of Lucio Fontana suggest Rosso as a possible source.

Rosso was respected by the Italian Futurist artists (and indeed fared better than Rodin, É.-A. Bourdelle, or Constantin Meunier in their spirited attack on sculpture as it had been practised in the years before the First World War) for his concern to evoke the spatial environment. In his *Technical Manifesto of Futurist Sculpture* (1912), Umberto Boccioni echoed Rosso in his dislike of monuments and the stasis of statuary. He proclaimed the 'ABOLITION OF THE FINITE LINE AND THE CLOSED STATUE'; advocating instead an 'ENVIRONMENTAL sculpture' in which the environment was inside the figure. The representation of speed or the city exterior was carried through by means of the fragmentation of the object, and in many ways this was more successful in the few sculptures which came out of the group than in the almost mechanical repetition of elements and angles across the picture plane.

In his *Technical Manifesto* Boccioni recognized how painting had been fortified by the 'landscape and the surroundings that the Impressionist painters made act simultaneously on the human figure and on objects', and suggested that sculpture could enrich itself by a similar extension. Boccioni's attempt to model the 'atmosphere' which the other Futurists were attempting to represent around their subjects in painting is not without precedent in sculpture. In society portraiture such as that executed by Paul Troubetskoy (Pavel Trubetski) we see the painterly touches of the non-finito which take on a more programmatic line in Boccioni. Though Boccioni may have spoken in arcane terms of a 'visible' and an 'interior plastic infinite', his means were quite simple: 'The new plasticity will thus be the translation in plaster, bronze, glass, wood or any other material, of atmospheric planes that link and intersect things.'

Having made a study of Archipenko, Brancusi, and Duchamp-Villon, Boccioni showed his Futurist sculptures in Paris in 1913. Boccioni's own background was in painting, and all his colleagues were painters, and thus he must have been more able to adapt not only the subjects of painting, but also its means in terms of atmospheric fragmentation. This was hardly new on the canvas, but rather more so in sculpture, which had clung for longer to the ideal of a static unity. In the preface to the catalogue of the 'First Exhibition of Futurist Sculpture' Boccioni introduced his wish to break down the stasis of sculpture, not simply by means of diverse substances, but also by a literal transference of the chiaroscuro and scumbling of painting by colouring grey and black paint on the edges of the contour. Boccioni had criticized Rosso for adhering too closely to the pictorial concept, and to the relief form, but Lipchitz described Boccioni's 'Unique Forms' as 'really a relief concept, almost a futurist painting translated into sculpture'.

Crossing boundaries

The new ground for private experimentation has, by the time of the First World War, brought sculpture into the world of painting, with distinctly pictorial results. We increasingly see painters claiming sculpture as a means of solving some of the problems that their painting was setting them. The paper sculptures which Braque made in 1911 he later characterized as being intended to 'clarify and enrich his pictorial idiom'. This has meant that we have tended to see sculpture through painting, and even to see painters as poaching sculpture. This is largely because we read Gauguin, Degas, Matisse, and Picasso as painters even when looking at their sculpture, but also because their sculptures often deserve to be spoken of as much as paintings as sculptures. Much of the work is made in relief, and the relationship between support and surface, and reality and representation, is always paramount. One thing is clear, and that is that sculpture was now close behind painting in moving inexorably towards becoming a formal experiment carried out in private in the artist's studio.

As artistic movements became more programmatic, so it became more possible to include sculpture within their fold. Though the historical accuracy of this fact might have forced a realization that it was no longer possible to write a self-contained 'History of Sculpture', it has more generally encouraged a tendency to suggest that sculpture trailed behind painting in most of modernism's movements: Cubism, Expressionism, Futurism, Dadaism, Surrealism. To talk about painting in terms of these movements is already outdated, but to write of sculpture within such a framework is even more reductive. It is certainly easy enough to speak of the sculptors in the Cubist movement, the sculptor in the Futurist movement and so on. (And indeed it is clear that groups of painters such as Die Brücke and De Stijl did indeed deliberately set out to find sculptors—George Minne and Lambertus Zijl in the case of the former, Georges Vantongerloo with the latter—to exemplify their artistic programme.) But such attempts are premised on painting and offer sculpture nothing more than a supporting role.

Instead of searching—ultimately in vain—for the sculptors in the Cubist movement, we are better advised to look at what is sculptural within Cubism. Cubist painting is an almost sculptural translation of the external world; its associated sculpture translates Cubist painting back into a semi-reality. (This appears to be particularly true of those making 'Cubist' sculpture out of the central European Expressionist tradition, such as Oto Gutfreund, Emil Filla, or William Wauer.) Any attempt to separate painting from sculpture has become—even by 1910—no longer either relevant or even possible. Just as in our own days it is increasingly hard to define the boundaries of sculpture, which seems all-encompassing, so perhaps at the beginning of the twentieth century painting took over whatever ground it was given. If painters

used sculpture for their own ends, so sculptors exploited the new freedom too, and we should look at what sculptors took from the discourse of painting and why. In the longer term we could read such developments as the beginning of a process in which sculpture expands, poaching painting's territory and then others, to become steadily more prominent in this century.

Claiming painting's means

Picasso's 1909 plaster 'Head of a Woman' and 'Pomme' had mainly revealed how Cubism was more interesting in painting—where it showed in two dimensions how to represent three dimensions—than in sculpture. Gradually Picasso began to put painting into his sculpture, first with the musical-instrument constructions of 1913–14, which he annotated with pencil and paint, and then more completely, with the 1914 'Glass of Absinthe' (which stands out from Picasso's sculptures at the time for being an object rather than a relief), painting the six bronze versions of the wax 'Glass' he had made earlier. In these works, each one different, he provided differentiated picture-planes with a common substantial support. The conventions of painting—not simply the paint, but its illusory and chiaroscuro characteristics—are put on an object in space, rather than on the plane of the canvas.

As we saw above, Boccioni had spoken of introducing painterly means into sculpture, and had demonstrated such possibilities in his 'Dynamism of a Speeding Horse + Houses' of 1914–15 which is made of wood,

67 Umberto Boccioni

Dynamism of a Speeding Horse + Houses, gouache and oil on wood and cardboard, with collage, copper and iron sheet, tin coating, 112.9/97cm, 1914–15

cardboard, copper, and iron with oil and gouache [**67**]. His colleagues, Fortunato Depero and Giacomo Balla, also made polychrome sculpture, though Depero's figures (1914–17) and Balla's 'Futurist Flower' pieces (1917–18) are painted in solid tones of unmodulated colour. Apollinaire commented on the parallels between the Futurists and their Russian contemporary Vladimir Baranoff-Rossiné. His 'Symphonie' of 1913 is more painterly in its facture, but still somewhat distant from the 'impressionistic results' Boccioni describes in his exhibition preface [**68**].

Alexander Archipenko's 'Femme à l'éventail' of 1914 is a perfect example of a painterly relief, and a close parallel of a Cubist painting [**69**]. Elements of wood, glass, and metal are arranged over canvas and waxed cloth, painted and shaded, and set within a frame. This openness is lost in later works, such as 'Deux femmes' of 1920, which are more tightly and cunningly constructed: surface shading painted over curled and rolled metal, accentuating or disguising the concave or convex plane.

Claiming painting's subjects

Most of the subjects of the few sculptures realized by Boccioni are traditional to the artist: the figure and the family portrait. Though Boccioni's 'Development of a Bottle in Space' (1912) is most famous for

69 Alexander Archipenko

Femme à l'éventail, painted wood and metal and glass on jute and waxed cloth, 108cm, 1914

demonstrating the Futurist wish to represent continuity and expansion, it is, no less importantly, a sculpture which, in being a still life, is claiming a new subject for itself from the repertory of painting. To make an object in sculpture was, in itself, quite radical. Because objects were already objects, they had been left to be translated into painting. In 1913 Apollinaire's *Les Soirées de Paris* made the point rather clearly in publishing five of Picasso's 'still lifes' in sculpture. Suddenly one of the prerogatives of painting had become a subject for sculptors. Sculptors had traditionally used the human figure (and occasionally the animal) both because of its more noble potential, but also because the art of composition, in sculpture, had been understood to reside principally within the disposition of one or more figures. Sculptors gave stasis to bodies which were normally animate. (Duchamp-Villon was one of the few artists associated with the Cubist school to return to the 'proper' subjects of sculpture—the horse, the portrait—and in representing the animate being, to try to give it energy rather than stasis.) The construction of a still object—a bottle, a glass, or a musical instrument—had been too close to home.

70 Pablo Picasso

Glass, Knife and Sandwich on a Table, painted wood with upholstery fringe, 25.4cm, 1914

Though few in number, some of those sculptures which best represented both contemporary debate and the cross-over between painting and sculpture carried the form of the still life. The single objects which Picasso made first, his 1912 'Guitar' or 1914 'Glass of Absinthe', soon moved to composite pieces: at first almost in the figurative tradition of the couple such as in 'Mandolin and Clarinet' of 1913, and then into full-blown still-life compositions. In so doing, as with 'Glass, Knife and Sandwich on a Table' of 1914, Picasso pushed the still-life sculpture back into the relief form [**70**]. When Laurens took it up again towards the end of the war, with 'Bottle and Glass', he worked from this basis.

Relief and collage

Sculpture was borrowing the subjects and the means of painting and, in joining the relief with the collage, it brought them together. The topos of the collage was made actual in the form of the relief—a form that was additive and constructed. By means of the collage, Cubism filtered into artistic movements all over Europe. Collage was recognized to pose the most fundamental questions about the unity of the picture's surface, the nature of artifice and illusion, and the artist's role in ordering them. In addition to posing formal questions as to the nature of the support and its surface, collaged elements represented real life: quotidian, humorous, elegiac, or scandalous.

By 1912 both Braque and Picasso were making rather ad hoc little cardboard reliefs, and soon Picasso was using more durable materials. By 1914 he was incorporating real elements such as upholstery fringes and skirting boards. Laurens, influenced by Braque, made his first sculpture in 1914, and the following year made 'Tête' [**71**] and 'Construction' which, in mixing different forms of wood and metal, and colour, and working out from the basis of the relief, move

on from the unified facture of the free-standing 'Spanish Dancer' of the previous year.

At around the same time, in Russia, Vladimir Tatlin was also making painterly compositions in relief, or in the round, using different planar elements. This kind of approach, which lasted until *c.*1920, when Tatlin and others put a much higher premium on functionalism, was essentially formal. As in Cubism, Tatlin's early constructions owe a great deal to an understanding of collage. Even the first motifs, 'The Bottle', are shared with Cubism, and indeed Tatlin had visited Picasso's studio in 1913–14. Naum Gabo also became acquainted with Cubism around this time, and the constructed heads which he made prior to his return to Russia in 1917 are perhaps the closest sculpture ever got to recreating—and to equalling—a Cubist painting.

Before long Tatlin moved beyond the recognizable motif to making arrangements which were about material, colour, contrast, space, and tension. They moved progressively out of the picture-frame and into the room. After 1914 Tatlin moved from calling these pieces 'painterly reliefs' or 'selection of materials' to 'counter-relief' [**72**]. They were exhibited in 1916 at '0.10 The Last Futurist Exhibition of Paintings', and mark a closure of this pre-utilitarian phase in Russian Constructivism.

Tatlin, like many others of his generation, was as interested in national folk art as in an international high art, and in his case his collages/assemblages owe a distinct debt to Russian icons. Other artists in Russia, notably Ivan Puni, Vladimir Lebedev, and Ivan Kluyn, were making reliefs which were closer to the picture-plane than those of

Tatlin and, in making reference to Cubist collage or Suprematist painting, more purely concerned with pictorial construction. The elegant reliefs produced by Lebedev through to 1920 emphasize the continuing concern with the aesthetic.

The Russian use of the relief varies between strictly formal investigations and humorous uses of the found object, as with Puni's 'Relief à l'assiette' of 1915–19. Collage had two quite distinct roots, which could lead apart, or together. The two oppositional principles were deployed in tandem by Dada. This may have been because Dada's wartime meeting-place, neutral Switzerland, brought together geographical and aesthetic opposites: Cubism from the West, nascent Constructivism from the East. At any rate, Dada offers us a window onto the conflicting tendencies of modernism, many of which are revealed by means of the collage relief.

The wooden reliefs of the Dadaist Hans Arp, which in themselves represent an amalgam of order and chance, of commissioned work and found effect, are generally on two or three uniform levels. Most are painted, at first colourfully (but not atmospherically) as in 'Forêt' of 1916, later more often in one or two colours, and then all over in white. At first the colours tend to respect the planed edges of the wooden shapes; later they follow their own laws. Sophie Taeuber, whom Arp later married, represented the greater formality of Constructivism in her simple but rigorous combinations of different materials and grids of colour which, although executed in a wider range of materials, were more often in two dimensions than in three.

After the war Dada moved to Germany, to Cologne, with Arp and Ernst, and to Hanover, where Kurt Schwitters was the focus of another Dada group. Ernst's exceptional Dada relief, 'Fruit d'une longue expérience', echoes the high coloration and dense texture of some of

73 Kurt Schwitters

*Merzbild 1924. Relief with
Cross and Sphere,* oil paint
and cardboard on wood,
69cm, 1924

Schwitters's collages. Schwitters's work also demonstrated an extreme
amalgam of chaos and order, from the anecdotal to the purely formal
found element, from the 'Merzbild 25A. The Star Picture' of 1920,
through to the 'Merzbild 1924, 1. Relief with Cross and Sphere' [**73**]
which is close to De Stijl in its rigid order and primary coloration. Such
a work sets the stage for many of the pictorial constructions produced
in the 1930s, while the collage-based compositions remained more
personal to Schwitters.

Composition

Though Laurens's 1918 'Fruit-dish with Grapes' is a free-standing assemblage, it is achieved by means of frontal pictorial planes. Given the logic of Cubism, it seems hardly surprising that Laurens, and Lipchitz, should start to work backwards, locking what had been generated as an open, fragile combination of materials and was all about illusion, into the solid mass of carved stone. Such carvings, which begin rather crudely, but come to achieve great elegance, are almost like a pastiche of Cubism, 'representing' the collage principle in a medium absolutely antithetical to its process. Carving implicates a subtractive approach which is the very opposite of the additive one which the constructed image denotes. These reliefs were extremely influential, not only on individual sculptors, like Joseph Csáky, who were looking for a way to 'sculpt Cubism', but also for a generation of decorative carving which comes to blend with Art Deco by the mid-1920s.

Lipchitz made his first relief sculpture when staying with Juan Gris in 1918. Lipchitz was by instinct a modeller rather than a carver, and indeed he employed a carver to translate his plasters into stone, which may account for the greater suavity of a work like his 'Still-life with Musical Instruments' [74] in comparison to Laurens's (who carved his own) slightly later 'Guitar and Clarinet'. Lipchitz's Cubism is one of volumes in comparison to Laurens's planes; modelled rather than constructed. The unifying effect of the single material, and of the modelled approach, accords with the direction Cubist painting was taking as it moved away from collage. Gris had demonstrated a similarly unifying treatment in his only sculpture, a coloured plaster 'Harlequin' of 1917, and this rhythmic approach to the human figure, with a play on concave and convex curves, is carried on in the work of Archipenko and Schlemmer.

This was synthetic Cubism at its most elegant and restrained; still lifes of musical instruments carved in a shallow relief which emphasized the curvaceous rhythms of painted Cubism. Might we even suggest that it may have been that Cubist excursions into sculpture—or at least into relief—affected Cubist painting, and effected the shift from the analytic to the synthetic? The build-up of flat overlapping planes with different surface treatments, in shallow space (real or suggested), is certainly a hallmark of both Cubist sculpture and of Cubist painting during the war and particularly thereafter. Such reliefs were perhaps the final exercise in illusion, making impenetrable what the follower of Cubism had been trained to see as penetrable, fixing on the picture-plane objects that were presented as sculptures. Such formal arrangement of elements across the plane—in the fullest tradition of the still life composition—proved to be a rich vein for sculpture.

Indeed composition, something we much more readily associate with painting, becomes increasingly central to modernist sculpture in

74 Jacques Lipchitz
Still-life with Musical Instruments, stone, 58cm, 1918

the inter-war years, and is carried through by means of diverse and discrete components. Collage has broken the unity of painting and of sculpture and encouraged a fruitful interaction between the two. Whether we look at Calder, Miró, Schwitters, Arp, Giacometti, Hepworth, Moore, Torres-García, or Kobro, we see work which deploys the arrangement of different elements, backgrounds and foregrounds, linear points of focus, varying kinds of texture, and colour in the construction of compositions which are both pictorial and sculptural.

A common agenda across dividing lines

While the pre-war movements may have used sculpture whenever appropriate, and made gestures towards sculptor-members, post-war tendencies made an aim of eradicating such divisions altogether. Group activity was increasingly important, organized now on a conscious and voluntary basis. The centres of energy, mostly centred on magazines (or on schools)—*De Stijl* in Holland (from 1917), the Bauhaus in Germany (1919), *Esprit Nouveau* in France (1920), a.r. (real avant-garde) in Poland (1929), and the various Paris-based groups through the 1930s which found their longest expression in *Abstraction-Création* (founded 1931)—all tended against the strict demarcation of painting, sculpture, and architecture. Though inter-disciplinarity was the 'message', most of the new groups were still predicated on painting, and directed by painters. Those which went farthest in breaking down the boundaries were the most radical, in political and in artistic terms, and will be the focus of Chapter 6. For all that, the subject of this chapter, the common ground between painters and sculptors, and the

increasingly pictorial nature of sculpture, finds much to detain it in the more private work of those who were readier to accept that they were simply fine artists.

The fact that it is nevertheless hard to find many examples of sculpture within these movements might be read in different ways. If we were simply to identify the sculptor in each movement—as we might have done for Futurism or Cubism, and could do with Vantongerloo and Domela for De Stijl, Schlemmer or Joost Schmidt for the Bauhaus, Katarzyna Kobro for a.r., Tutundjian for Art Concret—we would certainly ignore what is more important about these groupings. Firstly we would have to note that sculptures were also made by painters such as Herbin and Torres-García. But the members of such groups were primarily concerned to promote non-realistic art by the appropriate artistic means, which might often mean both painting and sculpture, and certainly the relief. That sculptors, and sculptures, are in a minority may indicate the truism that sculptors were anyway fewer in number than painters, or that they were indeed otherwise engaged in the commemorative and building work of the post-war period, or that sculpture was making important headways towards the spatial realization of art, but through the back door, by means of the ultimate tendency of these painterly movements towards architecture.

At the beginning of this book we touched on the Arts & Crafts concerns of the late nineteenth century in bringing together the different artistic disciplines. Such concerns live on in the early years of the twentieth century and take on renewed impetus during and after the First World War. In Holland the Open Wegen group was interested in bringing together painting, sculpture, and architecture, as was the November-gruppe in Germany, symbolized in the sculpture made by the group's founder, Rudolf Belling, the 'Triad' of the three disciplines (1919). De Stijl and the Bauhaus were probably the two dominant artistic tendencies in the 1920s, and despite their active disagreements, both internally and mutually, they were united in looking for a new art—a new vision—which broke down the traditional divisions between the fine arts. De Stijl precepts were primarily manifested through its magazine, and another important organ was *Esprit Nouveau*, the mouthpiece of the Purism promoted in painting by Le Corbusier and Ozenfant. The debate was marked both by its group ethic, and by its sharp divisions and disagreements. Throughout, painting and sculpture are closely associated, as are painters and sculptors, if only because they have the same concern to win a recognition for a non-naturalistic language.

Georges Vantongerloo was to some extent appropriated by Van Doesburg for De Stijl, and recommended to Mondrian as being in the line of Archipenko. Vantongerloo's small sculptural oeuvre was closely connected to his studies of pre-existing artworks—mostly in two dimensions—including, indeed, Archipenko's 'Gondolier'. His

75 Georges Vantongerloo

Triptych, painted wooden blocks on wood, 13cm, 1921

earliest series of abstract sculptures derived from drawings in which he 'enclosed' earlier sculptures within geometric shapes. After 1918 Vantongerloo began to paint his sculptures, and apparently to disperse them within his paintings. His 'volume' creations of 1921 again derive from drawings, often of the seated figure, though externally they resemble architectural models by colleagues such as Van Doesburg and Robert van't Hoff. Vantongerloo analysed Old Master works as well as modern ones; his 1921 'Triptych' [**75**] is probably based on Rogier van der Weyden's 'Deposition from the Cross'. When closed it is a painting, when open a combination of painting and sculpture. Thereafter Vantongerloo's works assumed a greater formal sobriety, shedding their colour, and assuming the visual expression of the mathematical formulae which gave them their titles, such as '$3 \forall L = h \quad 4 \forall L = b \quad 5 \forall L = L$ Geometrical Place', 1931.

Esprit Nouveau folded in 1925 (its pavilion at the 1925 Paris Exhibition a kind of swan-song), *De Stijl* in 1928, and the Bauhaus, working in increasingly difficult conditions in Germany, closed definitively in 1933. The combination of artistic and political changes gradually caused Paris to become something of a melting-pot for a range of different artistic positions. Such amalgams were nothing new; well before this Germany had absorbed the impact of artists such as Kandinsky and El Lissitzky who had resigned from their positions in the new Soviet artistic institutions. The resultant (if partial) increase in knowledge of Russian Constructivism in Germany, combined with the vestiges of Dada and the influence of the Bauhaus and De Stijl, sparked interesting results. El Lissitzky spent time in Berlin and in Hanover, where the 'abstrakten Hannover' group sprang up after 1925–7, which included Vordemberge-Gildewart, Buchheister,

Schwitters, and Domela. The new middle ground was represented in the form of the relief, which in the case of Domela and Vordemberge-Gildewart, following on from Schwitters's own turn to organic materials, became increasingly luxurious in its use of contrasting material qualities. Domela employed a particularly rich vocabulary, including both natural (walnut and rosewood, sharkskin and sealskin, ivory and ebony) and man-made (brass, aluminium, plexiglass) materials [76], and though more restrained, the elegantly textured reliefs of Buchheister and Vordemberge-Gildewart connote a similar *luxe*. Domela called his works pictures, or 'picture-objects', and considered them to be 'half-way between sculpture and painting', which is 'why I use materials other than colour'.

Belonging and not belonging

Paris was increasingly marked by immigrants as the 1930s saw the rise of authoritarianism in Russia and Germany, as well as in Italy, Spain, and Portugal. In this way Paris became a home to the abstract art which, barely three years previously, had been most actively explored in Berlin. This new focus was prefigured by the steady arrival in Paris, through the 1920s, of Pevsner, Tutundjian, Freundlich, Seuphor, Baranoff-Rossiné, Béothy, Calder, Torres-García, Vantongerloo, Van Doesburg, Arp, and Taeuber, and by exhibitions of Russian

Constructivism and De Stijl. Mondrian had been living in Paris since 1919 and was an important magnet: Calder described Mondrian as the 'necessary shock' (and made his first mobile after visiting Mondrian's studio in 1930), as he was for Max Bill, who visited him with Arp in 1932.

It was now the foreign immigrants, Belgian and Polish abstract artists notable among them, who took the lead in reorganizing tendencies that had previously been based outside France, thereby aiming to give themselves a context in the face of an apparent impasse in France. This was primarily effected by means of artists' associations, and it is difficult to talk of 1930s Paris without engaging with the group activity which not only provided the vehicle for, but also much of the subject of, contemporary discourse. Van Doesburg was a leading protagonist in activating the various factions and, despite his death in 1931, his activities very much set the stage for the 1930s in the form of three artistic groups: Cercle et Carré, Art Concret and Abstraction-Création.

Much of the stimulus for all this activity came from the dislike of Surrealism, and from the focus on painting—and academic painting—that Surrealism was developing after 1930. Thus it was perhaps inevitable that abstraction led away from painting pure and simple. Nevertheless, many artists straddled both camps (and perhaps inevitably some of the best ones, such as Ernst, Arp, Miró, Giacometti, Calder, and Moore) and some, such as Van Doesburg, even adopted a double personality for the two sides of his activity. Many abstract artists had come through Dada, but whereas Dada was able to combine Constructivism and figuration, as demonstrated so effectively in the relief, Surrealism's use of the visual arts was increasingly tending towards the narrative evocation of another time and place, away from the relief and back to the unity of 'magic realism' or the painting of dreams. As the abstract movement was determined to face and use the subjects of the real world, it is perhaps not surprising that the relief should now assume a position that might be understood as inherently oppositional.

Cercle et Carré and Art Concret were both set up in 1930, very much in competition, and neither lasted more than a year. Cercle et Carré broke up because Joachim Torres-García resigned within six months of founding the group, upset that what he had wished to see as a broad church capable of embracing various kinds of abstraction was being promoted by his co-founder Seuphor as a campaign for geometric abstraction. Before its demise the group had staged a large two-week exhibition of 46 artists from various backgrounds, which included the sculptures of Arp, Gorin, Cueto, and Torres-García himself [77]. Van Doesburg had wished to lead his own group, and though he had lost many potential members to Cercle et Carré, he set up Art Concret in what was essentially a five-man demonstration (with Carlsund, Hélion, Wantz, and Tutundjian) [78] against it. Its more extreme prescriptive basis for the execution of a work of art which

77 Joaquin Torres-García

Composition, oil paint on nailed assemblage in wood, 52cm, 1931–4

could be called *peinture concrète* in terms of its preconception and logical execution doomed it to a short life. The fact that their choice of terminology—the Concrete—was to endure well after their own demise was due to its later adoption first by Max Bill and then by Hans Arp. Bill, whose longevity and constancy did much for the cause of concrete art, established a constant dialogue between painting and sculpture, clearly demonstrated in his explorations into the turning surface in works like 'Ruban sans fin' of 1935.

Abstraction-Création developed out of Van Doesburg's attempts to build a more realistic alliance and had only one criterion for membership: works which neither copied nor interpreted nature: non-figurative art. Its title represented the two different ways of achieving non-figuration: two poles: one to abstract from nature, the other to create geometrically. Broadly speaking, French members distinguished themselves by their individualism in contrast to the De Stijl or Bauhaus schools, and thus too by their use of the circle. The group, led by Herbin and Vantongerloo after Van Doesburg's death, lasted from

78 Leon Tutundjian

Untitled/Relief with cylinder,
relief in painted wood and
metal, 60cm, 1929

1931 to 1936, and gathered together a changing membership of about 100 at any one time, including Gabo, Pevsner, Mondrian, El Lissitzky, Kandinsky, Magnelli, and Baumeister, with Arp and Tutundjian active on its committees alongside painters such as Gleizes and Kupka. Other sculptors who appear as affiliates, at one time or another, include Béothy [**79**], Bill, Brancusi, Calder, Freundlich, González, Gorin, Kobro, Melotti, and Rossiné. Abstraction-Création was no less riven by division, and in 1934, after a quarrel with Herbin, Hélion left the group, taking with him a number of members, including the Arps, Hepworth, and Domela.

However, the Parisian period of International Constructivism could be seen, as it was by a number of protagonists from an earlier period, as too conciliatory; little more than an artistic grouping, brought together for the traditional reason of providing a name and a profile for exhibiting purposes, rather than for any kind of radical or political change. This new antipolemical stance, which could be defined either as generous or as lazy, must however also reflect the increasingly precarious position of artists in the 1930s, with the rise of Fascism. Or is this the face of the split between painting—for these groups were dominated by painters—and architecture? Many artists were indeed prepared to use these groups as international exhibiting fora, and their diverse and numerous membership serves to confirm this. Though some had further ambitions beyond the realm of the fine arts, most wished to preserve the individualism of their practice.

The fact that, despite such a broad-based coalition as Abstraction-Création, members still felt themselves to be ostracized by the official French art world was brought home by the 1937 Paris International Exhibition. Non-French artists were clearly discriminated against, and though native-born abstract artists did get many of the commissions for pavilions and their surroundings, this tended to confirm that the French commissioners would understand abstract art only in the decorative sense. (Over half of the 718 commissions were for murals.) Notwithstanding, this must represent an achievement for the 'Art Mural' which had been perceived by a variety of artists—Léger, Schlemmer, Freundlich, and Robert and Sonia Delaunay among them—as the logical result of a wish to promote the plastic values of painting by means of 'The Wall'. Abstract–Concrete Art was only really integrated into the French art establishment with the post-war promotion, by Nelly Van Doesburg, of the 'Salon des Réalités Nouvelles'.

Neo-plasticism 'in exile'

Concrete Art or Neo-plasticism steadily expands its geographical range during the 1930s. Within Europe, it was naturally neutral Switzerland which saw the purest continuation of such tendencies, with the groups 33 and Allianz, but beyond the continent, it emerged too in Britain, Scandinavia, Spain, and then both South and North America. The American Charles Biederman [**80**] met Mondrian in Paris in 1936, and his encounter with De Stijl was marked by his verdict that the evolution of their idea was restricted by their material range. It was Biederman's crusade to reassert the centrality of the relief as the medium and support for this art. Biederman spent the war years writing his *Art as the Evolution of Visual Knowledge,* which later had so much influence on the Constructivist relief back in Europe. After Mondrian had moved from London to New York, a number of American adherents became visible within the American Abstract Artists' Group, which lasted from 1938 to 1946.

Charles Biederman had not encountered the reliefs of Jean Gorin, a second-generation De Stijl artist, while he was in Europe. In his text of 1936, *The Aim of Constructive Plastic Art*, Gorin acknowledged both the political climate and the continuing separation of the arts without abandoning his constructive aim: 'Throughout the tragic phase of the evolution that we are now experiencing, the new plastic art—still dominated by individualism and anarchy—is forced to manifest itself in the form of objects, pictures or sculptures, while awaiting social conditions that will enable it to be fully developed in the context of everyday life.'

By the late 1930s England had become one of the last safe havens for artists in Europe, and a brief bastion of constructive art, as demonstrated by the publication of *Circle* in 1937, in which Gabo and Mondrian both published important texts. Mondrian ends his text by suggesting that there would be reached, in a perhaps remote future, 'the end of art as a thing separated from our surrounding environment, which is the actual plastic reality. ... Art will not only continue but will realise itself more and more. By the unification of architecture, sculpture, and painting, a new plastic reality will be created.'

Back in 1920 Mondrian had gone so far as to publish a detailed description of his studio ('wall next to window divided by red, grey and white piece of cardboard, shelf with grey box and white jar, and ivory curtain under which was orange-red cabinet. Greywhite worktable, yellow stool, sofa with black pelt, against dark red wall panel'), but he was not ready to make the jump from the private to the public space. He told Van Doesburg, 'I completely agree with what you are writing [about the Berssenbrugge studio], namely that the interior has to become "it". But only in the future.' And indeed in his own manifesto 'Elemental Formation' of 1923 (published in *G*), Van Doesburg required the 'separation of the different realms of formation', attributing as special to sculpture the qualities of 'space-time-line, surface, volume'.

Nevertheless, that the private could (and had already) become public is brought home by the form of Hannes Meyer's denunciation following his dismissal as Director of the Bauhaus in 1930: 'Every path to a school of design which would satisfy the normal needs of life was barred by inbred theories ... The square was red. The circle was blue. The triangle was yellow. They sat and slept on furniture like coloured geometry. They lived in houses like coloured sculpture.' Such a sentiment is echoed by a De Stijl affiliate. Domela toned down the interior design for his second flat in Berlin, because 'you cannot live in a painting with your family'.

One point which I wish to bring across in this chapter is how the freedom that sculpture was now claiming was closely associated with the freedom of painting, and of the painter's studio. Though neither Mondrian in Paris, nor Domela in Berlin, nor Schwitters with his Merzbau in Hanover, understood their private space as public, they

had nevertheless effectively demonstrated the creation of the spatial environment: a synthesis of painting, sculpture, and architecture. Sculpture and painting were now closely bound together, which was as it had to be, for much modernist theory was premised on abstract painting's demonstration of universal laws of form. Once this had been established, sculpture had the choice of being private or public.

Pictorial investigations of the third dimension

In Mondrian's 1919 dialogue between two imaginary painters, painter Z asserts, 'Exactly. According to me "the statue" has to be completely abolished in sculpture.' Though the aim of Moholy-Nagy, even in the mid-1930s, may have been to create 'an art which will express public needs by some other means than the bronze statue', he had himself in fact already abandoned the *grands projets* and had devoted himself exclusively to the pictorial investigation of the three-dimensional. In his *The New Vision*, first published in 1928, and reprinted up until his death in 1946, Moholy asserts that 'the old notions of painter and sculptor cracked', but is also able to distinguish between the domains of architecture and sculpture, one of which deals with space, the other volume. He thus defines the Eiffel Tower as a sculpture, because it is a 'volume creation', a 'completely perforated block'. Moholy's conclusion is that 'sculpture is the path both from material-volume to virtual-volume, and from tactile-grasp to visual-grasp. Sculpture is the path to the freeing of a material from its weight: from mass to motion.'

The introduction and fusion of light, mass, colour, and movement —a sculpture that is painting in space and in time—as promoted by Moholy-Nagy is a sculpture we can recognize already in the work of Moholy's contemporaries and as a beacon of what was to come. Moholy's wish to provide sculpture with an alternative to the statue we have seen prefigured by Rosso, Boccioni, and Mondrian. Moholy used transparent materials and photography to capture the effects in which he was interested. This kind of drawing in space is a line of investigation we can trace through Boccioni, Rodchenko, Tatlin, Kobro, and Calder. After the war David Smith was to develop that pictorial tradition which is a central component of sculpture in this century, and which has enriched painting and sculpture in equal measure. Though much of Moholy's pictorial investigation of the third dimension was carried out on the picture-plane, by means of photography or of paint, he also spent the 1920s elaborating his 'Light Modulator', a machine which would revolve and refract light through its differently textured planes [81]. It is reflected in Archipenko's 'Archipentura' machine of 1924, and in the designs for the stage which both Frederick Kiesler and Oskar Schlemmer were elaborating at the same time in Germany. At this point we see how painting's conjunction with sculpture brings them inexorably to take the public stage, which will be the subject of Chapter 6.

81 László Moholy-Nagy

Space Modulator, metal, glass and wood, 151cm, 1922–30, reconstructed 1970

Sibyl Moholy-Nagy described the first time she saw the machine which Moholy had been working on for almost ten years. 'Moholy explained its genesis ... from the almost archaic wood sculpture he had done in 1921 to the floating light construction in the centre of the light machine, foreshadowing his later work with Plexiglass. The "Lichtrequisit" had been exhibited in the room Moholy designed for the International Building Exhibition in Paris in 1930, and now he planned to synchronize its movement with a musical score.' In 1936 Moholy published a text in *Industrial Arts* on 'Light Architecture': 'I dreamed of light apparatus, which might be controlled either by hand or by an automatic mechanism by means of which it would be possible to produce visions of light, in the air, in large rooms, on screens of unusual nature, on fog, vapor and clouds. I made numerous projects, but found no architect who was prepared to commission a light-fresco, a light architecture, consisting of straight or arched walls, covered with a material such as galalite, trolite, chromium or nickel, which by turning a switch, could be flooded with radiant light, fluctuating light-symphonies ...'

The Object:
Function, Invitation
and Interaction

5

The last chapter explored the private spaces of painting and the possibilities that pictorialism offered to sculpture. This chapter is still rooted in the private arena, but moves away from the dialogue between painting and sculpture, asking us to focus on the centre instead of its peripheries. Nevertheless, this focus on the object—the specifics of its form—continues and expands the relationship with the spatial environment, and is often revealed by two-dimensional means.

Rodin had probably come closest to exploiting the aura of the object in photographs which sufficiently obscure the detail of the handiwork to allow us instead to see an object in space, dark against light or light against dark. Photographs by Druet of Rodin's 'Clenched Hand', masked with a blanket, go further, evoking not only the aura of the object in space, the dismembered hand on the blanket, but the strange interior world of the photograph itself. While some sculptors, as we have seen, reacted to the scale of Rodin's workshop and its production by emphasizing the hand-made, others were increasingly attracted by the possibilities of forms that looked so perfectly finished that they might have been made either by machine or by some kind of external agency. The photograph did much to reveal not only the 'object' status of sculpture, but also the strangeness of that status.

Sculpture as object, object as sculpture

Towards the end of the first decade of the century, Brancusi's progressive simplification of the sleeping human head, from a realistically carved marble to a simple ovoid, led his sculptures to acquire the status of an object. Disembodied, lying on its side, sometimes on a table-like plinth which enhanced the suggestion that this was something one might pick up, the head lost its figurative connection and became something more like a stone or an ornament [82]. Though by 1910 Brancusi's 'plinth' had become a sculpture in itself, the contrast between the alternating upper and lower parts in material and facture, with those above being given greater definition and finish, only tended

to increase this impression. Such contrast was heightened by Brancusi's increasing use of polish and light—whether in the form of reflective material, or in that of the photograph so that the object acquires preciousness in addition to aura. One of the sculptor's patrons, Jacques Doucet, exclaimed, 'If it had come from an excavation, this object! People would marvel at it.'

Brancusi made stools, benches, and even archways to furnish his studios, and from 1914 a series of four cups which might also be seen to take their part among such an inventory. However, the cups' symbolic role as objects is more important. They are outsize, but nevertheless mobile, constituents representing both the domestic (Brancusi gave one to his patron 'to keep in his dining room') and the sculptural, featuring in the occasional mobile tableaux which Brancusi put together out of his sculptural 'stock'.

Brancusi's cups are not dissimilar to the simple, even comic forms of the notionally functional objects produced by Sophie Taeuber and Hans Arp after 1916; the 'Amphora' and 'Powder Box' [83] which probably reflect not only Taeuber's craft work on the lathe, but also her designs for the marionette theatre. Both artists were concerned to avoid the mark of the individual hand, rather like Brancusi, and by this means to achieve the 'radiance of reality'. The inevitable tendency of the wood lathe to produce symmetry, and thus to evoke functional forms, was to be interestingly counter-pointed by another group of wood pieces made together over 20 years later in which the now married couple expressed more forcibly the dualism inherent in their partnership: the geometric and the organic.

**83 Sophie Taeuber
and Hans Arp**

Powder Box, painted wood,
30cm, 1916 or later

The ready-made, the ready-made assisted

In April 1916, at the Bourgeois Gallery, New York, in an exhibition entitled 'Modern Art after Cézanne', Marcel Duchamp was represented by what were listed in the catalogue as two 'Ready Mades'. Before he left Paris for New York, Duchamp had already attached a bicycle wheel to a stool (1913), something which he later defined as more of a 'distraction'. He first used the term 'ready-made' himself in 1915 and later explained how difficult it was to 'approach something with indifference, as if you had no aesthetic emotion. The choice of ready-mades is

always based on visual indifference and, at the same time, on the total absence of good or bad taste.'

Duchamp's most famous ready-made, his 'Fountain', became famous without being exhibited, and was seen only after its 'suppression' from the Society of Independent Artists' 1917 New York exhibition (where it was boarded up behind a partition) when it was reproduced in a photograph by Stieglitz in Beatrice Wood's magazine *The Blind Man* (May 1917). Though Duchamp was one of the Society's committee, and had indeed hung the show, he resigned when the piece, a urinal purchased from Mott Works and submitted under the name Richard Mutt, was rejected. (Ironically, Beatrice Wood's own submission, 'Un peu d'eau dans le savon', which she had made in Duchamp's studio, was a great success.) 'The Richard Mutt Case', an editorial written jointly by Duchamp, Wood, and H.P. Roche, maintained that the artist's action was neither immoral, nor a plagiarism, but a creation of 'a new thought for that object'. 'Whether Mr Mutt with his own hands made the fountain or not has no importance. He CHOSE it.'

The urinal was not entirely unaltered: it had been turned 180 degrees, placed on a black pedestal, signed R. Mutt, and dated 1917. This signature was notably painterly in comparison to the inscriptions which Duchamp had already made a constituent part of the ready-made. These often provided the work's title as well as its supplementary meaning, as with the snow shovel which took its title from its inscription, 'In advance of the broken arm' (1915). We have a record of Duchamp's 1916 letter to his sister in Paris explaining how he had been purchasing objects of the 'same flavour' as those she would have seen in his studio which he had signed and inscribed; he then asks her to go back there with some white lead paint to inscribe the bottle rack which he had bought two years earlier, thus making it a 'Readymade at a distance'. In the same year he painted along the edge of a comb, '3 ou 4 gouttes de hauteur n'ont rien à faire avec la sauvagerie. M.D. Feb. 17 1916 11am' (3 or 4 drops of height [or arrogance] have nothing to do with savagery). Some of Duchamp's ready-mades carry their own object titles, like this comb ('Peigne'); some, like 'Fountain', are renamed. Others carry two titles, written and spoken, like 'A bruit secret' ('With hidden noise') which sounds like 'Abris secret' or secret shelter.

Function, anti-function and instruction

It is notable how many of Duchamp's ready-mades are objects on which one would hang other objects: coat-racks, hat-stands, or bottle-drainers, and how their spatial repositioning makes it impossible to use them. Though the hat-stand retains its title 'Portechapeau', the 'Bottlerack' is more properly known as 'Égouttoir', a richer title which makes reference to drains, sewers, and even to taste, and the coat-rack becomes a trap; 'Trébuchet' [84]. Duchamp's objects need the

84 Marcel Duchamp

Trébuchet, coat-rack of wood and metal, 11.7 x 100cm, 1917

viewer—and the viewer's imagined involvement—to be activated. They suggest a corollary action, and, as a result of our being involved with them, they lead us somewhere else. 'In advance of a broken arm' may have its roots in a preoccupation which Duchamp later described to Pierre Cabanne as 'doing a certain thing in advance, of declaring "at such and such an hour I'll do this ..."'.

Certain objects came with their instructions. Man Ray's 'Objet à détruire' (1923–30) at one time bore an actual invitation to the viewer to take a hammer and destroy the whole thing with a single blow, like a fairground game, and foreshadows Giacometti's 'Objet désagréable à jeter' of 1931 and Max Ernst's 'Objet mobile recommandé aux familles' of 1936. It is said that at the 1917 Independent Artists' Society exhibition Brancusi was represented by a sculpture 'enclosed in a bag with two sleeve-holes for hands to pass through', and whether or not this

story is true, in 1926 he certainly exhibited another sculpture, without the bag, as 'Sleeping Muse (Sculpture for the Blind)'. The crossed wires in this tale, and a sculpture with a designated audience which may be unseeing in all kinds of ways, are rich in meaning. What would it mean if we were to accept such instructions as being addressed to us?

Brancusi's 'Sculpture for the Blind' finds an echo in the works later made at the Bauhaus, where 'hand sculpture' was part of the syllabus. In *The New Vision* Moholy-Nagy describes the purpose of this exercise: 'Through this [the student] registers the function of the hands, that is, to catch, to press, to twist, to feel thickness, to weigh, to go through holes, etc. ... Hand sculptures are nearest to the timeless forms of any age because they express the pure functions of the hands.' Thus hand sculptures are not simply for the hands, but also about the hands. Moholy himself likens them to the 'free shape sculptures' of Arp, Moore, and Hepworth, and it is tempting to speculate that the works to which Hepworth gave the title 'Hand Sculpture' in the 1940s might indeed have been conceived within this context.

Presentation

Contemporary photographs present the works correctly installed—as with Duchamp's 'Trébuchet' which has to be understood as nailed to the floor—or being handled, as with Giacometti's 'Objet désagréable' shown caressed by a nude woman [85]. Man Ray's 'Obstruction' (1920) is understood as a mobile only when seen hanging from a ceiling, and his 'Enigma of Isidore Ducasse' (1920), published in the magazine

85 Man Ray

Nude woman with Alberto Giacometti's 'Objet désagréable', photograph, 22.9cm, *c.*1932

1916 Cabaret Voltaire opens in
Zurich; its participants take the
name Dada

1917 Publication of first issues of *Dada*
in Zurich

1919 André Breton, Louis Aragon,
and Philippe Soupault launch
Littérature in Paris

1920 Dada exhibition in Cologne;
Dada Season in Paris

1921 Publication of *New York Dada*
edited by Duchamp and Man Ray

1924 Breton publishes first *Surrealist
Manifesto*; launch of *La Révolution*

Surréaliste edited by Pierre
Naville and Benjamin Peret
(11 issues up to 1928)

1926 Galerie Surréaliste opens with
Man Ray exhibition

1928 Breton publishes his novel *Nadja*

1929 Breton's second *Surrealist
Manifesto*

1930 Launch of *Le Surréalisme au
service de la révolution*, edited by
Breton (6 numbers up to 1933)

1933 Launch of *Minotaure*, edited by
Breton, Duchamp, Éluard, Heine,
Mabille (11 numbers up to 1938)

La Révolution Surréaliste, is indeed nothing more than a photograph, despite its subject being the suggestion of material volume. Man Ray's objects were more constructed than were Duchamp's, and brought together two or more discordant parts, exemplifying what was to become the Surrealist dictum par excellence: Lautréamont's 'chance encounter of an umbrella and a sewing-machine on a dissecting table'. And indeed the title of Man Ray's 'Enigma' is an overt homage to the Comte de Lautréamont, Isidore Ducasse, while the wrapped object suggests itself as his 'original' sewing machine.

Presentation and participation played central roles in Dada, of which both Brancusi and Duchamp were occasional members. Brancusi took part in the 1920 Paris Dada season—Duchamp's refusal was also one of the exhibits—and they became close friends. (Later on, Brancusi was to provide much of Duchamp's living in the States, as Duchamp effectively became his agent there.) Though Dada's interest in non-sensical juxtaposition was mainly demonstrated in two rather than in three dimensions, Dada exhibitions embraced, and activated, a wider spatial arena.

The 1920 Cologne exhibition, 'dada-Vorfrühling', included an entrance through a urinal, and a hatchet supplied by Max Ernst was offered to the public for use on the art works. The 1920 Paris Salon Dada, held in the Galerie Montaigne, brought together a great array of objects hanging from the ceiling and 'sculptures' displayed on the floor, on tables and on pedestals. These included a glass cylinder called 'Penser' by Georges Ribemont-Dessaignes and the poet Benjamin Peret's combination of the Venus de Milo, a male head, a pair of nut-crackers and a sponge. Many of the works played on the tradition of painting, particularly the portrait, lampooning its subjects in aggressive or derisory fashion. This echoed Picabia's 'Tableau Dada'—a monkey surrounded by inscriptions declaring it to be a portrait of

Nougé's objects are absent;
signalled in the photographs
only by a person's reactions,
as suggested in the text which
accompanied them. 'What
feeling or what reaction may a
fan provoke in us, or a match-
box, a comb, a handkerchief,
a bird, a sponge, etc.? What
effect may be produced in
us by the sight of this private
reaction, the evidence of
which may be offered to
us by a photograph? For
the spectator, what may
be the consequence of
seeing a woman terrorized
by a tangle of string?'

Cézanne, of Rembrandt, and of Renoir, bearing the legend 'Natures Mortes'—which had been shown the previous year and then reproduced in *Cannibale*. Picabia had earlier published a series of 'object portraits' in the magazine *291*, including Stieglitz as a camera, and a girl as a spark plug.

The transition from Dadaism to Surrealism was effected mainly in the person of André Breton, who, in his writing, elaborated a more rigorous framework for an understanding of 'the marvellous' which allowed for the gradual foregrounding of the object within the movement's literature.

The marvellous in the everyday

In 1917 Breton published an article on Apollinaire which included an excerpt from a story by Paul Morand about a doll called Clarisse, who collects all kinds of objects, from the very rare to the most mundane. Her room is described as 'the museum of a young savage, the curiosity of a lunatic asylum, the collection of a consul consumed by the Tropics'. Breton's fellow-poet Louis Aragon also admired Morand's story, and around 1920 constructed a fictional literature which drew heavily on imagined environments, conflating different parts of the domestic interior, so that a house becomes full of traps and dangers, or, on a wider scale, Paris becomes a meeting-place of many kinds of terrain. Shop-windows and arcades become the special 'frames' for such encounters: spaces for the imagination.

In these years such object-juxtapositions are literary rather than pictorial; literature provides the mechanism and the frame for such transpositions. In his 1928 novel *Nadja* Breton described objects which he found at the Flea Market in St Ouen which seemed extraordinary either because he could not 'read' them, such as a wooden object whose grooves represented municipal statistics, or because pure flights of fancy were juxtaposed with everyday items, such as bronze gloves beside real gloves. Aragon's text, 'The shadow of the inventor', in the first issue of *La Révolution Surréaliste*, celebrated pure invention: machines with no practical purpose. It is ironic that in describing his disorienting experience of the Concours Lépine, an engineering Salon which was utterly foreign to the poet, Aragon set the stage for Duchamp's emergence as a genuine engineer, represented by his 'Rotoreliefs' in the 1935 Competition. Whereas Aragon transforms all objects by means of poetry, Breton is increasingly in search of the material realization of the elusive object. For this he is prepared to move away from the 'everyday' and into the world of the dream. In his *Introduction au Discours sur le peu de réalité* (1924), he asked, 'Are poetic creations soon likely to assume this tangible character?', and proclaimed that he found nothing inadmissable.

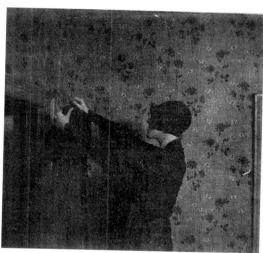

The image of the 'object'

The object was certainly actively present in literature, and then in painting, before it was 'made real'. Indeed the category 'disturbing objects' appeared as one of the defining characteristics of Surrealism, especially in Belgium. Many of René Magritte's paintings figure the surrealist object *avant la lettre*, while others are like games which ask us to match the object with its name. Magritte's collaborator, the poet Paul Nougé, imagined a Surrealist game, a 'poetry machine' made up of 32 objects. In 1929–30 Nougé used 19 photographs alongside a text which made objects Surrealist through their environment and the manner in which they are encountered [**86**]. The absence of the very thing which is signalled suggests another important piece of Surrealist sculpture: Giacometti's 'Invisible

Object', properly known as 'Mains tenant le vide' (1934) or 'Hands
holding emptiness', reading also as 'Now emptiness'. Nougé points
up the strangeness which absence can reveal and some scenarios
suggest a direct reprise of the invitation extended by Duchamp's
ready-mades.

Coat hanging in empty space
Action performed with an object, suppression of the object. A woman stand-
ing on a chair hangs her coat in empty space.

The relationship between the human being and the object is crucial to
what we have come to know as the 'Surrealist Object'. Nougé goes on
to suggest some abnormal relationships:

a woman whipping a chair, a loaf, a ladder
a woman caressing a clock, a coat-hook, an empty cage

and admits that these ideas require, not so much photography, as a
photographic performance. Or, of course, they could be painted. What
happens as the Surrealist Object category takes shape is that photogra-
phy does indeed document human interaction with the object—more
often a 'made' object than an ordinary object—and the spectator is
pulled into the object's functioning by this overt demonstration.
Indeed, some of the most successful renditions of the 'object' are car-
ried in the form of the image. Examples are Boiffard's photo of

Giacometti's 'Boule suspendue' [87] and five other pieces from 1929–31, Man Ray's photos of mathematical models from the Poincaré Institute (1936), Claude Cahun's 20 photographs for *Le Coeur de Pic*, a book of poetry for children published in 1937, and, most famously, the work of Hans Bellmer, first represented in France by the publication of a series of photos called 'Poupée: Variations sur le montage d'une mineure articulée' [88] in *Minotaure* in 1934.

The need for the object

The significant object might be something that existed in real life—which had something quaint about it, or which acquired a quaintness from its context—or something which took shape only in a dream. As early as 1923 Breton had called for 'the concrete realization and subsequent circulation of numbers of copies of objects perceived only in dreams'. He suggested that such dream-objects would not simply intrigue, but might also be the answer to a subconscious need.

One night recently, in my sleep, at an open-air market near Saint Malo, I had picked up a rather curious book. The back of this book consisted of a wooden gnome whose white beard, curled like that of an Assyrian statue, fell to his feet. The statuette was of normal size, yet made no difficulty in turning the pages of the book, which were of heavy black wool. I was eager to purchase it and, waking, regretted not having it beside me. It would be relatively easy to reconstruct. I should like to put in circulation several objects of this nature, whose fate seems to me infinitely problematical and disturbing ...

In a 1934 edition of *Documents*, later published in *L'Amour fou*, Breton told the story of helping Giacometti to complete one of his sculptures by finding the 'missing link' in the flea market of St Ouen. The mask they identified as 'remarkably definitive' was purchased by Giacometti and helped him to finish the face of the woman who became 'The Invisible Object': 'Here the found object rigorously performs the same function as the dream, in the sense that it liberates the individual from paralysing affective scruples, comforts him, and makes him realise that the obstacle he may have supposed insurmountable is overcome.'

This notion that certain objects fill a gap, without our quite knowing why, is important to an understanding of the functioning of the Surrealists' sculpture. Though Giacometti worked with his found objects to make them answer formal as well as private needs, others were less constrained by aesthetic imperatives. Only later did Breton learn from a letter that the mask was a gas-mask, and later still that it had only just been handled by the woman to whom he dedicated *Nadja*. On the same trip Breton himself found a wooden spoon with a slipper as its handle which seemed to fill one of the gaps in his own material-affective life, providing the realization of an object which Breton had asked

88 Hans Bellmer

Poupée: variations sur le montage d'une mineure articulée, photographs reproduced in *Minotaure,* No. 6, 1934–5

Giacometti to make, but which had not been forthcoming. We now know these two objects through photographs taken by Man Ray.

The private made public

Though the Surrealist Object is often likened to the fetish, it had to be seductive to an audience beyond its original maker. The subconscious of the artist had to make contact with other private subconscious. Aragon proclaimed that by means of the Cubist collage and the Surrealist Object 'art has truly ceased to be individual, even though the artist may be an irreducible individualist'. Exhibition themes at the end of the 1920s included almost literal demonstrations of the private made public: the display of religious and pornographic objects, items from private collections, selections made by significant individuals. The first exhibition (1926) in the new Galerie Surréaliste was 'Man Ray and Objects from the Isles'; it included objects by Man Ray as well as Oceanic items from the collections of Breton and others. The revelation of the private context of objects, the manifestation of otherwise un-stated or obscure desires, is thus a crucial corollary to the object itself.

Giacometti's objects, some of the most 'accessible', if tantalizing, of all Surrealist Objects, came out of particularly personal relationships or en-during fantasies of violence. One piece in particular, 'La Pointe à l'oeil', suggests the playing out of such feelings. In 1932 it was photographed by Man Ray and reproduced as 'Relations désagrégéantes', a comment not only on Giacometti's own fantasy, but on his relationship with the world as a man and as a sculptor. Nevertheless, Giacometti stated his concern that his sculptures allow him to make contact with other peo-ple. Bellmer's 'Poupée', frequently regarded as disturbingly objectified, also derives from a private stimulus: the receipt of a parcel of childhood souvenirs sent him by his mother in 1932 which provoked Bellmer to work through his aggression towards his father in the company of close friends and family. Arp on the other hand had a more benign relation-ship with his 'objects', which he addressed familiarly in the 'du' form.

The personal nature of the object, its particular relationship with its maker or owner, as introduced by Surrealism has been of fundamental importance to the potential of sculpture. The notion that an object reveals or betrays its 'owner' is something we have become quite used to, but which would not have been easily accommodated in the pro-duction of sculpture before the 1920s.

The Surrealist Object incarnated

Though the object assumes gradually greater importance through the 1920s, it is still an idea—or a vehicle—rather than a constructed reality. The December 1926 edition of *La Révolution Surréaliste* contained an advertisement for an 'Exhibition of Surrealist Objects', but the objects were slow to come.

The period in which sculpture emerges within Surrealism is relatively late, and indeed might be seen as integral to its second phase, after 1930, in which Salvador Dalí emerges as the champion of the unconscious, anchoring its founder, André Breton, on one side, against the pull of Aragon's championing of politics on the other. But such was the level of activity in the early 1930s that Breton was able to write, by 1934, in *Qu'est-ce que le surréalisme?*:

It is essentially the object on which the increasingly lucid eyes of Surrealism have remained open in recent years. It is through a most attentive examination of the numerous recent speculations to which the object has publicly given rise (real and virtual object, moving and mute object, spectral object, interpreted object, incorporated object, creature-object), and only through such an examination, that we may be able to grasp the full extent of the present temptation of Surrealism.

It began in early 1931 with a series of discussions held between Tzara, Aragon, Breton, Éluard, Crevel, Tanguy, Buñuel, Dalí, Giacometti, and others. The results emerged in the third issue of *Le Surréalisme au service de la Révolution*, published at the end of that year, in which texts by Éluard, on his poetic of objects, and by Breton, on the 'phantom-object', are joined by Dalí's crucial exposition of objects fabricated by Surrealist artists. Dalí suggested six categories of Surrealist Object, and provided examples of each:

1. Symbolically functioning object (automatic origin): suspended ball, bicycle saddle, sphere and foliage, shoe and glass of milk, sponges and bowl of flour, gloved hand and red hand
2. Transubstantiated objects (affective origin): soft watch, watches in straw
3. Objects to project (oneiric origin): In a physical sense, In a figurative sense
4. Wrapped objects (diurnal fantasies): Handicap, Sirenion
5. Machine objects (experimental fantasies): Rocking chair for thinking, Board for associations
6. Mould Objects (hypnagogic origin): Car-table-chair-blind, Forest

Dalí's text was accompanied by illustrations of four newly created 'symbolically functioning objects' by Breton, Gala Éluard [89], Valentine Hugo, and himself. Hugo's comprised a pair of gloves, one white, one red, one upturned, the other down, penetrating the cuff of the other. Dalí's was like an erotic machine, which, if activated, would lead to its own destruction. A woman's shoe contained a glass of milk, over which was suspended a sugar lump on which was painted an image of another shoe. This arrangement seemed to leave nothing open to the imagination, and both André Breton, and indeed Freud himself, found Dalí's constructions too comprehensible.

The use of the transformed ready-made object was a profound rebuff to the traditional sculptor's training. Dalí acknowledged

Giacometti's 'Suspended Ball' as a catalyst in his development of the Surrealist Object, but whereas it belonged to the realm of sculpture, he encouraged his friends to make objects that drew on found objects and eschewed any interest in form. Dalí asserted: 'Symbolically function-ing objects leave no room for formal preoccupations. They depend only on the amorous imagination of each person and are extra-plastic.' Many artists, and indeed writers, were now encouraged to make Surrealist Objects.

Dalí and his influence

Many of Dalí's objects were closely related to, or were even straight transcriptions of, his paintings. Their being made into objects only added the preposterous notion of reality to otherwise incredible com-binations. But Dalí did not go so far as to transform his objects: they were instead primarily cumulative constructions of found items rang-ing from the most mundane to the most bizarre. In 1933 at the Pierre Colle Gallery Dalí showed his 'Retrospective Bust of a Woman' [**90**], which consisted of a female bust in porcelain, dressed with cobs of corn worn like a stole, a baguette like a bonnet, and supporting a bronze inkstand derived from Millet's 'Angelus'. Heads balancing objects, and particularly food, recur in much of Dalí's work, and relate to his obses-sion with the legend of William Tell. Dalí's version of analysis—para-noia-criticism—allowed for the paranoiac to mould the outside world to his or her ideas. This allowed for sculpture an active role, in contrast to the passivity of other Surrealist states, as he demonstrated in his 1935 text *The Conquest of the Irrational*: 'All my ambition, on the plastic level, consists in materializing, with the most imperialistic fury for precision, the images of concrete irrationality.'

Two more issues of *Le Surréalisme au service de la Révolution* were devoted to the object during 1933. They included Duchamp's 'Large Glass', texts by Giacometti, Tanguy's 'Vie de l'Objet', and Dalí's 'psycho-atmospheric-anamorphic objects'. It was Dalí who set up the ground-rules for a series of sessions devoted to furthering the knowledge of the object and its possibilities published in the later issue. Answers to a questionnaire dealt with the different circumstances in which we can know an object at a particular point in time.

The Surrealist Object—and Dalí's influence—soon spread outside France. The ADLAN group promoted Surrealist exhibitions in Spain: Angel Ferrant's assemblages were presented in Barcelona in 1933; Oscar Dominguez's constructions in Tenerife in 1936; Léandre Cristofol launched his objects in Lleida in 1935. London saw the 'International Surrealist Exhibition' in 1936, and another, organized by E.L.T. Mesens, in 1937, devoted entirely to objects and poems. The London group presented itself within an international context which already counted 'Belgium, Yugoslavia, Czechoslovakia, Spain, Scandinavia, and Japan', in addition to France. Henry Heerup, the older Danish Surrealist, represented a concrete bridge with pre-war activity while the very boldness of his assemblages definitely linked him to a post-war aesthetic. The fact that in 1949 the newly formed Cobra group resorted to the object as the topic of their first exhibition demonstrates how it still offered a point of radical departure for young artists even after the war.

The material of the unconscious

Duchamp had taken a given object and declared it a sculpture. He had done little to the object, other than naming it, but his act was conscious and deliberate. The first Surrealist sculptures were similarly deliberate: the conscious concretization of dreams, and suggestive movements, or the taking of collage one step further into the real world. Dalí's next step was to foreground the unconscious over and above the conscious.

In *Minotaure*, in December 1933, Dalí presented different photographs of 'involuntary' (or unconscious) sculptures such as screwed-up bus tickets, a decorative bread roll, a used piece of soap, and a squirt of toothpaste. To call a screwed-up bus ticket sculptural was to take Duchamp's nomination one step further. Now Dalí called attention to the act of personal transformation, which made a given material into something peculiar to the person who had screwed it up. This interest in the individual 'handwriting', the unconscious but inevitable transmission of meaning, is important. The Surrealists set great store by the personal, the private, the individual, but they were not looking for the creation of a Surrealist style to recognize Surrealism across multifarious human activity.

91 Hans Arp

Two Thoughts on a Navel, bronze, 10.5 × 22 × 18cm, 1930

The notion of the unconscious taking form—as expressed in Dalí's screwed-up bus ticket, but also in his interest in the forms of Art Nouveau and of Gaudí—comes to fruition in Arp's plaster 'concretions' of the 1930s. With these Arp moved from his experiments with words and lines and profiles to full-blown imagining in the round. During the 1920s, while developing his object-language in the wooden reliefs, Arp had been deeply involved with interpreting his work. His object-signs—the navel, the clock, the torso, the moustache—were seemingly endlessly repetitive. But after his work for the Aubette Bar in Strasbourg (1928), and perhaps because here the navel, torso, and cloud had assumed monumental proportions, Arp entered a new stage in his making. He now shed the defined profiles of the object-language for the more ambiguous language of concretions such as 'Head covered by Three Annoying Objects' and 'Two Thoughts on a Navel' in which seemingly 'unformed' lumps, shapeless shapes, almost literally represent the solidification of the sculptor's thoughts [**91**]. Occasional works—'Stone formed by human hand' (1934) and 'Automatic Sculpture' (1938)—make deliberate play on the possibility of the 'unconscious' gesture of the human hand and the human psyche. Arp liked to think of his sculpture as having taken shape by itself, blooming in nature, or made by birds. He placed his 'Human Concretions' in the woods surrounding his studio in Meudon, and took photos of them in fields, nestling, like eggs, among the flowers and grass. This shift from

the 1920s to the 1930s did not simply involve the move from 'conscious' to 'unconscious' form, but also a new axis. Arp had turned from the vertical to the horizontal, from the wall to the ground.

The theory of the Surrealist Object sits in an interesting relationship to that of direct carving and truth to material. Though the unconscious was so rich a part of Surrealism, few artists brought sculpture and material into any kind of working association with the unconscious urge to form. Though Arp found in plaster the medium that could convey a putative coming into form, he was an artist with a quite unromantic relationship to his material. His approach was primarily expeditious, reusing templates to design reliefs, and using Taeuber's careful working drawings to give to craftsmen. Giacometti's inspiration was primarily pictorial, his sculptures appearing in his mind 'in a finished state'. He described their execution as 'almost a chore. I had to see them made, but actually making them was rather irritating. It was essential that, after I had made the preliminary sketch in plaster, a cabinet-maker should make them so that I could see them ready and finished, like a projection.' He was happy to make the same sculpture in various materials: 'Objet désagréable' exists in plaster, bronze, marble, and wood. In England, as we have seen, sculptors were much more monogamous in their relationship to the 'right' material, and this meant that they went further in unifying their concept with their material process. Thus sculptors like Moore, Hepworth, or McWilliam, who found form through material, stand apart from continental colleagues.

Empathy

Many of the most startling Surrealist sculptures deploy eroticism, sadism, or masochism as a way of stimulating and involving the viewer. This is often effected by means of material: Brancusi's or Hepworth's smooth alabasters suggest the caress, while the chains, nails, and sand of Miró and Picasso evoke savage pain. These latter works actually weld one material reality to another; they are, as Miró pointed out, plastic constructions as well as poetic ones. Certain arrangements, such as Man Ray's 'Les Ponts brûlés', hold within them the possibility of their own destruction; if we set them off they can live only once. Imagining touch through sight is something of as great an importance to eroticism as to an appreciation of the sculpture of Giacometti, Arp, Hepworth, or Moore. Hepworth was extremely interested in getting the viewer to imagine himself or herself into her sculptures. The potential for movement furthers the effects provided by materials, the increased tendency to combine several elements in one work making this possible.

Giacometti's 'Boule suspendue' of 1930–1 was and is seen as a proto-Surrealist Object. Its Surrealism lay primarily in its capacity

Toutes choses... près, loin, toutes celles qui sont passées et les autres, par devant, trois personnes, de quelle gare? Les locomotives qui sifflent, il n'y a pas de gare par ici,

 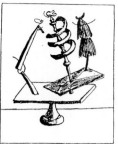

qui bougent et mes amies — elles changent (on passe tout près, elles sont loin), d'autres approchent, montent, descendent, des canards sur l'eau, là et là, dans l'espace, montent, on jetait des pelures d'orange du haut de la terrasse, dans la rue très étroite et profonde — la nuit, les mulets braillaient désespérément, vers le matin, on les abattait — demain je sors —

descendent — je dors ici, les fleurs de la tapisserie, l'eau du robinet mal fermé, les dessins du rideau, mon pantalon sur une chaise, on parle dans une chambre plus loin ; deux ou elle approche sa tête de mon oreille — sa jambe, la grande — ils parlent, ils bougent, là et là, mais tout est passé.

ALBERTO GIACOMETTI.

92 Alberto Giacometti

Objets mobiles et muets, from *Le Surréalisme au Service de la Révolution,* No. 3, 1931

for movement, and in the sexual overtones of any contact between the two elements, a supine crescent with a ball suspended above it; the ball appeared to gently graze the lower part, and perhaps to rock it like a cradle. The infinite repetition represented by the limited framework of a given sculpture emphasizes the frustration of sexual desire. 'Boule suspendue' (or 'L'Heure des Traces') was one of seven drawings published by Giacometti under the title 'Objets mobiles et muets' [92]: objects which move but which cannot speak.

At the first showing of 'L'Heure des Traces' the public was invited to actually set the ball moving. More often Surrealist Objects needed the viewer's imagined complicity to be completed. They needed someone to think about setting the object moving, releasing the trigger, swinging the pendulum. This element of imagined participation, a destructive kind of potential kineticism, goes back to Dada, in which an object like Man Ray's barbed iron—'Gift' (1921)—absolutely required the viewer to picture the result of ironing with it.

Objects on display

For one week in May 1936 the Charles Ratton Gallery in Paris presented a 'Surrealist Exhibition of Objects'—'mathematical, natural, found and interpreted, mobile, irrational, American and Oceanic' (over 200 of them). A special edition of the magazine *Cahiers d'Art* was

also devoted to the subject. This was the apotheosis of the Surrealist Object, but also set up the problematic of its display. Ratton's gallery was rather domestic in its arrangement, with some things on the walls or on plinths, but most on the shelves of the kind of glass vitrines one might associate with a natural history museum. Objects were thus treated with equality: older pieces such as Picasso's 'Glass of Absinthe', Duchamp's 'Égouttoir' (the first replica) and 'Why not sneeze?', were alongside new works like Meret Oppenheim's fur-covered teacup and shared the space with a diverse range of small non-art objects. Max Ernst's 'Asperges de la lune' was outside in the rather formal little garden, alongside more non-Western sculpture.

Oppenheim's 'Déjeuner en fourrure' (a title fabricated by Breton from Manet's 'Le Déjeuner sur l'herbe' and Sacher-Masoch's 'La Vénus en fourrure') came out of a chance discussion over a luncheon with Picasso and Dora Maar at which they admired a fur-lined bracelet she had made for Schiaparelli. The teacup was bought within the year by Alfred Barr, Director of the Museum of Modern Art in New York, who was planning his exhibition, 'Fantastic Art, Dada, and Surrealism'. It was at this exhibition, which signals the definitive arrival of Surrealism within the museological sphere, that the new work of the first indigenous American Surrealist, Joseph Cornell, was unveiled.

Cornell's boxes, Oppenheim's teacup, Giacometti's 'Palace at 4am', were all easily containable within a traditional museum survey. They were also easy to reproduce, and have since become icons for their period. But at the very time that the Surrealist Object was entering the world of the museum, where it would be preserved, the dynamic of Surrealist sculpture was taking it onto a wider, if more temporary, stage.

The object takes over the interior

In 1918 Duchamp had created a canvas for a space above his patron
Katherine Dreier's bookcases which recorded not only his own previ-
ous works, but also the spaces which they had customarily occupied in
his studios. This painting, 'Tu m" (You—me) [**93**], featured the cast
shadows of the bicycle wheel, the hat-rack and the bottle-rack as if
they were hanging from the ceiling, and an additional corkscrew cast
its own shadow.

After making this work, a kind of souvenir of his studio for unset-
tled times, Duchamp left New York for Buenos Aires, taking with him
two '*sculptures de voyage*'. One he described as taking up a whole room.
'Generally, they were pieces of rubber shower caps, which I cut up and
glued together and which had no special shape. At the end of each
piece there were strings that one attached to the four corners of the
room. Then, when one came in the room, one couldn't walk around,
because of the strings! The length of the strings could be varied, the
form was *ad libitum*.' Arp's 1920 'Travel Kit of a Da' and 'Travel Kit of
the Shipwrecked' evoke Duchamp's 'Travel Sculptures' (and not only
in their author's stateless quality), but the point about Duchamp's work
was that it was changeable, and could accommodate itself to the shape
of any space. This early piece foreshadows a work Duchamp was to
make in 1942, during the Second World War, and together they frame
his important activity as an artist who worked with the space of exhibi-
tion, installing sculptures (particularly Brancusi's) and creating experi-
ential environments.

In 1937 Duchamp designed the door for Breton's 'object shop', the
Galerie Gradiva, but the 1938 International Exhibition at the Galerie
des Beaux-Arts marked the end of the Surrealist Object per se, in that
it gave way to the creation of whole environments. A lobby dominated

by Dalí's 'Rainy Taxi' led into the Surrealist street, with dressed dummies, and then into a hall masterminded by Duchamp: 'I had had the idea of a central grotto, with twelve hundred sacks of coal hung over a coal grate ... real sacks, which had been found in la Villette. There were papers inside, newspapers, which filled them out.' The gallery was extremely dark, textured with leaves underfoot, and perfumed with the smell of roasting coffee.

Though Surrealism and the practice of architecture might seem incompatible—and it was in this that it differed so fundamentally from the abstract movement—Roberto Matta (who had indeed begun training in the studio of Le Corbusier in 1934) published an architectural project for a hallucinatory apartment in 1938. Involvement in interior design moved out from the gallery and into the vitrine on the street: the shop-window. Dalí created two window displays for a New York store in 1939, following this by taking advantage of that year's World Fair to present an environment. The shop-window is an area in which we see a cross-over between Constructivism and Surrealism; Moholy-Nagy and Ben Nicholson were as involved as Dalí, and perhaps Frederick Kiesler best represents the fusion.

By the early 1940s many Surrealists were among the French who arrived in America from the south of France after the fall of Paris. One of the first signs of their arrival, held in aid of the French relief societies, was a show entitled 'The First Papers of Surrealism' at the Whitelaw Reid Mansion [**94**] in New York (1942). This show not only included older American sculptors like Calder, and a new generation in the form of David Hare, but was also presented as a complete exhibition environment, unified by Duchamp (with the help of Sandy Calder) by means of endless lines of gun-cotton criss-crossing the room in a manner suggestive of the shallow-deep space of contemporary American painting. It was this web, obscuring the hang of paintings by Breton, which recalled Duchamp's 'Sculpture de Voyage' of 1918.

A week later Peggy Guggenheim opened her Art of this Century gallery [**95**], in which the collection she had acquired with the advice of Duchamp, Ernst, and Breton was installed over two floors to the design of Kiesler. Though the collection was dominated by two-dimensional works, the installation itself is a form of conclusion to the exploration into the Surrealist Object, which had indeed moved away from singularity, and portability, towards the total environment. In this it parallels moves made by artists such as Mondrian and Van Doesburg towards a dispersal of the finite artwork into a space that was more totally embracing.

Kiesler and Duchamp collaborated on the installation of an exhibition which marked a kind of terminus for Surrealism itself: the 1947 International Exhibition at the Galerie Maeght in Paris, which used the 1938 devices of darkness and water to set up a similarly

hierarchical/labyrinthine viewing space. This kind of layering of space and texture is reminiscent of Schwitters's 'Merzbau' [96], which extended over two floors and into a cistern, its exterior tending towards Constructivism, the inner part to Dada and Surrealism with a kind of narrative suite of chambers: from the Treasury to the Cathedral of Erotic Misery, the Great Grotto of Love and the Sex-Murder Cave. Schwitters talked about an 'immersion in art, like a religious service'.

Schwitters's connections in the early 1920s with the utopian architectural theorists of the Crystal Chain group, led by Bruno Taut, must have influenced his 'Merzbau', and in a much later letter (1936) to Alfred Barr, Schwitters was at pains to point out that his 'Merzbau' had nothing to do with decoration or with making a living space: 'I am constructing an abstract sculpture (cubist), in which one can come and go ... I am building a composition without frontiers, in which each

95 Frederick Kiesler

Surrealist gallery, Art of this Century, exhibition installation, New York, 1942

Peggy Guggenheim opened her Art of this Century gallery at 30 West 57th street with a benefit evening for the Red Cross. Kiesler's design created false walls which curved to give the effect of a tunnel, a railway carriage or the cabin of a boat, with pictures projecting still further into the central space, and sculptures — Giacometti's 'Woman with her throat cut' — lying on top of undulating settees. Repetitive sound and light effects corroborated the effect of being inside a railway tunnel. Duchamp's 'Boite-en-Valise' was arranged by Kiesler for its first public display: a spiral motif like a spider's web encased a peephole which allowed the viewer to see, one by one, fourteen images from the Valise as she turned the wheel.

Merzbau, Hanover,
photographed *c*.1930
At first Schwitters's *Merzbau*
doubled as his studio, but by
1927 it had displaced him and
he moved his studio into the
vestibule. The *Merzbau*
continued to grow around the
living spaces occupied by his
parents, wife and son. In 1937
Schwitters left Germany with
his son and settled in Lysaker,
a suburb of Oslo, where he
erected a hut beside their
appartment block in which
he built his *Merzbau* 'Haus am
Bakken' over the next three
years. Schwitters had holi-
dayed in Norway since 1934,
on the island of Hjertoy, where
he created his most intimate
Merzbau in the old forge
he stayed in. At the end
of the war Schwitters was
tempted to return to Hanover
to repair his *Merzbau*, but ill-
health forced him to restrict
himself to beginning a new
work in England, the
Merzbarn on the estate of
Elterwater, left incomplete
at his death in 1948.

element furnishes the context for its neighbours ...' The 'Merzbau'
disoriented its visitors because its uniformly white surfaces were
broken up by occasional touches of colour, mirrors, and tricks of
light. The work grew organically, absorbing material which came the
artist's way, including imagery and 'relics' of artist-friends, chang-
ing by means of assimilation rather than destruction. It reflected
private and public egoisms, topical crimes both sensational and politi-
cal, nationalist struggles for power. By the 1930s it would become ever
more of a hermitage in which Schwitters could retreat from the real
world outside.

Framing the object

We have seen how important painting and photography were to the
Surrealist Object in providing it with its own space and atmosphere.
We have seen how the object itself expanded to become the environ-
ment. But some sculptors, working from the same Surrealist frame-
work, looked instead to defining a concentrated space by opening their
sculptures within their own frame. It is notable how many of
Giacometti's Surrealist sculptures are enacted within a cage or frame-
work which is interior and limiting. It is notable too how many can be
read as upright, in a shallow space which is certainly theatrical if not
indeed pictorial. 'L'Heure des Traces' and 'The Palace at 4am' are
contained cubes, but 'Three Figures Outdoors' and 'Reclining Woman
who Dreams' are shallow, like open reliefs. An interesting 1929 photo-
graph by Marc Vaux brings four such pieces together. Set up as if to
have a conversation, the dialogue is mute, each piece locked into its
own space. Such linear inscription is very much echoed in the early
works of David Smith—'Interior for Exterior' (1939)—which are also
set within their own open yet self-contained spaces.

Sculpture that was presented not simply as 'Surrealist' but also as
the 'Object' must owe much to the pictorial debate which we saw
explored in the 1930s by the groups examined in the last chapter. Let us
not forget that in 1930 Arp and Schwitters joined Cercle et Carré, and
then its successor Abstraction-Création. The genre owes much too to
the increasing interest in open sculpture, to the 'Transparencies' of
Lipchitz, the welded works of González, and the twisted wire of
Calder. A number of Giacometti's works make play between ground
and motif, line and plane, and Leandre Cristófol's works make striking
parallels with abstract painting: see his 'Monument' and 'Noche de
luna' [**97**] (both 1935).

The pictorial nature of the composition—the square of the canvas,
the circle, and the line upon it—comes through clearly in sculptors'
work of the 1930s. It frequently announces itself in the relief form, and
Moore for instance applied relief to work in the round. The circle
becomes the hole and again invites the spectator, though in a less

overt manner, to participate. Moore was fully aware of the 'mysterious fascination of caves in hillside and cliffs', and Surrealism had given him the key to unlock this fascination and develop it more subtly.

Grounding the object

In 1933 Giacometti showed a piece called 'The Surrealist Table', in 1944 Ernst 'The table is set'. Both make reference to the still-life tradition in painting, but both also bring out the rootedness of form, of domestic ware as much as of sculpture, on the base on which it rests. Giacometti's forms seem almost to be sinking into the table, of it as well as on it; Ernst's plaster-casts of real objects solidify and ground them. This kind of 'concretization' is effected as much by the unifying material as by the forms themselves, and in this announces its affinities with paint.

While the paintings of Magritte or de Chirico had revealed the potential strangeness of objects which were unaltered other than in their context, those of Yves Tanguy [98] and Dalí suggested new sculptural forms. This is an aesthetic which is in contrast to the collaged

Surrealist Object, and indeed it might be argued that it is in paint-
ing—in its invention, made believable by its very unifying smooth-
ness—that we find more nourishing sources for sculpture 'proper'.
A striking example is Tanguy's 'The Certitude of the Never Seen'
(1933), which has a carved wooden frame with forms which appear
in the sculpture of French Surrealists and, more especially, the
British sculptors Moore [**99**], Hepworth, and McWilliam. The frame
makes explicit the connection which is an increasing feature of
contemporary sculpture between a ledge or support and the forms
which sit upon it. The links made between Tanguy's childhood on
the coast of Brittany and his menhir-like forms remind English
readers of the links made between Hepworth and Cornwall only a
few years later. A further parallel between Tanguy's painting (e.g.
'Indefinite Divisibility') and contemporary sculpture is found in the
work of Noguchi.

Grounding sculpture went further than providing it with a table-
top or ledge, even if, as with Giacometti's 'Surrealist Table', his
sculpture really was 'a table for a corridor'. The object gave way to
sculpture as the plinth gave way to a ground-plane which was part of

98 Yves Tanguy

Indefinite Divisibility, oil on
canvas, 102×88cm, 1942

the sculpture itself. No one part was more important than another,
even in pieces which invited the viewer's involvement, such as
Giacometti's work from the early 1930s, 'Man, Woman and Child',
'Circuit', and 'No More Play'. There was an increasing tendency for
pieces to rest on their ground-plane, in Arp's concretions, as in con-
temporary works by Hepworth and Moore. In these sculptures, as in
painting, ground and motif are all made of the same material.

Even ludic, mobile sculptures emphasized this new sense of gravity,
which ensured that loose elements returned to ground. In Arp's 'Tête
couverte de trois objets désagréables' three irritants—the large fly, the
small mandolin, and the moustache—persistently return to annoy.
Even sculptures with more than one way of resting, allowing the viewer
two or more options for placement, such as Giacometti's 'Disagreeable
objects' or Hepworth's 'Hand sculpture', emphasize their grounded-
ness because of their non-hierarchical alignment and the fact that they
have no need of a plinth. Giacometti's 'Objet désagréable à jeter' has
indeed also been called object or sculpture without a base.

In and of the ground

Brancusi had long been an 'honorary Surrealist'; like Picasso, or
Moore, his vocabulary was both sufficiently elastic, and sufficiently
powerful, to carry in a number of contexts. Brancusi's pieces had
indeed become increasingly object-like: heavily planted, clearly
delineated, carrying a kind of aura around them in the space they occu-
pied. This kind of rooting and expansion is what allows the simple
forms of Tirgu Jiu (1937) to resonate on a monumental scale, and

Tirgu Jiu might be seen as a huge enlargement of a table-top piece by Giacometti or Moore.

These works are all grounded: they focus attention on the way in which they meet the ground, whether that ground is a platform or the earth itself. Beyond this gravitational pull, Tirgu Jiu activates the surrounding space by multiplying the work, creating a 'space' in a manner which goes back to at least 1917, when Brancusi brought together three pieces as a *groupe mobile* in a photograph he sent to his American patron, John Quinn. Thus we see reconfirmed what has already been suggested; that the photograph encouraged sculptors to create environments, even if they were only temporary.

Brancusi's own studio increasingly became his major work of art, a cumulative space that documented the gradual chain of transformation which the sculptor effected upon a small range of motifs. This was why he hated to part with sculptures, insisted on retaining plaster-casts, and was traumatized at the thought of moving or losing his studio premises. His concern to preserve his studio, which he called a 'web of space and time', should not be equated with a concern to fix his work. Brancusi appreciated his studio precisely because it was always changing. He saw something similar in New York: 'All these blocks to be shifted and juggled with, as the experiment grows and changes.'

The space for sculpture became increasingly important, and sculptors knew how much they stood to lose if they lost control of the presentation of their work. In a note later printed by Ezra Pound (1916), Gaudier-Brzeska talked of how 'artists like Epstein, Brancusi and myself would easily build palaces in harmony with their statuary. The architecture that would result would be quite original, new, primordial!' (It is interesting to speculate whether Gaudier could have considered including Meštrović in this judgement.) None of the three ever got so far, but Brancusi got the closest. Around 1930 he met the Maharajah of Indore, who, over the next few years, prepared a plan for a 'Temple of Meditation', which was not simply to be an architectural project designed by the artist, but one specifically designed to create a home for four of his sculptures. As far as we know, the temple was to have been 12m square, half underground, allowing the visitor to emerge by means of a subterranean staircase into the light above. A letter of 1936 set out what the Maharajah visualized:

In the middle, a stream, or a reflecting pool (rectangular, elongated).
On one side, the black 'Bird in Space'.
Across from it, the white 'Bird in Space'. On one side, the bronze
 'Bird in Space'.
Across from it: a small temple of the Indian God.
General layout, the size of the niches, of the reflecting pool,
 of the Indian temple; to be determined by Brancusi.
Hedges, wall, selection of trees, procedure for planting trees: Brancusi.

100 Constantin Brancusi

Tirgu Jiu: Endless Column, iron and copper, 29.35m; *Gate of the Kiss,* travertine, 332cm; *Table of Silence,* limestone, 90cm, 1937–8

In 1935 the sculptor Militza Patrasco, acting on behalf of Mrs Tatarascu and the National Women's League of Gorj, asked Brancusi to study the proposal to build a First World War memorial. Prime Minister Tatarascu came from the same region as Brancusi, near to Tirgu Jiu, and his wife, also a sculptor, devoted herself to the project. In July 1937 Brancusi arrived to select a site, deciding on the old hay market. While there he recruited an old friend, the engineer Stefan Georgescu Gorjan, to act as project supervisor.

Though these sensitive plans never came to pass, Brancusi could take comfort from the realization of another sculptural 'place' at around the same time. Brancusi had been asked to commemorate the Romanian troops who had driven back the German offensive on the Jiu river in 1916, and at Tirgu Jiu, over a mile-long axis, he designed a three-stage unfolding: the 'Gate of the Kiss' in travertine, the 'Table of Silence' in limestone, the 'Endless Column' in copper-coated iron, each marker solidly planted in the earth. The ground-site, with existing features such as river and church, as well as its rise and fall, was deployed by Brancusi in an expansive manner which embraced the whole site as a base for his work [**100**].

As Brancusi's work at Tirgu Jiu suggested a merging of sculpture and base, so Noguchi, who had worked for some months with him, sought a more decisive fusion, in which sculpture and site would be in-distinguishable. In 1933 Noguchi submitted a design to the Public Works of Art Project called 'Monument to the Plow', a symbolic and commemorative pyramid with a base 1200 feet square. It was rejected, perhaps unsurprisingly, thus establishing a precedent for Noguchi's large-scale projects. The following year he presented a design for a

park, 'Play Mountain', to the New York City Parks Commissioner. 'Play Mountain' combined the stepped pyramidal profile of his 'Monument' with the curved planes which were to become so much a part of Noguchi's earth-works. This kind of modelling—which in small-scale relief reminds us of the by-then-established Surrealist bio-morphism, but is radically changed when it lies horizontal with the earth—is further elaborated in 'Contoured Playground' of 1941 [**101**]. Another plan, of 1945, was for a Jefferson Memorial Park in St Louis. Noguchi takes Giacometti's grooves and curves, the ludic element, the game-board ground, and gives them real organic life by their proposed marriage with the ground itself. The model has wonderful bumps and lumps, smoothly realized, with even shadows, smooth curves, and serpentine lines offset by straight-cut sections.

The period from 1935 also sees the first of Noguchi's extensive series of collaborations with the choreographer and dancer Martha Graham in which he would develop his exploration of form and movement in space, always anchored by gravity. Noguchi's use of the ground de-veloped as his awareness of the American desert conjoined with his elaboration of the aerial viewpoint. 'This Tortured Earth' (1943) was not only a model for a landscape project lamenting the war, but a

sculpture actually to have been created by military bombardment. Noguchi's despair around the end of the war produced a tragi-comic effect in the form of a project for an enormous earth face, first called 'Memorial to Man' but later renamed 'Sculpture to be seen from Mars' (1947) [144]. The quizzical face (the nose alone to be over one mile long) stares up at the onlooker from outer space. The object has assumed a magisterial but terminal command of its environment. Noguchi has used 'sculpture' to represent the surviving human trace of a planet which had wiped itself out.

A Shared Ideal: Building a New Environment

6

The last chapter ended by suggesting that the 'object' came to take over a wider spatial plane, principally within the gallery environment, but also outdoors. This chapter will explore the spatial environment with which another kind of artist wished to engage: the social space in which we live and work. This engagement reveals another role for the 'object', this time as a means of arriving at a goal at once realistic and idealistic.

The 'object' represented the contract between artist and audience, a relationship which was identified as central to the health of art and of society, but one in need of a radical overhaul. Critics proposed to bring this about by means of synthesis. Among various kinds of synthesis, two are dominant: the union of art and craft or art and industry, and the union of painting, sculpture, and architecture. Though sculpture could not have a pre-eminent place in any such synthesis, it will be seen that the language in which it is described might well be defined as 'sculptural' [102]. In some ways sculpture might be judged to have disappeared; in other ways to appear in everything. The nature of the joint approach is that it is not divisible.

As synthesis was such a concern in our period, we shall devote the bulk of this chapter to investigating what might be seen as its manifestations. We shall concentrate on the years after the First World War when, profoundly shaken by their wartime experience, creative artists came together with a renewed or a changed agenda. This agenda might be characterized by its hope that the two kinds of synthesis were mutually compatible, that is to say, that fine artists would both abandon the schools which divided them internally and also work with other schools—architects, engineers, and manufacturers—in the designing of the everyday world [103].

What was to develop into the international modernism of the interwar period has two essential earlier sources. One lies in the abstract art developed in relative national isolation during the First World War; the other in the debate about art and industry which goes back to the Industrial Revolution. Our link may be found in the culture of

**102 Theo van Doesburg
and C. van Eesteren**

Models for 'Maison
Rosenberg', 'Maison d'Artiste'
and 'Maison particulière' at
the exhibition *Les Architectes
du Groupe De Stijl*, Galerie de
l'Effort Moderne, Paris, 1923

materials which was such an important component in post-Cubist aes-
thetics, in technological development, and in Constructivism. We
shall begin with the years before the war, when the debate focused on
the renewal of craft by its partnerships, both with art and with industry.

Ensemble work

By the early 1900s many sectors of society were looking at the circum-
stances of the object's production. One solution lay in the conviction
that the split between art and craft must be overcome from the outset
of a student's education. The Debschitz School set up in Munich in
1902 by the Swiss designer and sculptor Hermann Obrist drew on the
theories of William Morris in identifying a need for students to study
both 'free' and applied art. In the years before the First World War, and
through the agency of local ruling aristocracies, a number of German
arts and crafts schools were overhauled along similar lines. An example
is the Grand Duke of Hesse's Artists' Colony on the Mathildenhohe in
Darmstadt, which proclaimed 'the unity of art and life, artist and arti-
san, house and decor'. The jump made by Peter Behrens—who left this
almost feudal haven of handicraft in 1903 and went on to harness his
talents to the twentieth-century production line when he became com-
pany designer for AEG (Allgemeine Elektricitätsgesellschaft) in
1907—exemplifies the very shift (from art and craft to art and industry)
which contemporary practice had to accommodate.

103 Gerrit Rietveld
Schröder House,
Utrecht, 1924

Much of the 'international' activity of these years sprang out of national rivalries. Hermann Muthesius spent seven years in England around the turn of the century studying British design for the Prussian Board of Trade. Impressed by his findings, in 1907 Muthesius made a speech in which he declared that artists must harness themselves to industry if Germany were to experience any kind of cultural renaissance. Twelve fine and applied artists came together with twelve small firms to form the Werkbund, aiming to 'ennoble professional work thanks to the cooperation between art, industry and manual labour'. Though the Germans were afraid of slipping behind, the French bowed to their superiority at the 1900 Exposition Universelle, a superiority deriving from 'a working method that is unknown to us: professionals associating themselves with designers, painters, sculptors, even writers, in order to complete an ensemble'. The Werkbund had indeed moved to a new position as regards the worker's alienation from his product, seeing the solution in the connections which bridged the gap, rather than in eradicating the gap altogether.

Muthesius wished to see an international and aspirational style, in which the practical and the ideal were mutually informative. In 1897 Samuel Bing argued that modern decorative art was naturally

international as it grew out of industry rather than localized folk cultures. Bing's 'Art Nouveau' shop in Paris was set up with a deliberately reforming mission, displaying complete interior ensembles which brought together different disciplines working to common principles. But, in contrast to the German Kunstgewerbevereinen, French craftsmen operated a defensive position as regards industry, preferring to see themselves as fine artists with unique products. Bing was soon forced to capitulate, and to return to the apparently 'French' quality of luxury.

The reforming spirit in Germany and Austria led a number of applied art schools to ask the French sculptor Rupert Carabin to take over their direction. On his trips there (c.1898) Carabin noted the results deriving from the large sums provided by local municipalities for artistic ensemble-work. For patriotic reasons Carabin refused the appointments offered to him, and instead devoted himself to making reports on international exhibitions for the Parisian municipality. His admiration for the 1908 Ausstellung München led him to suggest a wholesale reformation of practical training so that the French did not lose too much ground. Carabin provided evidence for the young C.E. Jeanneret (later Le Corbusier), whose 1911 account of German industrial and applied arts similarly ascribed the lead taken by the Germans to their educational institutions and embrace of the 'non-luxurious' product. By 1914 the Werkbund had nearly 2,000 members.

In France the emphasis was on integrating Decorative Arts into the Fine Arts, rather than into industry. The Société nationale des Beaux-Arts, encouraged by its president the sculptor Dalou, decided in 1891 to admit the Decorative Arts to their annual Salon on the same conditions as Painting and Sculpture. Many lamented their subsequent separation in the 1900 Exposition Universelle, and the Salon d'Automne was concerned to salvage the initiative. It invited the Munich Association which had pulled off the 1908 Exhibition to exhibit at its 1910 Paris Salon. The Munich ensembles were so effective that they influenced French artists to set aside the single virtuoso piece in favour of working together on harmonized interiors.

An example of the new emphasis was the team of twelve painters and sculptors brought together for the 1912 Salon d'Automne by the designer André Mare to produce what later became known as the 'Maison Cubiste', although only the ground floor of the pseudo-Cubist façade (by Raymond Duchamp-Villon) was actually constructed. Duchamp-Villon described the 'true goal of sculpture [as] above all architectural', and the Maison Cubiste might be seen as the 'appropriate frame' which he spoke of as providing for the objects of his time. 'We should fill our minds with the relationships of these objects among themselves in order to interpret them in synthetic lines, planes and volumes which shall, in their turn, equilibrate in rhythms analogous to those which surround us.' Though we might see this sentiment

as evidence of the kind of synthesis which we have already encountered, and of an interest in the expansion of the environment as voiced by Boccioni, it must also be seen within the context of contemporary interior decoration. No one object in the Cubist house was particularly striking (or even Cubist); instead, in tune with the newly fashionable teamwork of the *coloristes*, each rhymed with the others to create an overall effect.

After the war

The First World War had brought to a sorry conclusion the story of competitive nationalism. Those who had seen active service and survived were profoundly shaken and, optimistic or pessimistic, encouraged to rethink the scope and pattern of civilian life as a route out of war and into peace. Particularly marked by the war were Russia, which had undergone its own revolution and was still suffering from civil war, and Germany, which now emerged as a democratic republic following the Kaiser's resignation. In both countries we find almost simultaneous attempts to bring fine artists into the wider debate about the form and function of social organization. But whereas the Russian experience was closely linked to a political party, our German parallel, the Bauhaus, was directed by the architect Walter Gropius in a determinedly apolitical manner.

The urge to involve painters and sculptors in the search for improved design, and to establish a synthesis in a shared style that transcended national borders, is particularly clearly expressed in Soviet Constructivism [**104**] and in the school which Gropius reformed in Weimar. Neither was a stable entity, each subject to changes in political and aesthetic climate. Each influenced the other; Kandinsky, the first Director of the Moscow Institute for Artistic Culture (INKhUK) which was set up in 1920, was already aware of the Bauhaus's 'synthetic association of architecture, painting and sculpture'. Each learnt more of the other as the 1920s moved on, especially as changing circumstances in the Soviet Union led abstract artists to emigrate. In 1922 El Lissitzky announced that 'The Blockade of Russia is coming to an end' and suggested that parallel trajectories hidden by seven years of isolation would now be revealed.

Five years after establishing the Bauhaus, Walter Gropius wrote an essay which made clear his own sense of the debt he owed to his forebears, 'to Ruskin and Morris in England, van de Velde in Belgium, Olbrich, Behrens ... and others in Germany, and finally the German Werkbund'. His 1919 manifesto for the Bauhaus was a rallying cry for 'Architects, painters, sculptors!' 'Let us therefore create a new guild of craftsmen without the class distinctions that raise an arrogant barrier between craftsman and artist! Let us together desire, conceive and create the new building of the future, which will combine everything—

104 VKhUTEMAS workshop
Students with three-dimensional work on display in the studio, mid-1920s

architecture and sculpture and painting—in a single form which will one day rise towards the heavens from the hands of a million workers as the crystalline symbol of a new and coming faith'. We discern here what would amount to a link between pre-war Expressionism—its beliefs, and the forms and materials in which they were to be realized—and post-war Functionalism. The manifesto came out of beliefs common to a number of German groups which emerged out of the war, notably the Arbeitsrat für Kunst, to which Gropius belonged, and the Novembergruppe. The Novembergruppe, whose manifesto embraced architecture, training, museology, and legislature, determined to overcome national boundaries, and the Arbeitsrat für Kunst, with which it merged in 1919, determined to transcend the 'boundaries between the crafts, sculpture and painting, all will be one: Architecture'.

Such expressions are immediately pre-dated by De Stijl: in 1916 Van Doesburg dreamed of a 'monumental–collaborative art ... wherein the different spiritual means of expression (architecture, sculpture, painting, music, and the word) in harmony—that is each individual one gaining by collaboration with another one—shall come to the realization of unity'. 'The Style' was manifested through the integral relationship of parts to whole and whole to parts, itself harking back to Berlage's 'Unity in Plurality'. Though De Stijl was never organizationally unified, and though it never set up its own training scheme, its

precepts and their protagonists were relatively protected during the war and thus well placed to inform the debate on synthesis as it developed internationally during the 1920s. Now we must turn to that debate and the way it was conducted, both in theory and in practice.

Teamwork

One manifestation of synthesis was teamwork. The importance of the team should not, however, obscure the differing and changing interpretations of what 'teamwork' meant. When Gropius came out of the war it was with an idea of retreating from the wider world into a specialized community. In a speech given to the students on the occasion of the very first presentation of their work, in July 1919, Gropius told them how he and his colleagues had come to grief before the war, presuming that they could rationally bring art to the general public. 'Now', he said, 'it will be done the other way about. What will develop are not large, intellectual organizations but small, secret, closed associations, lodges, guilds, cabals which preserve a secret core of belief ...' While Johannes Itten, one of Gropius's earliest appointments, clung vehemently to the wish to preserve the conditions of a retreat, Gropius came to recognize the need to use and establish connections with the outside world.

The early Bauhaus made show of its democracy, including student representatives on its governing body. A system of double leadership was established, with each workshop being led jointly by a Master of Form and a Workshop Master. Equality was somewhat conceptual, however, and the Workshop Masters had cause to complain about their relative status and conditions. Some left, especially those who had been 'inherited' from the old School of Applied Arts, and Gropius had to acknowledge the need to go outside the school, to local craftsmen and to the School for Building Trades. Masters of Form used their

The Bauhaus

1919 Weimar: The Staatliches Bauhaus formed out of the amalgamation of the Grand Ducal Saxon Academy for the Fine Arts and the Grand Ducal Saxon School for Applied Arts. Dependent on the Ministry of Education of the Federal State of Thuringia for support. Walter Gropius is the founding Director.

1924 Thuringian Parliament gives Bauhaus notice.

1925 Invited by the Mayor of Dessau to make its new home there; local Socialist parliament provides generous budget, now supported by a city rather than a state. Additional title Hochschule für Gestaltung.

1928 Hannes Meyer succeeds Walter Gropius as Director

1930 Mies van der Rohe succeeds Meyer

1931 Nationalists take control of Dessau city parliament

1932 Dessau School closed and vandalized by Nazis; Mies moves school to a disused factory in Berlin where it operates as a private institution until closed by police in April 1933.

Workshop Master, and their students, on projects both within and without the Bauhaus. Though some criticized the Bauhaus for this confusion between public and private work, outside commissions were often the only way in which students could gain real experience. The early ideal of also absorbing the Fine Artists who had previously been teaching at the Academy of Fine Arts came to nothing; within a year the Academy was re-established, marking, perhaps, the end of an impossible dream.

After the Bauhaus moved to Dessau in 1925 the dual system was abolished, and craftsmen were seen as helpers rather than equals. Nevertheless, Dessau also saw the establishment of ex-Bauhaus students as Young Masters, who now made up half the teaching staff. In them we see something of what Gropius had been aiming for: artists who in themselves represented a combining of the dual approach. Thus teamwork shifts from the collaboration of different specialists to the creation of a new kind of artist. This artist, trained within the new system, tended away from a single specialism towards an approach which combined several skills and interests. Georg Schmidt, who took over the sculpture workshop, exemplifies the new range: he moved from painting to relief sculpture, executed reliefs for both the Sommerfeld House in Berlin and Schlemmer's Bauhaus vestibule mural scheme [105], practised typography, taught calligraphy, and succeeded Herbert Bayer as head of the printing workshop.

The tradition of architectural practice, in which a lead architect works with a number of younger colleagues, must have informed teamwork efforts in the Bauhaus. It may then seem ironic that an architectural department was established only in 1927. It is however notable that, once architecture was formally established within the school, it started to subsume other parts, ending the equality which a number of different trades had previously enjoyed. Though 'architecture' had existed outside the school in the form of Gropius's private practice, he may have been right to delay its incorporation, despite the criticisms, recognizing that the synthesis which was ultimately realized in building had to be built up holistically from below.

The Soviet Union offers us a more dispersed picture, but across its various geographical centres we still discern the importance of the group, of collective decision-making, and the move toward the all-rounder, away from the single-skill artist. One has only to look at the major Soviet artists—Malevich, Tatlin, Rodchenko, Stepanova, Popova, El Lissitzky—to see how individual fields of action encompassed wide-ranging activity: graphic, theatre, textile, ceramic, architectural, and interior design, while private 'studies' in two or three dimensions continued to occupy an important position in feeding into and informing this diverse production [106]. These artists had all been active before the war, absorbing Cubism and developing the culture of

105 Joost Schmidt

105 Joost Schmidt

Reliefs for Oskar Schlemmer's vestibule scheme in the Bauhaus, Weimar, 1923

Schlemmer's mural scheme decorated the Weimar workshop building designed by Henri van de Velde. It was concentrated in the entrance hall where it included blue plaster reliefs, 'temple guardians' at right and left, half figures on the ceiling, niches with figures, and a frieze of monumental torsos on the main staircase. Its vocabulary was triadic: red, blue and yellow (in addition to black and white); point, line and rectangle; cube, pyramid and sphere. Schmidt executed the relief work for Schlemmer. In 1930 the mural became the first victim of Nazi censorship of a public work of art. The previous year Thuringia had appointed the architect Paul Schultze-Naumburg to lead the United Weimar Art Institutes. The author of *Art and Race* (1928) was unable to tolerate the mural in his new headquarters and ordered that it be painted over.

material contrasts that was to find unique expression in the post-Revolutionary years. When the Institute of Artistic Culture was set up in 1920 it began from this pictorial basis, aiming to interrogate and establish agreed principles for the new art. Such principles were demonstrated and debated by means of texts and lectures, designs for theatre, and administrative liaison. Early research followed the interests of its first director, Kandinsky, in the correspondences across the arts and senses. After his departure, continuing debate led to the formation of the First Working Group of Constructivists, in the

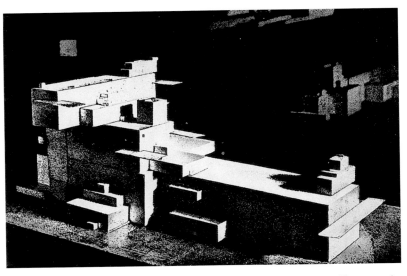

spring of 1921, which included Rodchenko, Stepanova, Konstantin Medunetskii, and the Stenberg brothers.

The student body was recognized to be an important part of the new practice, and a number of masters worked with students on joint projects. The Free Art Studios which had briefly succeeded the pre-Revolutionary Academies were 'free' in allowing students complete choice before selecting their master, but this came to be understood as antithetical to the propagation of an autonomous artistic foundation. The answer to this was to set up in 1920 the VKHUTEMAS, or Higher State Artistic and Technical Workshops. VKHUTEMAS might suggest a unified outlook, but the single name embraced several groups, as well as almost continuously changing priorities. Nevertheless, we find here, as in the more unified Bauhaus, tutors who teach across a range of disciplines; the architect Alexander Vesnin taught in the Woodworking faculty and El Lissitzky taught architecture in the Wood and Metal faculty. Both in specialist departments and in the Basic Course, 'specialisms' become more abstract, moving away from simply painting or sculpture, towards qualities of both, such as colour, space, and volume. In this way, students experienced teachers whose individual explorations of these qualities might vary widely in terms of their final form. Tatlin's 'Tower' was made with students in the Workshop in Material, Space, and Construction which he ran in Petrograd, and first shown there in November 1920 in a display of the collective work of the ateliers [**107**]. Two of his student–helpers, Shapiro and Meyerson, joined Tatlin in signing an article about the 'Tower'—'The Work Ahead of Us'—in the Bulletin of the Eighth Congress of the Soviets. Tatlin went on to head the Material Culture section of the Petrograd Museum for Artistic Culture, where he worked with a team on the kind of research project which necessarily involved many 'scientists'

1918 Stroganov School of Applied Art and Moscow School of Painting, Sculpture and Architecture closed and amalgamated to form First and Second Free Studios	1925 Success at Paris Exposition Internationale
1920 Reorganization of Free Studios leads to formation of VKhUTEMAS, established November	1926 Greater focus on industrial production; Basic Course reduced to one year
1920–1923 Period of constant internal evolution	1928 Title incorporates change from Workshops to Institute (VKHUTEIN)
1923–26 Period of consolidation and external interaction; Basic Course extended to two years	1929 Basic Course reduced to one term
	1930 VKHUTEIN dissolved; its departments absorbed into various new or existing institutions

rather than just one artist. Though Tatlin collaborated with external industrial concerns, comparisons were inevitably drawn between a 'research team' which represented an elite, and the real industrial proletariat.

A common curriculum

In the training offered by those committed to synthesis we witness the move away from a monolithic specialism, to the fostering of skills which were applicable across the board: in craft, and in industry; in painting and sculpture and architecture. This was formally recognized by the institution of foundation courses: the Bauhaus Vorkurs, the Basic Course of VKhUTEMAS. In both schools the existence of this first course remained sacrosanct, despite other changes in the syllabuses. In both, too, it was seen as compulsory, mirroring the Bauhaus's new emphasis on regular attendance, for a fixed time, over and above the random personal timekeeping tolerated by the fine arts academies. It was now understood that 'art' was not simply something that depended on teaching as much as talent, but also represented absolute standards that might be shared by a community.

Despite the differences between the two Masters primarily responsible for the Bauhaus Vorkurs in the early years, Johannes Itten and Josef Albers, their approaches have a number of central points in common. For both, a crucial technique was that of 'contrast'. Itten, who saw his own specialism as colour, fostered an understanding of contrast by means of play and analysis, believing, as a committed teacher, that his methodology could release individual aptitude. Early exercises involved the compilation of multi-part collages and assemblages emphasizing contrasting qualities in a nevertheless unified composition. Both Masters emphasized that knowledge of any one material required an understanding of its relationship with others. Albers also encouraged free play, starting directly with the material. Aiming to

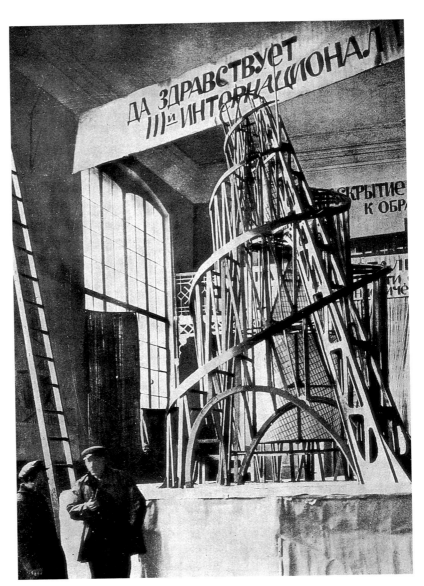

107 Vladimir Tatlin

Model of the Monument to the Third International, exhibited in Moscow in 1920, reproduced in 1921

remove any concern to master the requisite skills to make copies of successful precedents, Albers restricted the availability of both tools and materials, pushing his students to explore contrasting texture or the construction of volume and space simply by using paper, cardboard, and scissors.

Albers's method thus comprised two alternating strands: one construction, the other the study of surface qualities. He split surface appearance into structure, facture and texture, which normally engaged both sight and touch in their interpretation. Structure revealed the form of the material itself, facture the way it had been treated, and texture their combination. Though Albers's categorization applies

only to the material's surface, it is nevertheless reminiscent of the 'tectonics, *faktura*, and construction' by which the First Working Group of Constructivists denoted their available means. Tectonics derived from the appropriate use of industrial materials within the communist society, construction represented the organization of these materials, and *faktura* described a treatment which respected both the tectonic and the construction.

The Constructivist faction on the teaching staff of VKhUTEMAS was concerned to combine the study of those 'basic artistic disciplines which organize a work of art, their practical application in specialized industries, and the fundamentals of a specialized and professional education'. They best succeeded in the Basic Course and in the Wood and Metalwork departments. Staff of these two faculties, which merged in 1926 to become Dermetfak, included major Constructivist figures: Rodchenko, Klutsis, El Lissitzky, and Tatlin. Rodchenko taught artistic design, Klutsis space discipline, El Lissitzky the principles of architecture and furniture and interior design, Tatlin the culture of materials.

The Basic Course developed out of what began as a course based primarily on painting. Soon, however, strands in construction other than in colour—in space, graphics, and volume—were added. By 1923 it was simplified to three areas—plane and colour, volume and space, space and volume—dealt with by means, respectively, of painting and graphics, sculpture and three-dimensional construction, and architecture. Though the strands varied during the life of the School, the important point is that students in their first year studied all of them. Thus any one student would have studied the representation of surface, the properties of graphic elements, the structure of three-dimensional bodies and the relations of tensions in materials, and the definition and transformation of space. In the second year a choice was made, so that a student following metalwork, woodwork, sculpture, or ceramics would choose volume and space. Even then too narrow a specialism was impossible, as teaching and assessment were collective, and allotted according to the task in question.

Constructivism in the new Soviet Union must by no means be directly equated with Sculpture. Indeed the departments of Painting and Sculpture were notable in not reflecting Constructivism in their individual teachings, and concentrating instead on traditional figuration, especially after 1923. On the other hand, a 'Constructivist' training could produce non-Constructivist results, notably monumental realist sculpture. Though Architecture might have been best suited to absorbing Constructivist principles, this department split in two to cope with divergent possibilities. Constructivism was thus much more easily able to infiltrate Ceramics, Graphics, or Textiles. This diversification means that we have to be careful to leave the story

of Constructivism before it departs too radically from our own history of sculpture.

Industrial production

The area of production was one which both compelled and vexed the committed abstract artist, a vital area in both conceptual and practical terms. The production line was the end for which the well-thought-out object was destined, and the production line would reveal its flaws and strengths. We see therefore how its stages and vocabulary were fitted to the new art: the analysis of the object, testing the prototype, establishing the standard. As a Bauhaus student, Annelise Fleischmann, put it in 1924: 'The good object can offer only one unambiguous solution: the type.' Ultimately however it was the artists who found themselves tried by their commitment to the production line, only rarely able to enter into a mutually satisfactory relationship with the factory. For their enemies, right and left, this commitment represented their Achilles heel.

Mass production had ignited powerful aesthetic and social debate before the war. Did its compelling economic logic necessarily bring about a fitness for purpose which involved both function and form? The Werkbund came to grief in 1914 when Muthesius attempted to have his ten-point 'Typisierung' adopted as policy. Believing that the establishment of objective 'types' would ultimately protect the artist, he encountered opposition from those who believed instead that standardization would smother creative individualism. Many in both Germany and the Soviet Union were impressed—even entranced—by the wonders effected in practice by the efficient production line, as demonstrated in America, and in theory with the production engineering studies published by F.W. Taylor in 1911 which became known as Taylorism. After the war standardization was accepted as the inevitable result of machine-production.

In Russia it had become clear to the Constructivists by early 1921 that to differentiate themselves from those who still felt that Construction could be realized within the medium of painting, they had to insist that Constructivism had not only a fully material realization, but also a utilitarian purpose. By the autumn of 1921 INKhUK was moving to establish better links with VKhUTEMAS. The Constructivists' careful plotting of a path which engaged both art and technology necessarily discarded 'the applied arts' as an irrelevant concept. Osip Brik produced a manifesto which marked the subsuming of Constructivism into Productivism; it was signed by 25 members of INKhUK who probably included Rodchenko, Medunetskii, the Stenberg brothers, Stepanova, Ioganson, and Gan. In 1922 Gan published *Constructivism*, in which he argued that the movement was ready to replace art, and had to be accepted because art belonged to the

past, while Constructivism—the product of industrial culture—was waiting to be harnessed. His arguments are holistic: Constructivism is both formal and political; tectonics reveal Communism as they reveal the proper use of material; *faktura* concerns a total approach to material, not just one aspect; and construction disciplines 'the formation of the conception through the use of the worked material'.

Whatever the discipline, the 'object' represented both the starting point and the aim. Constructivism is sustained by the belief that abstraction—its analytic processes and synthetic result—offered new and better solutions to the practical problems of life. Analysis and synthesis were frequently couched in terms of the object, though the very aspirational nature of Constructivism means that much of its formal language was developed in terms of the drawing [**108**] and the model. The finished 'object' is rare, perhaps not wholly surprisingly if we remember its important theoretical status. The Constructivists' stated aim was not the beautiful object but the 'consciously made object'. Indeed, in their analysis of the ratio of production time to useful time, it was the easel painting which epitomized the 'object without function'.

In 1921 Tatlin had launched the slogan 'Let us create new objects through the discovery of material laws!' In Petrograd he set up a section dedicated to the construction of the object (Material Culture) within

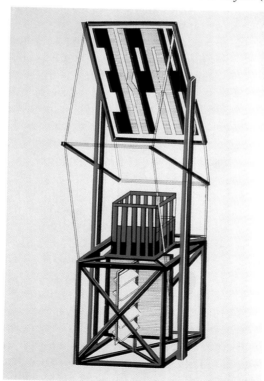

108 Gustav Klutsis
Design for a screen-tribune-kiosk for the Fourth Congress of the Comintern and the Fifth Anniversary of the October Revolution, watercolour and ink on paper, 24.6cm, 1922

Workers' Club, Exposition
Internationale des Arts
Décoratifs et Industriels
Modernes, Paris, 1925

In his letters to Varvara
Stepanova, Rodchenko
described his work on the
various Soviet sections in the
Exposition, and, when it was
finally ready, expressed his
delight with his Workers' Club.
'It is so simple, so clean, so
clear, that one has a natural
disinclination to let it get dirty
... all shiny gloss paint, lots of
white, red and grey ... Every
day Russians come and read
the journals and the books,
even though a cord is across
the entrance.' The furniture
was executed in Paris; it
included tables and chairs,
mobile shelves and show-
cases, a noticeboard and
lamps, demountable furniture
for meetings, and screens for
images and for text, though
other elements were not
realized. It was intended to
offer the scheme to the French
Communist Party after the
Exposition finished.

the Museum for Artistic Culture which pursued a methodical research programme over the succeeding years. In 1923 Tatlin reported that the research team had presented projects in the Museum, developed 40 samples of standard colours, and produced models for pans and clothing. By that time the programme was defined as research into the construction of the utilitarian object in the past, and then into materials and techniques for the development and standardization of new objects. The methodology involved the analysis and comparison of objects, materials and methods of production, single and serial, both past and present, Soviet and foreign.

In his object-based work Tatlin had effectively stopped making art. Though El Lissitzky remained a Suprematist, whose work instead aimed at establishing equivalences between different kinds of objects, including art, he provides us with a lucid exposition of the principles which lay behind the object: 'Every organized work—whether it be a house, a poem, or a picture—is an "object" directed towards a particular end, which is calculated not to turn people away from life, but to summon them to make their contribution toward life's organization.' This passage comes from the editorial of the eclectic magazine which Lissitzky and Ilya Ehrenburg launched in Berlin in 1922, *Veshch'/Gegenstand/Objet*, its title going some way to revealing both the importance of the object but also the much looser interpretation assigned to it within El Lissitzky's internationalized constructivism.

By 1922 Gropius had moved away from the reclusive craft aesthetic which characterized the early Bauhaus to embrace the force of economic and industrial argument. This was made clear in his 1923 lecture, 'Art & Technology, a new unity', which also gave its title to the School's exhibition that year. (Though Gropius had moved from a medievalizing socialism to a more 'realistic' industrialism, the divisions of the Bauhaus which were actually most successful in the market, the textile department and the ceramics department run by Gerhard Marcks, were closest to the original founding principles.) In Gropius's 1926 text on Bauhaus production he defined an object in terms close to those of Constructivism: 'The nature of an object is determined by what it does. Before a container, a chair or a house can function properly its nature must first be studied, for it must perfectly serve its purpose; in other words it must function practically, must be cheap, durable and "beautiful".' He went on, 'The Bauhaus workshops are essentially laboratories in which prototypes suitable for mass production and typical of their time are developed with care and constantly improved. In these laboratories the Bauhaus intends to train an entirely new kind of collaborator for industry and the crafts who has an equal command of technology and design.'

By 1928 Rodchenko, who in Dermetfak represented an unusually constant factor within the changing milieu of VKHUTEMAS, had defined his seven tasks for the student as follows:

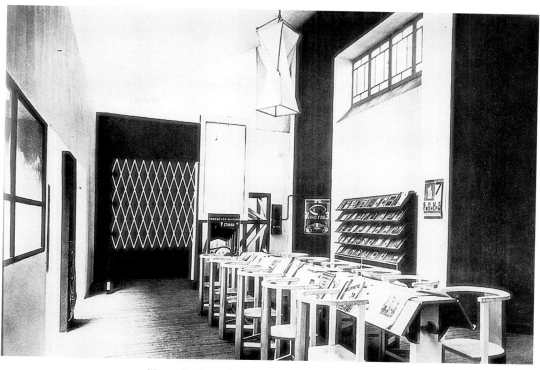

1. The selection of ready-made objects
2. The simplification of goods already in production
3. The elaboration of these
4. The creation of a new variant
5. Proposals for an entirely new product
6. Designs for a complete set of goods
7. Design for furnishing a complete building.

Apart from the ideological problems inherent in Russian Constructivism, it was not easy to realize projects in a country where industrial production had dropped by two thirds between 1914 and 1921. There were insufficient financial funds for any object to be tested on the production line, but though no objects went into mass production, Constructivist prototypes did embody design-solutions deriving from an analysis of the needs and circumstances of production, as embodied in Rodchenko's 'Workers' Club' [**109**]. Constructivism was accorded increasingly impoverished status among the various artistic positions which emerged in the Soviet Union in the 1920s. The proletarian organization, Proletkult, had been brought under government control by 1920. By the early 1920s the government was less willing to support artistic trends other than realism, and Constructivists found themselves up against both capitalism and academicism. The growing possibility of conceiving Production Art as separate from Fine Art allowed the state to support each in different ways, which meant that

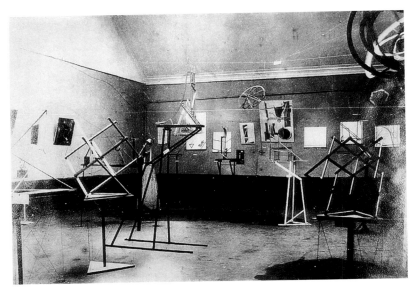

Constructivism was denied the role of effecting their integration. By the 1930s, in architectural competitions, the Constructivists increasingly fell by the wayside in favour of a new classicism expressed in bulk, scale, and permanence, the visual opposites of Constructivism. Moreover, the growing possibility of conceiving Production Art as separate from Fine Art allowed the State to support each in different ways, which meant that Constructivism was denied the role of effecting their integration. One can identify a rekindling of the debate about the relationship between art, production, and the proletariat in the late 1920s. Encouraged to return to the rigour of the old debate, the October (Oktyabr') group emerged out of a 1928 conference on the 'Tasks of the Artist', insisting on their belief that the spatial arts could survive only by serving the concrete needs of the proletariat. In 1930 Hannes Meyer arrived in Moscow with a group of students after his dismissal from the Bauhaus. Meyer had declared, 'I am going to the USSR in order to work where a truly proletarian culture is being forged', but in the years after his arrival the plurality, however unstable, of the 1920s was brought to a close by the monolithic hierarchy as imposed by Stalin in 1932 with the dissolution of independent artistic groups, and the subsequent articulation and imposition of Socialist Realism.

Laboratory work

In the light of difficulties with the production line, much of the work that was actually realized was presented as 'laboratory' work, that is, an as-yet unique object conceived as part of a production process with ultimately utilitarian ends. Some items were finished and functional; all that was lacking was their production. These were the prototypes. Other work appeared under a more non-utilitarian (even aesthetic)

111 Konstantin Medunetskii

Spatial Construction, tin, brass, iron, aluminium, 45cm, 1920

112 Katarzyna Kobro

Spatial Composition 4, painted steel, 40cm, 1929

aspect, but was defined as laboratory work to indicate its ultimate relevance to functional tasks. Thus laboratory work should be seen as another manifestation of the synthetic approach, combining art, craft, and industry in its conception, and often bringing together artists from quite different backgrounds.

Perhaps Tatlin's 1920 'Tower' might usefully be seen in this context: a 1:80 scale model for the 'Monument to the Third International' embodying a synthesis that Tatlin described as 'simultaneously architectonic, plastic, and painterly', designed to accommodate a range of functions both spatially and symbolically. Tatlin's model, measuring around 5m high, represented a structure 400m high, enclosing, on three storeys, 'three great rooms of glass' for legislative assemblies, executive bodies, and information services. Each storey was to rotate at a different speed, from one revolution a year, through one a month, to one a day. In his article 'The Work Ahead of Us' Tatlin declared that he had been attempting to rebuild a homogeneous foundation for the craft. By bringing painting, sculpture, and architecture together, he believed that one could avoid the individualism of earlier creation. Then he explained how pictorial work since 1914 had provided his material basis. More complicated investigations in 1917, into material combinations, movement and tension, and in 1918 into iron and glass—'the materials of modern Classicism'—had led to the unification of artistic forms with utilitarian ends, as exemplified by this project. Though it was important that the model was understood to represent steel and glass, it was fabricated in wood. The significance of synthesis is evident from the fact that in 1919 a collective was set up within the Soviet Department of Fine Arts to deal specifically with 'Sculptural and Architectural Synthesis', later expanded to include the Painterly. The fact that the 'tower' became both the problem and the solution, in terms of investigating synthesis, is demonstrated by its prevalence in this group's enquiries. The tower could represent the synthesis of disciplines, of materials and properties (light, air, and energy), and of functions. Its material make-up and function also allowed the tower to fuse with the fabric of the city, representing the place which politics provided for art within life.

A 1921 exhibition which has become famous from documentary photographs [110], that of the Society of Young Artists (овмокhu), has also to be understood in the context of laboratory work. The constructions of Medunetskii [111], Ioganson, and the Stenbergs which formed part of this show have formal links with the constructed work of Naum Gabo and Antoine Pevsner, but were presented as laboratory studies for the task ahead. The Society was explicitly founded to take production tasks forward, and had come together out of the shared experiences of decorating the streets of Moscow for the May and

October celebrations. Their light-weight open-work structures, like cranes or scaffolds, are indeed echoed in the stands and kiosks designed by Gustav Klutsis [108] (two of which were actually erected for the Fourth Congress of the Comintern in 1922), and in Constructivist theatre sets. We might make the same link between Rodchenko's collapsible 'Spatial Constructions' (five of which were also in this exhibition) and the furniture for his Workers' Club of 1925. Formal experiments feed into and are fed by practical circumstances: the need to economize with material, to find elegant engineering and space-saving solutions, and to provide portable and flexible structures informs the bulk of the work which was produced by Constructivism.

At the 1922 Düsseldorf Congress of International Progressive Artists Van Doesburg attacked the concept of an exhibition ('the warehouse') as an end in itself, proclaiming that '... the only purpose of exhibitions is to demonstrate what we wish to achieve'. Gropius had realistically admitted, when asking Schlemmer to execute a mural scheme for exhibition in their own Bauhaus building, 'Here, for the want of bigger tasks, painting and sculpture have an opportunity to display themselves and to work in collaboration with each other.' The 'bigger tasks' were indeed significantly lacking, even in Weimar Germany. Their exposition was carried out in model form and, all-importantly, on paper, in drawing and in writing. In an article of 1925, El Lissitzky likened Soviet Russia to France after the Revolution: 'Most ideas then, as in Russia now, remained on paper, which is why they are known as "problems".'

Though less strictly tied to the term 'laboratory work', other manifestations might be considered within this context. The models which Van Doesburg elaborated in Weimar with his students, and the joint models which he and the architect Van Eesteren showed in Paris in 1923, were described as demonstrating 'the will to materialize in architecture the ideal aesthetics established by the "liberal" arts' [102]. Their interlocking cubes around a central core are reminiscent not only of the sculpture of one of their De Stijl colleagues, Vantongerloo, but also of similar exercises undertaken at the Bauhaus.

Such exercises might be compared to the sculpture of Katarzyna Kobro (who left Russia for Poland in 1922) which, although not expressly utilitarian, was conceived as a parallel for architectural organization [112]. Kobro believed in the 'mutual exchange between the plastic arts and those of building'; in art as 'the organizing factor in life'. She held a similar view of the 'Architektons' which Malevich was making after 1919, first in cardboard, and then in plaster [106]. Though ideal rather than actual, these studies were nevertheless pertinent in terms of their organization of planes and volumes, fusing internal and external features so as to abolish the façade and thus dispel traditional architectural hierarchies. Though this was

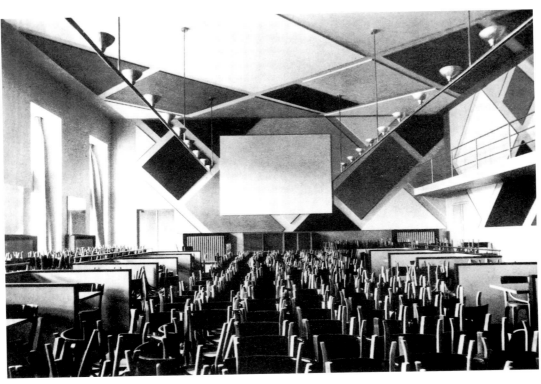

View of model room proposed
for Greater Berlin Art
Exhibition, 1923, reproduced
in *L'Architecture vivante*, 1924

Interior of the Aubette
building, Strasbourg, 1928
The refurbishment of one
wing of the enormous old
Aubette building was offered
as a commission to the Arps
(Michel Seuphor always
maintained that it was Sophie
alone who was invited at first)
by Paul and André Horn
(who had connections with
old family friends) and
extended by them to Van
Doesburg. Hans Arp took
the floor of the hallway, foyer
bar and dance hall in the
basement (Caveau Dancing)
and the staircase; Sophie
Taeuber-Arp the Tea Room,
Patisserie and Dance Hall
Bar; Van Doesburg the Café-
Restaurant and Brasserie,
first-floor salons and mural
decorations of the
Cinema–Dance hall. Ten years
after its inauguration the
whole scheme was destroyed
in a subsequent
refurbishment.

definitively fine art, many wished to read it as instructive for actual urban planning.

Collaborative work

Beyond the laboratory, in what form do we encounter realized manifestations of the synthesis? In the synthetic work of one artist, or in the collaborative work of a team? The latter is probably easier to identify, perhaps because of its very imperfect resolution. Architects did work with painters and sculptors, but the results were not so very different to those achieved with equal anxiety at the turn of the century. To identify such schemes, we have recourse to the limiting categories of the traditional 'professions', identifying the 'visual artist'—Van Doesburg, Vilmos Huszàr, Hans Arp, Sophie Taeuber, Oskar Schlemmer—at work within an interior designed (very often at an earlier date) by another architect. Even when the visual artist might, at times, be defined as a sculptor, this hardly gives a sure grounding on which to identify 'sculpture' within the collaboration. One such project, between Van Doesburg and the architect J.J.P. Oud for blocks of housing in Spangen, fell apart when Oud rejected his partner's schemes. Oud acknowledged that the architect must make room for the painter and sculptor, but refused to let his architecture be overwhelmed by their contributions. The results of 'collaboration' were often little more than superficial, the fundamentally additive work which had long been a cause for complaint.

The De Stijl aesthetic could on occasion engender successful teamwork across the disciplines, like that between Gerrit Rietveld and Vilmos Huszàr. Van Doesburg's commentary in a 1919 issue of *De Stijl*—on what was to be Rietveld's 'Red Blue Chair', but which was, at this point, still unpainted—helps us to understand something of the definition of 'sculpture' within the Neo-plastic environment. 'Through its new form, the furniture gives a new answer to the question of what place sculpture will have in the new interior. Our chairs, tables, cabinets and other objects of use are the (abstract–real) images of our future interior.' Sculpture was there but not there, represented in the form of items given other names such as 'furniture' and in the relationship between those items. Particular pieces by Rietveld—such as the 'Berlin Chair' and 'End Table', and the 'Child's Cart' and 'Wheelbarrow'—may thus be understood as sculptural exercises in colour, as well as components for environments as a whole [113].

Much collaboration took the form of mural intervention. Though the aim was spatial transformation, the means were painterly. Van Doesburg and Huszàr designed colour solutions for pre-existing buildings which used the different walls as so many free-floating planes, or worked against them, cutting across rectangular boxes with dynamic diagonal colour compositions. Arp and Taeuber invited Van

Doesburg to join them in their commission to refurbish the Aubette [114] in Strasbourg, a rare occasion for Van Doesburg to try out ideas which normally remained on paper. The artists apportioned the various rooms between them, while the hallway, stairway, foyer-bar, and billiard-room were executed jointly, by means of tiled floors, murals, and stained glass, using coloured materials such as synthetic leather, linoleum, glass, enamel, nickel, and aluminium. But this project, despite its scale, only taught Van Doesburg 'that the time is not yet ripe for an "all-embracing creation"'. His conclusion was to relinquish architecture, and applied arts, in favour of a '100% art'. The '100% art' was fine art.

In 1922 Oskar Schlemmer had talked of 'a yearning for synthesis [which] dominates today's art and calls upon architecture to unite the disparate fields of endeavour'. His concentration on the interaction of concave and convex elements was developed in the form of semifigurative relief sculpture. The programmatic recognition across the Bauhaus that relief sculpture fulfils its function in relation to architecture was demonstrated by Gropius's asking Schlemmer to design a mural scheme for the vestibule of the Weimar Bauhaus building on the occasion of the 1923 exhibition. Though Schlemmer was greatly enthused by the possibility of combining painting and sculpture within the architecture, his results seem tame, and hardly a radical

115 Bauhaus Curriculum

collaborative project across the disciplines [**115**]. The scheme might more justly be defined as collaborative in terms of its representing the mural and sculpture workshops which Schlemmer directed, employing the skills of Werkmeister Josef Hartwig and the student Joost Schmidt [**105**]. Most of Schlemmer's energies at the Bauhaus were directed towards the stage, perhaps a recognition that this was the arena which offered the best chance for real collaboration and transformation.

Theatre

Theatre design employed two- and three-dimensional work, painting, sculpture, and architecture. It required teamwork not only in its elaboration, but also in its animation. Many of the artists we have encountered above—Huszàr, Taeuber, Schlemmer, and Mondrian—engaged with theatrical space and, notably, the marionette theatre, but nowhere saw such sustained development as the Soviet Union, particularly in the productions of Vsevolod Meyerhold.

In 1921 Meyerhold saw the $5 \times 5 = 25$ exhibition and judged the artistic projects, by Exter, Popova, Stepanova, Rodchenko, and Vesnin, as 'quite feasible within the confines of theatrical performance', and particularly suited to his own circumstances, thereby defining their purpose as utilitarian rather than aesthetic. He invited Popova to join his workshop and it was she who, overcoming an initial reluctance to engage with a possibly decadent art form, helped the stage to become part of the Constructivist arena. The stage allowed planes to exist both volumetrically and pictorially. Certainly it was to the theatre, rather than the street festival, that Constructivist artists were able to transfer their spatial constructions and counter-reliefs from the gallery with real and sustained success.

Constructivist stage decor was built rather than painted, the prop rather than the backdrop. Theatre made similar demands on its 'props'

116 Varvara Stepanova

Acting Apparatus for Meyerhold's production of Sukhovo-Kobylin's *The Death of Tarelkin*, 1922

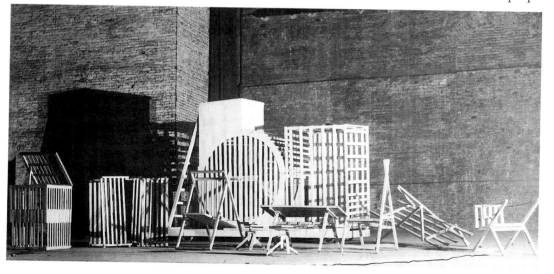

as the temporary exhibition or event: economy, easy storage and transport, mobility, flexibility, pictorial effect. It would appear that the Constructivist designers made a conscious effort to produce an environment which would mirror the play's direction, so that meaning and gesture would synthesize with their surroundings. Popova's designs for Meyerhold's production of *The Magnanimous Cuckold* (1922) reflect the director's 'biomechanics' or schematized gestures. In their next co-production, *The Earth in Turmoil*, Popova's use of the everyday object as prop reflects the wider contemporary move towards reportage (or 'factography'). Stepanova's design for Meyerhold's production of *The Death of Tarelkin* [**116**] made a similar effort to reciprocate the directorial intention. Her designs were for objects rather than a set, and photographs convey a primarily sculptural presence on the stage. Their multi-purpose nature was not easily mastered by the actors, but Stepanova believed that here she 'finally succeeded in showing the utilitarian content of spatial objects'.

Schlemmer's dance-dramas developed the choreography of his paintings, in which simple figural gestures—standing, coming, going, turning—rhymed with each other across the pictorial space. He intended his 'spatially-plastic costumery' to fuse with the 'apparently violated body'. The costumes for his 'Triadic ballet', in wood, cardboard, plaster, glass, metal, and fabric, were developed out of the Bauhaus sculpture workshops. He talked of 'the human figure, [who] plucked out of the mass and placed in the separate realm of the stage (the picture), is surrounded by an aura of magic', which suggests that we might see him using the actor as an object. The 'Form Dances' developed in

117 Oskar Schlemmer

Bauhaus Dances: Delineation of Space by a Human Figure, danced by Siedoff, Dessau, c.1927

Even before the war Schlemmer had been involved in theatre, echoing contemporary interests in Dalcrozian movement and Kleist's famous essay on marionettes (1810). After the war he returned enthusiastically to rehearsing his ballet, and became so involved in three theatrical productions that he could not immediately take up his appointment to the Bauhaus in 1920. The Dessau Dances made explicit the importance of the basic relationship between the dancer and the 'architectonic–spatial organism' by means of cage-like wire and rope delineations which 'locked' the dancer into position and represented his or her extension within the spatial box.

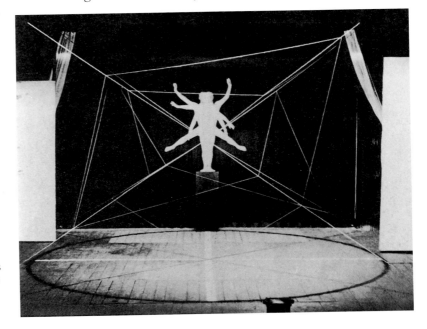

Dessau simplified the costumes, and made use instead of basic props, poles and balls, to represent the body's penetration of space [**117**]. Like Gropius, Schlemmer regretted the lack of building opportunities in post-war Germany; for him 'the illusionary world of the theatre offers an outlet' to modernist architects, and was delighted that the move to Dessau meant that the Bauhaus finally acquired a stage.

Exhibition technique

Like the sculptors discussed in Chapter 1, abstract artists made good use of the vehicle of the World Fair and the Trade Exhibition. Temporary exhibition stands introduced wide-ranging possibilities. Piet Zwart's 1921 'Stand for a Celluloid Manufacturer' [**118**] prefigured both El Lissitzky's 'Proun Room' for the 1923 Greater Berlin Art Exhibition [**121**] and Huszàr's collaboration with Rietveld at the same event. As Klutsis realized early on, the task was to organize the best presentation of information: information variously mediated by photography, graphics, radio, and cinema. Their multi-functional purpose informed the design of his stands, and thus reinforced their message. Constructivist artists had their designs incorporated into Russian exhibitions—the 1923 All Union Agricultural Exhibition featured pavilions and kiosks—and were also exhibited abroad, for instance in the 1925 Exposition des Arts Décoratifs et Industriels Modernes.

In 1918 Le Corbusier had been asked to make a presentation to the Ministère de l'Instruction Publique about the training he had developed in the regional art school at La Chaux-de-Fonds. His audience, a committee charged with meeting the German challenge and ultimately responsible for the 1925 Exposition, comprised members of the three principal applied art societies, many of whom, like Hector

118 Piet Zwart
Design for an exhibition stand for a Celluloid Manufacturer, ink and gouache, 45.7×64.7cm, 1921

City in Space, Exposition des
Arts Décoratifs et Industriels
Modernes, Grand Palais,
Paris, 1925

For the Paris Exposition,
the Austrian Commissioner,
architect Josef Hoffmann,
asked Kiesler to design a
structure to display some of
the theatrical material shown
in Vienna. In the Grand Palais
Kiesler built a 'system of
tension in open space' which
he called his 'City in Space'.
He then travelled from Paris
with 40 crates of material
to open his 'International
Theatre Exposition' in New
York. Success led Kiesler to
be hopeful about a future in
America; he was a founder
of the American Union of
Decorative Artists and
Craftsmen (AUDAC) and
his 1929 book, *Contemporary
Art Applied to the Store and
Its Display*, exercised
widespread influence, but
architectural opportunities
were relatively limited.

Guimard, had a background in Art Nouveau. Despite, or perhaps be-
cause of, its long genesis (going back to at least 1907), the Exposition
was to please few sectors of the professional community. Financial prob-
lems forced various compromises upon the organizers, 'Industrial' was
added to the 'Decorative Arts' of the title, but neither traditional nor
modern craftsmen were satisfied. The show was a lost opportunity for
effective change. Le Corbusier's Pavillon de l'Esprit Nouveau, nestling
in the shadow of the Grand Palais, nevertheless attracted attention for
its modernity. It may well have been Le Corbusier's grounding in the
'Salon' tradition outlined above, in which harmoniously grouped ob-
jects effected an overall ensemble, which made his pavilion appear so
'modern' in the eyes of the French public. Much of its supposedly
standardized inventory, 'ordinary' everyday objects, had actually been
specially commissioned or altered to build up the synthetic 'effect'.

The Soviet Union made a striking impression at the 1925
Exposition. Konstantin Melnikov's pavilion was probably the most
radical building there, and the other exhibits combined to give the
West the first contextualized account of Russian Constructivism.
Stepanova's mini-models for stage decor were also on show, as was a
smaller, simplified model of Tatlin's 'Tower'. Dermetfak exhibited de-
signs for a reading room and a workers' club, and exhibits from the
vkhutemas training courses attracted a number of prizes. The Basic
Division took the only prize awarded in the methodological section.
Rodchenko's Workers' Club was, though in exhibition form, one of the
few fully realized examples of Constructivist interior planning and
revealed a much more holistic approach than Le Corbusier's. Though
Constructivism was now at last shown as an all-embracing political
and cultural vision, and one whose form was derived from the real de-
mands of 'modern life', little more than its look was really assimilated
by a Western public dazed by the fairground architectures of the
Exposition site.

Frederick Kiesler's electro-mechanical montaged backdrop for
Karel Capek's *R.U.R.* (Berlin 1923) led to his being invited to join De
Stijl. The exhibition he arranged the following year in Vienna—
Internationale Ausstellung neuer Theater-technik—brought him
international attention. It included an elevated spiral stage (not so dis-
similar to Tatlin's 'Tower') and an innovative L + T installation system
used to display documentation of recent theatrical productions. This
red, white, and black framework might be seen as one the largest built
De Stijl environments, and a demonstration of Kiesler's declaration, in
their magazine, that there should be 'no more walls!' For the 1925
Paris Exposition Kiesler set up an equally striking structure on which
to display the Austrian part of the documentation [119] and then re-
configured the material for a large exhibition in New York. In America
Kiesler's embrace of organicism gradually led him into the Surrealist

movement, as we saw in the previous chapter, but he retained the flexibility and transparency of the display systems he had developed within Constructivism. All his work revealed his concern for both a 'continuity' within the interior—abolishing the breaks between ceiling, wall, and floor—and a 'correalism' in the object's relationship with the exterior. Kiesler had moved from theatre to architecture via the increasingly autonomous category of exhibition design. The shift made good the absence of the 'original object', now represented by means of documentation given presence by the form of its display. It was by means of the theatre and of exhibition technique, including

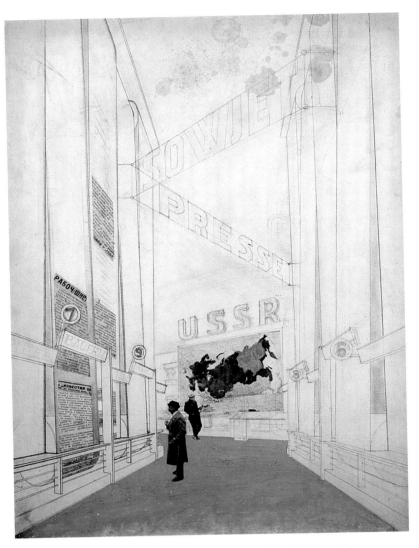

commercial window display, that Constructivism's formal legacy was most readily disseminated.

In the absence of the finished Soviet product, but in the presence of a strong 'message', Constructivism saw itself harnessed to developing the means and methods of display. El Lissitzky was especially effective in this, and his designs for artistic and industrial exhibitions were mutually influential. In both he sought to make the spectator an active participant in the exhibition space, and in this his work develops a similar sentiment to that expressed by Schlemmer in 1924, when he described 'sculptural quality' as a 'temporal succession of vantage points'. This was a moral as well as an aesthetic position, with ties to the involved contractual (and codified) behaviour of the church-goer as well as the street activist.

121 Lazar El Lissitzky

Proun Room for the Greater
Berlin Art Exhibition, 1923,
reconstruction, coloured
wood, 3m square

El Lissitzky's designs for the exhibition installation of abstract art-
works at Dresden (1926) and Hanover (1927-8), and for the Soviet Press
and Fur pavilions at the International Pressa Exhibition in Cologne
(1928) [**120**], and the Fur Exhibition in Leipzig (1930), were innovative
and effective demonstrations of the use of shifting background and
alternating focus for different exhibits. In this we might well discern
El Lissitzky's background in typography, in which elements are used in
space, and whose reader scans the book spread by spread. He described
his plan for Dresden as 'a showcase, or a stage, on which the pictures
appear as actors in a drama'.

Architecture as synthesis

In 1920 El Lissitzky had defined his 'Prouns' (literally 'projects for the
establishment of a new art') as 'the interchange station between paint-
ing and architecture' [**121**]. In a text later published in *De Stijl* he
explained, 'Proun begins as a level surface, turns into a model of three-
dimensional space, and goes on to construct all the objects of everyday
life.' In 1930 he went further: 'Painting was thus superseded and gave
way to pure volumetric formation. The architectonic character of this
stereometric formation was immediately understood. Thus painting
became a transfer point for architecture.'

Many argued, and would argue, that architecture represented, in
itself, the synthesis of the arts. Does this mean that we might discern
that synthesis by looking at contemporary architecture? Or does
successful synthesis lie in the fact that it cannot be pulled apart? We
have seen how compromised were the efforts of painters and sculptors
who tried to work within architecture's givens. Rather than fixing on a
building project that might have been designed by a visual artist (say,

Georg Muche's Haus am Horn for the 1923 Bauhaus Exhibition, or Taeuber's house in Meudon), we need to look at the buildings designed by architects, and ask whether they reveal the influence of contemporary 'laboratory' work.

Gropius had described Muche's Haus am Horn as 'the best distribution of space in form, size and articulation'. In that year's essay on 'The Theory and Organization of the Bauhaus', he posed the question which we pose ourselves: 'The objective of all creative effort in the visual arts is to give form to space ... But what is space, how can it be understood and given form?' Katarzyna Kobro put it another way when she asked, in a 1929 text, why there were very few modern sculptors. 'Are there material reasons? or is it because sculpture is nowadays too directly involved in architecture, so that each truly modern architect must be a good modern sculptor?' We might transpose her question to ask whether all good modern sculptors manifested themselves in architecture.

At the Greater Berlin Art Exhibition Mies van der Rohe showed drawings for a 'Concrete Country House' and a 'Brick Country House'. These centrifugal plans presented a non-hierarchical distended space most reminiscent of De Stijl paintings. In his 'House for a Childless Couple', for the 1931 Berlin Building Exhibition, Mies was able to give three-dimensional form to the free-flowing spaces expressed in the earlier drawings. Once again we see the exhibition affording the architect a showcase for the demonstration of formal principles; in the case of Mies, zones offering the choice of movement, transition, or quiescence by means of richly demarcated colour, light, and texture.

By the late 1920s this very concern with differentiation had led Mies away from social architecture to the luxury interior. We can find simpler, and earlier, examples of the crossover between sculpture and architecture such as Rietveld's Schröder House (1924) in Utrecht [103], Gropius's Bauhaus building and masters' houses in Dessau (1926), Alexander Vesnin's Leningrad Pravda Building (1924), as well as Melnikov's 1925 Pavilion. In addition to further German examples we might add Aalto in Finland or Neutra in America. It is not hard to identify here the economical study of the best organization of materials, the interpenetration of vertical and horizontal planes, the transparency resulting from the merging of exterior space with interior, as expressive of an approach in the spatial arts which, though sculptural, finds its fullest expression in architecture. Much of this was made possible by new materials and building technologies, the strength and firmness of minimal joining elements allowing for open, light and airy spaces.

In their canonic text, first published in 1932 as *The International Style: Architecture since 1922*, Henry-Russell Hitchcock and Philip

Johnson described a style which Alfred Barr, in his preface, summarized as 'emphasis on volume: space enclosed by thin planes or surfaces as opposed to the suggestion of mass and solidity; regularity as opposed to symmetry or other kinds of obvious balance; and, lastly, dependence upon the intrinsic elegance of materials, technical perfection and fine proportions, as opposed to applied ornament'. Though their book was entirely made up of architectural examples the parallels with sculpture are easily found.

Despite its name, the Bauhaus did not have an architectural department until 1927, when Gropius invited Hannes Meyer from Switzerland to establish it. After Meyer took over as Director, architecture moved to become more than just the symbolic synthetic aim for the school. Most workshops were now subordinate to an over-arching department which was divided into building theory and practice, and interior design. Though Meyer's successor, Mies van der Rohe, might be seen as his opposite in many ways, he intensified the shift towards a school of architecture, in which there were simply two divisions: exterior building and interior design. This must lead us to ask, did synthesis lead inexorably to architecture?

Retreat and regroup

In 1930 the Werkbund was invited to Paris to exhibit at the Société des Artistes Décorateurs; Gropius used his ex-Bauhaus colleagues—Breuer, Bayer, and Moholy-Nagy—to deliver a presentation which provoked distinctions similar to those made at the beginning of the century, setting the French 'objet d'art' versus the German 'objet d'usage'. Another popular interpretation, which saw the restrained functional nature of the display as a sign that the Germans were moving away from the colossal towards a more modest and egalitarian art, was unfortunately misplaced.

The Bauhaus had moved from Weimar, and then from Dessau, when the National Socialists took power in the local elections. When, in 1933, the Nazis closed the much-reduced Bauhaus in Berlin, there was nowhere left in Germany to which Mies could relocate. The Bauhaus had lasted as long as the Weimar Republic. Its closure suddenly made the Bauhaus famous abroad, and famous as a symbol of the left, despite Gropius's long-held apolitical position. Works we have discussed were among the many artworks censored by the Nazis: Schlemmer's two monumental mural projects—Weimar, and that of 1930 which surrounded Minne's fountain at the Folkwang Museum in Essen—were removed in 1930 and 1933 respectively, as was El Lissitzky's gallery for the abstract department of the Hannover Landesgalerie. A more obvious target was the monument to the Communists Rosa Luxemburg and Karl Liebknecht, designed, almost 'accidentally', by Mies van der Rohe in 1926. Nevertheless, it would

be wrong to see Nazism as the 'end' of modernism; on the one hand functionalism was already riven with internal contradictions by the end of the 1920s, while on the other, its mode and form were used in much of the lower-profile, non-domestic building projects of the Third Reich.

Bauhaus artists were only some of the many who fled Germany and central Europe after 1933. The Soviet Union offered a more complex position. Though some artists had despaired of conditions for creative production as early as 1922, others stuck it out. Even after the definitive clamp-down as represented in Stalin's 1932 Decision 'On the Reconstruction of Literary and Artistic Organizations', some artists found a niche in which they could work. Tatlin, for instance, went on to design over 80 theatre productions, Rodchenko to pursue photographic reportage, Lissitzky to design for Soviet exhibitions until his death in 1941.

Bauhaus work had been exhibited in the United States since the 1920s. In 1938 the Museum of Modern Art commissioned three of the artists who had now made their homes in the States to produce the authoritative 'Bauhaus 1919–1928'. Its legacy was more forcibly preserved in the form of the new courses which were now established by, among others, Albers at Black Mountain College, Moholy at the New Bauhaus and Mies at the Armour Institute in Chicago, and Gropius and Breuer at Harvard. The International School came to dominate the American skyline, while in Europe the collaborative ideas imported from central Europe informed the efforts at reconstruction after the war.

Though the gains may have been so few, Constructivist artists did not lose hope, even in the later 1930s, that fine art did have a role to play in the better organization of real life. This view is well represented by Katarzyna Kobro in 1936:

Nonfunctional art produces beautiful paintings, sculptures, architecture. Those works of art do not unite with life into an organic whole, because the life in which we have been and are still living, has been directed to drain out maximum profits and to produce welfare for individuals. Those aims, called 'practical' but actually antisocial, have neglected both the human needs and the necessity continually to supplement the store of energy of a man, exhausted by the struggle for survival. The result [is that] art, instead of being the organizing factor in life, becomes a factor of illusions and dreams.

The Figurative Ideal

7

Sculptural production has largely been premised upon the form of the human figure, which we have already seen appearing as the vehicle for allegorical decoration, commemoration, material innovation and Surrealist symbolism. But I propose in this chapter more particularly to look at the figure as an ideal in itself—an ideal which represented a possible 'answer' for sculptors—and as a solution that moved from being primarily formal to being primarily symbolic.

The period before the Second World War was to see a new weight of meaning associated with, or imposed upon, figurative sculpture. Within the space of one generation, Europe had experienced two world wars, each ushered in by the rise of nationalism. The totalitarian regimes which took hold in the inter-war years each, in different ways, linked the figure with an official imagery which was often realized in the medium of sculpture. Thus, in this period especially, the figure carried an ideal beyond itself, representing an 'other' dependent on the circumstances of its production. The figure was used in national contexts with claims for universal meaning. Nationality was reinforced by looking backwards, to a supposedly distinctive past which was in fact an ill-defined Classical Age, an international patrimony to which separate modern nations now wished to claim exclusive lineage. Figurative sculpture represented one of the more tangible links with this past, in the very real form of surviving ancient statuary. Historical subjects and forms invoked a peaceable ideal which was often fundamentally aggressive; the past was a kind of disguise for the present and the future.

Carrying various meanings conflated in its person, the figure may resist attempts at analysis, especially now that we have largely lost our ability to 'read' figurative sculpture. I aim in this chapter to emphasize the need to read the nuances in a vocabulary which is fundamentally meaningful despite its repetition. This can properly be done only by an intensive study of difference: in the case of the human body 'finish' is all, for in representing skin and bone, tone and musculature,

it communicates physical and mental intention. This chapter can instead only attempt a schematization of how we might represent what we find in terms of different combinations of the local, national, and international; of the past, present, and future; and of the private and the public.

After Rodin: the way forward

It is important to recognize that the reaction to Rodin remained firmly anchored in the figurative mode. It is within this mode that we have to discern how problems were identified and rectified. Manship, Meštrović, and Bourdelle were so enthusiastically embraced around the time of the First World War because their work represented the possible way forward for 'modern sculpture'. Though by the 1920s the position their work represented might be seen to have left them marooned in something of an impasse, this is a retrospective reading. Before assessing their terminability, we have to understand their continuity.

Many of the German sculptors who visited Rodin (who might be divided into two waves: those there around the turn of the century, such as Georg Kolbe and Karl Albiker, and those there just before the war, like Ernesto de Fiori and Edwin Scharff) were at the forefront of the reaction against him, and Germany offered an alternative 'master' in Adolf von Hildebrand, whose opposition to Rodin's fragmentation was noted in Chapter 2. Hildebrand contrasted the 'tectonic' (or autonomous) to the architectonic (or site-specific): two ways pertinent to the evolution of figurative sculpture in our period, and particularly so towards its end. Hildebrand considered the latter, the stable relationship of different planes, to be the solution, but it was in autonomous sculpture that others, notably Maillol, found their way forward.

It is proper to speak of Hildebrand, unlike Rodin, as a teacher. His influence was associated with Munich, where he worked after returning from Florence, and Munich thus came to represent a restrained and archaizing classicism. From 'Standing Young Man' (1881–4), through the 'Amazon Triptych' to the monumental fountain schemes that occupied him right through the First World War, Hildebrand can be seen to give thought to the setting that will ensure a stable and symmetrical grounding for his individual sculptures [**122**]. Though most of his disciples were German, some were Italian (Arturo Martini went to train with him in 1909, then taking home Hildebrand's influence and transmitting it, for example, to Mirco Balsadella and to Marino Marini, who succeeded him as professor in Monza), and Munich was never far removed from the Italian tradition. Hildebrand's influence lived on in Munich through Hermann Hahn, who taught Ludwig Kasper and Toni Stadler.

The road which led away from Rodin while retaining the figurative subject engages an interesting mix of protagonists and of modes.

122 Adolf von Hildebrand

Der junge Jäger, bronze,
*c.*2m, 1910–20, from the
Hubertusbrunnen,
Nymphenburger
Schlosskanal, Munich,
1895–1919

Within a space which might, superficially, seem rather narrow—occu-
pied principally by the female figure—we find a diverse range of sculp-
tors. This space ties up the avant-garde with the rearguard in such a
way that though we must attempt to distinguish meaning within the
figurative mode, we must be careful not to foreclose on its categories.
Such a crossover is well represented by the remarkable closeness of two
very different sculptors—Jacques Lipchitz and Paul Manship—in
their independent versions (1911 and 1916) of 'Woman with Gazelles'.

It is among those who worked for Rodin that we find some of the
most sustained and subtle attempts to work out of him, notably the
'Bande à Schnegg' associated with the Schnegg brothers. One of their

number, Charles Despiau, worked for Rodin for over seven years before the First World War, and it is clear that his own work can be seen as a considered reaction to that of his master. Despiau attracted admiration from a wide range of artists and critics: Lipchitz was particularly interested in a stable figuration which many saw as a constructive way forward. Despiau's bust, 'A Girl from the Landes' of 1905–9 [123] was repeatedly mentioned as an absolutely key piece. Though it represents the modesty of Despiau's work in subject and scale (he was rarely a monumental sculptor), it was ascribed an importance which suggests a rather grander vision.

In 1908 Matisse described a sculptor in his *Notes* for whom 'composition is nothing but a grouping of fragments', thus concurring with the sculptural establishment in his judgement of Rodin, similarly concerned with the restoration of wholeness to the objects of art. In 1907 Matisse had returned to his own 'Golden Age', the reclining nudes he had already placed at the centre of his paintings, and attempted to give greater wholeness to the figure by modelling it. The clay collapsed before it was finished, but Matisse had arrived at his image, a linear arabesque which encircled the figure, and transferred it into the 'Nu bleu' painting . The clay was later reconstituted and cast as 'Nu couché' and recurs in many of Matisse's paintings thereafter. It gave Matisse a line, his own line, which also described a form.

This wholeness of line is something Matisse could use in conjunction with the more shifting space of his paintings. (Something similar

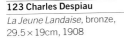

123 Charles Despiau
La Jeune Landaise, bronze, 29.5 × 19cm, 1908

is pursued by Bonnard in his use of the poses of famous classical sculptures.) For others, more exclusively sculptors, the closed profile of the female nude was infinitely satisfying in itself. Under cover of its apparent sameness, the figure is used in markedly different ways. Indeed the close focus given the female nude can be understood as a modernist interest in art for art's sake, removed from the literary symbolism of the late nineteenth century, and, as yet, largely innocent of the political symbolism of the succeeding period. Though Rodin's idiosyncratic genius may have paralysed his admirers, artists were already looking to give stability to the body without jettisoning the 'modern'. This conundrum provoked the use of a figural type sufficiently established in itself to allow sculptors to concentrate on nuances of internal and formal variation rather than on dramatic profile or narrative thrust. Such a framework was provided by the standing female nude, the treatment of which was progressively simplified. By rejecting naturalistic modelling and smoothing out the 'accidental' incident, sculptors were able to focus on the overall relation of forms and volumes. Such a focus was understood to be modern, but also to owe much to the past.

Archaism

Paul Manship admired in archaism the 'power of design, feeling for structure in line, harmony in division of spaces and masses'. When Gaston Lachaise presented his first exhibition in 1918 it was described as 'early-Egyptian, early-Arabian, at least pre-Greek!'. The morphologist Henri Foçillon, writing on Maillol in 1931, described a 'space conceived as a limit [which] is the space of the archaic Greek, of Romanesque art, and of some contemporary sculptors'. All these stylistic attributions were carried by, and recognized in, the treatment of the figure. The period between 1870 and 1914 has been described as an 'age of the great excavations' and the increased knowledge which they occasioned was largely embodied in the form of figurative sculpture.

The new classicism of the early twentieth century owed as much, if not more, to pre-classical or non-Western sources as to the Classical and Renaissance traditions. Turn-of-the-century pre-classical excavations were particularly influential for our subject, with archaic sculpture acquiring a poignant lustre in the eyes of cognoscenti. Such sculpture showed new ways of representing the human form, and helped to make acceptable profiles which were very different from the established classical models. Sculptors were, probably inevitably, among the first to appreciate what such alternatives offered them: in Greece Maillol preferred Olympia to the Parthenon; Bourdelle made a collection of some of the finds from the Cycladic, Minoan, and Mycenean excavations. A group of the most important Etruscan tombs was opened during and after the First World War, and the study of Etruscan art officially consolidated only in the 1920s.

The influence of archaism can be traced from master to pupil. In America we find such a lineage behind Paul Manship, who had studied with Isidore Konti, who had studied with Karl Bitter. This affected the way in which Manship used his Rome Scholarship, and indeed led to the American Academy in Rome becoming closely associated with an archaizing neo-classicism perpetuated by Manship's circle there: Sherry Fry, John Gregory, and Carl Jennewein. Manship's study of Roman and Renaissance bronzes was to play an important part in his own production. Such consciously historical sources allowed critics to set Manship in opposition to Rodin and thus, perhaps ironically, to characterize him as independent. Manship absorbed his homework without making it too obvious; he wore his learning lightly.

The Expositions Universelles of 1889 and 1900 introduced diverse material to new audiences. Maillol studied the Khmer sculpture and took moulds of Angkor reliefs in the Indo-Chinese pavilion. Maillol and Manship were both drawn to Hindu and Buddhist sculpture which was now becoming increasingly established in the West. The India Society was founded in 1910 and by 1917 Manship was one of seventeen US members. William Rothenstein, one of the Society's English founders, introduced Eric Gill to Ananda Coomaraswamy, who in 1917 became the first American Curator of Indian Art in Boston. Gaston Lachaise, who arrived in the USA from Paris in 1906, studied the Boston Far Eastern Collections before going to work for Manship in 1912. Finally, one of the most spectacular of all archaeological finds, the opening of Tutankhamun's tomb in 1922, rekindled a popular enthusiasm for Egyptian art. It is worth noting how often this new figurative material was found within the context of architectural sculpture.

The heavy-limbed figure

The heavy, well-rooted female figure which is such a hallmark of the period may be seen to emerge from the developing interest in archaism. Rik Wouters's 'Domestic Cares' (1913) and, more explicitly, Bourdelle's heavy-limbed 'Pénélope' (1907–12) express patience and long-suffering to the point of immobility [124]. Slowness might be seen as a crucial element in the reaction to Rodinesque spontaneity, part of the measured search for balance and structure, and here this kind of heavy female figuration stands apart from contemporaneous representations of women deriving more exclusively from non-Western sources. The 'gravitas' inherent in the heavy-limbed figure is often borne by a nominally 'innocent' subject: the child, the girl, the peasant. Such topics are powerfully brought together in images associated with the First World War: the orphan, the widow, those who wait. The rooted figure now emerges more clearly as the mourner, the figure who grieves at the foot of the memorial to the lost son or husband. In France and elsewhere, mourner was conflated with peasant to express

124 Émile-Antoine Bourdelle
Pénélope, bronze,
120cm, 1909

the deep-rooted nostalgia for home. The peasant figure represented the locality, René Quillivic for Brittany or Manolo for Roussillon, and the unbroken tradition of those who stayed behind. Those who are present represent those who are absent. These figures were now not only conceptually rooted—of the earth, of the locality, of the country—but also quite often physically rooted, brought down off the pedestal. This new foil encouraged the multiplication of figures—the one as many, the many as one—extending into a wall of carved stone, sometimes represented as civilians, and sometimes as foot-soldiers.

Aristide Maillol and É.-A. Bourdelle were exact contemporaries whose southern origins were used to contrast them to Rodin. The Midi (which already had claims to its own school of sculpture) was

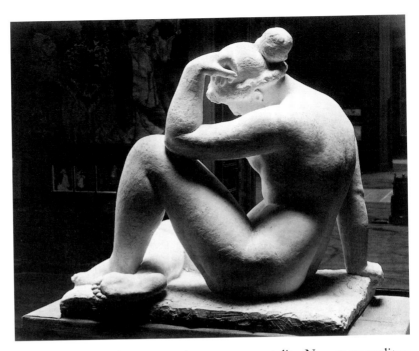

seen as offering a vigorous southern monumentality. Non-metropolitan
sculptors were newly in vogue at this time, seen to represent some kind
of ancient and unsophisticated authenticity. Regionalism had political
as well as artistic ramifications, and a good example is found in the sep-
aratist aspirations of Catalonia and Provence. The imagery of the
Catalan writer and activist Eugeni d'Ors, the '*ben plantada*', found echo
in the 'well-rooted' female figure of contemporary sculpture, and specifi-
cally so in the commission to Enric Casanovas for a façade in Gerona.

The work that launched Maillol at the 1905 Salon d'Automne (and
which Matisse helped to cast), simply titled 'Woman' [**125**], was re-
ceived with warmth and erudition by a wide variety of writers, and
studied by other artists who embraced the classical context, such as
Manolo, Clara, and Casanovas, as well as Picasso. His supporters al-
most all defined Maillol in terms of a French Mediterraneanism which
they saw as entirely instinctive, and in no way affected or learned.
Nevertheless, 'Woman' was repeatedly retitled, first becoming known
as 'Latin Thought' and then as 'The Mediterranean'.

The nationalistic interest in invoking a classical plenitude began be-
fore the First World War, though it became more urgent, and for dif-
ferent reasons, thereafter. Auguste Renoir's late work offered a vision
of a golden age which, combined with his status and longevity (compa-
rable to Rodin's), seemed almost eternal. Renoir began to make sculp-
tures with the help of Richard Guino, who had been recommended by
Maillol as someone in keeping with the 'Mediterranean spirit'.
Renoir's 'Venus Victorious' (1914) is part of the increased interest in a

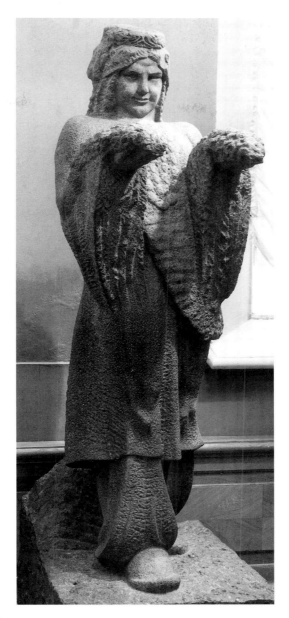

French Mediterraneanism and presages the images of victory and
peace provoked by the war.

The stocky peasant figure was a regular part of the Socialist Realism
developed after 1932 in the Soviet Union, especially after the
Stakhanovite 'worker-hero' phenomenon of 1934, and the link is tan-
gible in that sculptors such as Vera Mukhina and Sergei Bulakovski
had studied under Bourdelle. Peasant life was linked to archaism
to produce images of great stoic monumentality, such as Marina
Ryndzyunskaya's 'Cotton Field Girl' of 1940 [126].

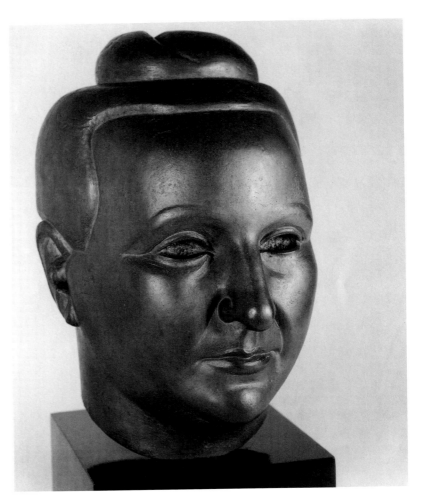

A modest anonymity

In his account of the 1905 Salon d'Automne, André Gide compared Rodin's sculptures—'breathless, anxious, meaningful, and full of clamorous pathos'—to Maillol's 'Woman': 'She doesn't signify a thing. She is a silent work of art.' Gide is effectively contrasting Rodin's noisiness to Maillol's silence, but is he claiming for Maillol an absence of meaning, or rather a withholding of meaning? In this ambiguity lies the fascination of a study of figuration as it develops in the inter-war years.

The judicious means which lead away from Rodin lead away from associations with individual genius. A rejection of virtuosity meant a rejection of the possibly random or spontaneous traits of the hand. In seeking a more collective, but more permanent, manner, it was probably inevitable that younger sculptors would find in historical models the attractions of anonymity and timelessness. By the inter-war period, such attractions had become a conscious and preferred strategy for many artists.

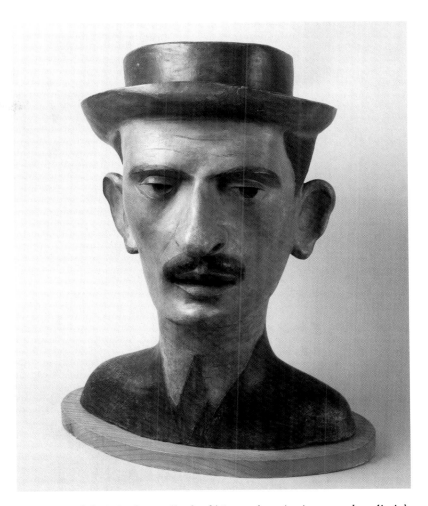

Marino Marini often talked of his work as 'reticent and realistic', having a ' classical quality of anonymity'. Marini looked to funerary busts of unknown Romans and to Etruscan funerary portraits as models for his own busts. He was interested in refinding the anonymous quality which made these ancient portraits 'human documents stripped of all historical pathos'. Their quality is unsentimentally documentary, and reminiscent too of Manship's striking marble bust of John D. Rockefeller (1918) (carved by Lachaise), of Martini's 'Head of a Boy' (1920), which had similar precedents, or of Ernesto de Fiori's polychromed portrait of Barbara Diu (1927). In their deathly (or deathless) life we recognize Marini's wish to 'transport the subject into the realm of the dead, who remain alive'.

Such timelessness is found more widely, for example in the portrait busts which Lipchitz made around 1920, like that of Gertrude Stein [127] with its Oriental impassivity. This head relates to two trends in the treatment of the human form: one being the more radically

simplified sectioning which we see in pre-war heads by Matisse and Duchamp-Villon; the other being an increasingly hierarchical frontality found in post-war heads by Lachaise, Matisse, and Picasso, especially from the years around 1930. Lipchitz asserted simply, 'There was, after the war, a movement towards realism on the part of many artists in Paris and elsewhere', but this masks the particular realism which we find in his 'Stein' and in his 'Raymond Radiguet'. These are unseeing polished caskets similar to anomalous portrait heads by Dobson, Fergusson, or Noguchi in their lifeless perfection.

The inter-war interest in terracotta and in polychromy springs out of concerns outlined above. Moreover, social realism made knowing use of materials which fostered links with indigenous folk art. Oto Gutfreund's terracotta portrait heads [128] are followed by his small coloured groups of workers in wood and plaster. Gutfreund's later work and that of those who followed him is normally couched within the modest quotidianal realism associated with Czechoslovakian independence (and which is contemporaneous with German Neue Sachlichkeit) but we can also detect its links with Italian classicism. Josef Jiřikovsky, Bedřich Stefan, and Karl Dvořák used coloured terracotta in the mode of fifteenth-century Italian portrait busts to produce portraits of an arresting simplicity.

We might extend this argument from the human to the animal figure, a category which, perhaps because of its 'secondary' status, has frequently guaranteed its exponents significant freedom of action. We saw in Chapter 3 how the animal subject helped sculptors to push their own boundaries in material terms. Even better than the female nude, the animal form lent itself to the quiet simplification which led out of Rodin, of which François Pompon (who had carved for Rodin) is an exceptional exponent. In addition to decorative appeal, the animal offered roots into the archaic past, an apparently naïve (or innocent) way of not saying too much in a period when this was important. Toni Stadler, who had trained with Hermann Hahn, developed a distinctive 'Etruscan' *animalier* style which slightly anticipates Marini's polychrome terracotta riders and influenced others, including Heinrich Kirchner.

Lehmbruck's use of artificial stone for his figures appears to be an important component in their pre-historic connotations. Despite their intensely anti-physical attitude, Lehmbruck's figures suggest a comparison with the almost carnal torsos of Gela Förster, as both share something of the same approach to line and material. Förster's work picks up on Lehmbruck's typically narrow inclined head and eroded profile, but allows the volume to swell as it reaches the belly and groin. Picasso's bulbous Boisgeloup sculptures of Marie-Thérèse, which he most liked in their original plaster, were transferred into concrete for the 1937 Spanish pavilion, thus linking the new and the old, the public

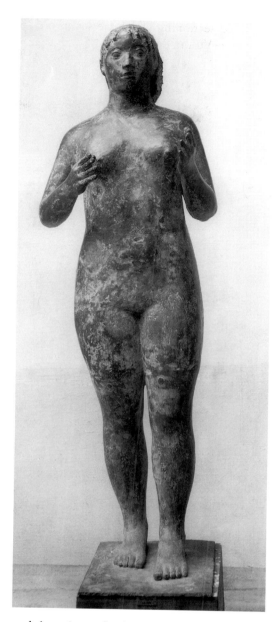

129 Toni Stadler
Standing Woman

and the private. Such materials connoted an age and inevitability—the kind of precedence to which Moore also laid claim at this period—which went beyond the hand of their maker.

Arturo Martini's manner of ageing his materials and their forms to suggest a now illegible codification takes on added significance in the political climate in which he lived, and we can identify similar strategies among artists in Italy, Germany, and other authoritarian states. Marini believed that his own use of classicism allowed him to express his private life, in contrast to the blatantly public art of Fascism. The

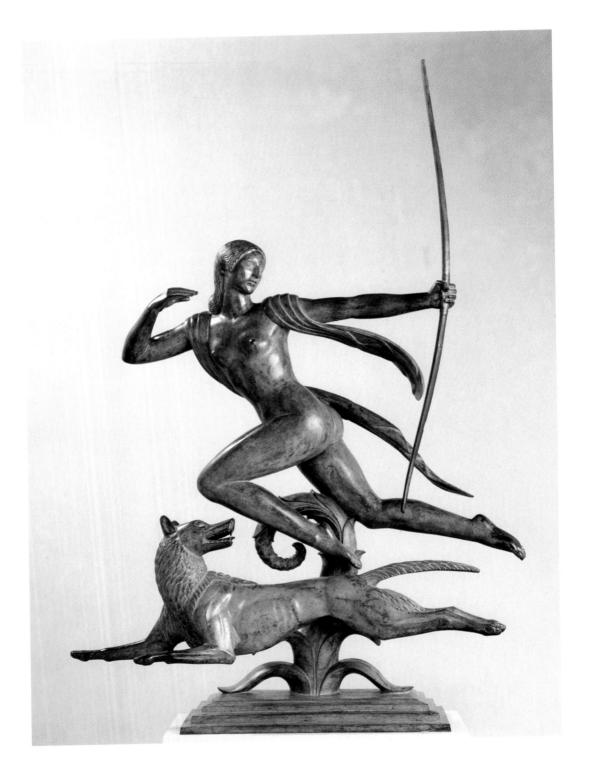

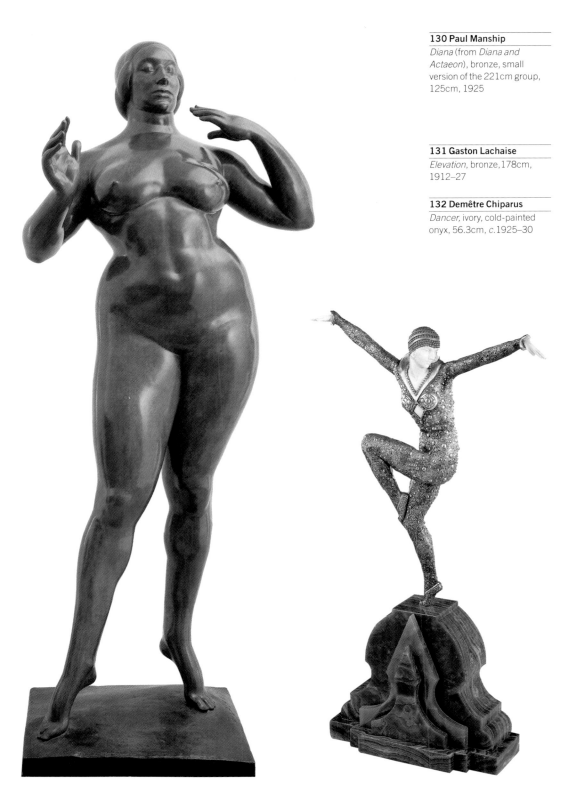

130 Paul Manship
Diana (from *Diana and Actaeon*), bronze, small version of the 221cm group, 125cm, 1925

131 Gaston Lachaise
Elevation, bronze, 178cm, 1912–27

132 Demêtre Chiparus
Dancer, ivory, cold-painted onyx, 56.3cm, c.1925–30

need to differentiate between one type of figurative classicism and another is further highlighted by the case of Gerhard Marcks, who, like Marini, saw in figurative classicism a humanist alternative to National Socialism. Multivalent 'historicism' allowed sculptors to hide, masking themselves in its cloak in a manner that can thus be associated with the 'inner emigration' of many German artists during the Third Reich. Martini's assumed 'naïveté' is akin to that of Toni Stadler, who, along with Ludwig Kasper and Hermann Blumenthal, continued to practise an unassuming figuration which must be understood in the context of their retreat into internal (or 'Berlin') 'exile' [129]. Kaspar's synthetic-stone statues of children are uncannily present and absent: both of their time and like casts from ancient history.

The light-footed figure

A notable alternative tendency to the stasis of the rooted figure and archaizing bust is a swift-footed, airborne agility. Movement is effectively stilled by being pulled in two directions, the combination of stasis and mobility often reconciled by means of the base. An elegantly tapering finial—an inverted pyramid—presents a figure which seems to hover above the ground. The syncopated poise of Georg Kolbe's 1922 'Dancer' raised above the jets of water of his fountain reflects not only the Baroque-like coil of Expressionist sculpture (and especially Archipenko), but also Kolbe's pre-war studies from Nijinsky.

Archaism had fed into the growing interest in free dance, a 'modern' form with ancient sources. Sculptors were inspired by the experiments of Isadora Duncan, Ruth St Denis, Mary Wigman, and others, and it is well known that Rodin, Bourdelle, Clara and Fergusson made drawings after them. The resulting work tended to represent the 'classical' in terms of chorus, frieze, and drapery. Perhaps more influential for sculpture, however, is the asymmetry we might relate to Oriental dance, both in performance and as it was represented in Asian sculpture.

Manship's concern to retain movement, and his more particular interest in Indian sculpture, reminds us of Rodin's own fascination with the 'suspended' movement of the Cambodian dancers whom he saw in 1906. Milles [4] and Manship habitually pushed their figures up, on columns or on supports wider at their top than at their base, as if balancing in perpetual motion above a fountain spring. Broad and gamin smiles corroborate the effect of spontaneity made permanant [130].

Despite the broad girth of many of Lachaise's nudes, they too are notable for a graceful balance which hovers between stability and mobility. 'Elevation', the single figure which marked his maturity [131], and which spanned the years 1912 to 1927, floats on tip-toe, while the body rises above it in increasing monumentality. Elie Nadelman, who arrived in the States some years after Lachaise, was quicker to exhibit there, though his distinctive contribution seems to have been made in

France, around 1910. His serpentine treatment of the female nude, at once heavy and light, realistic and mannerist, provides a comparable precedent to the work Lachaise was to develop in America.

The representation of mobility within the stability of sculpture becomes more prevalent in the inter-war years in the genre of the statuette. Might we even identify this as the 'syncopation' of contemporary rhythm? Figures representing classical themes gave way to modern life, and the dancer motif was extended to include theatre and sports personalities. Though the commercial and decorative aspects of the genre might be seen to account for a light-heartedness of profile, its formal antecedants lie firmly within the mainstream traditions of sculpture. Sculptors such as Demêtre Chiparus [**132**], Ferdinand Preiss, and Pierre Le Faguys were at the lower end of a market which included Milles and Manship, and their figures exhibit a poise which, if literally light-weight, is nevertheless comparable to that of the 'high' art of their peers. Even within a genre as 'serious' as Soviet Socialist Realism we find plenty of such images of play, including Sarra Lebedeva's 'Girl with a Butterfly' (1936) and the popular series of animals produced by Alexei Sotnikov and, above all, Dmitri Tsaplin. Playfulness is a large part of the inter-war figurative mode which became known as Art Deco.

The luxury of style

The 1925 Paris Exhibition of Modern Decorative and Industrial Arts was very much a showcase for the display of 'style' as a prerogative of the large department store as much as the individual stylist. 'Art Deco' came to represent the apparently 'exclusive' luxury now made available to a larger public by means of new materials and working methods often to be found in close association with the figurative mythological. In private the display took the form of the chryselephantine statuette, in public the form of the 'permanent' masthead or logo. Though the former inclined towards the playful, and the latter towards the serious, their combination is a characteristic of Art Deco. Source-searching provoked elegant pastiches with graphic qualities suited to architectural schemes. Alternative sources in early, Oriental, or Middle Eastern sculpture, combined with the ludic quality outlined above, led to work that was 'lightly learned'. Mythology lent a respectability to designs that were fundamentally decorative. It also gave a human face to technologies which were without real precedent: witness Eric Gill's 'Ariel' for the British Broadcasting Corporation (1931), or Lee Friedlander's 'Television' on the Rockefeller Center (1933).

American business liked to express its knowledge of quality. Manship's commission for the Rockefeller Center (which he had to bring off in the space of one year from 1933) was explained in the following

terms: 'The elite of this generation almost instantly recognised Mr Manship to be their sculptor. They get from him what they would get in surgery from the highest priced surgeon of the day, in engineering from the very best engineer, and so on.' Clients wanted a 'good job well done', which in Manship's case usually meant casting in Belgium or Italy, and visible expenditure, in this case the pounds of gold-leaf applied to his Rockefeller 'Prometheus'.

That design which Manship admired in Archaism was often expressed in a symmetry, of profile or silhouette, that would have been anathema to Rodin; we see it not only in Manship's own 'Woman with Gazelles', but in echoing works such as Gaston Lachaise's 'The Peacocks' (1922). Gaston Lachaise had worked in the studios of the goldsmith René Lalique to earn his passage to America and took with him a material finesse which stood him in good stead with American clients. Combining this with his interest in Indian sculpture, Lachaise used gilt patinations and marble tints to overlay his sculpture with decorative patterning.

Garden sculpture

The garden was a particularly happy home for sculpture which represented the arts of love and leisure rather than those of commerce and citizenship. Here the classical subject was appreciated for its openness, its unattached and playful nature, if not for its potential for a very 'absence' of meaning. Just as important, its conventionalized framework liberated the artist to express him- or herself by means of variation on the form. In the United States garden sculpture offered a particular route out of heavily traditional Beaux-Arts symbolism. Women were especially prominent in a field on the margins of the establishment: they included Manship's follower Harriet Whitney Frismuth, Malvina Hoffman, Edith Baretto Parson, and Janet Scudder. Scudder's 1901 'Frog Fountain' launched her in this line, and her 1911 'Diana' was designed for a clearing in the grounds of a Long Island estate. Before the Crash wealthy businessmen commissioned works such as Manship's 'Theseus and Ariadne' or Lachaise's 'Peacocks' for their estate gardens. Artistic patrons used much the same genre; a good example is 'The Mountain' which the painter G.L.K. Morris commissioned from Lachaise for his Massachusetts estate.

Though less common, there are some parallel examples of European patronage, more particularly combining an avant-garde 'classicism' with the spaces of luxury apartments and villas. Such commissions represent a new alliance between the Cubist avant-garde and 'Society', and Cubism's new 'respectability' within the French tradition. Laurens, Lipchitz, Giacometti, the Martels, Csáky, and Miklos enjoyed the patronage of designers such as Coco Chanel, Paul Poiret, and Jacques Doucet, as well as, most famously, that of the de Noailles. Such

commissions may be seen as having played a part in encouraging 'free' sculptors to find ways of marrying their forms with the conventional elements of interior and exterior decoration and thus to have enriched both vocabularies. Cubism acquired a newly rococo curvaceousness in combination with such horizontal or vertical cadres. Laurens sculpted his 'Femme à la draperie' (1927) for the garden of the de Noailles's villa on the Côte d'Azur, a figure which accrued its iconography by means of its siting in relation to the garden and to water. Laurens went on to develop his 'Woman' as a pivot between exterior and interior, the public and the private. In Germany we might note a comparable combination in the use which Mies van der Rohe made of the sculpture of his friend Wilhelm Lehmbruck (and, when this was unavailable, of Georg Kolbe): an insertion of a bronze punctuation mark of almost ungainly figuration within interiors of increasingly sumptuous texture, and as transitions facilitating the passage from one area to another. Henry Moore was to describe the 'Recumbent Figure' (1938) which he made for the architect Chermayeff as a 'mediator between modern house and ageless land', and indeed it echoed and extended the very transparency of modernism.

In 1929 Maillol's 'Monument to Cézanne' (rejected by its 1912 commissioner, the town of Aix) was erected in the Tuileries Gardens in Paris. Though this piece was carved in stone, other of Maillol's monumental works were cast in lead, a medium he specifically associated with the sculptures at Versailles, of Coustou and Coysevox. The Tuileries were perhaps the natural home for Maillol's works, which were big enough to be monumental, but sufficiently universal to be placed anywhere. They might be seen either as a resurgence of the tradition of garden statuary, or as a prefiguration of sculpture for sculpture parks.

Garden sculpture has a close interface with the work designed for the Expositions and World Fairs to which we have so often had recourse, and indeed the four fountains which Laurens designed for the Sèvres Pavilion at the 1937 Exposition lead back to his garden commissions for the de Noailles. The 'garden furniture' of such expositions—of which an extreme example is the enormous sun-dial which Manship designed for the 1939 World Fair—refers to the formal arrangements of Versailles. Despite all their historical precedents, the World Fair figures (designed by Manship, Donald Delue, Theodore Roszak, and Marshall M. Fredericks) were designed to represent 'The World of Tomorrow'.

Variations on a theme

It might be said that the subjects of the classical myths were in the repertoire of any artist up until the middle of the twentieth century. Nevertheless, there is an apparently striking prevalence of certain

mythic figures in our period, and especially in the inter-war period, and Prometheus, Apollo, Orpheus, Diana, and Europa appear not only across the oeuvres of 'official' artists such as Henri Bouchard, independents like Despiau, Martini, Milles, and Manship, or 'avant-garde' like Lipchitz and Zadkine, but also on the walls of ballrooms and cinemas. (Another prevalent genre, a kind of sub-classicism, is the Harlequinade, which we see in the work of sculptors such as Gargallo and Lipchitz, as well as in the paintings of Severini, Gris, and Picasso.)

For those who knew their stories, the classical myths offered the possibility to veil personal feeling in a public exterior. On occasion the guise was insufficient: Lipchitz's monumental 'Prometheus strangling the vulture', erected in plaster on the site of the 1937 Paris Exhibition, caused heated debate within the French establishment, and its premature destruction must have been fuelled by a message judged to be overtly hostile to foreign guests. Appropriately enough, when Lipchitz arrived in America in 1941, he brought with him 'Flight' and the 'Rape of Europa' and Meštrović marked his arrival there in 1947 with themes betraying his grief about the Europe he had left behind: 'Persephone', 'Prometheus', 'The Fall of Icarus'.

The 'classical' combined with 'sculpture' to represent a particularly private world of retreat, well illustrated by Picasso's immersion in his new sculpture studios at Boisgeloup, as represented by Brassaï's photographs, and by Picasso himself in 'The Sculptor's Studio' section of the 'Vollard Suite' of etchings. Brassaï's photos were published in *Minotaure* in 1933, the year in which Picasso embarked on this run of over 40 etchings depicting the artist as sculptor within a secluded space peopled by classical sculpture, the figurative ideal which embodied subject and object, creation and inspiration.

The classical tradition is one of appropriation, multivalency, and revision. Similarly Maillol's art depends on a slow reprise of a small number of central components. Poses were not simply gradually refined over long periods, but were disassembled, even sliced, in order to contribute to a new whole. His monument to the pilots of the Airmail Service represented 'Air' (1938), a figure toppling as if off balance and derived physically from the 'Monument to Cézanne'. 'The River' (1938–43) (as it is known now) began as a monument to Henri Barbusse. Like 'Air', 'The River' derived from an earlier work called 'The Mountain', whose angle was changed so that it was now definitively tilted back, out of control. This very interchangeability—in which alignments are altered and torsos given new arms or legs—parallels the anonymity on which the longevity of the 'classical' tradition depends.

Maillol's treatment of 'the subject' is instructive for a more general reading of his sculpture, and mythology makes this especially clear. Components of the narrative are progressively discarded until we are

left with a figure who might have been plucked out of a *tableau vivant*, an isolated figure whose gesture makes reference to the missing narrative fabric. 'Leda', an early work from 1900, presages this *dépouillement* of the narrative theme, omitting the swan altogether. Here, and perhaps elsewhere, the absent represents the external threat which is male. Something similar is managed by Maillol in his monumental work, in which the 'subject' is shifted onto its accessory. He won the competition for a monument to Auguste Blanqui (beating Bourdelle) with a female figure, 'Action enchaînée' (1906), which made only the most oblique reference to the many years Blanqui spent in prison. Maillol may be seen as a vigorous example of the anti-literary trend which marks the figurative ideal in this period, and his use of the physically fragmented form may also be understood as a metaphorical fragmentation.

North and south

Maillol's 'Mediterranean', seemingly simple, was arrived at through a series of models, and was seen as a constructed shape within a square [125]. It was this rigour which distinguished its classicism. French Classicism was now posited as being a combination of order and voluptuousness, of geometry and fertility, and thus different to both Italianate Classicism and to German Expressionism.

However, Maillol was immensely influential in the North, and sculptors such as Adam Fischer and Astrid Noack introduced his manner to Denmark, and Waïnö Aaltonen to Finland. Even during the First World War Maillol's friendship with Count Harry Kessler and other German patrons occasioned xenophobic reaction in the French press. Nevertheless, the series of war memorials in and around Maillol's native Banyuls (between 1921 and 1933) testifies to his acceptance as a local. His influence in Germany was only really consolidated in the later 1920s, as exemplified by his exhibitions there. Arno Breker, who had been part of the Paris scene from 1927 to 1933, had, with Kessler, Kolbe, and Kogan, helped to secure an important show for Maillol in Berlin in 1928, and included him again, as late as 1939, in a group show in Düsseldorf. Though Maillol's ill-health saved him from the opprobrium associated with those French sculptors who made the 'voyage' to Breker's studio in 1941, he nevertheless naïvely visited Breker's show the following year in German-occupied Paris.

In 1930 Gerhard Marcks brought 'north' and 'south' together in his 'Thüringer Venus', a homely conflation of the resolutely local with the timeless and universal ideal of the Goddess of Love [133]. Marcks's conceit would soon become common in the 'Peasant Venuses' of Third Reich painting, and the fact that Thüringia had more than local significance, in being the first German state where National Socialism took

control, makes this work particularly complex. In 1928 Marcks had had a chance to experience the classical world for himself, after winning the Villa Romana prize, and went on to tread a careful line by means of a figuration which acknowledged both the German North and the classical South without going so far as to embrace either one.

Well into the 1930s the National Socialists sought to lay claim to a double pedigree: to combine Germanic mythology with the Greek. The Hellenizing amphitheatres built for the 'Thingspiele' are an example of the hybrid form, as is decoration like the heavy stone reliefs by Adolf Wamper for the Berlin Waldbühne (1935–6). Early in the Third Reich it was even possible for some National Socialist

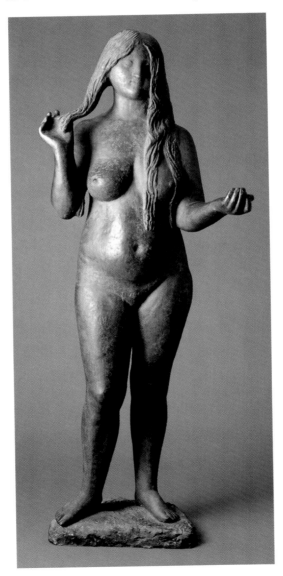

133 Gerhard Marcks
Thüringer Venus, bronze, 177cm, 1930

134
Palais de Tokyo, view of terrace and pool, Paris, Exposition internationale des arts et techniques dans la vie moderne, 1937

This building was designed to house two modern art collections: that of the City of Paris, and that of the French state. Anna Quinquaud and Pierre Vigoureux were the authors of the two free-standing stone sculptures; the pool was flanked with stone nymphs by Louis Dejean, Léon Drivier and Auguste Guenot and the façades were decorated with low reliefs by Marcel Gaumont and Leon Baudry. Alfred Janniot executed the reliefs on either side of the staircase. Bourdelle's 'La France' continues to this day to occupy the place which was originally intended for Despiau's 'Apollo'.

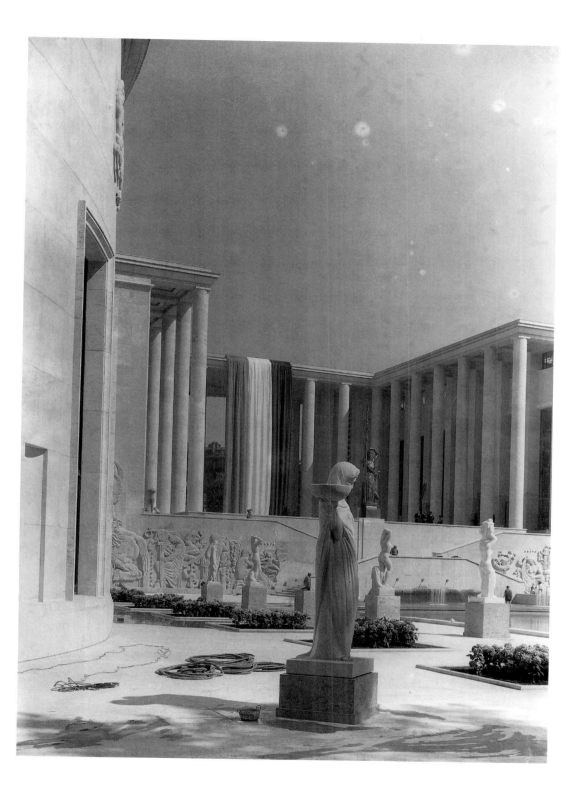

curators to promote pre-war Expressionism as the true 'German' descendant of the Gothic.

In the later 1930s there was a tendency across Europe to return to an indigenous past, leading to a curious co-habitation between the classical and the vernacular, the international and the national. Italian Fascism was interested in using and interacting with modernism, though its protagonists also enquired how it might be possible for modernism to represent a rooted cultural specificity, and in particular, Italianness. The French had long been troubled by the *déraciné*, the phenomenon of the displaced or uprooted person, and were now additionally conscious of foreign critique of a racial melting pot which was particularly apparent in the Parisian art world. The concern to reassert Frenchness accounts for the fact that they used the international stage of the 1937 Exposition Internationale to celebrate French regionalism in a series of 'village' pavilions.

The decorative scheme for the 1937 Exposition (for which commissions were adjudicated by Despiau and Bouchard, among others) proposed the homogeneity of a French school in terms of its smoothly executed figurative statuary [134]. These commissions were reserved exclusively for French artists, unlike the exhibition 'Les Maîtres de l'Art indépendant', where a compromise position allowing established immigrants to exhibit ironically resulted in Lipchitz, Zadkine, and Orloff ranking close seconds to Maillol and Despiau in terms of the numerical strength of their representation in the exhibition. Their roughly carved and fragmented figurative sculpture offered a very different idiom to that displayed outdoors.

Sculpture, more than painting, became publicly associated with Fascism in Germany and Italy, while in France it was peculiarly associated with Jewishness. Outstanding exponents such as Zadkine, Archipenko, Orloff, and Lipchitz were not simply foreign, or Cubist, but Jewish. By the late 1920s French critics (many of them Jewish themselves) had become concerned to reinforce a pure French school. This urge necessitated the discarding of foreign influences, particularly Jewish ones, which were conveniently located to Montparnasse and restyled École de Paris.

The celebratory body

It is understandable that a European generation which had become used to seeing disfigured soldiers might have wanted to see the image of the whole body in their monumental art. A man whose career exemplifies such a desire is the Canadian Robert Tait McKenzie, a physical education instructor who, having offered his services to a War Office appalled by the poor state of its conscripts, went on to collaborate on early attempts at plastic surgery in reconstructing the bodies of those who were wounded, and finally to recreating the whole body of the lost

soldier on First World War memorials in England, Scotland, the United States and Canada.

Tait McKenzie had 'created' the ideal contemporary figure by taking tabulated measurements from 400 Harvard students. A correlation between human health and beauty, which may presage the sinister message of Nazi Aryanism, was widespread by the 1920s. Certain star athletes, such as the Finnish runner Paavo Nurmi, occasioned sculptures not just in their home country (by Wäinö Aaltonen in 1924), but also abroad (by the German Renée Sintenis in 1926). Paul Niclausse's model of the French 100-metre champion André Mourlon (1923) reminded critics not only of the benefits of 'modern gymnastics', but of the ancient Grecian habit of dedicating statues to their sporting champions.

Projects in which classicizing statuary adorned the stadia of contemporary sport—now too readily associated with totalitarian regimes—were widespread; one might cite Gra Rueb's Van Tuyll-monument (1927) for the Amsterdam Olympic Stadium or Pablo Gargallo's sporting sculptures for the 1929 Olympic Stadium in Barcelona. In Italy the Foro Mussolini opened in 1932, designed by Enrico del Debbio as a premier site for physical culture and headquarters of the Fascist youth organization. It was full of marble statues, nowhere more so than

135 Enrico Del Debbio
Stadio dei Marmi, Foro Mussolini, Rome, 1932
The Foro Mussolini lay to the North of Rome, at the foot of Monte Mario where the blackshirts had camped out on the 'March to Rome'. The Stadium seated 20,000 people, was surrounded by marble statues (one of the project managers had close contacts with the quarries at Carrara) and marked by a spectacularly large single marble obelisk at its entrance. Aroldo Bellini's 100m figure of Mussolini [**36**] was originally designed for Monte Mario, but later schemes incorporated the (still unfinished) statue in a parade ground below the hill.

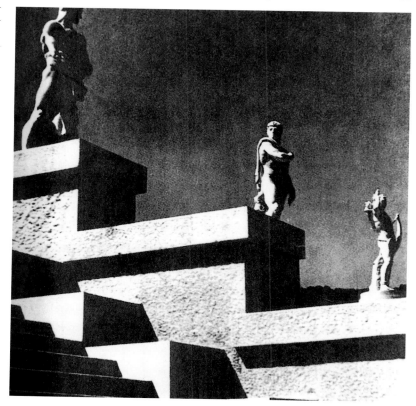

round the boundary of the sunken Stadio dei Marmi, which was demarcated by 60 4-metre statues donated by cities all over the country, the works of 18 different sculptors [135]. Here, however, the 'athlete' has become so anonymous as to be abstract, over life-size, of another age.

The same elements—a grandiose, austere, and symmetrical architecture, regularly punctuated by verticals in the form of upright figurative sculptures—can be seen in the Palais de Tokyo buildings designed to house the new Museums of Modern Art in Paris and built for the 1937 Paris Exposition. The scheme attracted some hostile criticism (Georges Besson considered it an excuse for Janniot's '*déchets bourdelliens*', Bourdellian offcuts, 'in order to celebrate some antique amusement or a new kind of permanent wave') but was very much representative of its time. (In Russia the 1939 All-Union Agricultural Exhibition featured reliefs at its entrance by Georgi Motovilov reminiscent of Janniot's work.) The celebratory schema here and in the nearby Palais de Chaillot was understood to represent a French Renaissance couched in the form of classicism. Statues of 'Athlete' or 'Sporting Girl' were juxtaposed with 'Venus' or 'Woman with Shell'. One critic voiced a widespread conviction that 'if stone, marble and bronze refind the traces of nymphs and of Olympians, let us rejoice to see the Greek gods, alive again, rejuvenated, in the positivism of our period'.

Remarkably similar expressions are found in Nazi Germany. In his preface to *Deutsche Plastik unserer Zeit*, Albert Speer proclaimed, 'The visual artists have returned to simplicity and to naturalism, and therefore have returned to truth and beauty', and its author, Wilfried Bade, concluded, 'Our time is once more able to be Greek.' In Germany, however, the figurative ideal of Greek sculpture was understood as embodying the healthiest and purest specimens of the Nordic race, and thus 'Greek' passed for 'German'. Its corollary was that the figure which did not conform to this ideal was progressively eliminated, and modernist sculpture was an early victim. The hybrid Cubo-Expressionism of the post-war years (centred upon a fractured human body, and simplistically associated with woodcarving) was politically

136 Osbert Lancaster
'Third Empire' and 'Marxist Non-Aryan', cartoons satirising Nazi and Soviet monumental architecture and sculpture, 1950

137 'Garvens'
Caricature from the
German satirical magazine
Kladderadatsch, 1933

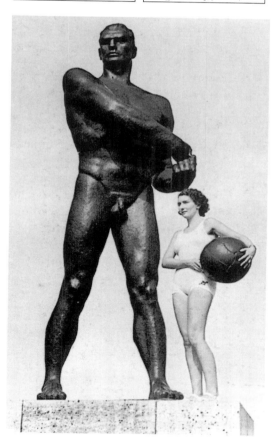

139 Vera Mukhina

*Industrial Worker and
Collective Farm Worker*,
stainless steel cladding on
armature, Paris, 1937

Mukhina's group, originally
modelled in 1935, was
constructed for the 1937
Paris exhibition out of 65
separate pieces of stainless
steel by a team working on
the site over 13 days.
Mukhina was impressed by
her collaboration with Boris
Iofan, the pavilion's architect:
'For the first time an architect
proposed to round off an
architectural composition
with a massive sculpture,
which was to continue the
idea inherent in the building,
and this sculpture was to be
an inseparable part of the
whole structure.' This
combination made a
striking impression on its
viewers; a contemporary
critic considered that it
would always be associated
with the 1937 Exhibition, just
as the Eiffel Tower was always
associated with that of 1889.

linked to the Socialism of the Arbeitsrat für Kunst and its expressive forms particularly vulnerable to Nazi critique of 'deformed cripples and cretins'. The Nazis made a point of correlating this imagery with both the Weimar government and its Jewish patrons. The 1937 Degenerate Art exhibition, which drew on nearly 16,000 works dating back to 1910 (and earlier) confiscated by Adolf Ziegler and his commission, was organized by genres which largely corresponded to social types categorized by gender, religion, and race.

The new body type, and with it a clarified National Socialist aesthetic, began to emerge in the stadium of the 1936 Olympic Games, where statues of athletes by Kolbe, Albiker, Breker, and Thorak were displayed. Instructive parallels were drawn: Kolbe's 'Decathlon' was placed beside a Greek *ephebe*; propaganda photographs showed a young female athlete beside Thorak's monumental 'Boxer'; films merged modern Olympic victors with classical statuary; and much of the new sculpture was indeed more effective in a two-dimensional image than in the round [**138**]. Classes brought artists and gymnasts together in creative association with antique statuary; Thorak's 'Boxer' was modelled on the champion Max Schmeling, Breker used the athlete Gustav Stuhrk. 'The Judgement of Paris' was a favourite subject, allowing the male gaze to make its selection from three specimens of female beauty; Adolf Ziegler made a famous version in painting; Thorak in sculpture (1941).

Abandoning the relatively subdued effect of the integrated carved relief, the Nazi figurative statue would develop to provide a more actively potent symbol, combining as it did action and stasis, in attitudes at once convivial and hierarchical, relaxed but commanding. Couched in the forms of the past, given authority by means of its siting, its message was uniquely about the future. This is the turning-point in terms of official programmes of Nazi sculpture, away from the stone relief which went back to Hildebrand, away from the integrated architectural groups of Albiker and Wackerle, towards the differentiated body of the smooth bronze athlete. Models at once chaste and fulfilled, and notably male, relate both to the cult of the 'body beautiful' and to the increasing sophistication of two-dimensional image-making. The polish of the Nazi figural type can be premised within a broad decorative trend for pastiche, and makes an interesting comparison to the glossiness of Art Deco, and to the increasingly slickly articulated musculatures of Meštrović and Lachaise.

Figure as monument

The large-scale figure had an important part in the architectural schemes of totalitarianism, as we saw in Chapter 2. In the USSR the monumental figure was increasingly massive, and increasingly the figure of Stalin, represented in monolithic form, as in Merkurov's statue

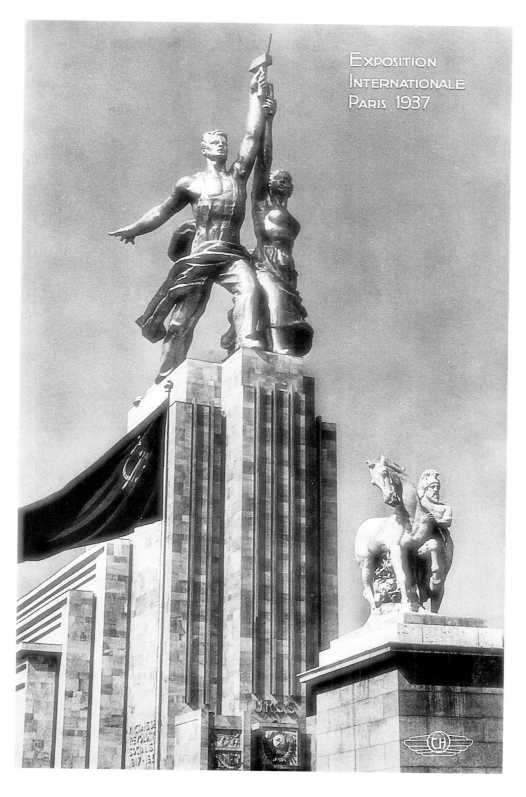

EXPOSITION
INTERNATIONALE
PARIS 1937

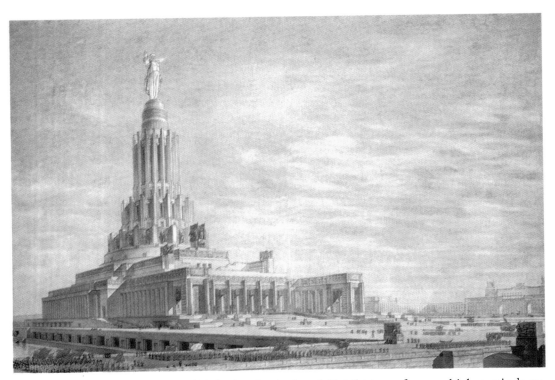

140 B.M. Iofan, V.A.
Shchuko, V.G. Gel'freikh

Project for the Palace
of the Soviets

at the All-Soviet Agricultural Exhibition of 1939 which reminds us, with its constructed masonry, of the German national monuments of the early years of the century. Unlike Mukhina's dynamic workers [**139**], Stalin, and on occasion Lenin (as in Manizer's monument at Ulianovsk (1940)), gave form to figures wrapped in great-coats and of an enormous stillness. Religious iconography might be similarly marshalled by the authoritarian state, as with Landowski's 98-foot 'Christ the Redeemer' (1931) above Rio de Janeiro or Francesco Salamone's Cemetery portals (1938) around Buenos Aires.

In 1936, following the capture of Addis Abbaba, Mussolini made his Declaration of Empire, which he conflated with that of the Emperor Augustus. Artistic corollaries were increasingly imperial, and sculptors engaged with its forms and scale: the victory arch, obelisk, equestrian statue, 'god-like' athlete, and image of the leader. Throughout the following year the Mostra Augustae della Romanitá, a celebration of the 2000th anniversary of the birth of Augustus, was a reminder of Italy's imperial past. Marshalling hundreds of fragments and casts of ancient statuary, this exhibition brought monumental classicism to its apogee.

In Germany some of the largest statues—Thorak's 20-metre models for the Nuremberg stadia, and Breker's 11-metre figure for Speer's Berlin plan—were never erected, so though we need to recognize the part that physical scale played on a conceptual level, most monumental

figures were given scale by their architectural context. Breker's figures 'The Party' and 'The Army' were set inside the inner courtyard of the Reich Chancellery; his 'Readiness' was planned to top an architectural monument to Mussolini. Breker's vocabulary was premised on the warrior and scenes from the cycle of war; his figures were well-muscled naked males, clasping swords or beacons [141]. The neo-classicism we associate with Albert Speer is a neo-classicism widespread over northern Europe in the 1930s. The difference is the scale on which Speer could operate, a scale made possible by authoritarian controls and material resources provided by the inmates of concentration camps.

Continuities

The body of art in which the Nazi Party saw the human form portrayed with overt expression or abstraction was defined as 'degenerate' and exhibited as such. But though it specified what it did not like, Nazism did not actively define its artistic programme. Nazi art and architecture

142 Georg Kolbe
Studio photograph, 1934

was by no means monolithic; it found room for the neo-classic, the vernacular, and the modernist, according to the medium, and the message. Modernism featured not only in appropriately 'marginal' constituencies (such as industrial architecture), but as a defining practice in terms of the organization of visual propaganda. Keen to embrace as many artist-members as possible, and thus deliberately eschewing long-established professional criteria, the party left it to artists to develop their own self-regulation by means of the positions offered them within the system.

National Socialism had not emerged with a new aesthetic; on the contrary, the continuities are manifold. The classicizing school which had existed in Germany since the early years of the century was now oddly caught up in the defining of the new regime. Hildebrand's lessons were absorbed by many who were to make monuments for the Third Reich, such as Wamper, Meller, Schmid-Ehmen, and Granel. Others who found themselves espoused by the regime—Klimsch, Kolbe, Scheibe or Thorak—had established their careers, and their styles, well before its rise.

Nevertheless, styles change, and changes bear witness to the evolution of the figurative ideal within the climate of the Third Reich. We have noted how Maillol enjoyed increased success in Germany after the 1920s, and a 1937 reading of his work illustrates its changed

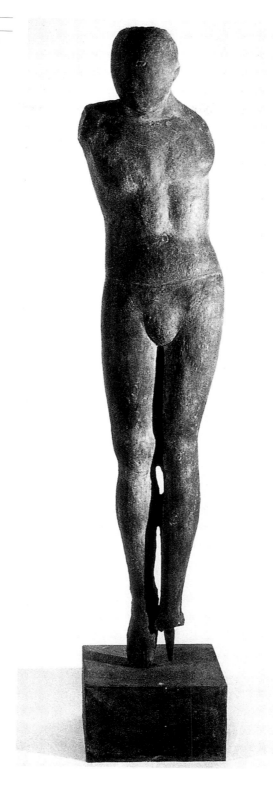

interpretation: *Die Kunst* declared that Maillol 'showed the way to a new European monumental art' which the author identified as genuinely Greek and thus genuinely popular, a Volkskunst that made 'all Classicist art appear thin-blooded in comparison'. The shift may be seen as tending towards a glossy solidity, a stability which might be read as either assertive or vacuous. The move towards an increasingly rooted stasis is visible within single careers, for example that of Kolbe, who by 1930 had definitively abandoned the twisting figure with outstretched arms for a heavy plumb-line of gravity.

Though the best-known German artists of the period may be those who emigrated, and while others responded to a policy which amounted to empowerment, many went into what has become known as 'internal emigration'. The lack of outright rejection of sculptors who portrayed the body naturalistically allowed them to continue working, and this very possibility means that we must be careful not necessarily to equate the naturalistic use of the figure with National Socialism. Sculpture covers a range of such withdrawal, from that of Marcks to that of Kollwitz, from the almost imperceptibly dissident to the clearly autobiographical. Sculpture marks some of the most radical self-interrogation, such as that of Max Beckmann, which echoes Lehmbruck's withdrawal into pacifism in neutral Switzerland in the previous war.

Kollwitz's 'Lament' of 1940, marking the death of Ernst Barlach, is one of several personal reworkings of religious set pieces. Likewise in Italy Giacomo Manzù, a Communist sympathizer who had been spared conscription because of his teaching duties, made a series of eight reliefs on 'Cristo nella nostra umanita' (1938–9), using Christian iconography as a way of expressing his deep isolation as well as his criticism of the Fascist state. Like 'classicism', Christian iconography could offer an alternative, an option providing sufficiently ambiguous cover for artists to use it for private rather than public ends. Meštrović had done the same when, suddenly disgusted by the results of patriotism, he turned during the First World War to making an intensely tragic series of woodcarvings based on the 'Life of Christ', and similarly 'dissenting' examples of religious woodcarving were found in contemporary Germany, with Karl Albiker, Ludwig Gies, Christoph Voll, and, most famously, Barlach himself.

The loss of the ideal

Like many of the Bande à Schnegg, Despiau received a commission to make work for the 1937 Exposition building projects. His was a 5-metre-high Apollo figure for the Palais de Tokyo. 'Apollo' is a long way from Despiau's 'La Jeune Landaise', and might be seen to mark a point of no return. (Despiau was indeed unable to finish it in time, and went on working on it up until his death in 1946.) Developments which had enjoyed a variable and multivalent existence until this time—

including both the cult of ideal beauty in the figure of the classical youth, and its association with monumental architectural schemes— were to become strongly associated with authoritarian regimes and increasingly open to criticism.

The climate of the 1930s, and the ensuing war, both invigorated and desecrated the tradition of the figurative ideal. Marini's works express this duality—a use of a traditional ideal which, he felt, had been pretty much definitively destroyed. His works express not only the maiming of the human figure, but also its inability any longer to function symbolically. His 'tragic fossils' are just that, shells of a previous existence. Figures which depend on wholeness and agility—his acrobats, jugglers, and dancers—are here crippled and maimed [143]. Marini's figures are not so much anti-war, as evidence of the futility or duplicity of the very positivism which had been expressed by the figurative ideal in the years before its outbreak. The 'uglifying' of the body—by Marini, Moore, Picasso, Richier, Fautrier, and many others, during the war and after—must be seen as some kind of antidote to its earlier beautification. The end of the war was not to restore Marini's faith. His horses and riders come increasingly to express a sense of disconnectedness. He likened his world view to 'what some Romans felt, in the last years of the Empire, when they saw everything around them, a whole world order that had existed for centuries, swept away by the pressure of contemporary events'.

Conclusion

The tendency of most of the chapters in this book has been to empha-size the wider spatial environment occupied by sculpture as the period progressed. Modernist movements can be demonstrated to have tended away from the single object towards a more extended space, whether within the space of the photograph, the studio, the theatre, the building, the exhibition, or the shop-window. The importance of presentation, and the control of presentation, have become acute con-cerns, often resulting in a merging of the spaces of the home, the stu-dio, and the exhibition, and in the artist taking on the role of exhibition designer. But such a tendency has also been demonstrated to have in-formed much of the work undertaken within the still vigorous tradi-tion of architectural and monumental sculpture, and indeed we need to entertain the possibility that the two spheres may have informed each other to a greater extent than has conventionally been allowed.

Such an extension by sculpture into the wider spatial field has nor-mally been associated with initatives, particularly in the United States, in the period following that of this book. The projects of American Minimalism were a radical challenge to the object-bound plinth-top sculpture of the immediate post-war period: of Moore, Marini, Fautrier, Giacometti, Richier [145], or Picasso. Such works had offered a compelling iconography of damage, and one that is still most effective. But perhaps we might look at the figurative sculpture of the 1940s and 1950s as an interlude in a rather longer history which has roots in the period we have just been reviewing, even if its projects have less successfully entered the space of the Museum.

Assessing continuity across the twentieth century has been and is difficult. The Second World War is such a tremendous hiatus that it has necessarily historicized the period which went before, sealing it off from what came after. In part such a reading was facilitated by modern sculptors and writers themselves. The end of the 1930s saw a handful of important exhibitions and books which, in attempting to define the modern movement in sculpture, or to explicate modernism, almost

144 Isamo Noguchi
Model for *Sculpture to be seen from Mars,* sand on board, 30.5cm, 1947. Destroyed

inevitably provided it with its own history. Between 1936 and 1938 the Museum of Modern Art in New York mounted the survey exhibitions 'Cubism and abstract art', 'Fantastic art, dada, surrealism' and 'Bauhaus, 1919–1928'. A seminal publication was the 1937 *Contemporary Sculpture: an Evolution in Volume and Space*, by Carola Giedion-Welcker. Giedion-Welcker's pictorial narrative suggests an understanding of sculpture informed by the architectural (and the writer's husband was the architectural historian, Sigfried Giedion) but may have been interpreted more narrowly as establishing a canon for modern sculpture. Similarly, though the publications of Moholy-Nagy which gathered pace just before his death in 1946 (especially in English translation) offered a methodology which might have been taken as an approach for the future, they inevitably read as a retrospective summary of a period, and of a career, that had now been terminated. 'Modern Sculpture' enjoyed a real blossomimg after the war, but in becoming an established category, it became narrower, and lost much of the interaction with non-modernist modes which make the pre-war period so rich.

In 1945 Arturo Martini wrote a text entitled: *Scultura Lingua Morta* or 'Sculpture Dead Language'. In it Martini derides the kind of sculpture he had himself been making over the previous 40 years. He deplores sculpture's lack of poetic potential, seeing the forms of the human or animal figure as a strait-jacket, and regrets sculpture's illustrative burden. He contrasts painting's new vernacular with sculpture's Greek and Latin, used only for epigraphs and mass.

Despite its definitive title, and acerbic commentary, the text's conclusion is curiously difficult to decipher. 'Sculpture is the eternal repetition of statues', declares Martini, and 'for as long as he is obliged to model a statue' the sculptor 'is pushed to deny the essential act'. Only in the very last lines do we find a hint that Martini might believe that sculpture could have a future—'let us no longer confuse the real life of sculpture with the apparent life of a statue'—and among his fourteen commandments he offers us:

That I should not be an object, but an extension.
That I should not stay three dimensional, for death can hide within.

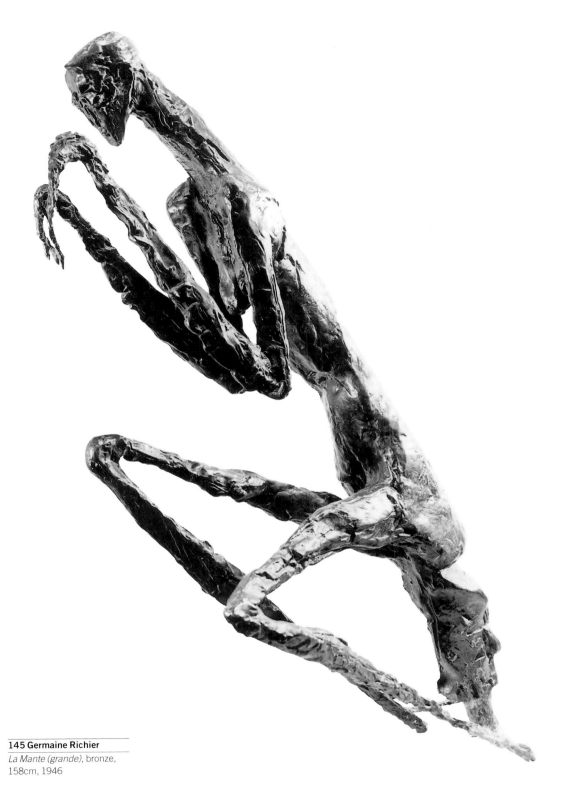

145 Germaine Richier
La Mante (grande), bronze,
158cm, 1946

253

List of Illustrations

The publisher would like to thank the following individuals and institutions who have kindly given permission to reproduce the illustrations listed below.

Frontispiece: Exhibition of the century's sculpture, Grand Palais, Paris, 1900. © Roger–Viollet, Paris.

1. The Rodin exhibition, Pavillon de l'Alma, Paris, 1900. Musée Rodin © ADAGP, Paris and DACS, London, 1999.
2. C.L.J. Doman and T.J. Clapperton, *Britannia with the Wealth of East and West*, Liberty's, Regent Street, London, 1924–6, © The Conway Library, Courtauld Institute of Art, London.
3. Raoul Larche, *La Seine et ses affluents*, Grand-Palais, Paris, 1910, © The Conway Library, Courtauld Institute of Art, London.
4. Carl Milles, *Orpheus Fountain*, Concert Hall, Hotorget, Stockholm, 1926–36, © The Conway Library, Courtauld Institute of Art, London.
5. Daniel Chester French, *The Continents*, United States Custom House, Bowling Green and Broadway, New York, 1903–1907, © The Conway Library, Courtauld Institute of Art, London.
6. Frederick MacMonnies, *Columbian Fountain*, World's Columbian Exhibition, Chicago, 1893. Photo: C.D. Arnold, © The Chicago Historical Society .
7. Henri Rieek (arch) and Auguste Rodin (sc), Cornelis building, Boulevard Anspach, Brussels, 1872 (destroyed 1929), © Musée Rodin, Paris/ © ADAGP, Paris and DACS, London, 1999.
8. Hôtel de Ville, Paris, 1879–89. Photo © Corbis UK Ltd.
9. John Belcher (arch) and Hamo Thornycroft (sc), Institute of Chartered Accountants Building, Moorgate Court, London, 1888–93, © The Conway Library, Courtauld Institute of Art, London.
10. Lambertus Zijl, *Keystone*, Koopmansbeurs (Stock Exchange), Amsterdam, 1899–1900, private collection.
11. Stanislav Sucharda (sc) and Jan Kotera (arch) *Okresní Dům*, Hradec Králové, 1903–4, private collection.
12. Mikhail Vrubel, Majolica stove-seat at Abramtsevo, 1890. Photo courtesy Hayward Gallery, London.
13. Émile-Antoine Bourdelle (sc) and Auguste Perret (arch), Théâtre des Champs-Elysées, Avenue de Montaigne, Paris, 1913, © The Conway Library, Courtauld Institute of Art, London.
14. Frans Metzner, *Gable sculpture*, Haus Rheingold, Bellevuestrasse, Berlin, 1906 (destroyed). Private collection.
15. Charles Holden, London Underground Electric Railways Headquarters, 55 Broadway, London, 1928. Photo courtesy London Transport Museum.
16. Edwin Lutyens, *The Arras Memorial*, Faubourg d'Amiens cemetery, 1925–8. Photo courtesy Commonwealth War Graves Commission, Maidenhead.
17. Reinhard and Hofmeister *et al.*, Rockefeller Center, 48th to 51st Street, Fifth and Sixth Avenues, New York City, 1931–9. Photo © Professor Michele H. Bogart.
18. Auguste Rodin, *La Porte de l'Enfer* from 1880, posthumous cast, © Musée Rodin © ADAGP, Paris and DACS, London, 1999.
19. Gustav Vigeland, Frognerpark, Oslo, 1901–50, © Vigeland Museet/BONO and DACS, London, 1999.
20. Thomas Brock, *Queen Victoria Memorial*, Pall Mall, London, 1901–11. Photo © Illustrated London News Picture Library.

21. Pedestrians by Saenz Pena monument, Avenue Roque Saenz Pena, Buenos Aires, Argentina. Photo © South American Pictures.

22. Bertram MacKennal, *Queen Victoria* (Ballarat, Victoria). Photograph by Julie Millowick, © National Library of Australia, Canberra.

23. Jules Dalou, *Monument to Eugène Delacroix*, Luxembourg Gardens, Paris, 1890, © The Conway Library, Courtauld Institute of Art, London.

24. Augustus Saint-Gaudens, *Monument to David Glasgow Farragut*, Madison Square, New York City, 1881. Collection of the New York Historical Society.

25. Ettore Ferrari, *Monument to Giuseppe Mazzini*, Piazzale Romolo e Remo, Rome, 1902–22, © The Conway Library, Courtauld Institute of Art, London.

26. Alexandre Falguière, *Monument to Ambroise Thomas*, Parc Monceau, Paris, 1902, © Roger–Viollet, Paris.

27. Ladislav Jan Saloun, *Monument to Jan Hus*, Old Town Square, Prague, 1900–15, photo © Roger–Viollet, Paris.

28. Auguste Rodin, *Monument to Victor Hugo*, from 1889, installed in the Jardins du Palais-Royal, Paris, 1909, photo © Musée Rodin, Paris/© ADAGP, Paris and DACS, London, 1999.

29. Albert Bartholomé, *Monument aux Morts*, Père Lachaise, Paris, 1899, private collection.

30. Charles and Henri Malfray, *Victory Monument*, Orléans, France, 1922–9. The Conway Library, Courtauld Institute of Art, London.

31. Richard Kuöhl, *Kriegerdenkmal des Infanterie Regiments 76*, Hamburg, 1936. Private collection.

32. Charles Sargeant Jagger, *Royal Artillery Memorial*, Hyde Park Corner, London, 1921–5. The Conway Library, Courtauld Institute of Art, London.

33. Rheinhold Begas, *Monument to Bismarck*, Berlin, 1901. The Conway Library, Courtauld Institute of Art, London.

34. Hugo Lederer, *Monument to Bismarck*, Helgolaender Allee, Hamburg, 1903–6.

35. Karl Albiker, *Decorative sculpture*, Olympic Stadium, Nuremberg, 1936. Private collection.

36. Aroldo Bellini, *Monumental Head of Mussolini*, 1934. Private collection.

37. Vladimir Schuko & Sergei Evseev, *Monument to Lenin*, Finland Station, Leningrad, 1926. Photo © Society for Cooperation in Russian and Soviet Studies, London.

38. Albert Speer, Kurt Schmid-Ehmen and Josef Thorak/ B.M. Iofan and Vera Mukhina, German and Soviet pavilions, Paris, 1937. Roger–Viollet, Paris, © DACS, 1999.

39. Auguste Rodin, *Monument to Balzac*, Boulevard Raspail, Paris, erected 1939. Musée Rodin, ADAGP, Paris, and DACS, London, 1999.

40. Charles Sargeant Jagger, Studio photograph with assistant and pointing machine. Private collection.

41. Eric Gill carving direct. Leeds Museums and Galleries (Centre for the Study of Sculpture)

42. André Derain, *Man and Woman*, 1907, Wilhelm Lehmbruck Museum, Duisberg. ADAGP, Paris, and DACS, London, 1999.

43. Constantin Brancusi, *Kiss*, 1907–8, Muzeul de Arta Craiova. ADAGP, Paris and DACS, Lodon, 1999.

44. Bertram MacKennal, *Diana Wounded*, 1907. Tate Gallery, London.

45. Joseph Bernard, *Effort vers la Nature*, 1906–7, Musée D'Orsay. Réunion des Musées Nationaux, Paris.

46. Auguste Rodin, *Bust of Lady Warwick*, Musée Rodin. Photo © Bruno Jarret/ADAGP, Paris, and DACS, London, 1999.

47. Paul Gauguin, *House of Pleasure*, polychrome carving on giant sequoia wood, 1901. Musée D'Orsay, photo © RMN–R.G. Ojeda.

48. Jacob Epstein, *Sun God*, 1910, The Metropolitan Museum of Art, New York, Gift of Kathleen Epstein and Sally Ryan, in memory of Jacob Epstein, 1970.

49. Amadeo Modigliani, *Tête*, c.1911–12. Tate Gallery, London.

50. Ludwig Kirchner, *Dancing Woman*, 1911, Stedelijk Museum, © DACS, London, 1999.

51. Henri Gaudier-Brzeska, *Birds Erect*, 1914. Museum of Modern Art, New York. Gift of Mrs W. Murray Crane. Photo © 1998 The Museum of Modern Art, New York.

52. Barbara Hepworth, *Mother and Child*, 1934. Tate Gallery, London, and estate of artist.

53. *Pergola de la Douce France*, 1925. Private collection.

54. Ivan Meštrović, *Tomb of the Unknown Soldier*, Avala near Belgrade, 1934. Courtesy of Embassy of the Federal Republic of Yugoslavia.

55. Studio of Ernst Ludwig Kirchner, Dresden, c.1910. Courtesy Galleria Henze, Campione d'Italia .

56. Joseph Bernard, Patio Joseph Bernard with *La Danse* (1912–13) enlarged version, 1925. Private collection.

57. Hildo Krop carving limestone, Villa Den Tex, Apollolaan, Amsterdam, 1928. Netherlands Architecture Institute archive.

58. Pablo Picasso, *Tête de femme*, 1929–30. Musée Picasso, Réunion des Musées Nationaux, Paris, © Succession Picasso/DACS, London 1999.

59. Julio Gonzalez, *Tête tunnel*, 1923–3, © Tate Gallery, London, © ADAGP, Paris and DACS, London, 1999.

60. David Smith, *Construction*, 1932. The Collection of Candida and Rebecca Smith, New York. Photo: Gary Gold, © David Smith/VAGA, New York and DACS, London 1999.

61. David Smith, *Agricola Head*, 1933. The Collection of Candida and Rebecca Smith, New York, © David Smith/VAGA, New York and DACS, London 1999.

62. Alexander Calder, *Mobile*, c.1934. Photo: David Heald, 1993 © The Solomon R. Guggenheim Foundation.

Jean Arp, *Bird Man*, c.1920. Yale University Art Gallery, Gift of Katherine S. Dreier to the Collection Société Anonyme.

63. Auguste Rodin, *Head of Camille Claudel and Left Hand of Pierre de Wissant*, after 1900. © Musée Rodin© ADAGP, Paris, and DACS, London, 1999.

64. Henri Matisse, *Nu de dos*, I, 1909; II, 1913; III, 1916–17; IV, 1930. Kunsthaus, Zurich, © ADAGP, Paris and DACS, London, 1999.

65. Edward Steichen, Rodin's *Monument to Balzac* Seen at Night at Meudon, gelatin silver print, 1908. Photo © ADAGP, Paris and DACS, London, 1999.

66. Medardo Rosso, *Conversation in a garden*, 1893–6, © Museo Medardo Rosso.

67. Umberto Boccioni, *Dynamism of a Speeding Horse + Houses*, 1914–15. Photo: David Heald, 1993, © The Solomon R. Guggenheim Foundation.

68. Vladimir Baranoff-Rossine, *Symphony No. 1*, 1913. The Museum of Modern Art, New York, Katia Granoff Fund. The Museum of Modern Art, New York, 1998.

69. Alexander Archipenko, *Femme à l'éventail*, 1914. Tel Aviv Museum of Art, © ARS, New York, and DACS, London 1999.

70. Pablo Picasso, *Glass, Knife and Sandwich on a Table*, 1914, © Tate Gallery, London, Succession Picasso and DACS, London, 1999.

71. Henri Laurens, *Tête* (also known as *Sainte tête d'homme*) 1915–18. ADAGP, Paris and DACS, London, 1999.

72. Vladimir Tatlin, *Selection of Materials: counter-relief, rosewood and zinc*, 1916. David King Collection, DACS, London, 1999.

73. Kurt Schwitters, *Merzbild*, 1924. Kurt Schwitters Archiv in Sprengel Museum, Hanover, © DACS, London, 1999.

74. Jacques Lipchitz, *Still-Life with Musical Instruments*, 1918, © Kunst Museum Hanover, Sprengel Collection.

75. Georges Vantongerloo, *Triptych*, 1921. Haags Gemeentemuseum, The Hague. Photo: Beeldrecht, © ADAGP, Paris and DACS, London 1999.

76. Cesar Domela, *Composition in relief*, 1936. Haags Gemeentemuseum, The Hague. Photo: Beeldrecht, © ADAGP, Paris and DACS, London 1999.

77. Joaquin Torres-García, *Composition*, 1931–4, IVAM, © ADAGP, Paris and DACS, London 1999.

78. Leon Tutundjian, *Untitled/Relief with cylinder*, 1929, Galérie Lucien Durand le Galliard, Paris.

79. Etienne Béothy, *Column in amaranthus*, 1935, © Musée de Grenoble.

80. Charles Biederman, *Structurist Work No. 3*, 1937. Private collection, © Bridgeman Art Library, London/New York.

81. László Moholy-Nagy, *Space Modulator*, 1922–30, reconstructed 1970. Van Abbe Museum, Eindhoven, Holland, © DACS, London 1999.

82. Constantin Brancusi, *Prometheus*, 1911. Philadelphia Museum of Art, The Louise and Walter Arensberg Collection, © ADAGP, Paris and DACS, London 1999.

83. Sophie Taeuber and Hans Arp, *Powder Box*, 1916 or later. Private collection, © DACS, London 1999.

84. Marcel Duchamp, *Trébuchet*, 1917. Palazzo Grassi, Venice, © ADAGP, Paris and DACS, London 1999.

85. Man Ray, *Nude woman with Alberto Giacometti's 'Objet désagréable'*, c.1932. Fundacio Gala–Salvador Dalí, © ADAG, Paris and DACS London 1999.

86. Paul Nougé, *La Subversion des Images*, selection of 5 out of 19 photographs, 1929–30. Courtesy Sylvio Perlstein Collection, Antwerp.

87. Jacques Boiffard, *Alberto Giacometti's 'Boule suspendue'*, 1931. Lucien Treillard, Paris.

88. Hans Bellmer, *Poupée: variations sur le montage d'une mineure articulée*, photographs reproduced in *Minotaure* 6, 1934–5. Courtesy Mme Ivana de Gavardie, © ADAGP, Paris and DACS, London 1999.

89. Gala Eluard, *Object of Symbolic Function*, reproduced in *Le Surréalisme au Service de la Révolution*, No. 3, 1931. Private collection.

90. Salvador Dalí, *Retrospective Bust of a Woman*, 1933, Dalí Theater-Museum,

Figueres, © Salvador Dalí, Gala–Salvador Dalí Foundation and DACS, London, 1999.

91. Hans Arp, *Two Thoughts on a Navel*, 1932, Stiftung Hans Arp und Sophie Taeuber-Arp, © DACS, London 1999.

92. Alberto Giacometti, *Objets mobiles et muets*, from *Le Surréalisme au Service de la Révolution*, No. 3, 1931, © ADAGP, Paris and DACS, London, 1999.

93. Marcel Duchamp, *Tu m'*, 1918, Yale University Art Gallery, © ADAGP, Paris and DACS, London, 1999.

94. Marcel Duchamp, *First Papers of Surrealism*, exhibition installation, Whitelaw Reid mansion, New York, 1942, © ADAGP Paris and DACS, London, 1999.

95. Frederick Kiesler, *Art of this Century* exhibition installation, New York, 1942. Private collection.

96. Kurt Schwitters, *Merzbau*, Hanover, photographed c.1930. Kurt Schwitters Archive in Sprengel Museum, Hanover, © ARS 1997, New York/VG Bildkunst, Bonn and DACS, London, 1999.

97. Leandre Cristófol, *Monument*, 1935. Private collection.

98. Yves Tanguy, *Indefinite Divisibility*, 1942, Albright-Knox Art Gallery, Buffalo, New York, Room of Contemporary Art Fund, 1945, © ARS, New York and DACS, London, 1999.

99. Henry Moore, *Four-Piece Composition: Reclining Figure*, 1934, © Tate Gallery London and The Henry Moore Foundation.

100. Constantin Brancusi, *Tirgu Jiu: Endless Column, Gate of the Kiss*, and *Table of Silence*, 1937–8, © ADAGP, Paris and DACS, London 1999.

101. Isamo Noguchi, *Contoured Playground*, 1940–1. Photo: Rudolph Burkhardt, © The Isamu Noguchi Foundation, New York.

102. Theo van Doesburg and C. van Eesteren, *Models for 'Maison Rosenberg', 'Maison d'Artiste' and 'Maison particulière'* at the exhibition *Les Architectes du Groupe De Stijl*, Galérie de l'Effort Moderne, Paris, 1923. Private collection.

103. Gerrit Rietveld, *Schröder House*, Utrecht, 1924, © Centraal Museum, Utrecht.

104. VKhUTEMAS workshop, students with three-dimensional work, mid-1920s. Photo courtesy of Dr Catherine Cooke.

105. Joost Schmidt, *Reliefs for Oskar Schlemmer's vestibule scheme in the Bauhaus*, Weimar, 1923, Bauhaus Archiv, Museum für Gestaltung, Berlin, © Dr Fritz Bliefernicht.

106. Kazimir Malevich, *Architekton Alpha*, 1923, © David King Collections, State Russian Museum.

107. Vladimir Tatlin, *Model of the Monument to the Third International*, exhibited in Moscow in 1920, reproduced in 1921. David King Collection © DACS, London, 1999.

108. Gustav Klutsis, *Kiosk Design*, 1922, David King Collection, © DACS, London, 1999.

109. Alexander Rodchenko, *Workers' Club*, Exposition Internationale des Arts Décoratifs et Industriels Modernes, Paris, 1925. David King Collection, © DACS, London, 1999.

110. Third OBMOKHU exhibition, Moscow, 1921, reproduced in *Veshch'*, 1922, David King Collection, © DACS, London, 1999.

111. Konstantin Medunetski, *Spatial Construction*, 1920, Yale University Art Gallery.

112. Katarzyna Kobro, *Spatial Composition 4*, 1929, Muzeum Sztuki, Lódz, photo: Piotr Tomczyk.

113. Vilmos Huszár and Gerrit Rietveld, *View of model room proposed for Greater Berlin Art Exhibition*, 1923, reproduced in *L'Architecture vivante*, 1924. Private collection.

114. Theo van Doesburg, *Aubette*, Strasbourg, 1928. Private collection.

115. Bauhaus Curriculum, Bauhaus-Archiv, Museum für Gestaltung, Berlin.

116. Varvara Stepanova, Acting Apparatus for Meyerhold's production of Sukhovo-Kobylin's *The Death of Tarelkin*, 1922, Society for Cooperation in Russian and Soviet Studies, © DACS, London 1999.

117. Oskar Schlemmer, *Bauhaus Dances: 'Delineation of Space by a Human Figure, danced by Siedoff'*, c.1927, Dessau. Private collection.

118. Piet Zwart, Design for an exhibition stand for a celluloid manufacturer, 1921, Haags Gemeentemuseum, © DACS, London, 1999.

119. Frederick Kiesler, *City in Space*, Exposition des Arts Décoratifs et Industriels Modernes, Grand Palais, Paris, 1925. Private collection.

120. Lazar El Lissitzky, Entrance to *Pressa* exhibition, Cologne, 1928, Museen der Stadt Köln, © Rheinisches Bildarchiv and DACS, London, 1999.

121. Lazar El Lissitzky, *Proun Room for the Greater Berlin Art Exhibition*, 1923, reconstruction, Haags Gemeentemuseum, © DACS, London, 1999.

122. Adolf von Hildebrand, *Der Junge Jäger*, 1910–20, from the Hubertusbrunnen, Nymphenburger Schlosskanal, Munich, 1895–1919.

123. Charles Despiau, *Jeune fille des Landes/ Jeune Landaise*, 1909, Musée des Beaux Arts, Bordeaux, photo: Lysiane Gautheir © ADAGP, Paris, and DACS, London, 1999.

124. Émile-Antoine Bourdelle, *Pénélope*, 1909, Stedelijk Museum Amsterdam © ADAGP, Paris and DACS, London, 1999.

125. Aristide Maillol, *Femme* (later known as *La Méditerranée*), 1905, Bibliothèque Nationale de France.

126. Marina Ryndzyunskaya, *A Stakhanovite Girl from the Cotton Fields*, 1940, State Tretyakov Gallery. Courtesy Matthew Cullerne Brown.

127. Jacques Lipchitz, *Head of Gertrude Stein*, 1920–1, The Cone Collection, Baltimore Museum of Art, © Baltimore Museum of Art.

128. Oto Gutfreund, *Self Portrait*, 1919, © Narodní Galerie V Praze, photo: Oto Pakin.

129. Toni Stadler, *Standing Woman*, Städtische Galerie, Stadelsches Kunstinstitut, Frankfurt, © Stadelsches Kunstinstitut, Frankfurt.

130. Paul Manship, *Diana* (from *Diana and Actaeon*), 1925, National Museum of American Art, Smithsonian Institute, Washington DC, gift of Paul Manship/Art Resource, New York.

131. Gaston Lachaise, *Standing Woman called Elevation*, 1912–27, Salander–O'Reilly Galleries, New York and Lachaise Foundation.

132. Demetre Chiparus, *Dancer*, c.1925–30, Virginia Museum of Fine Arts, Richmond, Gift of Sydney and Frances Lewis. Photo: Katherine Wetzel, © Virginia Museum of Fine Arts, ADAGP, Paris, and DACS, London, 1999.

133. Gerhard Marcks, *Thüringer Venus*, 1930, © Gerhard Marcks Stiftung, Bremen.

134. Palais de Tokyo, view of terrace and pool, Paris, Exposition internationale des arts et techniques dans la vie moderne, 1937, © Roger–Viollet, Paris.

135. Enrico Del Debbio, *Stadio dei Marmi*, Foro Mussolini, Rome, 1932. Private collection.

136. Osbert Lancaster, 'Third Empire' and 'Marxist Non-Aryan', cartoons from *Faces and Façades* (John Murray, London, 1950). Courtesy of John Murray Publishers Ltd, London.

137. 'Garvens', caricature from the German satirical magazine *Kladderadatsch*, 1933. Private collection.

138. Josef Thorak, *The Boxer*, press photograph 1936. Private collection.

139. Vera Mukhina, *Industrial Worker and Collective Farm Worker*, stainless steel cladding on armature, Paris, 1937, David King Collection, © DACS, London 1999.

140. B.M. Iofan, V.A. Schuko and V.G. Gel'freikh, *Project for the Palace of the Soviets*, © Schusev Architecture Museum, Moscow.

141. Arno Breker, *The Party*, courtyard of the New Reich Chancellery , Berlin, 1939. Private collection.

142. George Kolbe, *Studio photo*, 1934 © Georg Kolbe Museum, Berlin, and DACS, London, 1999.

143. Marino Marini, *Giocoliere*, 1939, Museo San Pancrazio, © DACS, London, 1999.

144. Isamo Noguchi, model for *Sculpture to be seen from Mars*, 1947. Courtesy Isamo Noguchi Foundation, New York.

145. Germaine Richier, *La Mante (grande)* 1946, Museum an Ostwall, Dortmund, © VG Bildkunst.

Bibliographic Essay

This bibliography relates to the writing of this book; it is by no means comprehensive. The bibliography for each chapter lists books specifically relating to the text. Sources cited are not necessarily recommended but may be all that is available. This is especially so in the case of monographs on individual sculptors on which we continue to be reliant in the absence of more scholarly works integrating sculpture into a broader historical context. Readers looking for alternative surveys are advised to look at sections II and III at the end, which list other surveys currently in print and post-1945 publications.

Note: Monographs on individual artists are listed under the artist's name.

General background

The following pre-war surveys, contemporary with our period, provide an excellent background, and all but the first provide a useful corrective to a modernist reading of the period:

Carola Giedion-Welcker, *Modern Plastic Art* (Zurich, 1937). A book designed to instruct and to convert, doing this partly by means of comparative illustrations of ancient and vernacular sculpture or natural forms. A seminal book defining what was to be established as the canon of modernism in sculpture.

A. Heilmeyer & Rafael Benet, *La Escultura moderna y contemporanea* (Barcelona, 1928).

Malvina Hoffman, *Sculpture Inside and Out* (London, 1939). A lively personal account, enriched with informative studio photographs (as well as illustrations of Carnac, like Giedion-Welcker).

Herbert Maryon, *Modern Sculpture* (London, 1933). Excellent and unusual illustrations.

Kineton Parkes, *Sculpture of To-Day*, 2 vols (London, 1921). A broad-ranging international survey.

Wilhelm Radenburg, *Moderne Plastik: Einige Deutsche & Ausländische Bildhauer & Medaillaure Unserer Zeit* (Düsseldorf/Leipzig, 1912).

Agnes Rindge, *Sculpture* (New York, 1929).

Lorado Taft, *Modern Tendencies in Sculpture* (1921), (Freeport, N.Y., 1970).

and, in addition:

Robert Maillard (ed.), *A Dictionary of Modern Sculpture* (London, 1962). A most helpful and unusually comprehensive reference book including 365 biographical sketches from 25 national specialists.

Section I

Introduction
Rodin

There is an enormous literature on Rodin; here I single out sources specific to the writing of this book:

Nicole Barbier, *Marbres de Rodin, Collection du musée* (Paris, 1987).

Ruth Butler, *Rodin in Perspective* (Englewood Cliffs, N.J., 1980). A useful collection of contemporary reviews and articles.

Ruth Butler, *Rodin, The Shape of Genius* (New Haven & London, 1993). The most recent biography.

Albert E. Elsen, *In Rodin's Studio, A photographic record of sculpture in the making* (Oxford, 1980).

A.E. Elsen, *Rodin Rediscovered* (Washington, National Gallery of Art, 1981-2). Excellent group of essays; see especially those by Rosenfeld, Varnedoe and Elsen himself on Rodin's workshop and on his relationships with photographers and technicians.

Chapter 1: The Public Place of Sculpture

The bibliography for this section is organized by country. I have asterisked particularly helpful introductory texts.

The Conway Library in the Courtauld Institute of Art, London, is a photographic library particularly helpful for the architectural and decorative sculpture poorly served by books. Some of the most useful publications are those published before 1945, before the tide had so definitively turned in favour of modernist sculpture. Much of my background for this chapter derives from research undertaken for my doctorate (see under France in Ch.2).

General
Art and Power, *Europe under the Dictators*, exh. cat. (London, Hayward Gallery, 1995).

Belgium
Paris–Bruxelles, exh. cat. (Paris, Grand Palais, 1997).
Micheline Hanotelle, *Paris–Bruxelles* (Paris, 1997).

Czechoslovakia
Peter Cannon-Brookes, *Czech Sculpture 1800–1938* (London, 1983).
Penelope Curtis, 'Oto Gutfreund and the Czech National Decorative Style', *The Journal of Decorative and Propaganda Arts* (Miami, Spring 1987), 30–45.
Antonin Matejcek & Zdenek Wirth, *Modern and Contemporary Czech Art* (London, 1924).

France
*Maurice Agulhon**, 'Imagerie civique et décor urbain dans la France du XIXe', *Ethnologie française*, 1975, 33–56.
Coloniales, 1920–1940 (Paris, Musée Municipal de Boulogne-Billancourt, 1989). French artistic–colonial links.
Penelope Curtis, 'The Hierarchy of the Sculptor's Workshop' in Jackie Heuman (ed.), *From Marble to Chocolate* (London, 1995). A case-study using the example of E.-A. Bourdelle.
Alain-Renaud Diot, *Le Pierre de Sacrifice ou l'art de la guerre: les monuments aux morts en France, 1870–1940*, doctoral thesis, (University of Paris I, 1980).
H.C.E. Dujardin-Beaumetz, *Discours prononcés* (Paris, 1913). A collection of ministerial inauguration speeches.
Bruno Foucart et al., *L'Art Sacré au XXe Siècle en France* (Boulogne-Billancourt, 1993).

Useful collection of essays and inventory of artists working for the church.
Livre du Centenaire de la reconstruction de l'Hôtel de Ville 1882–1982 (Ville de Paris, Bibliothèque Administrative, 1982). In-depth study of the scheme of commissions.
A. Le Normand-Romain, *Mémoire de Marbre, La Sculpture funéraire en France 1804–1914* (Paris, 1995).
1913: Le Théâtre des Champs-Elysées, exh. cat. (Paris, Musée d'Orsay, 1987).

Germany
Robert R. Taylor, *The Word in Stone*, *The Role of Architecture in the National Socialist Ideology* (Los Angeles, 1974).

Great Britain
Alan Borg, *War Memorials* (London, 1991). Flawed account with some useful material.
Richard Cork, 'The British Medical Association Building' in *Jacob Epstein, Sculpture and Drawings* (Leeds, 1987), and 'Overhead Sculpture for the Underground Railway' in *British Sculpture in the Twentieth Century* (London, Whitechapel Art Gallery, 1981).
Terry Friedman et al., *The Alliance of Sculpture and Architecture, Hamo Thornycroft, John Belcher and the Institute of Chartered Accountants Building* (Leeds, 1993).
Eric Gill, *Autobiography* (London, 1940).
T. S. Halliday & George Bruce, *Scottish Sculpture: Record of 20 years* (Dundee, 1946).
Fiona MacCarthy, *Eric Gill* (London, 1989).
*Catherine Moriarty**, 'The Absent Dead and Figurative War Memorials', *Transactions of the Ancient Monuments Society*, vol. 39, 1995, 7–40.
Helen Smailes, *A Portrait Gallery for Scotland* (Edinburgh, 1985).

Netherlands
*Yves Koopmans**, *Fixed and Chiselled, Sculpture in architecture 1840–1940* (Rotterdam, 1994), covering Holland. Excellent introductory text in Dutch and English and informative illustrations.

Norway
Ragna Stang, *Gustav Vigeland, The Sculptor and His Works* (Oslo, 1980).
Gustav Vigeland (1869–1943), exh. cat. (Paris, Musée Rodin, 1981).

Russia
The Twilight of the Tsars, Russian Art at the Turn of the Century, exh. cat. (London, South Bank Centre, 1991).

Spain
Edward Tolosa & Daniel Romani, *Barcelona: escultura guia/sculpture guide* (Barcelona, n.d.).

United States of America
*__Michele H. Bogart__, *Public Sculpture and the Civic Ideal in New York City, 1890–1930* (Chicago, 1989). Excellent.
*__James M. Dennis__, *Karl Bitter, Architectural Sculptor 1867–1915* (Madison, Milwaukee, 1967). Illuminating.
*__Timothy J. Harvey__, *Public Sculptor, Lorado Taft and the Beautification of Chicago* (Chicago, 1988).
Elisabeth Liden, *Between Water and Heaven, Carl Milles, Search for American Commissions* (Stockholm, 1986).

Chapter 2:
The Tradition of the Monument
There is a substantial overlap between the bibliography for this chapter (again divided by country) and that for the last. My own research (see below) has inevitably provided my background to the area. Contemporary guides are invaluable; see especially Kineton Parkes and Agnes Rindge cited under general background.

Argentina
Alain Amato, *Monuments en exil* (Paris, 1979). Revealing introduction to the work of French sculptors in South America (especially Argentina), North Africa and elsewhere.
Eduardo Balieri et al., *Buenos Aires y sus esculturas* (Buenos Aires, 1981).

Australia
Graeme Sturgeon, *The Development of Australian Sculpture 1788–1975* (London, 1978).

France
Michèle C. Cone, *Artists under Vichy: a case of prejudice and persecution* (Princeton, 1992).
Penelope Curtis, *E.-A. Bourdelle and Monumental Sculpture in France 1890–1930*, PhD (London, University of London, 1989).
Penelope Curtis, 'E.-A. Bourdelle, The Statuaire's Status', *Gazette des Beaux-Arts*, Paris, VIe Période, CXXI, May–June 1993, 241–50.
Bruno Foucart, Michèle Lefrançois et al., *Paul Landowski* (Saint Ouen, 1989).
*__Jacques Lanfranchi__, *Statues de Paris, 1800–1940*, doctoral thesis (University of Paris I, 1979).
'Les statues de Paris', *L'Illustration*, 3692, 29 November 1913, 414.

Young Bang Lin, *Les statues commemoratives de Paris 1870–1940*, Mémoire principal pour le diplôme d'Études supérieurs de l'Institut d'Art et d'Archéologie (Paris, 1961).
*__Chantal Martinet__, *Statues et monuments commemoratifs en Seine-et-Marne 1852–1914*, doctoral thesis (University of Paris I, 1979).
Nineteenth Century French sculpture: monuments for the middle class, exh. cat. (Louisville, J.B. Speed Art Museum, 1971).
Antoine Prost, 'Les monuments aux morts' in **Pierre Nora** (ed.), *Les Lieux de mémoire, I: La République*, vol. 1 (Paris, 1984).
Michel Vovelle, 'Le deuil bourgeois. Du faire-part à la statuaire funéraire', *Le Débat*, 12 May 1981, 60–82.
Michel Vovelle, *La Mort aujourd'hui* (Marseille, 1982).
Auguste Rodin: Le Monument des Bourgeois de Calais (Calais, Musée des Beaux-Arts/Paris, Musée Rodin, 1977).

Germany
Peter Adam, *The Arts of the Third Reich* (London, 1992).
Art and Power (London, Hayward Gallery, 1995), especially the essays of Bernd Nicolai and Ian Boyd White.
E. Mai (ed.), *Denkmal–Zeichen–Monument, Skulptur und öffentlicher Raum heute*, Conference, Munich 1986–7 (Munich, 1989).
Barbara Miller Lane, 'National Romanticism in Modern German Architecture' in *Nationalism in the Visual Arts*, Conference, Baltimore, 1987 (Washington, 1991).
Karen Lang, 'Monumental Unease: Monuments and the Making of National Identity in Germany', in *Imagining Modern German Culture 1889–1910* (National Gallery of Arts, Washington, 1997).
Irit Rogoff (ed.), *The Divided Heritage: Themes and Problems in German Modernism* (Cambridge, 1991), especially the essays by Sebastian Müller, Hans-Ernst Mittig, and Ian Boyd White.

Great Britain
Penelope Curtis, 'The Whitehall Cenotaph: An Accidental Monument', *Imperial War Museum Review*, 9 (London, 1994).
*__Ben Read__, *Victorian Sculpture* (London, 1982).

Italy
Art and Power (London, Hayward Gallery, 1995), essays by Tim Benton.
Richard Etlin, 'Nationalism in Modern Italian Architecture 1900–1940' (Washington, 1991). See Lane under Germany above.

Laura Malvano, *Fascismo e politica dell'immagine* (Turin, 1988).

Mexico
Helen Escobedo, *Mexican Monuments* (New York, 1989).
M. Nelken, *Escultura Mexicana* (Mexico, 1951).

United States of America
Marianne Doezma & June Hargrove, *The Public Monument and Its Audience* (Cleveland, 1977). Despite its title, this slim book relates only to Ohio.

USSR
Brandon Taylor, *Art and Literature under the Bolsheviks* (London, 1991–2).
Matthew Cullerne Bown, *Art Under Stalin* (Oxford, 1991).
Igor Golomstock, *Totalitarian Art in the Soviet Union, the Third Reich, Fascist Italy and the People's Republic of China* (London, 1990).

Chapter 3:
Direct Expression through the Material
The bibliography here mainly relates to individual monographs, arranged alphabetically by artist's surname. British readers are advised that the library of the Henry Moore Institute in Leeds is especially useful for monographic material.

General
***Stephanie Barron**, *German Expressionist Sculpture* (Los Angeles, County Museum of Art, 1983). Includes translations of contemporary texts by artists and critics such as Max Sauerlandt, P.R. Henning, Kirchner, and Pechstein.
Philippe Durey, 'Techniques et organisation des ateliers au XIXe siècle', *Monuments historiques*, VIII/2–3, 191–200 (Paris, 1985).
Carl Einstein, *Negerplastik* (Leipzig, 1915 & Munich, 1920).
***Patrick Elliott**, *Sculpture en taille directe en France de 1900 à 1950* (Saint-Rémy-les-Chevreuses, Fondation Coubertin, 1988).
Gillian Naylor, *The Bauhaus Reassessed* (London, 1985).
A. Le Normand-Romain, 'La taille directe' in *La Sculpture française au XIXe siècle* (Paris, Grand Palais, 1986). One of many helpful texts in a major catalogue covering most aspects of sculptural practice.
Pergola de la Douce France: Documentation du Musée d'Orsay.

Monographic
Arp: *On my Way* (New York, 1948), and see Carola Giedion-Welcker, *Contemporary Sculpture* (London, 1961) 114–15 for examples of his concretions photographed outdoors.
***Barlach**: N.J. Groves (Königstein im Taunus, 1972) which includes translations of Barlach's writing, and (Paris, Musée d'Orsay, 1988). Bernard: exh. cat. (Lisbon, Calouste Gulbenkian, 1992) in Portuguese and French; useful group of essays including Bernard's influence in Portugal.
Boccioni: see Robert Herbert, *Modern artists on art: ten unabridged essays* (New York, 1986).
Brancusi: E. Balas, *Brancusi and Romanian Folk Trades* (New York, 1987) and monographs by E. Shanes (New York, 1988), R. Varia (New York, 1986), A.C. Chave (London, 1993), S. Miller (Oxford, 1995).
Calder: *An Autobiography with Pictures* (London, 1967).
Casanovas: (Barcelona, Palau de la Virreira, 1984–5).
***Costa**: see Paul-Louis Rinuy, 'Joachim Costa (1888–1971) "Apôtre de la taille directe" dans l'entre-deux-guerres', *Soc. Hist. Art. français*, 13 January 1990, 296–307.
José de Creeft: Jules Campos (New York, 1972).
Epstein: *Let there be Sculpture* (London, 1940).
Flannagan: see Wayne Craven, *Sculpture in America* (Cranbury & London, 1963 revised 1984).
Gauguin: Christopher Gray, *Sculpture and Ceramics of Paul Gauguin* (Baltimore, 1963 & New York, 1980).
Giacometti: Valerie Fletcher (London, 1988).
González: exh. cat. (London, South Bank Centre/Whitechapel, 1990).
Hepworth: *Retrospective* (London, Tate Gallery Liverpool, 1994); *Pictorial Autobiography* (London, 1998).
Kirchner: see Jill Lloyd's *German Expressionism* (New Haven & London, 1991).
Lacombe: Blandine Salmon and Olivier Meslay (Paris, 1991).
Lipchitz: exh. cat. (Toronto, Art Gallery of Ontario, 1989).
Meštrović: Dusko Keckemet (Belgrade, 1983).
Modigliani: Alfred Werner (New York, 1962) and (Paris, Musée d'Art moderne de la Ville de Paris, 1981).
Moholy-Nagy: *The New Vision* (1928, 4th edn, 1947) and useful edition of writings by and on Moholy edited by Richard Kostelanetz (New York, 1970).
Noguchi: exh. cat., Walker Art Center (Minneapolis, 1978); *Essays and Conversations*,

ed. by B. Altshuler and D. Apostolos-Cappadona (New York, 1994); illuminating.

Picasso: see Peter Read's essay in *Picasso: Sculptor/Painter* (London, Tate Gallery, 1994) and also *Age of Iron*, exh. cat. (New York, Guggenheim, 1993).

Smith: see his own biography (1950) in C. Gray (ed.) (London, 1988); Rachel Kirby's biography in J. Merkert (ed.) (Munich, 1986) and K. Wilkin (New York, 1984).

Stokes, *Stones of Rimini* (London, 1934, & New York, 1969).

Zorach: see J.I.H. Baur (New York, 1959) for 'Direct Sculpture', a paper given in New York in 1930 and Wayne Craven, *Sculpture in America* (Cranbury & London 1963, rev. 1984).

Chapter 4: The Private Arena
Key texts

Années 30 en Europe: Le Temps Menaçant 1929–1939, exh. cat. (Paris, Musée d'Art moderne de la Ville de Paris, 1997). Profusely illustrated pan-European survey of painting and sculpture.

Arte Abstracto, Arte Concreto, Cercle et Carré 1930 (Valencia, IVAM, 1990) with important essays by Gladys Fabre.

Stephen Bann, *The Tradition of Constructivism* (London, 1974). Invaluable collection of contemporary texts with useful commentary.

Carel Blotkamp, *De Stijl: The Formative Years 1917–1922* (Utrecht, 1982; Cambridge & London, 1986). Excellent group of research essays by Blotkamp and his students.

Qu'est-ce que la sculpture moderne? exh. cat. (Paris, Centre Georges Pompidou, 1986). See also contemporary Parisian magazines including *Abstraction-Création* (1932-6) and *Plastique* (1937–9).

General

Riva Castleman (ed.), *Art of the Forties* (New York, MOMA, 1991).

Milton Friedman (ed.), *De Stijl: 1917–1931* (Oxford, 1982) (exh. cat., Walker Art Center) with accessible range of essays.

Serge Lemoine, 'Les Rendez-vous de Hanovre', in *Paris–Berlin 1900–1933* (Paris, Centre Georges Pompidou, 1978). Helpful on Hanover's combination of significant exhibition sites (Kestner-Gesellschaft and Provinzial Museum), curators (Paul-Erich Kuppers and Alexander Dorner) and artists (Schwitters, Jahns, Buchheister, Vordemberge-Gildewart, Domela).

Carsten-Peter Warncke, *De Stijl 1917–31* (Cologne, 1991).

Monographic

Archipenko: exh. cat. ed. by D.H. Karshan (Washington, 1969).

Arp: S. Poley & J. Hancock (Cambridge, 1987).

Chester Beach: see Katherine Solender, *The American Way in Sculpture 1890–1930* (Cleveland Museum of Art, 1986).

Boccioni: see Robert Herbert, *Modern artists on art: ten unabridged essays* (New York, 1986).

Brancusi: Pontus Hulten (London, 1988).

Calder: J.J. Sweeney (New York, MOMA, 1951).

Domela: Christian Zervos (Amsterdam, 1965), and exh. cat. (Calcutta, 1979).

Freundlich: *Eröffnung der Stiftung* (Pontoise, 1969).

Gorin: Alberto Sartoris (Venice, 1975). In four languages.

Lipchitz: *My life in sculpture* (London, 1972).

Matisse: Isabelle Monod-Fontaine, *Sculptures*, exh. cat. Arts Council of Great Britain (London, 1984) and Lawrence Gowing (London, 1979).

Meyer: *Architekt Urbanist Lehrer Hannes Meyer 1889–1954* (Berlin, 1989); cat. of travelling exh., Bauhaus-Archiv, Berlin etc.

Mondrian: see Carel Blotkamp and Robert Herbert cited above.

Picasso: *The Essential Cubism 1907–1920*, exh. cat. (London, Tate Gallery, 1983).

Rosso: exh. cat. (Santiago de Compostela, Centro Galego de Arte Contemporanea, 1996). Interesting group of texts by Rosso and by contemporary artists like Tony Cragg and Thomas Schütte; see also exh. cat. (London, South Bank Centre 1994).

Vantongerloo: see Blotkamp above and *Vantongerloo/Bill*, exh. cat. (London, Annely Juda Gallery, 1996).

Vordemberge-Gildewart: exh. cat. (London, Annely Juda Gallery, 1974).

Chapter 5 : The Object: Function, Invitation and Interaction
Key texts

Friedrich Teja Bach, Margit Rowell, & Anne Temkin, *Brancusi*, exh. cat. Paris & Philadelphia (MIT, Cambridge & London 1995).

André Breton, *Manifestoes of Surrealism* (trans. by Richard Seaver & Helen R. Lane) (Ann Arbor, University of Michigan Press, 1982). *El Objeto Surrealista*, exh. cat. (Valencia, IVAM, 1997–8) with stimulating essay by Emmanuel Guignon.

Jane Hancock & Stefanie Poley, *Arp 1886–1966* (Cambridge, 1987) (Minneapolis

Institute of Arts, 1986). An exemplary exh. cat., with essays by the editors and by Jean-Louis Faure, Aline Vidal, and Gabriele Mahn.

Pontus Hulten, Natalia Dumitresco, & Alexandre Istrati, *Brancusi* (London, 1988) (first pub. Paris 1986). A useful book combining catalogue of works, a detailed chronology by Brancusi's two Romanian assistants, and an essay by Hulten.

Pontus Hulten (ed.), *Marcel Duchamp* (London, 1993) (exh. cat., Palazzo Grassi, Venice). Divided into two sections, life and work, this seemingly impenetrable catalogue is in fact a revealing and rich source of information.

See also contemporary Surrealist journals: *Le Surréalisme au service de la Révolution*, *Documents*, *Minotaure*, and also *Cahiers d'Art*.

General

Années 30 en Europe: Le Temps Menaçant 1929–1939, exh. cat (Paris, Musée d'Art moderne de la Ville de Paris, 1997).
Alfred Barr, *Fantastic Art, Dada and Surrealism* (New York, MOMA, 1936).
L'Ivresse du Réel, exh. cat. Carré d'Art, Nimes (Paris, RMN, 1993).
Robert Motherwell, *Dada Painters and Poets* (New York, 1951).
William Rubin, *Dada, Surrealism and Their Heritage* (New York, MOMA, 1968).

Monographic

Dali: Dawn Ades (London, 1982).
Duchamp: Pierre Cabanne, *Dialogues with ...* (London, 1971) and *Duchamp: The almost complete works of ...*, exh. cat. (London, Tate Gallery & Arts Council, 1966).
Giacometti: (Edinburgh, Scottish National Gallery of Modern Art & Vienna 1996) and monograph by Yves Bonnefoy (Paris, 1991).
Kiesler: (New York, Whitney Museum of Art, 1989). Accessible essays, though rather repetitive of each other.
Moholy-Nagy: *The New Vision* (New York, 1967). Reprint in 'The documents of modern art' series from the 1947 4th edn (first published 1928).
Noguchi: Bruce Altshuler (New York, 1994).
Schwitters: exh. cat. (Paris, Centre Georges Pompidou, 1994). See esp. essay on the Merzbau by Dietmar Elger; see also Robert Motherwell and William Rubin above.

Chapter 6: A Shared Ideal: Sculpting Public Space

Key texts

Stephen Bann, *The Tradition of Constructivism* (London, 1974).
Bauhaus 1919–1928, exh. cat. ed. by Herbert Bayer, Walter Gropius, & Ise Gropius (reprint of MOMA 1938 catalogue) (London, 1984).
Christina Lodder, *Russian Constructivism* (New Haven & London, 1983).
Gillian Naylor, *The Bauhaus Reassessed: Sources and design theory* (London, 1985).
Nancy Troy, *Modernism and the decorative arts in France: art nouveau to Le Corbusier* (New Haven & London, 1991).
Paris–Berlin 1900–1933, exh. cat., Centre Georges Pompidou (Paris, 1978) with useful texts by Hans Wingler on Bauhaus pedagogy and Wend Wischer on the Werkbund.
Frank Whitford, *Bauhaus* (London, 1984).

General

Ulrich Conrads & Hans G. Sperlich, *Fantastic Architecture* (London, 1963). Useful for illustrations and extracts from architects' writing.
Klaus-Jurgen Sembach, *Into the Thirties: style and design 1927–34* (London, 1972). Useful for photographs of buildings.

Germany

Eberhard Roters, *Berlin 1910–1933* (Berlin, 1983). Broad-ranging and useful illustrations.
B. Schrader & Jurgen Scheben, *The 'Golden' 20s: Art and Literature in the Weimar Republic* (New Haven & London, 1988).
Frederic J. Schwartz, *The Werkbund: Design Theory and Mass Culture before the First World War* (New Haven & London 1996). Detailed discussion of the early (and divided) years of the Werkbund and its shift from focusing on the producer to focusing on the product and its dissemination.
Uwe Westphal, *The Bauhaus* (London, 1991).
H.M. Wingler, *Das Bauhaus* (Schauberg, 1962). Authoritative account full of original documentation.

Great Britain

Thirties, exh. cat., Arts Council (London, Hayward Gallery, 1979).

Netherlands

De Stijl: see Blotkamp above and also Paul Overy (London, 1969).

USSR

David Elliott, *New Worlds: Russian Art & Society 1917–37* (Oxford, 1986). Introductory overview.

M. N. Iablonskaia, *Women Artists of Russia's New Age 1900–1935*, (London, 1990). Includes a broad range from monumental-realist sculptors such as Mukhina and Lebedeva to the better-known female Constructivists.

John Milner, *Russian Revolutionary Art* (London, 1979).

O.A. Shvidkovsky, *Building in the USSR 1917–32* (London, 1971).

Brandon Taylor, *Art and Literature* ... see above under Ch. 2; 2 vols useful for the non-avant-garde and for the complex shifts within the party-political–art nexus during the later 1920s and early 1930s.

The Avant Garde in Russia 1910–30, *New Perspectives*, exh. cat. (Los Angeles, County Museum, 1980).

Monographic

Arp: see J.L. Faure's essay on the Aubette in Hancock & Poley (Cambridge, 1987) and C.P. Warncke's *De Stijl* (Cologne, 1991) for photographs.

Carabin: exh. cat., Musée de Strasbourg/Musée d'Orsay (Strasbourg, 1993).

Duchamp-Villon: M.N. Pradel, 'La Maison Cubiste en 1912', *L'Art de France* (University of Paris I) 1961.

Huszár: see Blotkamp, and also Nancy Troy's essay in Friedman (ed.), both listed under Ch. 4.

Kiesler: see Whitney catalogue (New York, 1989) listed above under Ch. 5.

Klutsis: Angelica Rudenstine, *The George Costakis Collection, Russian Avant-Garde Art* (London, 1981).

Kobro: exh. cat. (Mönchengladbach, 1991, and Leeds, 1999). Useful for her original Polish texts in German and English.

Le Corbusier: see review by A. Saint of H.A. Brooks, *London Review of Books*, vol. 19, no. 19, 1997.

Le Corbusier and Ozenfant: see text on Purism reprinted in Robert Herbert cited above.

Lissitzky: *Life–Letters–Texts*, ed. by Sophie Lissitzky Kuppers (London, 1980, reprint of 1967 edition).

Malevich: exh. cat. (Washington, Los Angeles, New York, 1990–1); Rainer Crone & David Moos, *Kazimir Malevich* (London, 1991); see also the 'Suprematism' extract republished in Robert Herbert.

Mies van der Rohe: Franz Schulze (Chicago, 1985 & 1989); Werner Blaser (Barcelona, 1996);

Frank Russell (ed.) (London, 1986).

Popova: see M.N. Iablonskaia listed above under USSR.

Rodchenko: *Écrits complets* (Paris, 1988).

Schlemmer: Karin von Maur (Stuttgart, 1972) and exh. cat. (Baltimore, Museum of Art, 1986). Substantial work with useful range of essays.

Rietveld: see Paul Overy on Rietveld's Furniture in P. Voge (ed.), *Complete Rietveld Furniture* (Rotterdam, 1993).

Stepanova: Alexander Lavrentiev (London, 1988).

Tatlin: Larissa Jadova (ed.) (Paris, 1990). Major selection of original letters and documents.

Chapter 7: The Figurative Ideal
Key texts

Art and Power, Europe under the Dictators, exh. cat. (London, Hayward Gallery, 1995). *On Classic Ground*, exh. cat. (London, Tate Gallery, 1990), esp. essays by Robin Barber, Emily Braun, Patrick Elliott, and Marilyn McCully.

General

Années 30 en Europe: Le Temps Menaçant 1929–1939, exh. cat. (Paris, MAMVP, 1997).

Franco Borsi, *The Monumental Era: European Architecture and Design 1929–39* (London, 1987). Not as helpful as it might be, but good illustrations.

Igor Golomstock, *Totalitarian Art* (London, 1990). See under Ch. 2.

Art Deco

Art Deco lends itself all too easily to glossy publishing; only the first of the books here can be recommended for its text.

Jeffrey L. Meikle, *Twentieth Century Limited: Industrial Design in America 1925–39* (Philadelphia, 1979).

Alastair Duncan, *Art Deco* (London, 1988).

Alastair Duncan, *American Art Deco* (London, 1986).

Patricia Bayer, *Art Deco Source Book* (Oxford, 1988).

Bevis Hillier & Stephen Escritt, *Art Deco Style* (London, 1997).

France

Michèle C. Cone, *Artists under Vichy* (Princeton, 1992); see Ch. 2.

Penelope Curtis: 'Sculpting in Patois' in *From Rodin to Giacometti: Sculpture and Literature in France 1880–1950* (ed. Keith Aspley et al.) (Amsterdam & Atlanta, 1999).

Romy Golan, *Nostalgia and Modernity:*
art and politics in France between the wars
(New Haven & London, 1995).
L'art indépendant (Paris, Musée d'Art
moderne de la Ville de Paris, 1987).
La Bande à Schnegg, exh. cat. (Paris, Musée
Bourdelle, 1974).
Marilyn McCully in *On Classic Ground*;
see under key texts above.
Paris 1937: Cinquantenaire de l'exposition
internationale des arts et des techniques dans la
vie moderne, exh. cat. (Paris, Musée d'Art
moderne de la Ville de Paris, 1987).
Paris–Paris 1937–1957 (Paris, Centre Georges
Pompidou, 1981), see esp. Patrick Weiser,
'L'Exposition Internationale, l'État et les
Beaux-Arts'; also helpful on 'Les maîtres de
l'art indépendant'and on artists' flight to the
south during Occupation.

Finland
Lauri Leppänen, *Suomen Kuvanveistotaidetta*
(Porvoo/Helsinki, 1954).

Germany
Peter Adam, *The Arts of the Third Reich*
(London, 1992).
Stephanie Barron (ed.), *German*
Expressionism 1915–25: The Second Generation
(Los Angeles, County Museum, 1988).
Ursel Berger, *Figurliche Bildhauerei im*
Georg-Kolbe Museum (Cologne, 1994).
German Art in the Twentieth Century: Painting
and Sculpture 1905–1985 (London, Royal
Academy, 1985); see especially essays by
Schuster and Hohl.
Alfred Hentzen, *German Art of the 20th*
century (New York, MOMA, 1957).
Berthold Hinz, *Art in the Third Reich*
(Oxford, 1980). Predominantly about
painting, but useful illustrations.
Hans-Ernst Mittig, 'Art and Oppression in
Fascist Germany' in Irit Rogoff (ed.), cited
above at Ch. 2. Subtle and nuanced evaluation.
Bernd Nicolai, 'Tectonic Sculpture', in
Art and Power cited above at Ch. 1.
Alan E. Steinweiss, *Art, Ideology and*
Economics in Nazi Germany: The Reich
Chambers of Music, Theatre and the Visual
Arts (Chapel Hill, N.C., 1993).
Brandon Taylor & Wilfried van der Will
(eds), *The Nazification of Art* (Winchester,
1990). Useful collection of essays; see esp.
Fischer-Defoy.
Gert von der Osten, *Plastik des 20.*
Jahrhunderts in Deutschland, Österreich
und der Schweiz (Taurus, 1962).
Ian Boyd Whyte, 'Berlin 1870–1945',

in Rogoff (ed.) *The Divided Heritage*,
cited above at Ch. 2.

Italy
See Braun in *On Classic Ground* listed under
key texts.
Scultura italiana del primo novecento (exh. cat.,
Castello Estense) (Mesola, 1992).

USSR
Matthew Cullerne Bown, *Art under Stalin*
(Oxford, 1991).

Monographic
Aaltonen: exh. cat. (Turku, Waino Aaltonen
Museum, 1994).
Chiparus: Alberto Shayo (New York, 1993).
Despiau: *Collections du Musée Municipal*
(Mont-de-Marsan, 1982).
De Fiori: Beatrice Vierneisel (Berlin, 1992).
Gargallo: exh. cat. (Paris, Musée d'Art
moderne de la Ville de Paris, 1981).
Gutfreund: see Peter Cannon-Brookes cited
above at Ch. 1.
Hildebrand: Sigrid Esche-Braunfels
(Berlin 1993); substantial account of his
complete oeuvre.
Kolbe: Ursel Berger (Berlin, 1994). Account
of life and work with informative studio
photographs and catalogue of the collection.
Berger also edited the recent catalogue
(Munich, 1997) with various essays including
Josephine Gabler on Kolbe in the Third
Reich.
Lachaise: Sam Hunter (New York, 1993).
Laurens: exh. cat. (Lille, Musée d'Art moderne
de Villeneuve d'Ascq, 1992). See esp. essay by
Gladys Fabre on his architectural sculpture.
Lipchitz: *My Life in Sculpture* (London, 1972)
and A. M. Hammacher (New York, 1975).
Maillol: Maillol is not well studied. The
catalogue of the recent exhibition ed. by
Ursel Berger & Jorg Zutter (Munich, 1996),
which includes useful texts by Antoinette
Le Normand-Romain, Paul-Louis Rinuy,
and Arie Hartog, is not translated. Bertrand
Lorquin (Geneva 1994/London 1995) is
more than the coffee-table book which
it appears to be.
Manship: Harry Rand (London, 1989).
Manzu: Livia Velani (ed.) (Milan, 1987)
(exh. cat., Edinburgh, 1988); see also earlier
monographs by C.L. Ragghianti (Milan, 1957)
and John Rewald (London, 1967).
Marcks: biographical material from Gerhard
Marcks Haus, Bremen; for English language
material see also exh. cat. (Los Angeles,
UCLA, 1969).

Marini: Sam Hunter (New York, 1993) and interview in Edouard Roditi, *Dialogues on Art* (London, 1960).

Martels: cat. of travelling exh. Roche-sur-Yon/Boulogne-Billancourt/Mont-de-Marsan/Roubaix (1996-7). Useful on general context.

Martini: Guido Peroco (Treviso, 1966). Helpful account.

Matisse: exh. cat., Centre Georges Pompidou (Paris, 1989); see also E.G. Guse, ed. (Munich, 1991).

Mukhina: see Iablonskaia in Ch. 6 above.

Picasso: M.-L. Besnard-Bernadec et al. (eds), *Musée Picasso, Catalogue sommaire* (Paris, 1985), *Picasso: Sculptor/Painter*, exh. cat. (London, Tate Gallery, 1994).

Pompon: Catherine Chevillot et al. (Paris, 1994); exh. cat., Dijon/Paris/Roubaix/Rodez; substantial cat of works and of his commissions as a *praticien*.

Schnegg (Gaston): exh. cat., Musée des Beaux-Arts (Bordeaux, 1986).

Scudder: see Katherine Solender, op. cit. in Ch. 3 above.

Speer: *Inside the Third Reich* (London, 1970).

Tait McKenzie: Christopher Hussey (London, 1929).

Section II

Other surveys currently available, listed in order of publication.

Herbert Read: *A Concise History of Modern Sculpture* (London, 1964); reprinted 1974, 1992. Read's is an unashamedly modernist account of formal development centred on Paris. He covers the period from Rodin to the mid-1960s, and particularly focuses on Matisse, Picasso, Brancusi, Arp, Pevsner, Gabo, and Moore.

Apart from Moore, there is surprisingly little mention of British sculptors. Read is interested in those who have dealt with 'the essential sculptural values which are tactile and haptic', and divides his sculptors into those who seek vitalism and those who seek harmony. Read's concern with 'vitalism' gives the survey an idiosyncratic flavour. This is a proselytizing text from a period when modern art was still seen as marginal.

A. Hammacher, *Modern Sculpture & Tradition* (New York, 1969; enlarged edn, 1988). A luxurious book, unremarkable in its coverage other than in devoting a whole chapter to Martini. Later chapters cover post-war period.

Albert Elsen, *Origins of Modern Sculpture: Pioneers and premises* (New York, 1974). An enlarged version of the catalogue for an exhibition at London's Hayward Gallery in 1973. An almost magazine-like approach to 26 topics, some covered in less than a page. These include modernity, the nude, sexuality, self-portraits, heads, partial figures, colour, light, pedestals, reliefs, etc. A formalist survey of types of sculpture, and of the materials and approaches associated with the evolution of modernism.

William Tucker: *The Language of Sculpture* (London, 1974); reprinted 1977, 1992. Originally a series of lectures, and still more or less an anthology of chapters treating individual subjects: Rodin, Brancusi, Picasso, González, Matisse, The Object, Tirgu Jiu, Gravity.

Rosalind Krauss, *Passages in Modern Sculpture* (Cambridge, Mass. & London, MIT, 1977; 9th edn 1993). This is a formalist account of major developments in twentieth-century sculpture, ranging from Rodin to the 1970s in seven thematic and roughly chronological chapters. These look at narrative time, analytic space, ready-mades, surrealist games, welded images, theatre, and minimalism. This is a major book, not a survey, but a series of arguments.

Albert Elsen, *Modern European Sculpture 1918–45, Unknown Beings and other realities* (New York, 1979). From the 1979 exh. at the Albright Knox Museum. Deals essentially with motifs or forms in sculpture: the figure, the head, the relief. Brings in discussions of science, the monumental, and Fascism as foils to modernist responses.

Jean-Luc Daval et al., *La Sculpture, L'Aventure de la Sculpture moderne—XIXe et XXe Siecles* (Geneva, 1986). Survey in bite-sized pieces with large, well-chosen illustrations, especially for the nineteenth century, which is also more satisfactorily served by the texts of Le Normand-Romain and Pingeot than is the twentieth century by its three allotted authors.

One might also mention *Rudolf Wittkower's Sculpture* (Harmondsworth, 1977/79/91). Only the last chapter deals with this century, but offers a useful survey, focusing on the carving versus modelling debate, and treats a wide variety of figures.

Section III

Post-war surveys

A spate appeared in the 1960s, especially from German-speaking countries. These books have the distinction of being better printed and set, with better illustrations, than the ones currently in print. The most significant:

Carola Giedion-Welcker, *Modern Plastic Art* (Zurich, 1937). A seminal book in its time, was revised in 1954 and 1960 (London, 1956 and 1961) as *Contemporary Sculpture, an Evolution in Volume and Space* with biographies of the artists and an important bibliography by Bernard Karpel, Librarian at the Museum of Modern Art, New York.

R.W. Valentiner, *Origins of Modern Sculpture* (New York, 1946). Acknowledges its debt to both Moholy-Nagy's *New Vision* and Giedion-Welcker's book above. Like Giedion-Welcker, Valentiner used old and new illustrations to give modern sculpture its ancient, even prehistoric, antecedents.

E.H. Ramsden, *20th Century Sculpture* (London, 1949), mainly plates, and *Sculpture: Theme and Variations* (London, 1953), which looks at sculpture as decorative/imitative/creative; at the Modellers/ the Carvers/ the Innovators; and at Social Connotations/ Philosophical Analogies and Aesthetic Conclusions. Uses historical material to 'prove' argument for modern sculpture.

Andrew Carnduff Ritchie, *Sculpture of the 20th Century* (New York, 1952), which has only a short text of some 30 pp. preceding plates. A MOMA exhibition. Chapters deal with The Object: Idealized/ purified/ dissected/ constructed etc.

Michel Seuphor, *The Sculpture of this Century* (Neuchatel & London, 1959, 1961). A predictable account, person by person, from Rodin through to contemporary period.

Eduard Trier, *Form and Space: the Sculpture of the 20th Century* (London, 1961) (orig. Berlin, 1960). Deals with the 'problem of form', 'the problem of meaning' and 'the problem of Purpose'.

Jean Selz, *Modern Sculpture: Origins and Evolution* (London, 1963). Selz's is an unusually wide-ranging picture of academic and modernist sculpture that takes in a number of nineteenth-century figures and focuses particularly on the years around the turn of the century.

Fred Licht, *Sculpture 19th & 20th centuries* (London, 1967). Informative pictorial survey concerning wide stylistic and geographical range.

A more recent catalogue, worth including here, is the Pompidou Centre's *Qu'est ce que la sculpture moderne?* (Paris, 1986). This large work, in French, covers the century up to about 1965, setting up a dialectic between culture and nature as sources of inspiration.

	Art	Event
1888		1888 Accession of Kaiser Wilhelm II
		1889 Paris: Exposition universelle
		1898 Centenary of French Revolution
		Bismarck dismissed
		Dreyfus affair splits France
1890	1890 Jules Dalou: 'Monument to Eugène Delacroix'	1890 Pan-German League founded
	1892 'Balzac' commissioned from Rodin	
	1893 London: Institute of Chartered Accountants	1893 Chicago: World's Columbian Exhibition
	Founding of National Sculpture Society of	
	America	
	1895 First Venice Biennale	
		1897 Brussels: Exposition universelle
	1898 Paris: Rodin's 'Balzac' shown at Salon	1898 Death of Bismarck
	and rejected as monument	
	1899 Moscow: 'Mir iskusstva' (World Of Art)	
	launched	
1900	1900 Amsterdam: Bourse (Berlage)	1900 Paris: Exposition universelle
	Paris: Republican holiday to inaugurate	
	Dalou's 'Triumph of the Republic'	
	1901 Weimar: Van de Velde founding director	1901 Buffalo Exposition
	of School of Arts and Crafts	Death of Queen Victoria
	1902 Death of Dalou	End of Boer War
	Munich: Debschnitz-Schule	Turin: International Exhibition
	Moscow: Arts Theatre (Shektel')	
	1903 Hagen: Folkwang Museum opens (Karl Ernst	1903 Russia: Pogroms
	Osthaus)	Mass emigration from Europe to USA
	Death of Paul Gauguin	
	1904 Founding of Society for British Sculpture	1904 St Louis Exposition
1905	1905 Maillol's 'Mediterranean' shown at Salon	1905 Russia: Tsar issues October Manifesto
	d'Automne	promising constitution and elected parliament
	Venice: Bistolfi wins gold medal for sculpture	Crew of battleship Potemkin mutinies
	at Biennale	Norway separates from Sweden
	Dresden: Die Brücke group forms	
	Moscow: first number of *Iskusstvo*	
	Brussels: Palais Stoclet begun	
	Death of Constantin Meunier	
	1906 Paris: Gauguin Retrospective at Salon	1906 Russia: Prime Minister Stolypin introduces
	d'Automne; Diaghilev organizes Russian	period of stability
	section	UK: Liberal landslide
	Rodin's 'Thinker' erected at Panthéon	France: separation of Church and State
	Berlin: Haus Rheingold	
	Hamburg: inauguration of Lederer's Bismarck	
	Monument	
	1907 London: British Medical Association building	1907 Foundation of Der Deutsche Werkbund
	(Holden)	Persia: first successful oil drilling
	Death of Augustus Saint-Gaudens	
	1908 Steichen photographs Rodin's 'Balzac'	1908 Congo becomes a Belgian colony
	Die Ausstellung München	Austro-Hungarian Empire annexes Bosnia-
	Moscow: 'Golden Fleece' Salon	Herzegovina
		Bulgaria becomes independent
		Portugal: assassination of King
		Prague: International Exhibition
		USA: invention of bakelite and first Model T
		Ford car
	1909 Paris: inauguration of Rodin's 'Hugo'	1909 Iran: oil drilling begins
	in Palais-Royal	
	Manifesto of Futurism published in *Figaro*	
	Paris: first season of Ballets Russes (continues	
	until 1929)	
	Brussels: Carpeaux retrospective	
	Berlin: AEG Turbine factory (Behrens)	

Art		Event	
1910			
1910	Milan: publication of *Manifesto of Italian Futurist Painters* Paris: Salon d'Automne invites Munich section St Petersburg: 'Union of Youth' Moscow: 'Jack of Diamonds'	1910	Portugal: military insurgents overthrow monarchy and declare republic
1911	Alfeld-an-der-Leine: Fagus Factory (Gropius and Meyer)	1911	Portugal: Afonso Costa initiates programme of democratic reform Rome and Turin Expositions
1912	Paris: Galerie Bernheim-Jeune, exhibition of Futurist paintings travels to London, Brussels, Amsterdam, Munich Salon d'Automne: 'Maison Cubiste' Boccioni publishes *Technical Manifesto* of Futurist Sculpture	1912	Balkan League formed by Serbia and Bulgaria, joined by Greece First Balkan War Italian colonization of Libya
1913	Paris: opening of Théâtre des Champs-Elysees Leipzig: Volkerschlacht Monument New York: Armory of the 69th Infantry, International Exhibition of Modern Art Picasso's earliest Cubist constructions first reproduced in 'Les Soirées de Paris'	1913	Albania and Macedonia achieve independence from Turkey USA: conveyor belt assembly technique introduced by Henry Ford
1914	Cologne: Werkbund Exhibition	1914	June, Assassination of heir to Austro-Hungarian throne; July, Austro-Hungarian government challenges Serbian government with Ultimatum, which Serbia largely accepts, but Austria declares war on Serbia; refuses international conference seeking mediation August, German troops occupy Luxembourg and then Belgium Germany declares war on Russia and France; Russia defeated at battle of Tannenberg Britain declares war on Germany September, Battle of the Marne
1915			
1915	Petrograd:'Tramway V' exhibition shows Malevich and Tatlin, as does 'The Last Futurist Exhibition of Pictures: 0-10' New York, *291* magazine launched Rome: Monument to Victor Emmanuel II Death of Gaudier-Brzeska	1915	Panama–Pacific International Exposition Italy enters war on side of Entente in return for territories to the north and east
1916	Zurich: Dada group at Cabaret Voltaire Hanover: founding of Kestner-Gesellschaft Death of Boccioni Death of Rik Wouters New York: Bourgeois Gallery 'Modern Art after Cézanne'	1916	Battle of the Somme; July–November Germany; Social Democrats opposing war found Spartacus League Dublin: Easter Rising
1917	Deaths of Rodin and Degas First issue of *De Stijl* appears Zurich: first issue of *Dada* New York: Grand Central Palace, First Annual Exhibition of the Society of Independent Artists Moscow: Narkompros (People's Commissariat for Enlightenment) established under Lunacharsky	1917	USA enters war as 'associate' 2nd Battle of Verdun 3rd Battle of Ypres (Passchendaele) Russia: riots by civilians and soldiers, Tsar abdicates; April, Lenin and Trotsky return from abroad; Provisional government reorganized by Kerensky; November, storming of Winter Palace by Bolsheviks Finland declares independence
1918	Russia: Tatlin heads IZO (Visual Arts) Narkompros, Moscow Academy of Fine Arts replaced by Free State Art Studios (SVOMAS) Lenin: Decree of Monumental Propaganda Museums of Painterly Culture established in cities Berlin: first Dada evenings First meeting of Novembergruppe Holland: publication of first De Stijl manifesto Rome: first issue of *Valori Plastici*	1918	Petrograd: Bolsheviks dissolve Constituent Assembly; constitution sets out RSFSR March: Treaty of Brest-Litovsk takes Russia out of war and cedes Poland, Ukraine, Finland and Baltic provinces to Germany November, Compiègne, Germany signs armistice with Allies Russian Civil War; until 1920 Europe has sustained over 8 million deaths in battle Declaration of Czechoslovakian republic

Art			Event	
1918	1918	Death of Duchamp-Villon	1918	Proclamation of Polish republic Proclamation of Austrian republic Proclamation of United Kingdom of Serbs, Croats and Slovenes November Revolution in Germany; Kaiser abdicates, republic declared UK: First stage of women's suffrage
	1919	London: erection of Cenotaph, Whitehall Weimar: opening of Bauhaus Vitebsk: Malevich replaces Chagall as Director of Art Institute Tatlin moves from Moscow to Petrograd Free Art Studios Paris: launch of *Littérature,* edited by Aragon, Breton, Soupault Berlin: I B Neumann gallery, Arbeitsrat show of 'Unknown Architects' Publication of *Ja! Stimmen*; replies to Arbeitsrat für Kunst Arbeitsrat für Kunst and Novembergruppe merge Death of Wilhelm Lehmbruck	1919	Russia: Founding of Third International (Komintern) for propaganda abroad Founding of KPD (German Communist Party) Berlin: January, Spartacus rising Weimar: National Assembly meets and adopts Weimar Constitution Versailles Peace Treaty signed, establishes League of Nations which excludes Germany and which USA fails to join Milan: Mussolini forms Fascio di combattimento Spanish flu epidemic Amritsar: massacre by British army
1920	1920	Moscow: Formation of INKhUK (Institute of Artistic Culture), and then in Petrograd and Vitebsk Gabo and Pevsner publish *Realist Manifesto* Exhibition of model for Tatlin's 'Monument to the Third International' Svomas replaced by VKhUTEMAS Holland: Publication of second De Stijl manifesto Berlin: Erste Internationale Dada-Messe Cologne: Dada-Vorfrühling Paris: Dada evenings First issue of *L'Esprit Nouveau* Death of Modigliani New York: Creation of Société Anonyme by Duchamp, Man Ray, Dreier	1920	Germany: Kapp Putsch defeated by General Strike after government retreat to Dresden Munich: founding of NSDAP (National Socialist German Workers' [or Nazi] Party) USA: Women's Suffrage Treaty of Rapallo; Italy and Yugoslavia settle Adriatic claims UK: founding of Communist Party, funded by Comintern Ireland: Separate parliaments north and south Poland invades Russia; in October concludes armistice Hungary: Miklos Horthy de Nagybanya begins 20-year Regency
	1921	Third De Stijl manifesto Moscow: *5 x 5 = 25* exhibition Third OBMOKhU exhibition Creation of First Working Group of Constructivists Paris: Galerie Montaigne, Salon Dada is last major Dada show Prague: Banka Legii building Oslo: Vigeland signs contract with city Amsterdam: Eigen Haard housing Death of Adolf von Hildebrand	1921	USSR: Kronstadt revolt ends legal opposition to Bolsheviks 10th Party Congress; birth of New Economic Policy (NEP) Hitler becomes Chairman of NSDAP Southern Ireland becomes Irish Free State: Civil War (1921–3)
	1922	Berlin: Van Diemen Gallery, Erste russische Kunstausstellung Düsseldorf: Congress of Progressive International Artists Weimar: International Congress of Constructivists and Dadaists Berlin: Publication of 'Veshch'/Gegenstand/Objet' Moscow: 'Exhibition of Pictures of Realistic Trends' marks beginning of Socialist Realism and AKhRR group (Association of Artists of Revolutionary Russia) Popova and Stepanova design for Meierhold's theatre Amsterdam: Mondrian 50th birthday retrospective	1922	Declaration of USSR 11th Party Congress, Stalin becomes General Secretary Italy: Fascist gathering for 'March on Rome' preceded by King Victor Emmanuel III's invitation to Mussolini to be Prime Minister; forms a cabinet; Fascist government established Turkey: Ataturk forms Republic Egypt: opening of Tutankhamun's tomb

Art	Event

1922

1922	Paris: Breton relaunches *Littérature* second series
	Chicago: inauguration of first part of Taft's 'Midway Beautification'
1923	Weimar: Bauhaus Exhibition, 'Art & Technology – A New Unity'
	Greater Berlin Art Exhibition
	Hanover: First edition of *Merz* and Schwitters begins *Merzbau*
	Paris: Galerie de l'Effort Moderne, De Stijl architecture exhibition
	Utrecht: Schröder House
1924	Paris: Publication of Surrealist manifesto
	Magazine *La Révolution Surréaliste* launched by Naville and Peret
	Vienna: International Ausstellung neuer Theater-Technik
	Death of Popova; retrospective

1923	Germany, KPD and NSDAP (National Socialist German Workers' Party) banned
	Mussolini establishes permanent Fascist militia
	London: Wembley, Great Exhibition
1924	Death of Lenin
	UK recognizes USSR
	UK: First Labour Government
	Dawes Plan restructures Germany's war debt on more generous terms

1925

1925	Moscow: founding of Society of Easel Artists (OST) and Four Arts Society represent further alternatives to Constructivism
	Paris: Galerie Pierre, first exhibition of Surrealist painting
	Last issue of *L'Esprit Nouveau*
	Exposition des Arts Décoratifs et Industriels Modernes, Paris
	Bauhaus moves to Dessau
1926	Dessau: Gropius's new Bauhaus building opens
	El Lissitzky designs Abstract Cabinet for Hanover Provincial Museum
	VKhUTEMAS becomes VKhUTEIN
	Zurich: International Exhibition of Abstract art
	Paris: opening of Galerie Surréaliste
	New York: International Theatre Exhibition
1927	INKhUK is closed
	Stuttgart: Werkbund Exhibition with Weissenhofsiedlung
	Death of Oto Gutfreund
1928	Strasbourg: opening of Aubette *Café Bar*
	Cologne: International Pressa Exhibition
	USSR: 'October' group set up
	London: Underground Headquarters
	Last regular issue of *De Stijl* magazine
	First edition of Moholy-Nagy's *New Vision*
	Death of Medardo Rosso
1929	Paris: launch of 'Documents'
	Last issue of *La Revolution Surréaliste* presents Second manifesto
	Alfred Barr asked to head new Museum of Modern Art in New York; opens November
	Moscow: Lunacharsky resigns
	Garches: Le Corbusier's Villa Savoye
	Basel: CIAM debates low-cost housing
	Wroclaw: Werkbund Exhibition
	Moholy-Nagy publishes *Vom Material zur Architektur*
	Lódź: founding of 'a.r.' (revolutionary artists)
	Death of E.-A. Bourdelle

1925	Hitler reforms NSDAP from within
	Mussolini assumes dictatorial powers
	Locarno 'Honeymoon' Treaty, France, Germany and Belgium to respect frontiers, with British and Italian guarantees
1926	Portugal, Military coup d'état overthrows republic
	Formation of Hitler Youth
	Germany joins League of Nations
	Italy: police state established
	UK: General Strike
	Imperial Conference provides for changing definition of the British Commonwealth
1927	Stalin triumphs over Trotsky who is expelled from Party
	BBC founded
1928	Portugal, Antonio Salazar accepts Ministry of Finance and thus extends his power to reign as first minister 1932–68
	Italy: Fascist Party constitutionalized
	USSR: First Five Year Plan (to 1932)
	UK: Representation of the People Bill extends suffrage to woman aged 21 to 30
	Kingdom of Serbs, Croats and Slovenes renamed Yugoslavia
1929	Wall Street Crash, October 29
	Young Plan further reduces Germany's war debt
	Founding of Kampfbund für deutsche Kultur by Rosenberg
	Barcelona: World Exhibition
	Lateran Accords, reciprocal recognition between Italy and the Vatican
	USSR: Stalin emerges as undisputed leader
	Yugoslavia: Dictatorship of King Alexander

1930

| 1930 | Paris: Salon des Artistes Décorateurs |
| | Paris: International Building Exhibition |

| 1930 | Leipzig: International Fur Trade Fair |

	Art		Event	
1930	1930	Paris: creation of Cercle et Carré and Art Concret groups Paris: launch of *Le Surréalisme au Service de la Révolution* (ed.Breton) Kharkov: Second International Congress of Revolutionary Writers VKhUTEIN dissolved	1930	Germany: First National Socialist participation in a 'Land' government; (Thuringia), cabinet makes first Nazi appointment, leads to 'Ordinance against Negro Culture' Romania: King Carol begins personal rule
	1931	Paris: creation of Abstraction-Création Publication of Dalí's text on the Surrealist object in SASDLR New York: Rockefeller Center scheme initiated Death of Theo van Doesburg	1931	Japan seizes Manchuria from China Paris: Exposition Coloniale Spain becomes a republic on abdication of King Alfonso XIII Statute of Westminster provides legal framework for Commonwealth self-government UK: National Government Coalition France: launch of Chantiers du Cardinal
	1932	New York: MOMA, Modern Architecture: International Exhibition, by Philip Johnson, Henry-Russell Hitchcock and Barr, travelling show Rome: inauguration of Foro Mussolini Dessau: municipality votes to close Bauhaus	1932	USSR: Decree 'On the Reconstruction of Literary and Art Organizations' makes group activity illegal NSDAP emerges as strongest party in Reichstag elections Peak unemployment in Britain British Union of Fascists founded Ottawa: Imperial Conference
	1933	Berlin: Bauhaus closed Paris: SASDLR terminates as *Minotaure* is launched Picasso's sculpture studio at Boisgeloup published in photographs by Brassaï London: creation of Unit One and Artists' International Association (AIA)	1933	Germany: Hitler assumes Chancellorship; Enabling Law grants him dictatorial powers for four years Germany leaves League of Nations, as does Japan Reichstag fire blamed on KPD Civil Service laws instituted discriminating against Jews First concentration camp established Opponents of the regime begin to emigrate Law against refounding other political parties Spain: establishment of right wing Falango Española USSR: Second Five Year Plan (1933-7) USA: Franklin D Roosevelt initiates New Deal to alleviate Depression
	1934	Moscow: Competition for Palace of the Soviets won by Iofan, Shchuko and Gel'freikh Moscow Underground begun Death of Pablo Gargallo	1934	Socialist Realism ratified at First All-Union Congress of Soviet writers Italy: introduction of 22 official professional corporations making up the 'Corporative State' Germany: President Hindenburg dies and Hitler assumes Presidency Austria: Chancellor Dollfuss assassinated London: Labour take control of County Council
1935	1935	Lucerne: 'Thèse, Anthithèse, Synthèse' exhibition London: AIA mounts 'Art against Fascism and War' Paquebot *Normandie* launched Death of Gaston Lachaise Death of Malevich	1935	Germany: Nuremberg Laws deprive Jews of civil rights Italy invades Abyssinia (Ethiopia); League of Nations vote for economic sanctions in protest; Manchuria and Abyssinia show League to be ineffective 7th Congress of the Comintern adopts a United Front against Fascism USA: Works Progress Administration
	1936	Paris: Charles Ratton Gallery, 'Exhibition of Surrealist Objects' End of Abstraction-Création New York: Museum of Modern Art, March, 'Cubism and Abstract Art'; December, 'Fantastic Art, Dada and Surrealism' New York: Foundation of Association of American Abstract Artists	1936	Spain: General Franco unconstitutionally declared Head of State, recognized by Germany and Italy, Republican government flees to Valencia. League of Nations adopts policy of non-intervention Spanish Civil War to 1939 France: Popular Front in government Berlin: Olympic Games

	Art	Event
1936	1936 — London: New Burlington Galleries, 'International Surrealist Exhibition'	1936 — German troops recoccupy Rhineland Mussolini's Declaration of Empire Rome–Berlin axis formed USSR: show trials UK: Royal abdication crisis Greece: Metaxus becomes dictator
	1937 — Chicago: Moholy-Nagy's New Bauhaus New York: founding of Museum of Non-Objective painting, later the Solomon R. Guggenheim Museum	1937 — Paris: Exposition internationale des arts et techniques Rome: Mostra Augustae della Romanita Munich: Great German Art and Degenerate Art exhibitions Nuremberg Rally Creation of Republic of Ireland Bombing of Guernica by German Condor Legion Republicans flee to Barcelona Fascist powers sign Anti-Comintern Pact
	1938 — Romania: inauguration of Brancusi's monument at Tirgu Jiu London: '20th century German Art' exhibition Paris: Galerie Beaux-Arts, Exposition Internationale du Surréalisme New York: MOMA, 'Bauhaus 1919–1928' Amsterdam: 'Abstract art' exhibition and International Surrealist exhibition Death of Ernst Barlach	1938 — Germany invades Austria; forced Anschluss (union) Partition of Czechoslovakia: Britain and France agree to Germany taking majority-German speaking areas Reichskristallnacht, destruction of Jewish synagogues Munich Conference: Chamberlain, Daladier, Hitler and Mussolini agree on transferral of Sudentenland to Germany
	1939 — Berlin: burning of seized degenerate art in Central Fire Department Lucerne: Degenerate art auction Paris: First Exhibition of the Salon des Realités Nouvelles Inauguration of Rodin's 'Balzac'	1939 — March, Hitler occupies Prague thus destroying basis of Chamberlain's policy of appeasement Barcelona falls; Franco establishes personal dictatorship (–1975) Italy invades Albania New York: World's Fair Italo-German 'Pact of Steel' Nazi–Soviet Pact agrees on partition of Poland German invasion of Poland Britain and France declare war on Germany USSR: All-Union Agricultural Exhibition
1940	1940 — France: American Committee of Aid to Intellectuals helps French artists in unoccupied France Death of Eric Gill Death of Charles Malfray	1940 — German occupation of Denmark and Norway German conquest of France, Holland, Belgium and Luxemburg June, German army enters Paris, France signs armistice Marshall Pétain recognized as Head of State of unoccupied Vichy France Third Republic legally abolished London: Blitz begins Three-Power Pact signed by Germany, Italy and Japan and also Romania and Hungary Mussolini declares war and invades France
	1941 — Death of Georg Minne Visit to studio of Arno Breker by group of French sculptors Death of El Lissitzky Death of Hermann Blumenthal on the Russian front	1941 — Yugoslavia: coup sets up pro-Allied government German Invasion of Russia, Yugoslavia and Greece Beginning of Leningrad blockade Japanese attack on Pearl Harbor Germany declares war on USA
	1942 — Death of Julio González New York: 'First Papers of Surrealism' and Art of the Century Gallery open Pierre Matisse gallery shows 'Artists in Exile' Launch of VVV Death of John B Flannagan	1942 — German troops occupy Vichy France Midway and El Alamein key Allied victories UK: Beveridge Report
	1943 — Death of Otto Freundlich in a Polish concentration camp	1943 — Allied Invasion of Italy

	Art		Event	
1943	1943	Death of Moissey Kogan in a German concentration camp	1943	Grand Council of Fascism votes Mussolini out of office
		Death of Oskar Schlemmer		German surrender at Stalingrad
		Death of Sophie Taeuber-Arp		Allied bombing of Germany begins
		Death of Gustav Vigeland		
	1944	Deaths of Aristide Maillol and Robert Wlérick	1944	Italy: Allies break through Gustav Line to capture Rome and Florence
				Allied Advance 'D' Day, 6 June
				August, Liberation of Paris
				October, Allies recognize de Gaulle's provisional government
				Greece: Civil War (1944–9)
1945	1945	Deaths of Ludwig Kaspar and Käthe Kollwitz	1945	Italy: Allies break through Gothic Line to capture Bologna, find Northern Italy largely freed by partisan resistance
				February, Yalta Conference: Stalin, Roosevelt and Churchill
				German Surrender, 8 May
				August, Potsdam Protocol. The Allies – Britain, France, USSR and USA – assume power in Berlin and in occupied zones
				Atomic bombing of Hiroshima and Nagasaki marks beginning of Cold War between USA and USSR
				August, Japanese Surrender
				Over 5 million Jews discovered to have perished in Nazi camps
				Mussolini shot
				United Nations formed
				Yugoslavia becomes republic
	1946	Death of Despiau	1946	Churchill coins the term 'Iron Curtain'
		Death of Moholy-Nagy		Nuremberg trials of Nazi war criminals
		Death of Elie Nadelman		Italy votes to become a republic
	1947	Death of Georg Kolbe		
		Death of Arturo Martini		

Index

Oxford History of Art

Titles in the Oxford History of Art series are up-to-date, fully-illustrated introductions to a wide variety of subjects written by leading experts in their field. They will appear regularly, building into an interlocking and comprehensive series. Published titles are in bold.